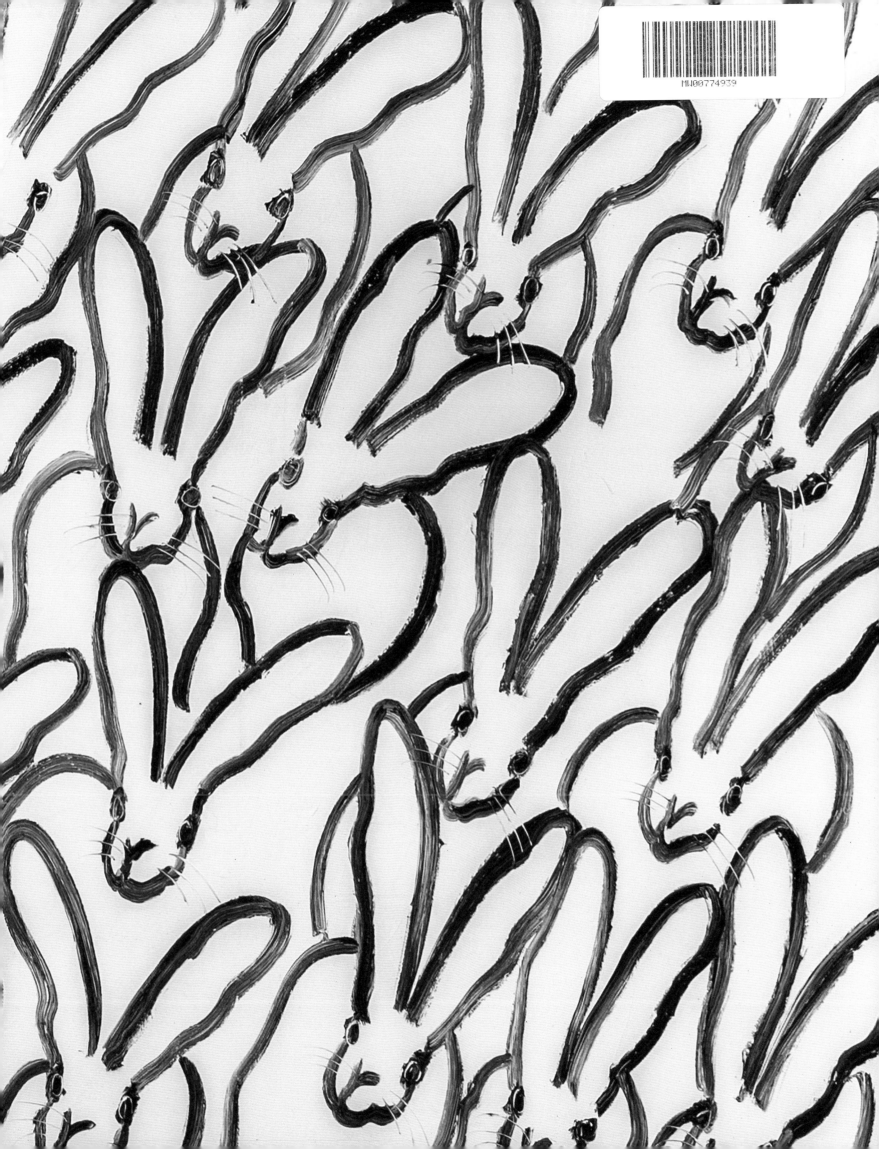

THE SPIRITED HOMES OF
HUNT SLONEM

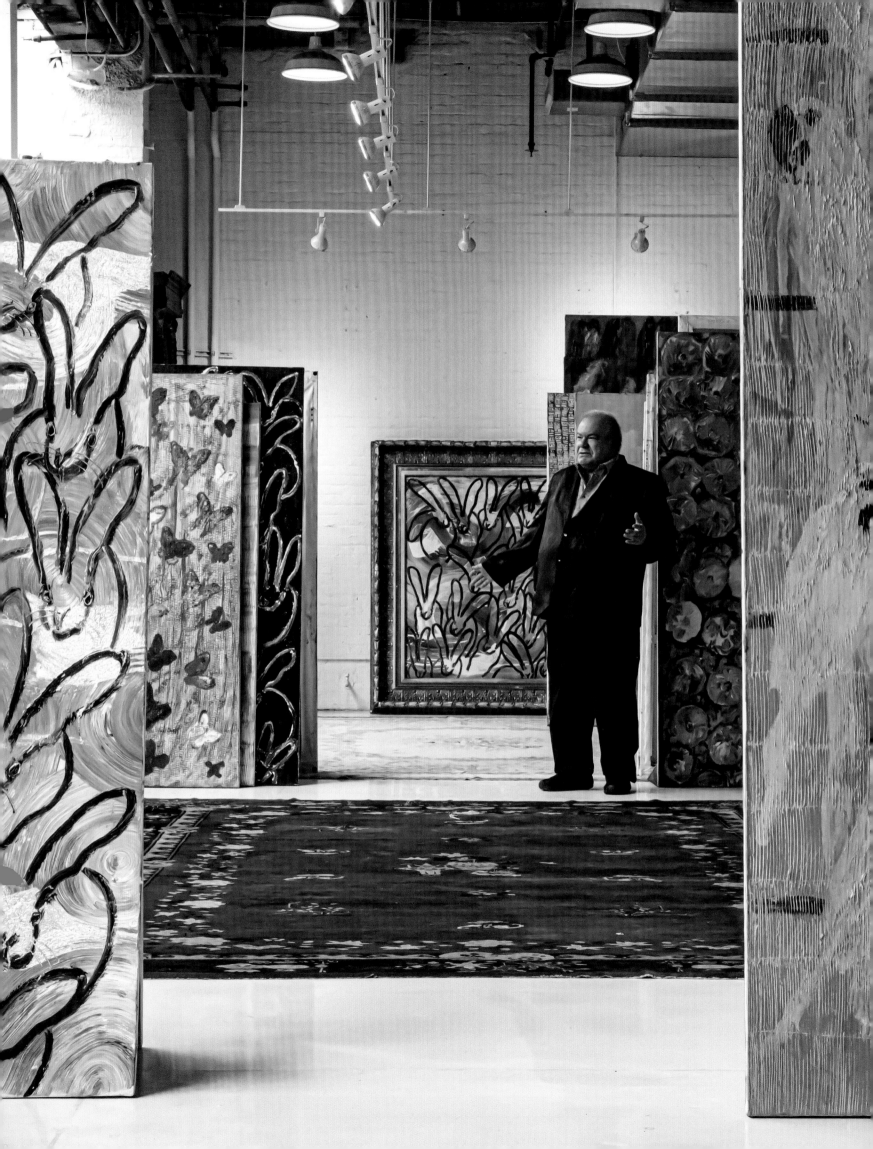

THE SPIRITED HOMES OF
HUNT SLONEM

BRIAN D. COLEMAN
PHOTOGRAPHS BY JOHN NEITZEL
FOREWORD BY WHOOPI GOLDBERG
PREFACE BY HUNT SLONEM

Gibbs Smith

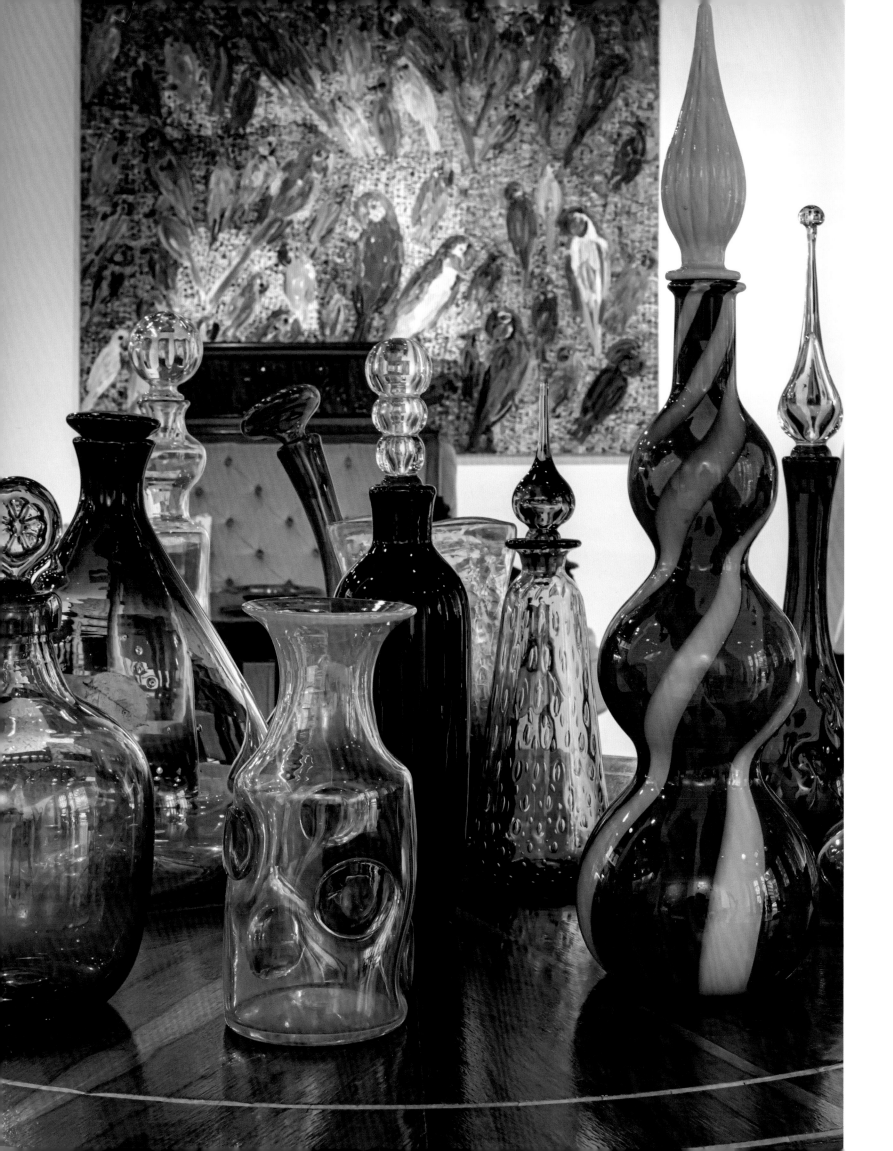

To my husband, JJ Divino, and my longtime editor,
Madge Baird, both of whom made this project possible.
—Brian D. Coleman

I dedicate this work to three mentors who helped me
some forty years ago: Roy Gonsenhauser, Dave Wilder,
and John Gotman. Thank you for taking an interest
in me and encouraging me to "go for it"!
—John Neitzel

Contents

8 **Foreword** by Whoopi Goldberg

11 **Preface** by Hunt Slonem

12 Introduction

14 SEARLES CASTLE

64 BELLE TERRE

120 WATRES ARMORY

170 MADEWOOD

200 CORDTS MANSION

226 LAKESIDE MANSION

268 THE STUDIOS

304 Acknowledgments

Foreword by Whoopi Goldberg

There are many times in the day that I think about Hunt Slonem. I think about him when I go into my office and am surrounded by a million monkey eyes looking at me. Or when I go into my bedroom, where Josephine Baker is mid-switch in her dance. Sometimes when I'm going downstairs, I look over to see a bunny looking at me, and I get nervous because I don't have enough lettuce for him. There's something really wonderful about being surrounded by Hunt's work; he makes me laugh; he makes me giggle. And yet, when you meet him, that's not the first thing that comes to mind. The first thing that comes to mind is . . . this guy, he has a lot of class . . . he has a lot of style . . . and his ideas are fantastic. And sometimes when you're talking to him, you think, "What's going on in that brain of yours?" I once went to see him and he was surrounded by birds—birds in cages, birds flying around, birds talking—and I just thought, wow, this is extraordinary.

I always wondered what makes him paint, what he decides to paint at any given time. Hunt is always impeccable. He is extraordinary and unique. His art takes many different turns. He is interested in painting so many different types of things that it's never boring, never dull, and that's what you want in an artist you love. You want your favorite artist to be funny and amusing and engaging. Hunt makes you feel like a million bucks. He makes you feel like you know what you're looking at when you look at his art. His work brings out the "you" in "you." It brings out the joy deep inside you. Hunt is one of a kind, and that is what I like more than anything else.

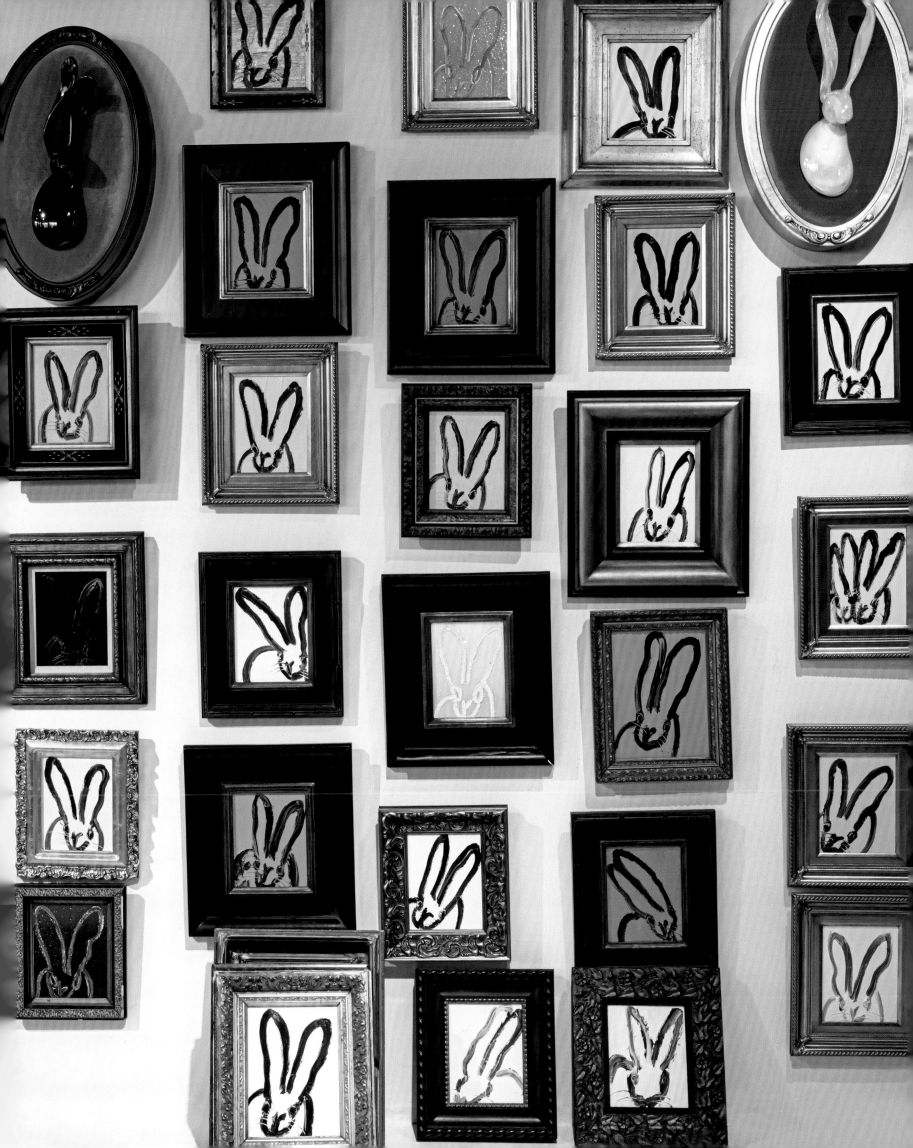

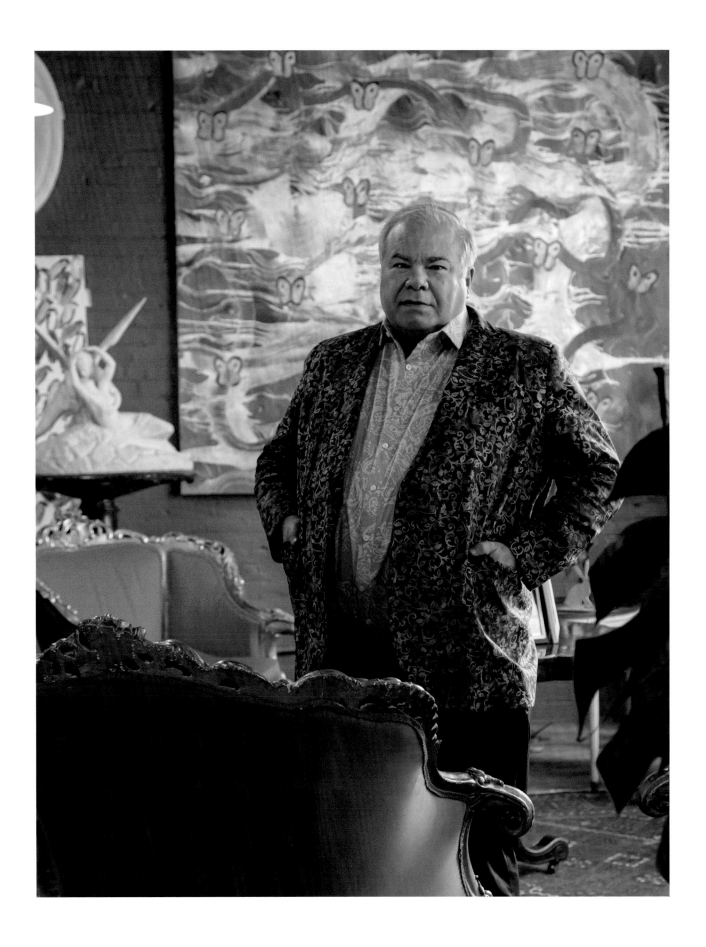

Preface by Hunt Slonem

This book began when I was looking for a photographer to capture my homes. Allison Dayka, who manages my social media and gallery relations, discovered New York photographer John Neitzel, and we both thought his portfolio was stunning. We asked him to shoot Belle Terre and were so pleased, we had him photograph several more of my homes. John put together a little pamphlet, *Hunt's Homes*, and I loved it! John also showed it to author Brian Coleman, with whom he had produced *Zuber: Two Centuries of Panoramic Wallpaper*. Synchronously, Brian, I learned, had been the author of another book I love for historic color ideas: *Farrow and Ball: The Art of Color*; it's been of great use and a tremendous tool for me.

I met with Brian and John, and they proposed a new work on my homes, including Antebellum Madewood and my most recent acquisition, Searles Castle (known as Kellogg Terrace) in Great Barrington, Massachusetts, neither of which had been photographed previously. So, working with publisher Gibbs Smith, we began. Brian and John traveled to New York City, Louisiana, Pennsylvania, the Berkshires, and upstate New York photographing my homes and studios.

It's been an exciting collaboration. Brian and I spoke often, editing and fine-tuning the text, and we frequently discussed antiques and architecture as well. My homes are my life's work—making old houses into a new form of my art.

Introduction

Hunt Slonem's two main passions in life, he explains, are painting and collecting. His colorful, neo-Expressionist paintings of nature—birds, butterflies, tortoises, and rabbits, as well as his portraits of famous figures—from Abraham Lincoln to Queen Elizabeth—are in over 250 museum collections and have been shown in over 350 solo shows and galleries around the world.

Another side to Hunt's work is his love of antiques and architecture, in particular the Victorian era. He has collected nineteenth-century portraits and porcelains, parlor suites and marble busts, colorful jardinières, and pedestals by the thousands. In the spirit of *Gesamtkunstwerk*, a German word that translates as "total works of art," in which multiple art forms are combined for a creative whole, Hunt has purchased large-scale historic mansions to display his myriad antiques and his art making.

The Spirited Homes of Hunt Slonem reveals six cohesive homes that Hunt has restored, five of which he now maintains as private residences. Lakeside, a dusty pink, 1832 Southern mansion deep in the Louisiana countryside, was renovated with its patina of faded elegance carefully preserved, rooms updated with strong colors of Mykonos blue, Pompeian red, tangerine, and coral and filled with nineteenth-century Louisianan portraits, important Gothic Revival furniture, and Hunt's paintings of nature, from butterflies to birds and bayous.

Hunt had admired Madewood since studying it at college at Tulane over fifty years ago. The 1846 mansion by architect Henry Howard is considered one of his masterpieces. The Greek Revival home is set among live oak trees on Bayou Lafourche in southeastern Louisiana. Hunt was able to purchase it in 2018, and after significant structural work, he reinterpreted its nineteenth-century interiors with period-appropriate, Antebellum antiques, ornate window treatments, upholstered furniture, and his colorful paintings.

While moving studios in 2015, Hunt found the historic Watres Armory in Scranton, Pennsylvania. The 100,000-square-foot Romanesque Revival building, once considered one of the finest armories in the country, was then largely empty and a perfect place to store and display his collections of antiques as well as many of his larger works that had been rolled up and placed in storage.

Hunt enjoys the challenge of a large-scale project and embarked on a two-year restoration, using dozens of brilliant hues from the color wheel to distinguish the various rooms, and turned the military warehouse into a magical setting.

When Belle Terre, an elegant, 1906 Georgian Revival mansion in upstate New York's Delaware County, came on the market, Hunt drove there in a snowstorm to see it. The 35,000-square-foot mansion, once the summer home of copper baron James McLean, featured grand spaces, classical molding and woodwork, and sixteen bedrooms. There would be room for large events—after all, Eleanor Roosevelt and McLean's daughter, Alice, had once given a party there for 6,000 guests. The mansion had later been divided into offices and cubicles; following a several-year restoration, Hunt brightened the interiors with bold colors. Rooms were filled with Staffordshire figurines, Georgian-style antiques, and Hunt's colorful paintings, often displayed in period frames that complemented and accented the home's classic architecture.

The Berkshires in western Massachusetts are home to many Gilded Age mansions, including Searles Castle, an 1885 turreted, stone castle originally designed by Stanford White and considered one of the earliest great houses in the region. With more than forty rooms, seven turrets, and thirty unique fireplaces, it is set behind gray stone walls on seventy acres. Hunt was attracted to its massive scale and proportions and, after purchasing it in 2021, began the process of returning it to a private residence for the first time since 1920. He filled the rooms with combinations of fine antiques and his own artwork. Furniture upholstered in his fabrics—such as "Star of India," with multicolored tortoises—highlighted the rich oak paneling and woodwork, returning the castle's interiors to the opulence of its origins.

All the photography was created specifically for this book, impeccably composed and framed by John Neitzel to bring out the themes of each home and to share Hunt's extraordinary, expansive sense of his art making. It was a pleasure and privilege to work with John and Hunt to capture all the grand homes in a way that inspires a personalized look at design. We hope you enjoy your palatial tour.

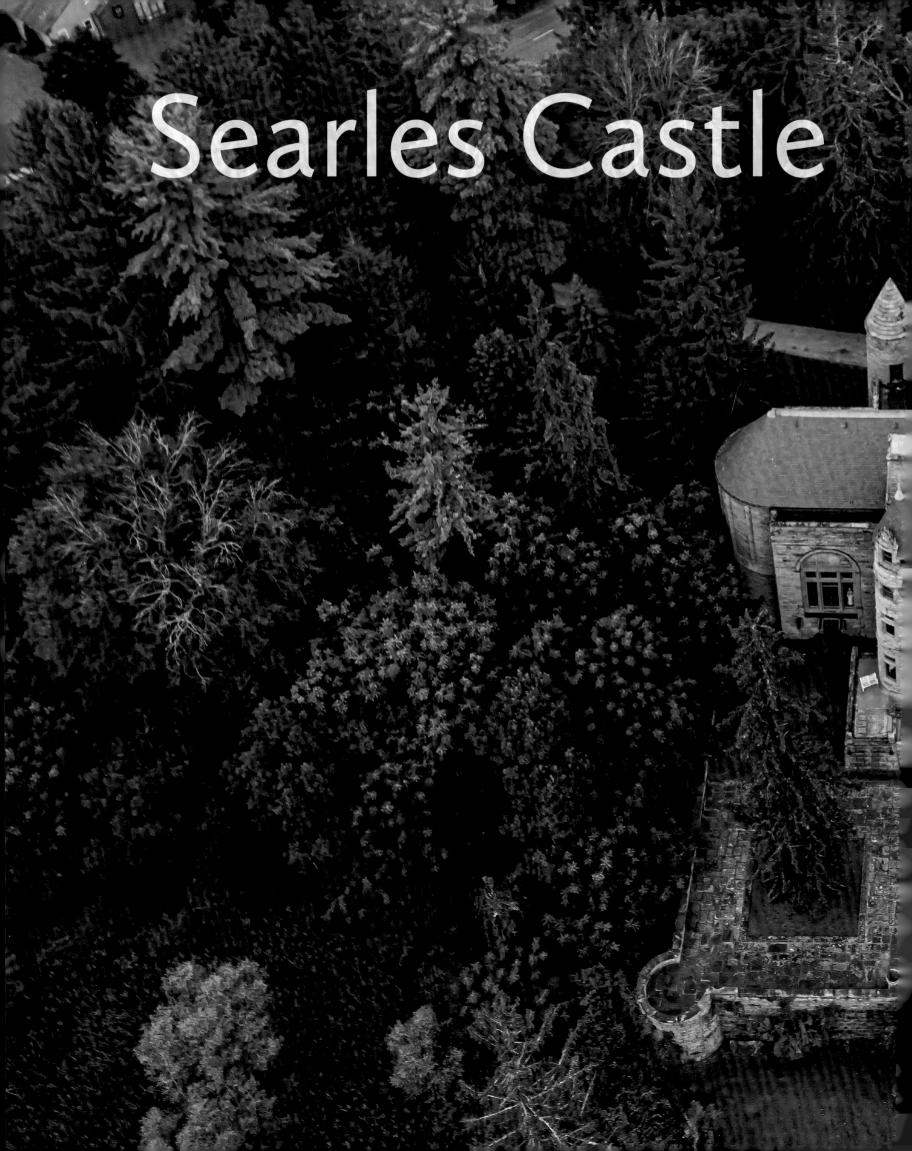

Searles Castle

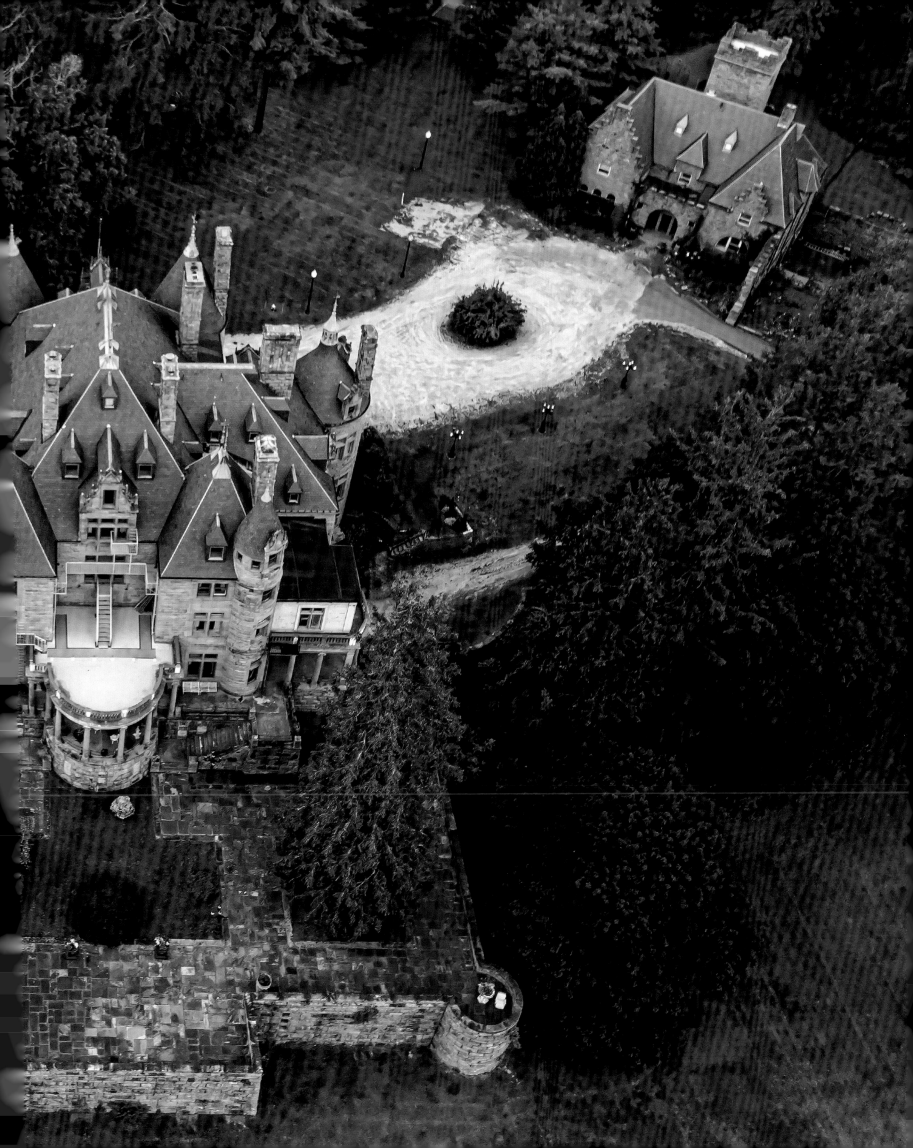

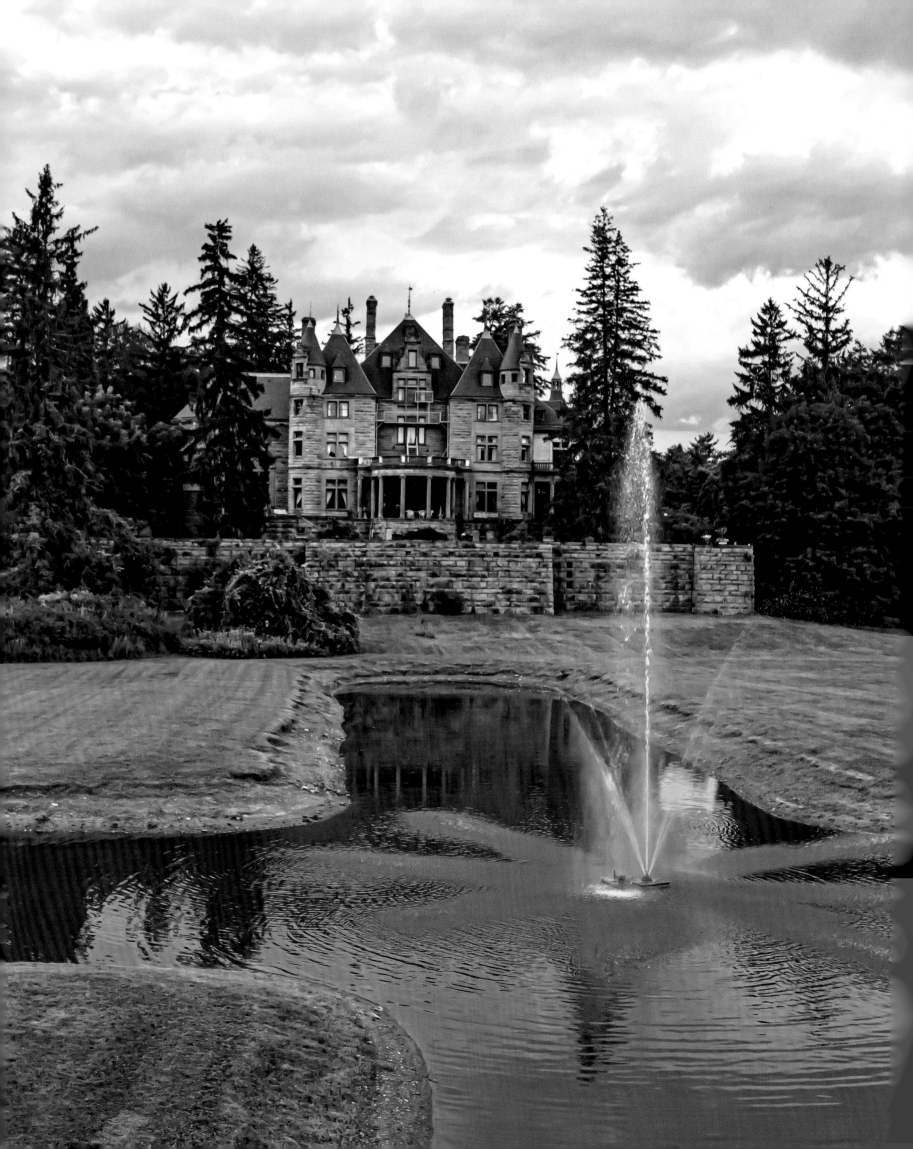

Searles Castle Great Barrington, Massachusetts

The Gilded Age is a term coined by Mark Twain to describe the period following the Civil War from roughly 1870 to 1900. It was a "glittering" time of rapid economic growth (before government regulations) that allowed entrepreneurs to accumulate vast fortunes. Many built mansions to celebrate their wealth, and in the Northeast a favorite locale was the Berkshires, a scenic section of western Massachusetts.

One such Gilded Age mansion is Searles Castle. Constructed between 1885 and 1888 for Mary Sherwood Hopkins, wife of railroad tycoon Mark Hopkins, on land she had inherited from her Kellogg relatives, the castle was initially named Kellogg Terrace.

Designed by McKim, Mead and White and thought to be one of Stanford White's best baronial works, it is a stately, seven-story edifice reminiscent of a medieval French chateau, solidly built of blue dolomite quarried nearby. It has forty-eight rooms, seven turrets, thirty-six fireplaces, a two-story domed Music Hall, and even a dungeon in the basement. Set on seventy acres in the center of Great Barrington, it is protected by gray stone turreted walls and large iron gates and is sited toward expansive, southeastern views over a private pond and fountain, with a classic Doric pavilion beyond. Following Mark Hopkins's death in 1878, Mary Hopkins surprised family by marrying her decorator, Edward F. Searles, who had worked on their San Francisco Nob Hill mansion with the Herter Brothers firm. Although twenty-one years her junior, he was a handsome and charismatic man who was well versed in the arts and music as well as interior design; he took over the task of overseeing the castle's construction and decoration. It became known as Searles Castle following its completion.

No cost was spared. Richly veined and colored marble in red, green, and black is used on many of the floors and walls. The entry Great Hall was already paneled in hand-polished English oak said to have been taken from two antique English ships towed to the United States and taken apart for the wood. An ornate, vaulted plaster ceiling inspired by Windsor Castle has been added to a circular reception room off the Great Hall, while the large upstairs hall, which functioned as the family living

The castle overlooks a private pond and fountain.

room, is capped by an elaborate plaster ceiling modeled after a ducal palace in Venice. The dining room is paneled in antique English oak with a red marble mantel. The center of the home features a light-filled, two-story atrium opening to the rear loggia, anchored by sixteen pink, round columns; walls are covered with polished ivory-rose marble from Africa set on white marble floors, all of which are reflected in floor-to-ceiling mirrors inset along the eastern walls.

Following Mary's death in 1891, Searles kept the castle until he died in 1920; however, he began removing many of its architectural elements, along with the art and antiques, and installing them in his other homes, including the main staircase's ornate brass-and-steel railings and banisters, which were replaced with simple wooden railings. The castle went through a variety of uses over the next 150 years, from a girls' school to an insurance conference center to a country club, but, fortunately, survived intact. For the recent twenty-five years, it had been the Deerfield Academy, a private school, before closing in 2021. Hunt heard from a friend it might become available and he didn't hesitate, attracted not only to its history but its massive scale and proportions.

Time had taken its toll, though, and the castle needed significant work to bring it back from an institutional school to a private residence. Hunt removed dated school materials, replaced old wiring, updated plumbing, and reconfigured baths for private use. He returned the once grand staircase to its original beauty with custom iron railings and banisters. He added period chandeliers and sconces, and gave new life to rooms with strong colors, highlighting the castle's woodwork and architecture: tangerine, pink, yellow, blue, and green, along with royal blue carpeting in the corridors and on the staircase. All these updates added new life to the period interiors. Hunt slowly filled the rooms with fine, nineteenth-century antiques from his collections as well as new acquisitions and his artwork. In the Music Hall, for example, he had settees upholstered in his "Star of India" fabric featuring multicolored tortoises to set against the rich oak paneling; he hung Victorian oil portraits above and enlivened the space with bright blue walls and his paintings of tropical birds.

Hunt directed the repointing and repair and restoration of the exterior stone walls, wooden windowsills, and the pavilion in the back garden. He had the gardens planted with annuals and perennials, and nineteenth-century, cast-iron urns were added and filled with flowers grown on the grounds. And although the restoration is not yet complete as of this writing, with Hunt's vision, Searles Castle is slowly returning to the grandeur of its original, late-nineteenth-century design.

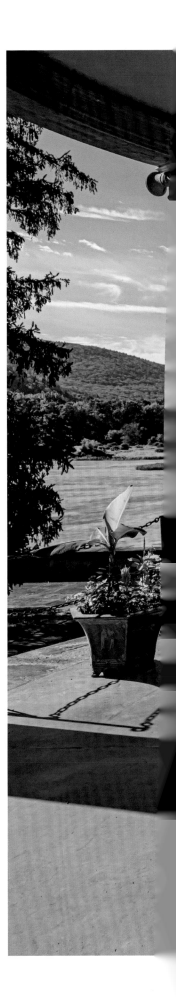

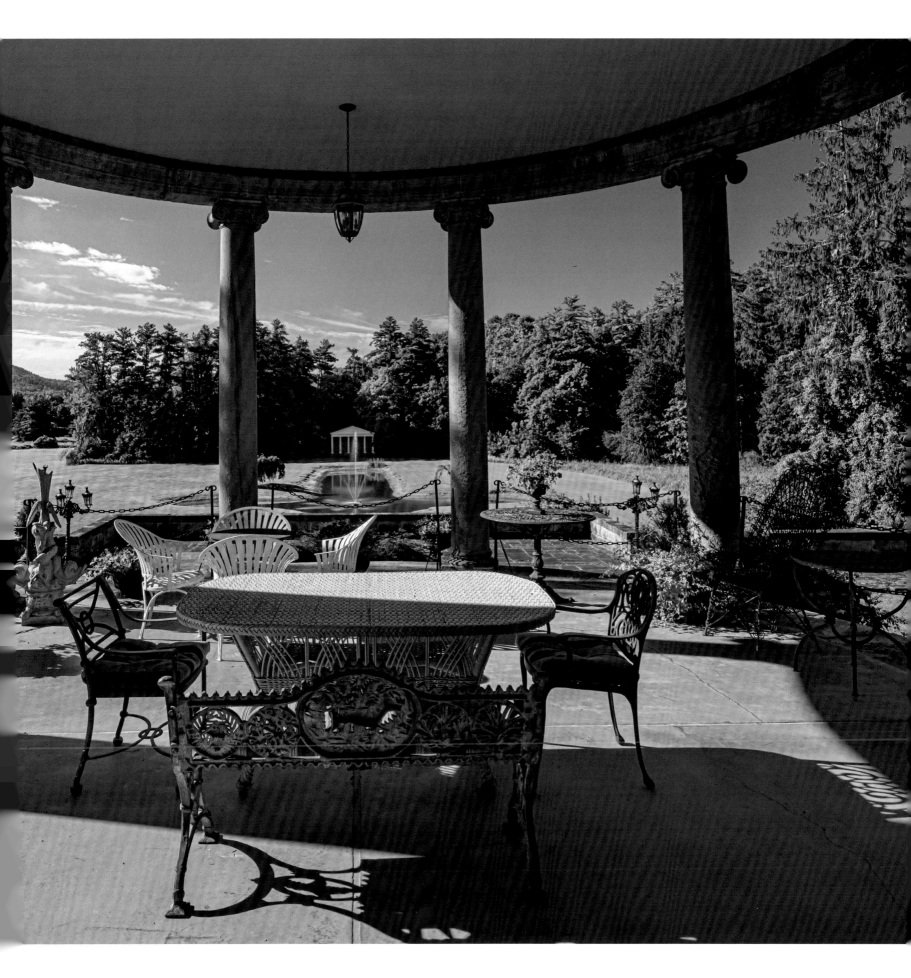

The rear loggia is furnished with an eclectic array of cast-iron
seating and tables. The Doric pavilion is seen beyond the pond.

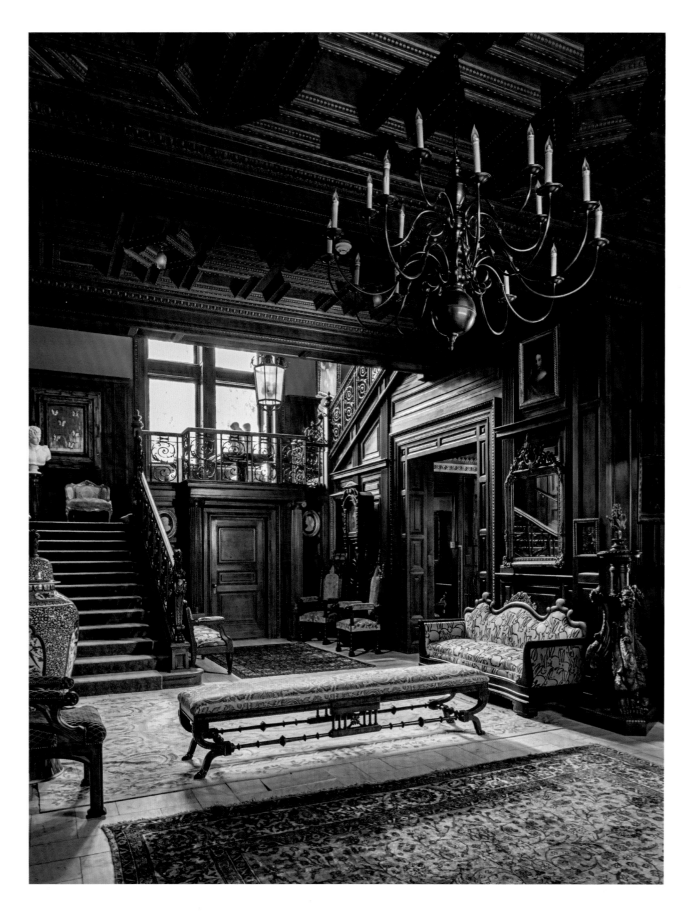

▲ The English oak–paneled entry hall holds an Aesthetic bench, Gothic chairs, and a sofa upholstered in black-and-white "Hutch," for Lee Jofa.

▶ Hunt's *Blue Ascension* and Victorian oil portraits line the staircase.

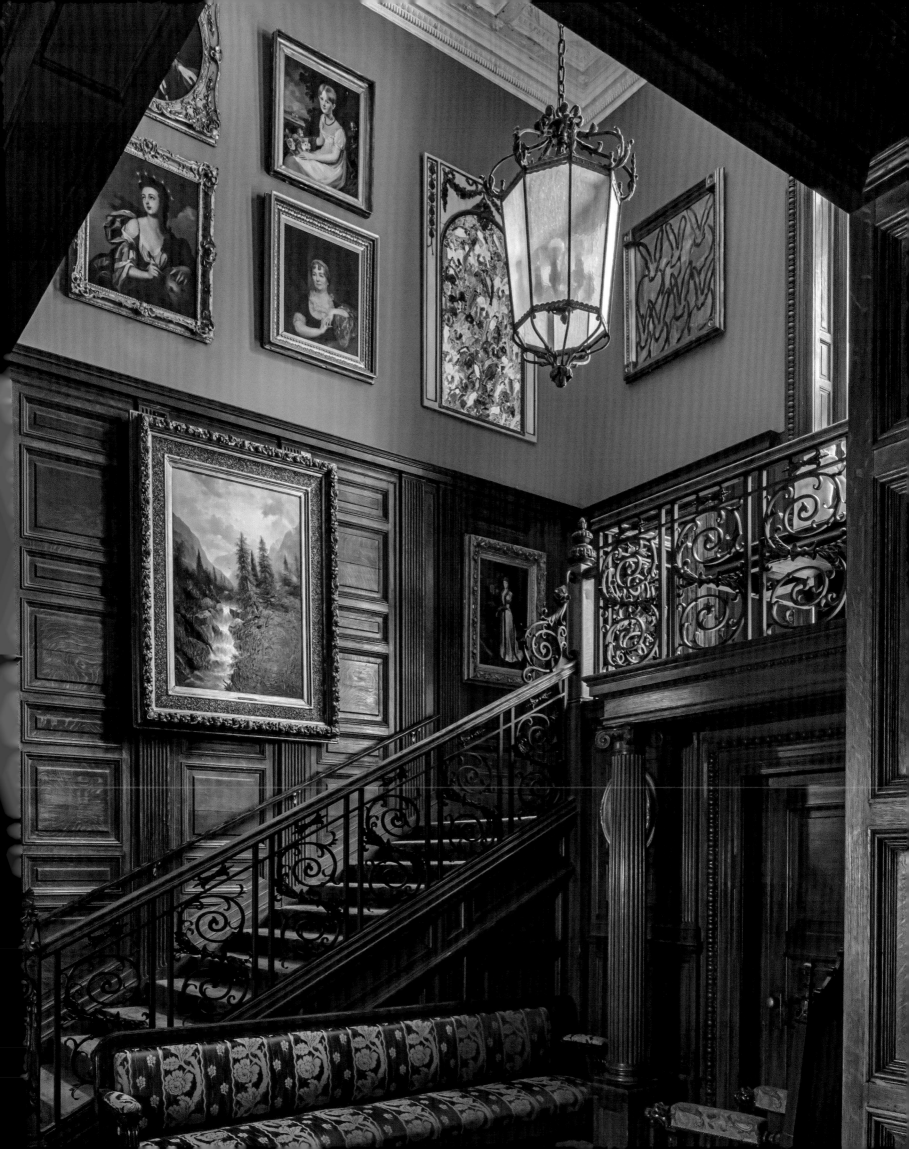

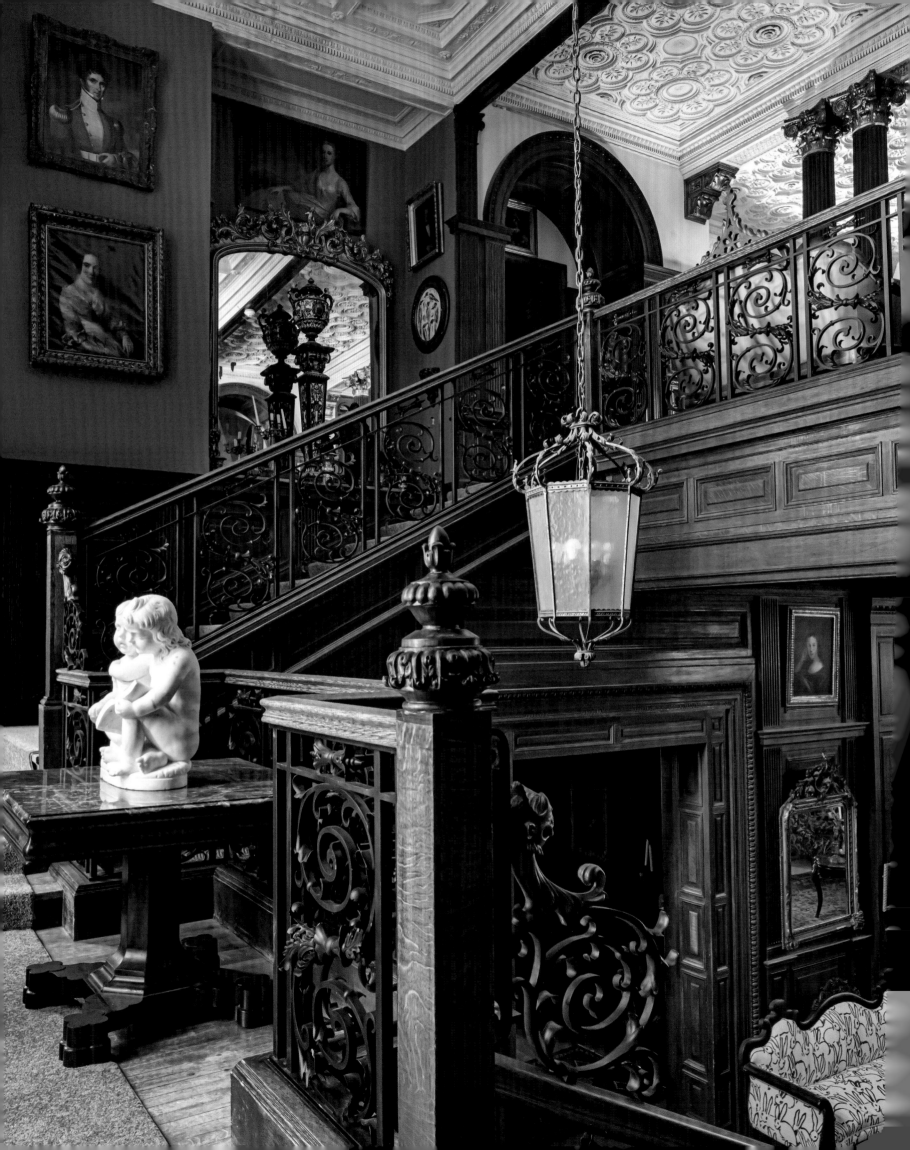

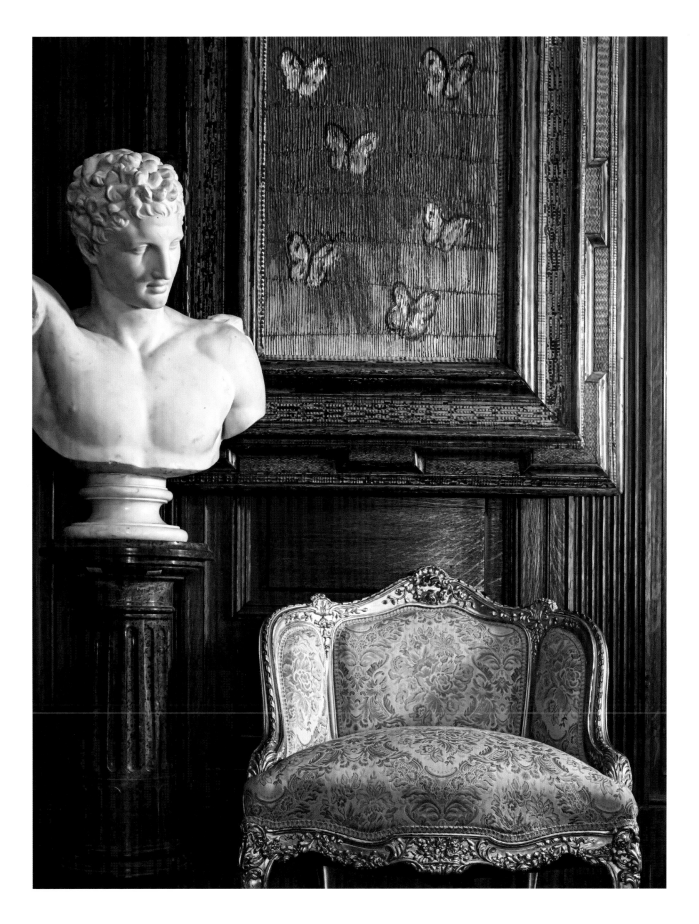

◀ The original iron railings were reinstalled, copied from Stanford White photographs.

▲ *Monsoon Ascension* butterflies on a scored, blue metallic background, a classic marble pedestal and bust, and a gilded chair rest on a staircase landing.

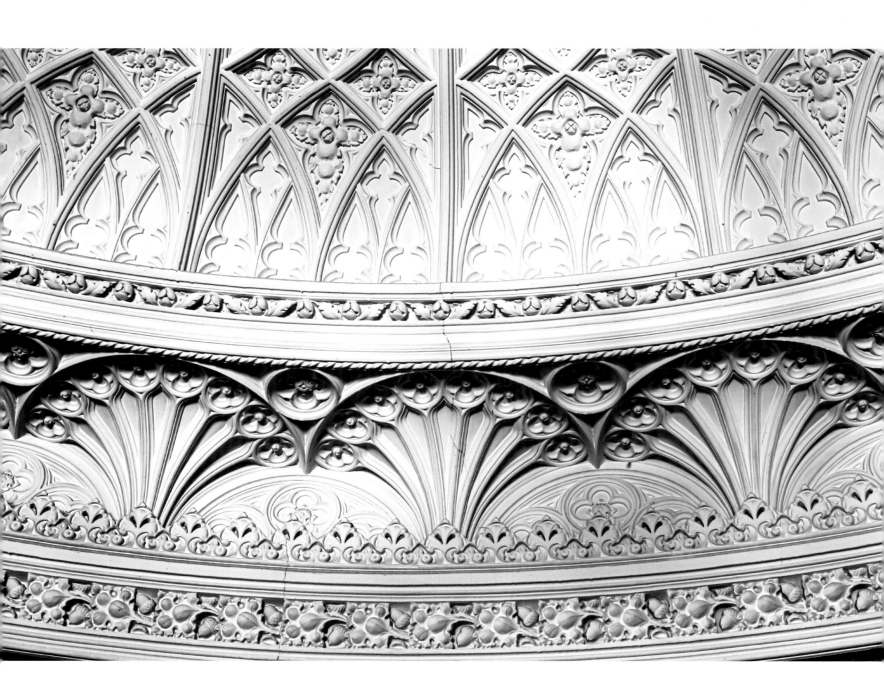

▲ A round, Gothic men's receiving room off the main entry hall features an elaborate, vaulted plaster ceiling.

▶ The room is lined with linenfold paneling. Gothic Revival furnishings include a rare Stanton Hall chair, a figural Gothic chandelier, Victorian portraits, and Grand Tour objects in the Gothic taste.

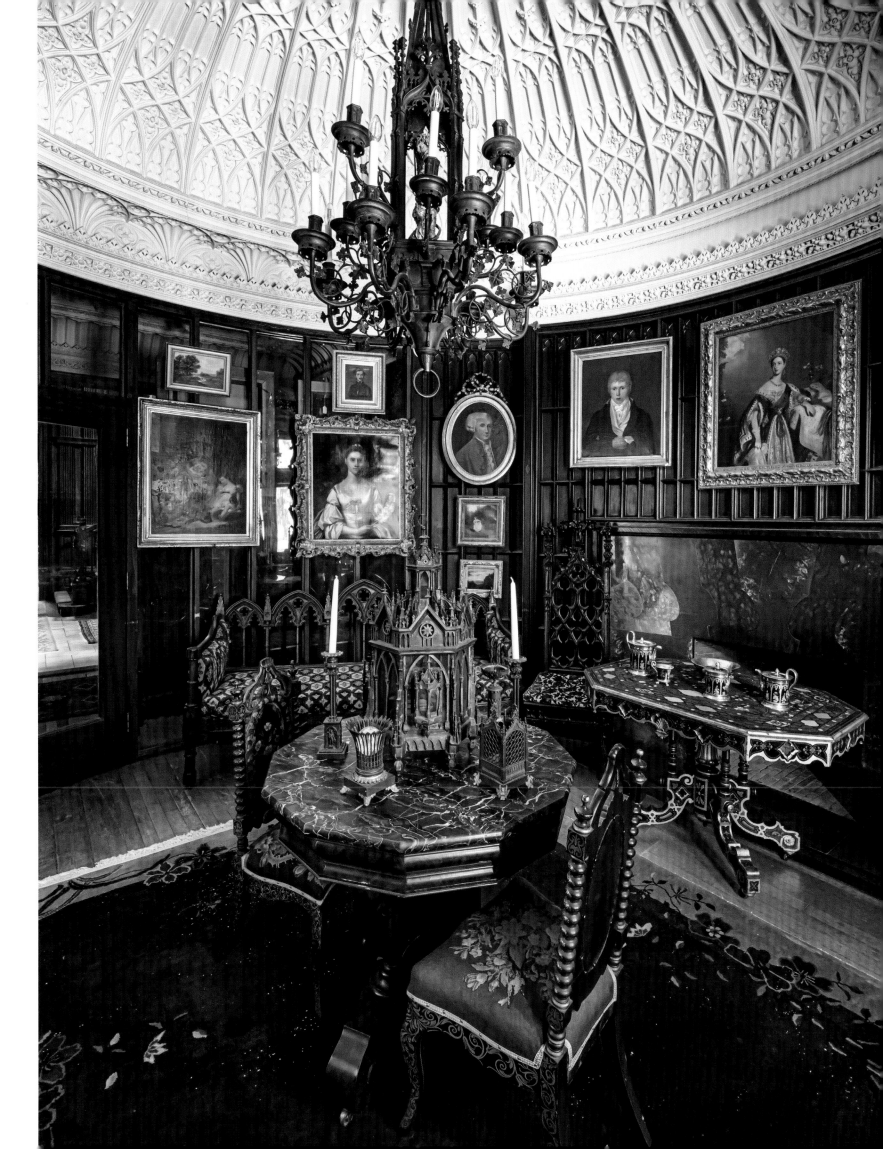

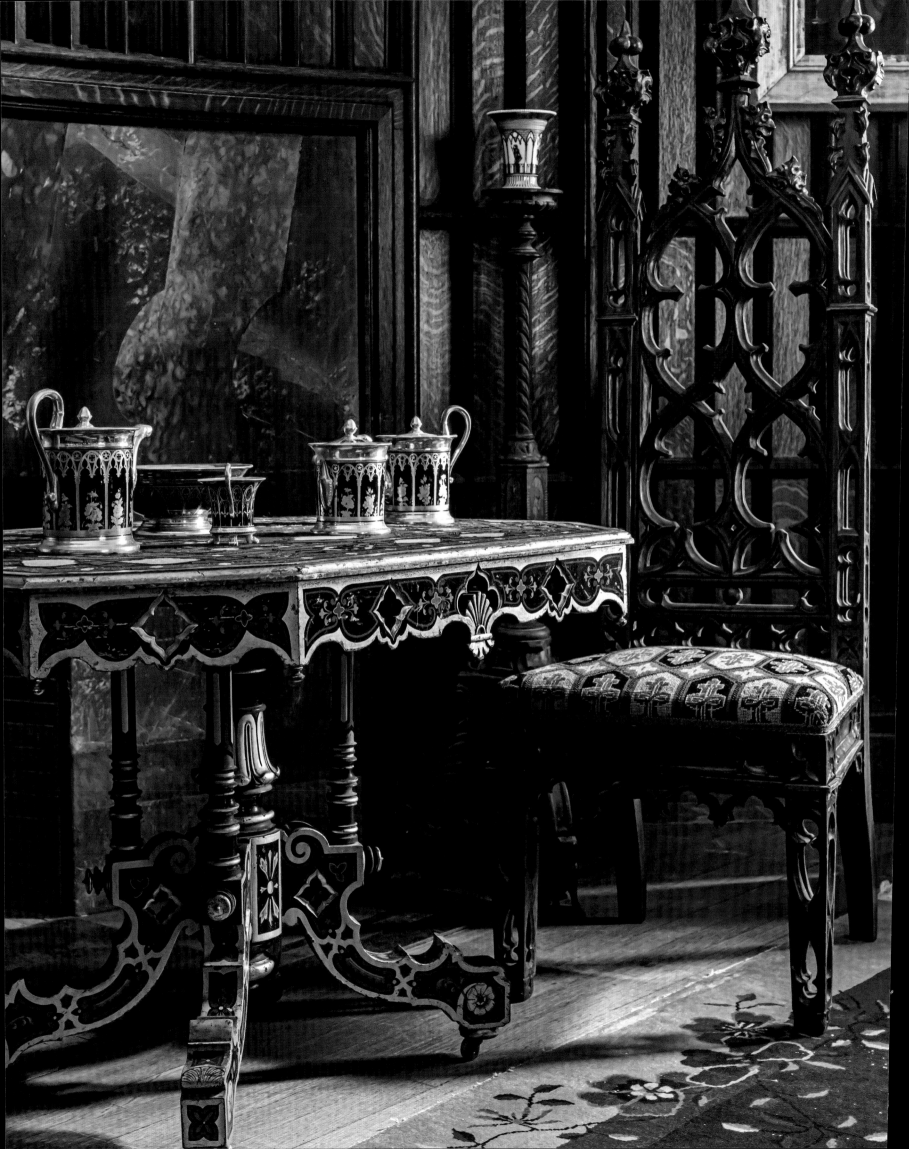

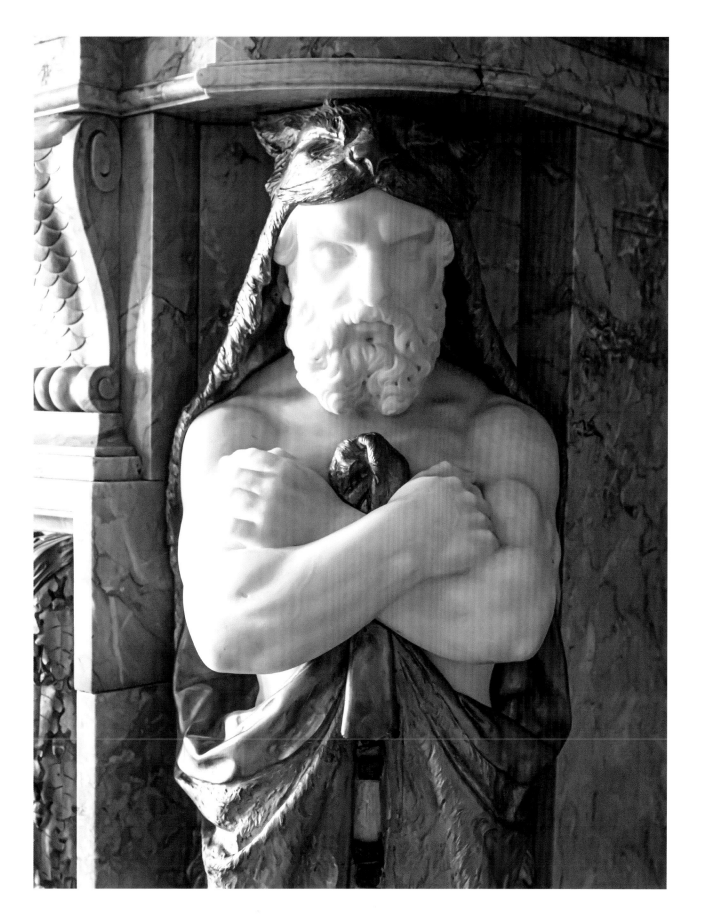

◀ A gilt and polychrome Napoleon III center table, an Old Paris porcelain Gothic Revival coffee set, and a Stanton Hall chair are powerful accessories in the men's receiving room.

▲ The mantel in the French blue sitting room features marble and bronze columns of Hercules on either side.

▲ Bunny paintings augment the ornate plasterwork in the sitting room.

▶ Gilded furniture, Old Paris porcelain, and Parian busts in the sitting room include a nineteenth-century, Italian circular center table with a pietra dura tabletop.

Overleaf: Detail of the elaborate painted and gilded plaster sitting room ceiling.

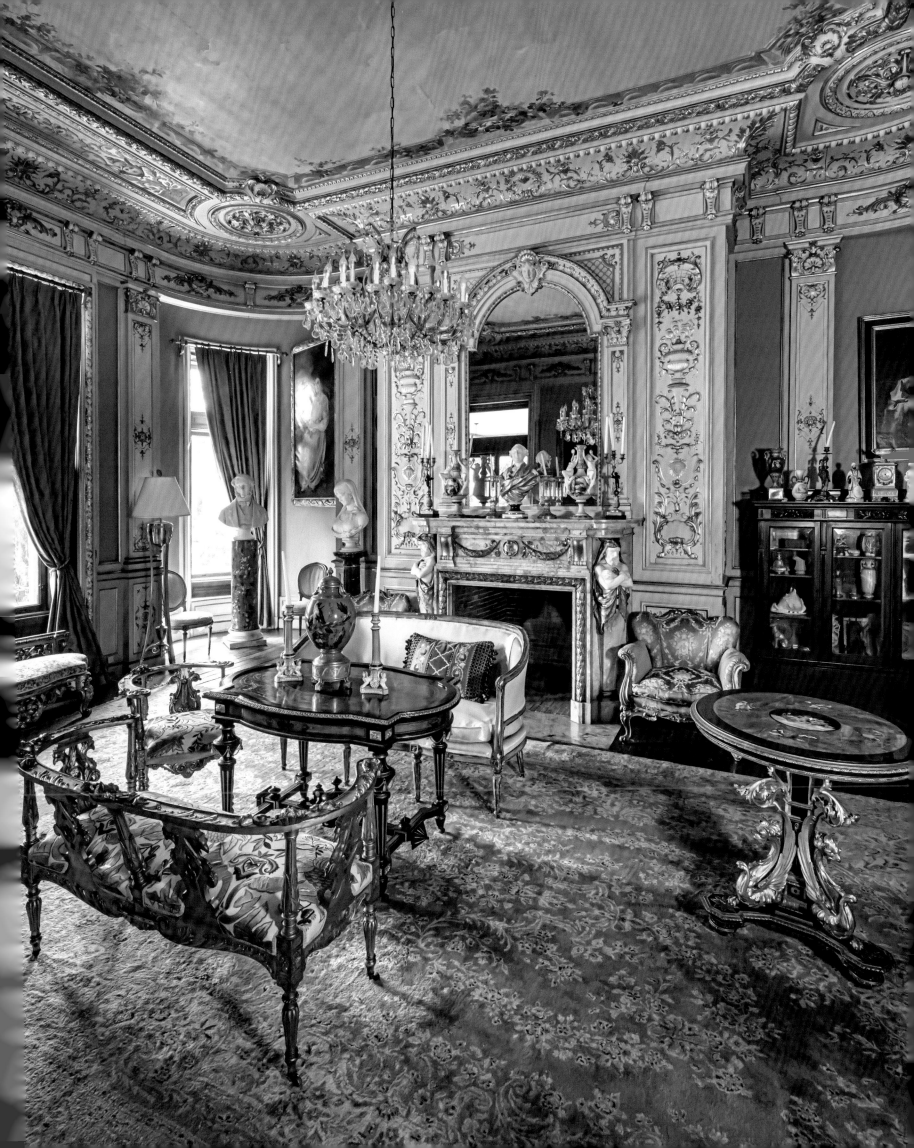

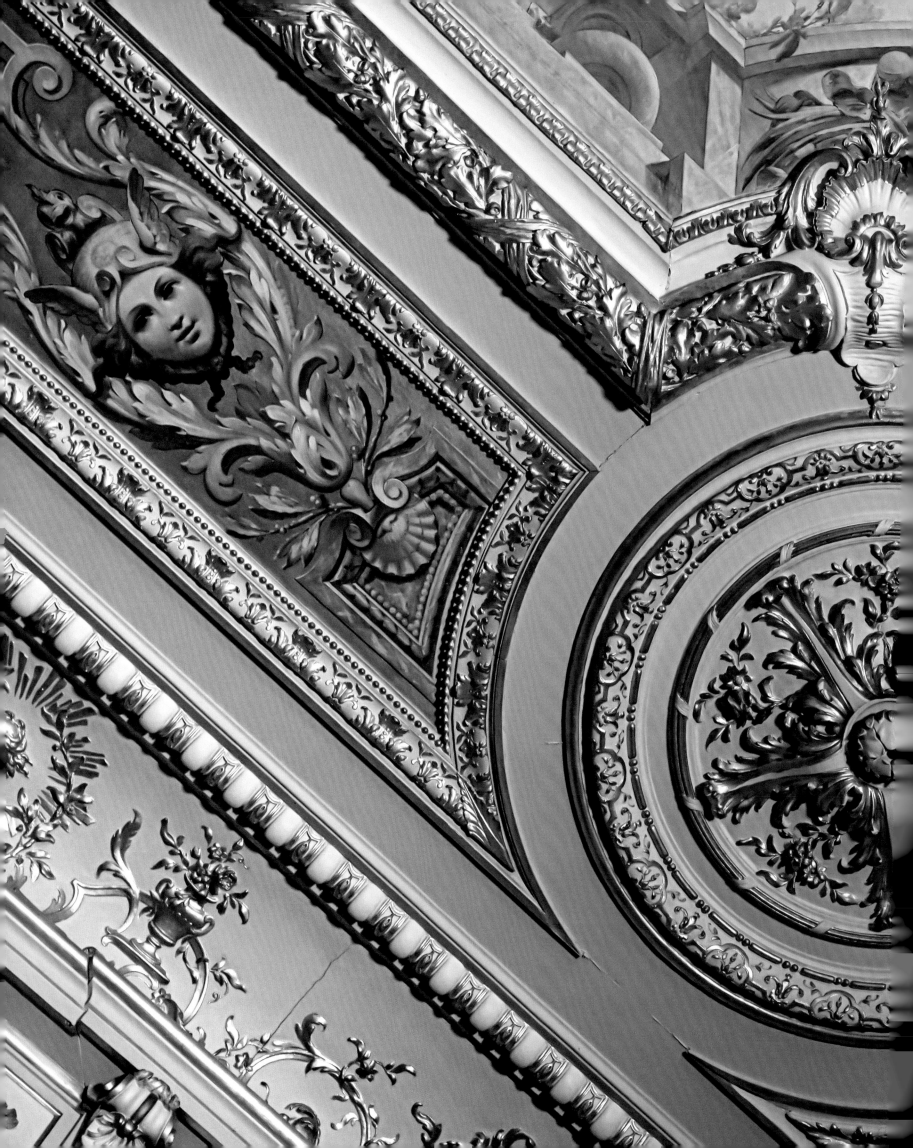

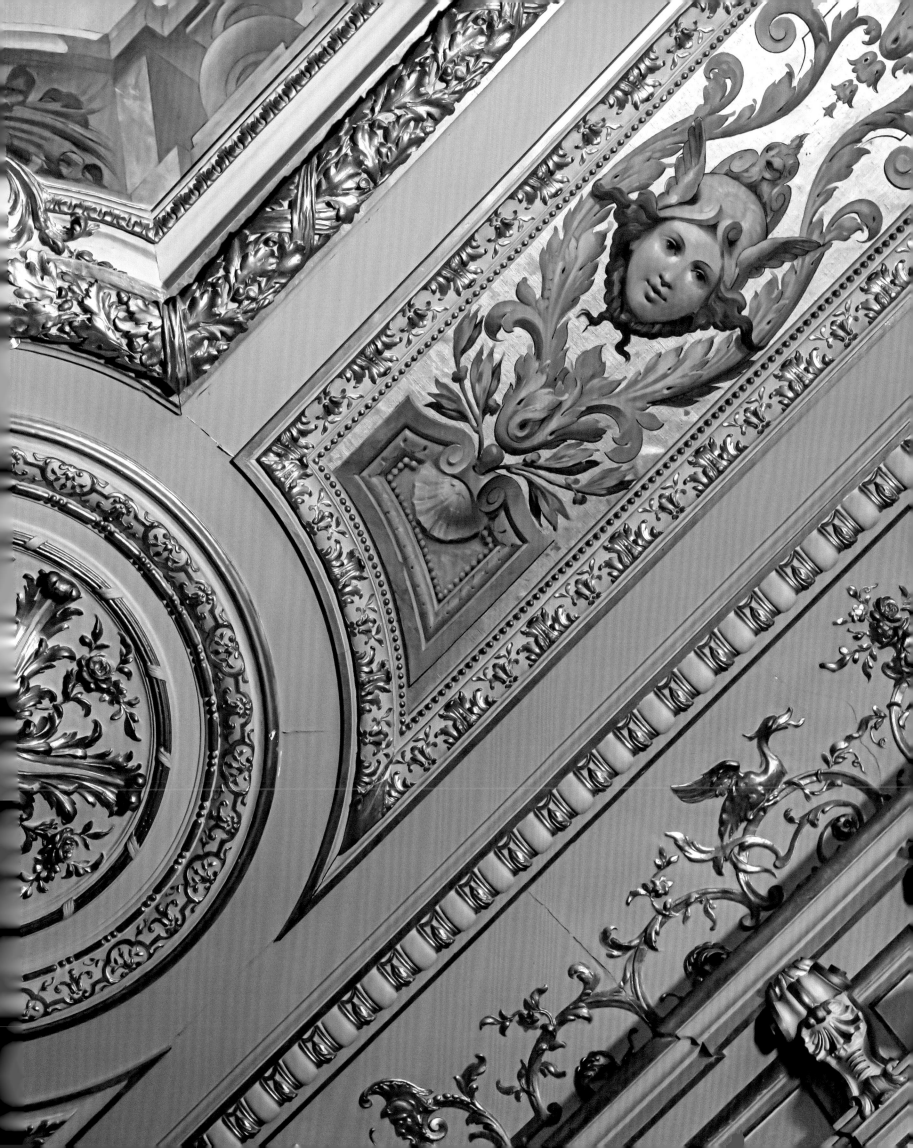

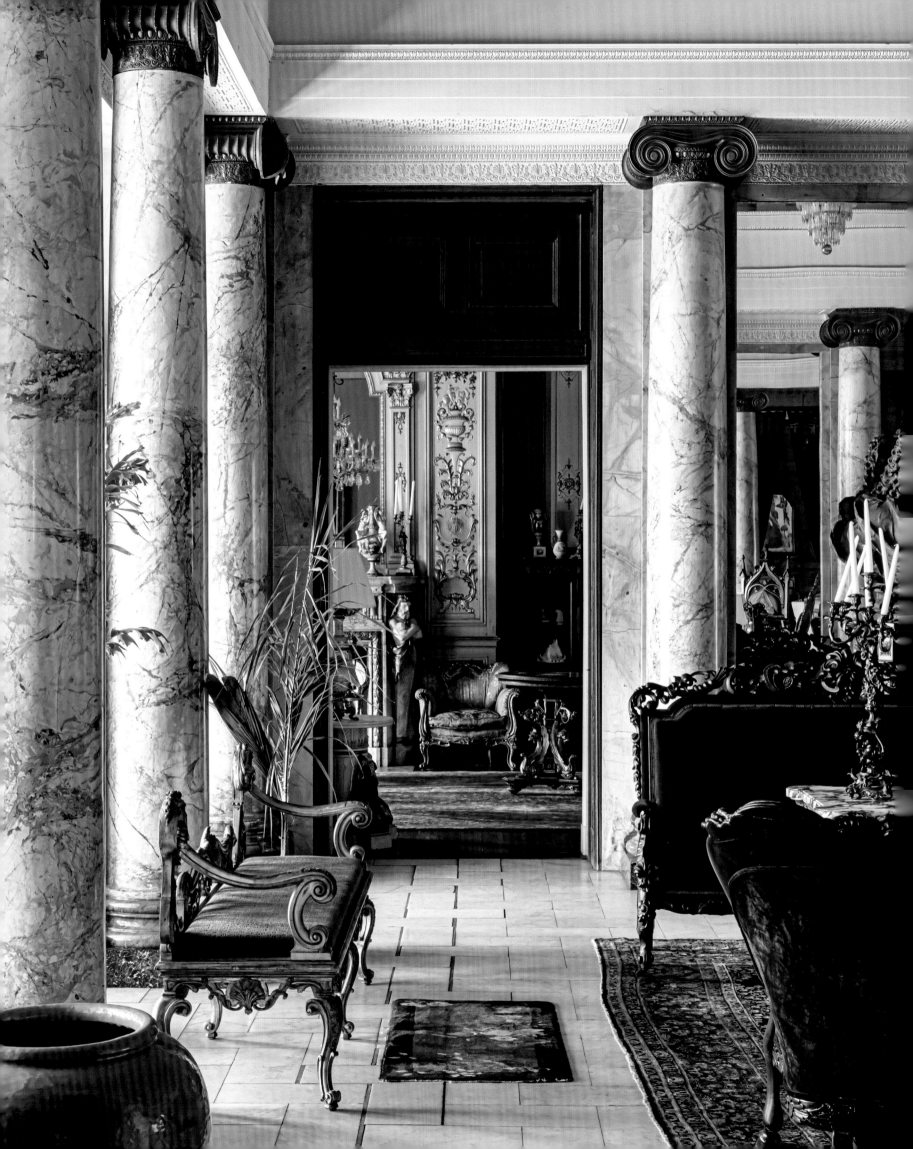

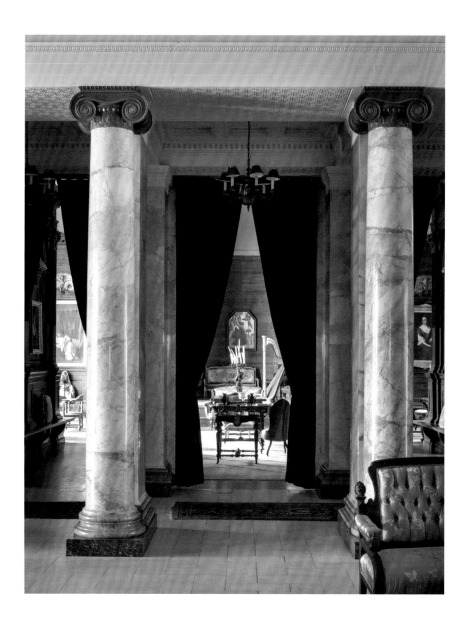

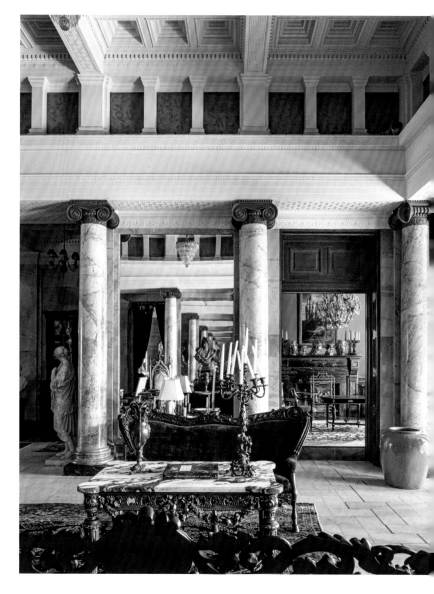

The two-story atrium in the center of the castle opens to principal rooms, including the French blue sitting room, music room, dining room, and green parlor.

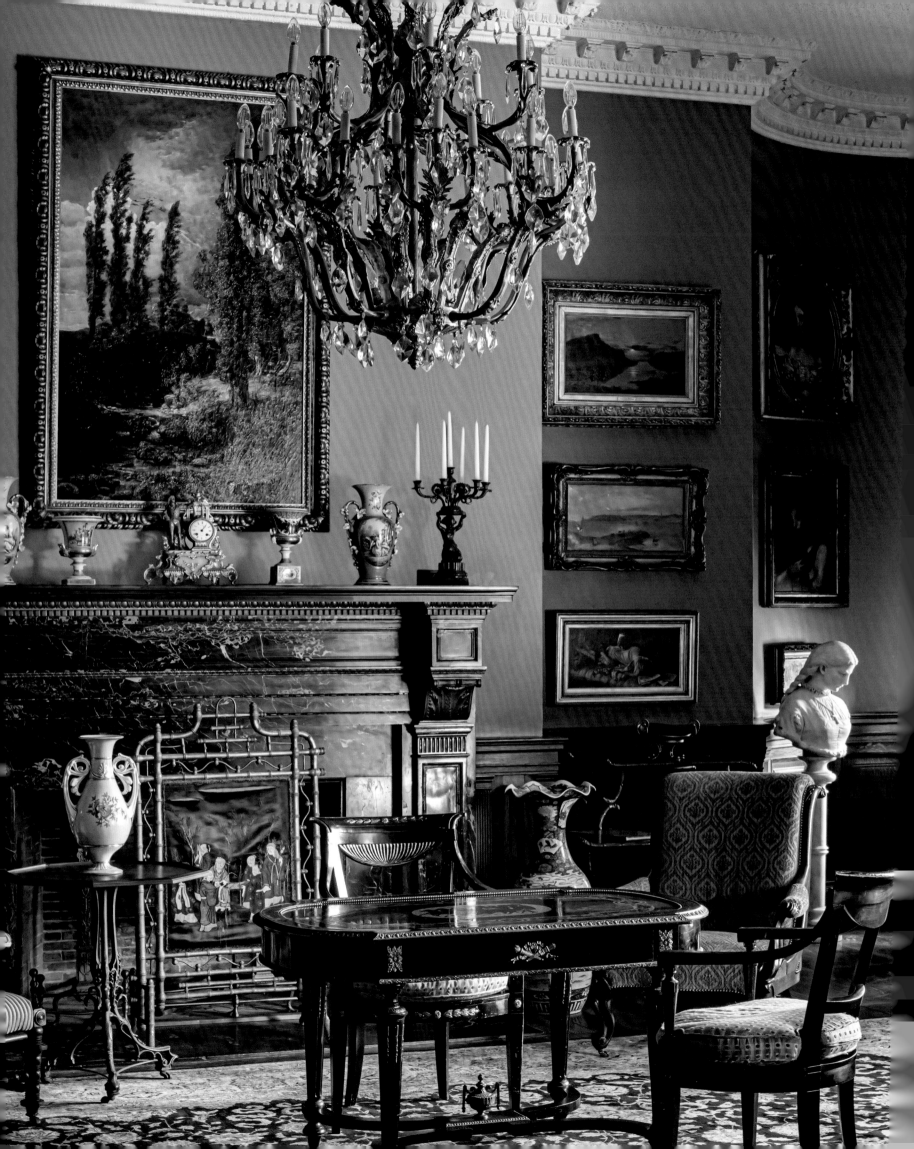

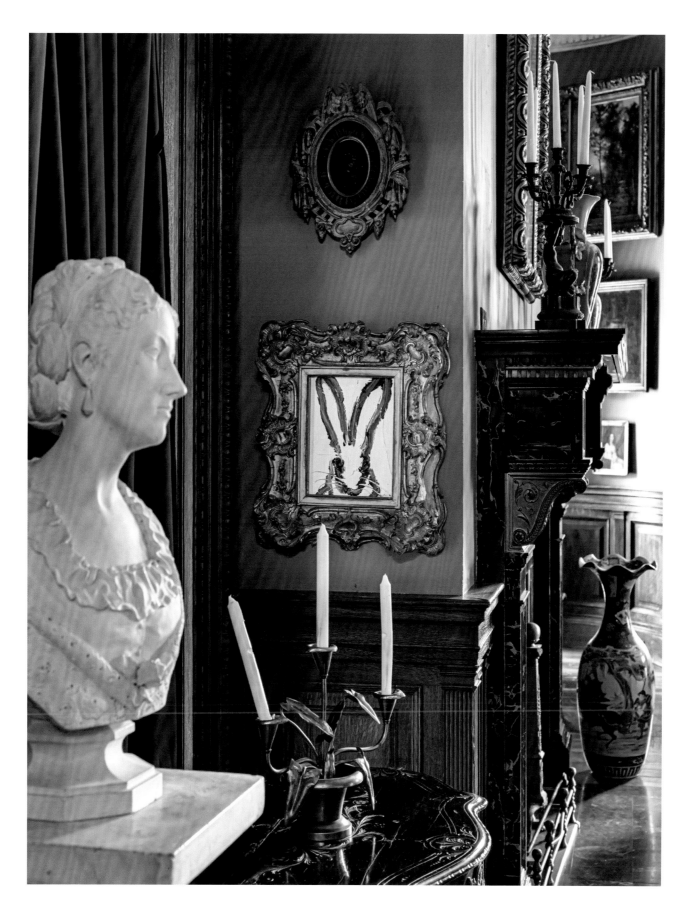

◀ The green parlor is centered on an Egyptian marble mantel with ebonized Aesthetic furnishings and nineteenth-century oils in gilded frames.

▲ Detail of the green parlor.

▲ "Spring Butterflies" place mat from Hop Up Shop.

▶ The dining room is paneled in antique English oak highlighted with a frieze of brass panels below the beamed ceiling. A richly veined, red marble mantel centers the room. A Pottier & Stymus pedestal holds a sparkling candelabra.

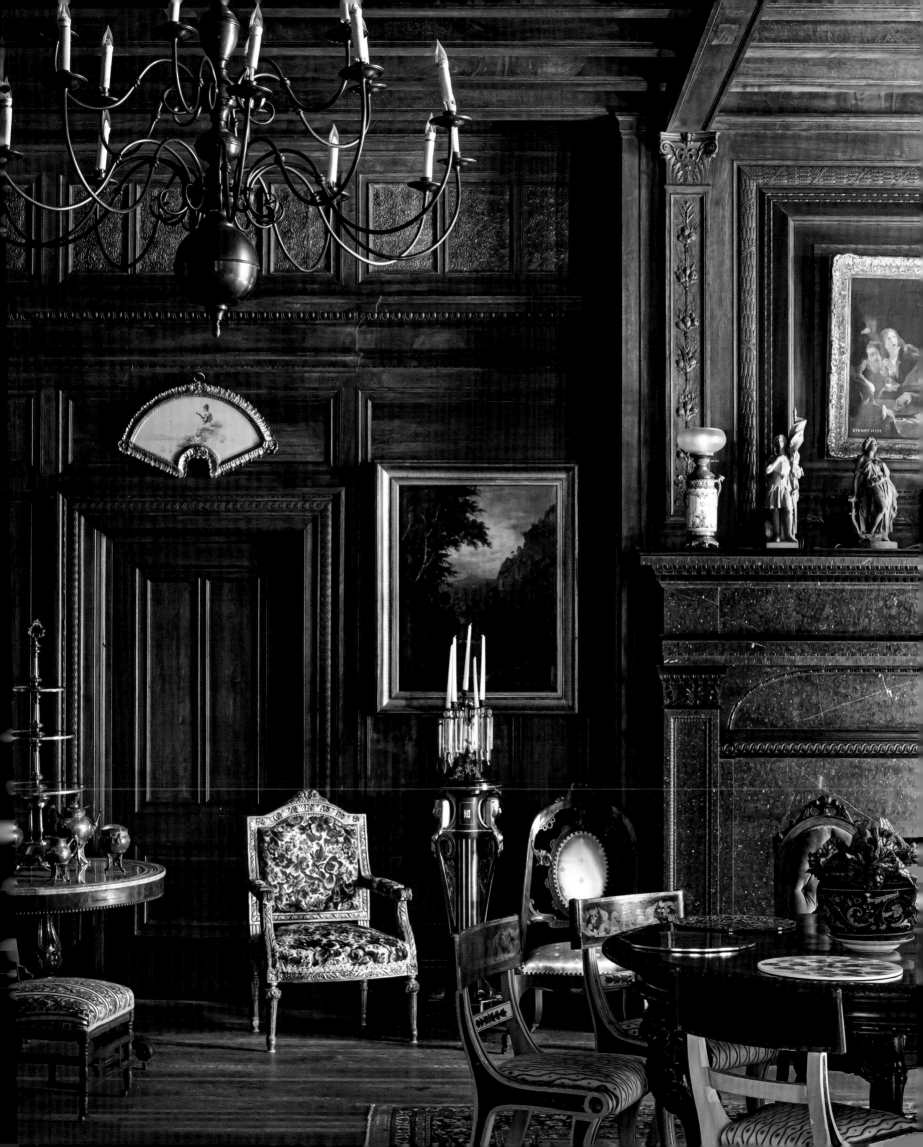

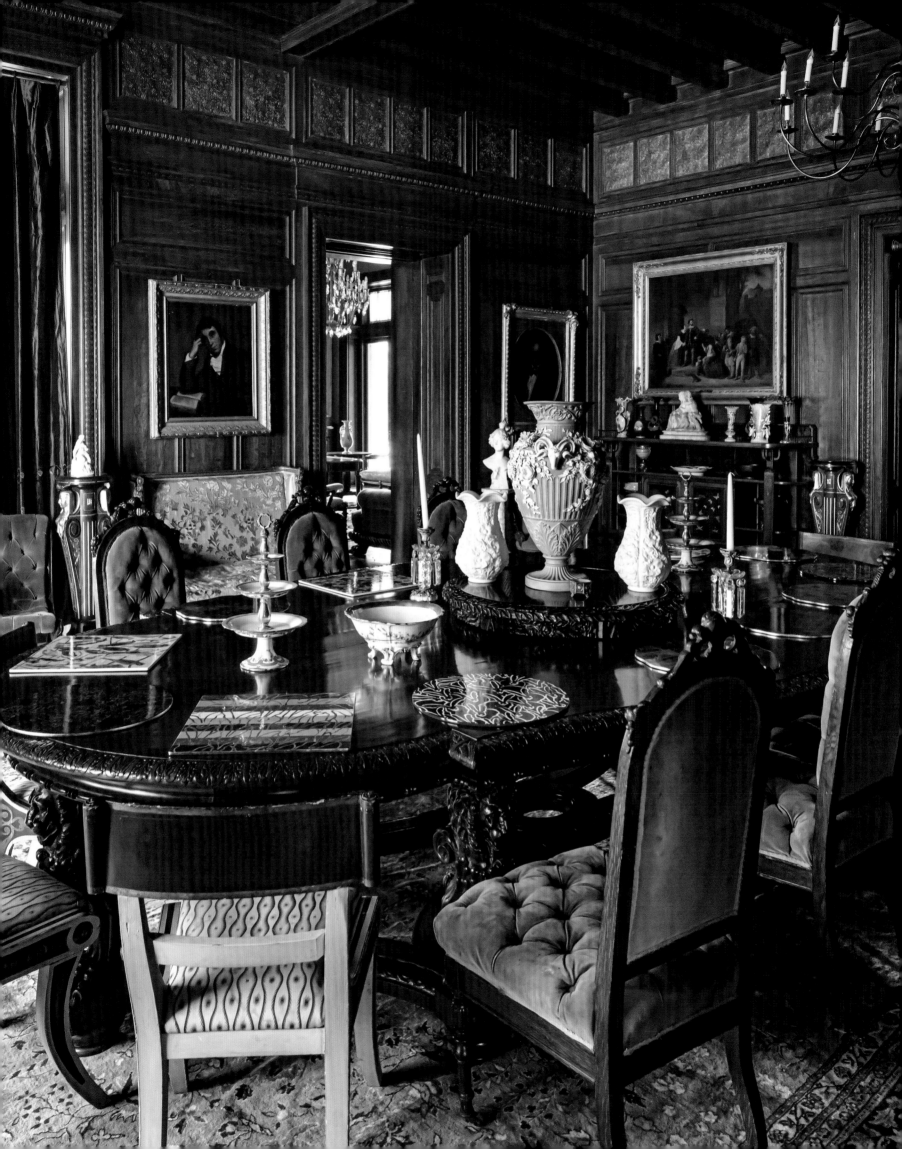

◀ A portrait of Benjamin Disraeli overlooks the dining room table set with Hunt's "Butterflies" and "Bunnies" place mats from Hop Up Shop and an assortment of chairs. A blue Wedgwood vase on a mirrored plateau centers the table.

▲ Hunt's paintings are highlighted in antique frames.

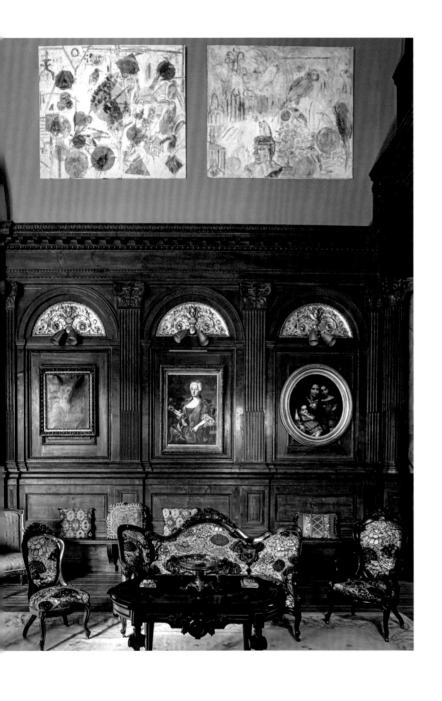

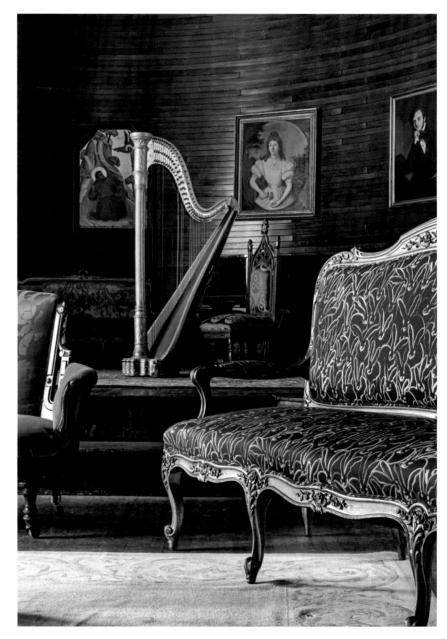

◀ Hunt's 72" x 84" paintings, an early *Chinensis Aviary* and *Chandelier with Oranges and Indian*, hang above nineteenth-century oil portraits in the music room.

▲ Gothic chairs and an antique harp are displayed on the stage in the music room.

▶ The barrel-vaulted music room is furnished with an array of nineteenth-century seating upholstered in Hunt's fabrics, including "Star of India," for Lee Jofa.

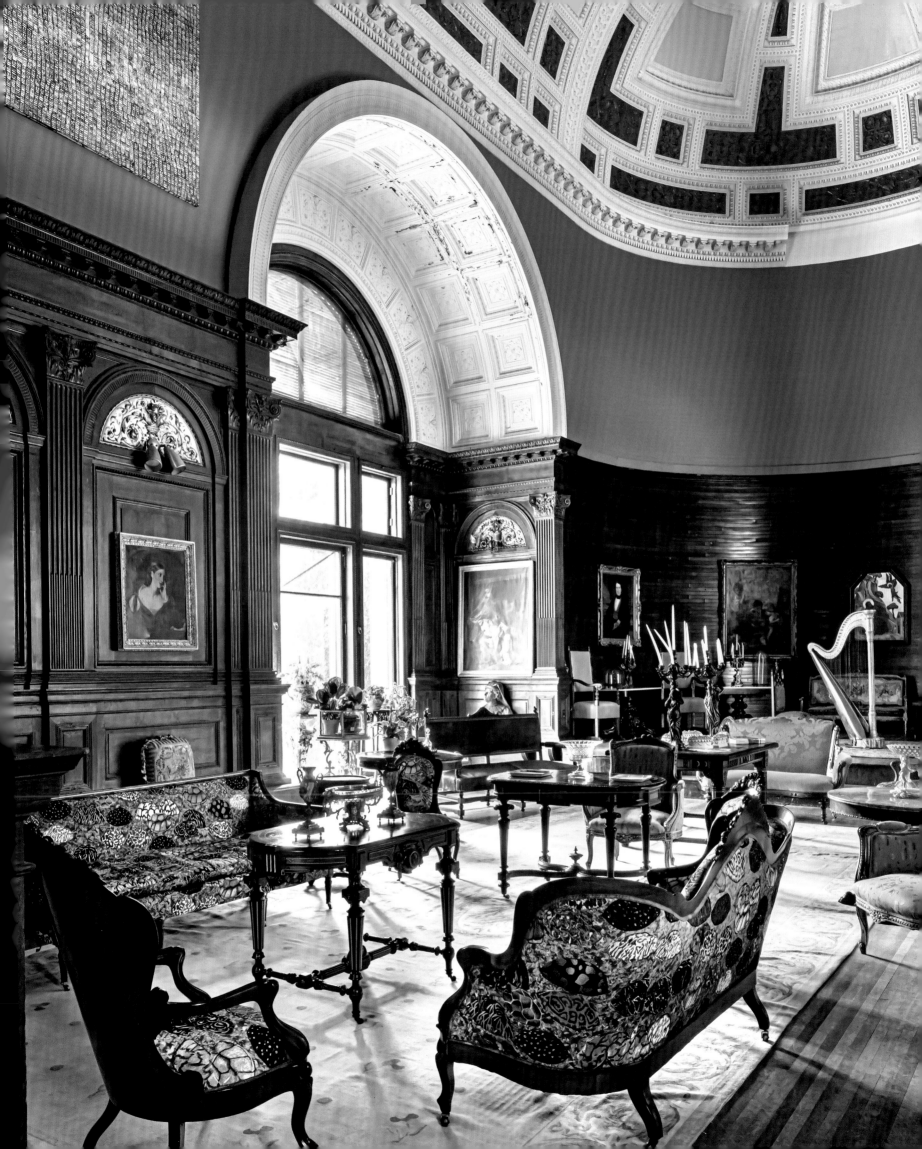

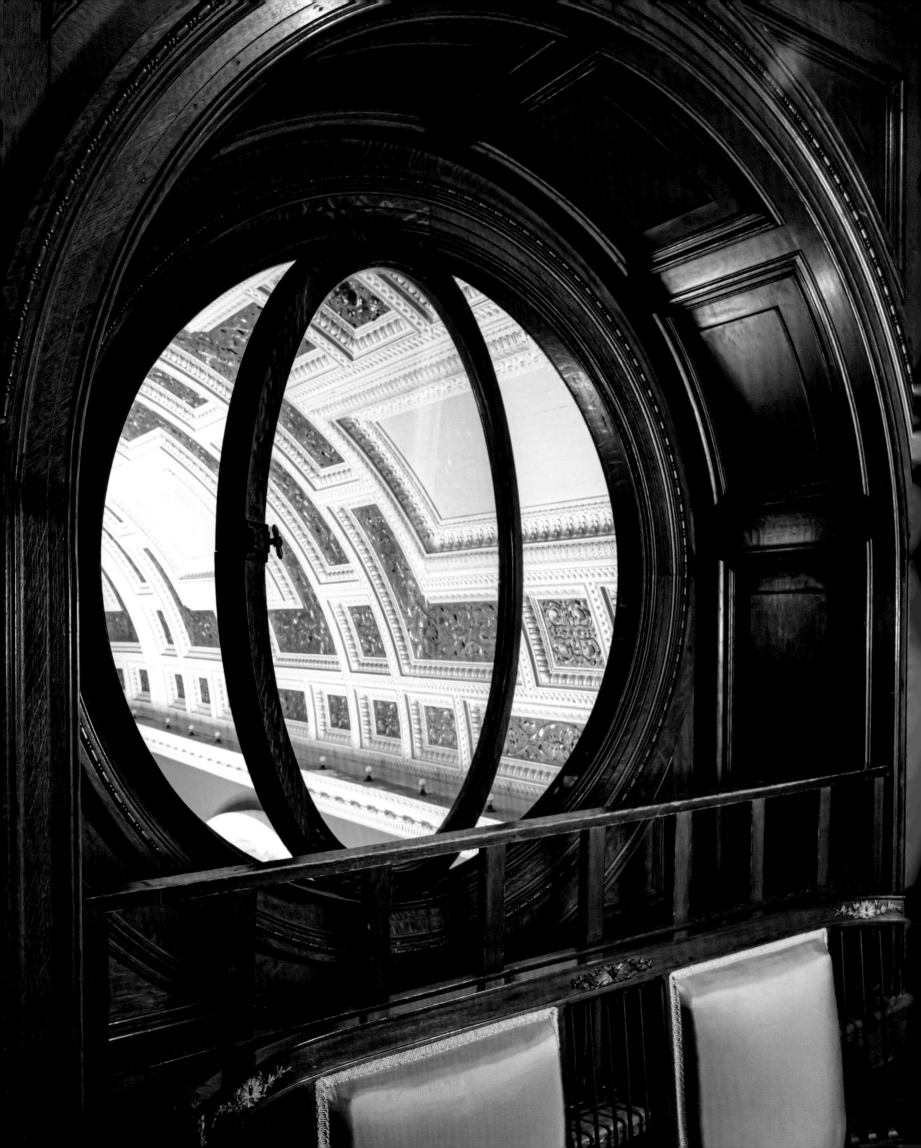

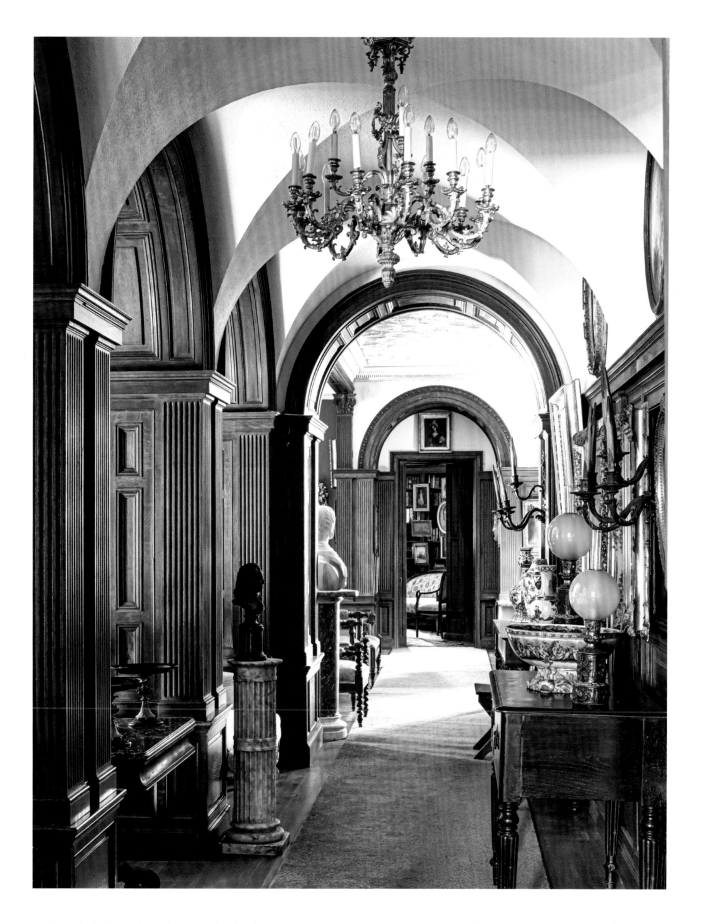

◄ An oeil-de-boeuf window overlooks the music room in the third-floor hallway with views of the ornate plasterwork ceiling.

▲ A groin-vaulted ceiling highlights the third-floor hallway lined with busts and a pier table.

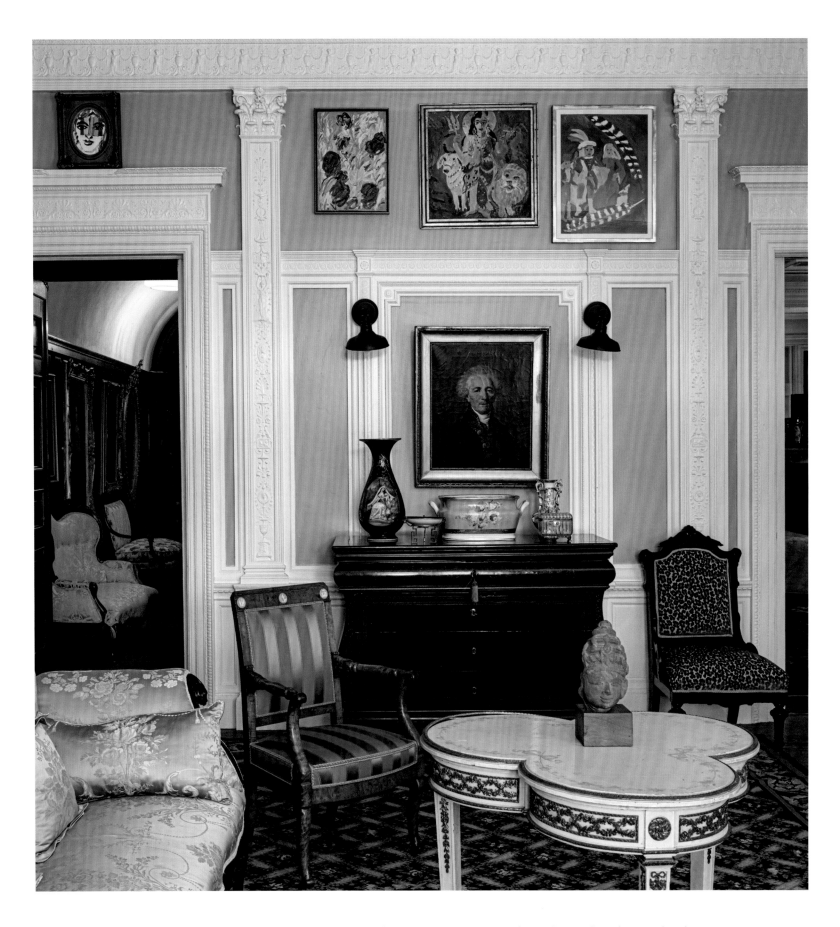

▲ The green sitting room is outlined with classic door entablatures and molding.

▶ A Parian Greek maiden is placed at eye level on an ebonized pedestal.

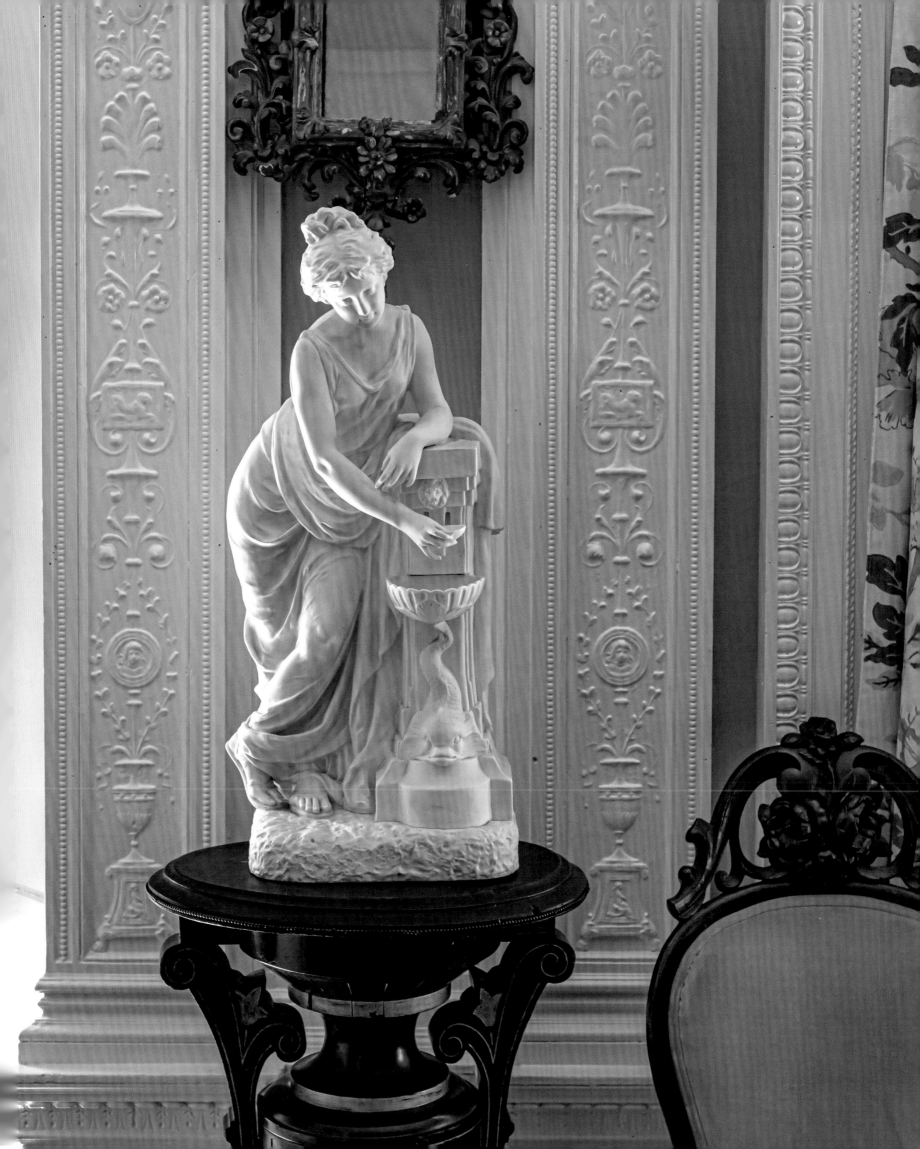

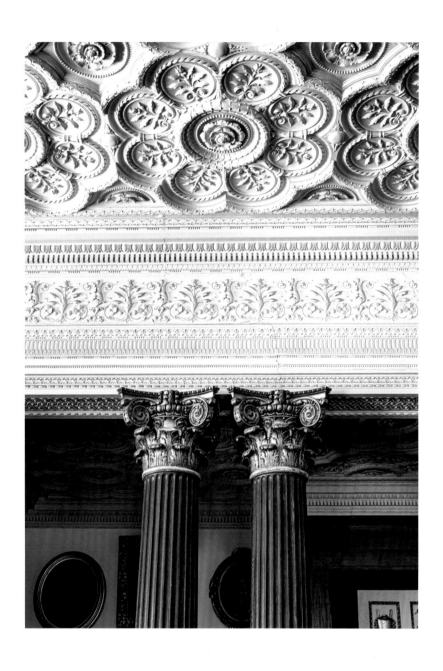

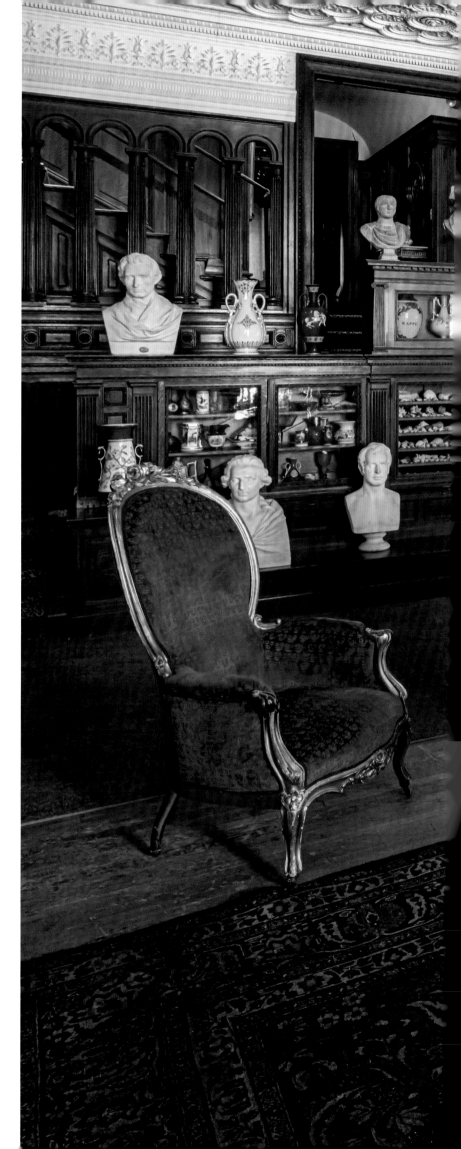

▲ The second-floor common room is crowned with a plasterwork ceiling.

▶ A trove of plaster busts and a display case featuring Hunt's shell collection reside in the common room. Nineteenth-century seating is upholstered in rich blue "Guardians," Hunt's fabric for Lee Jofa.

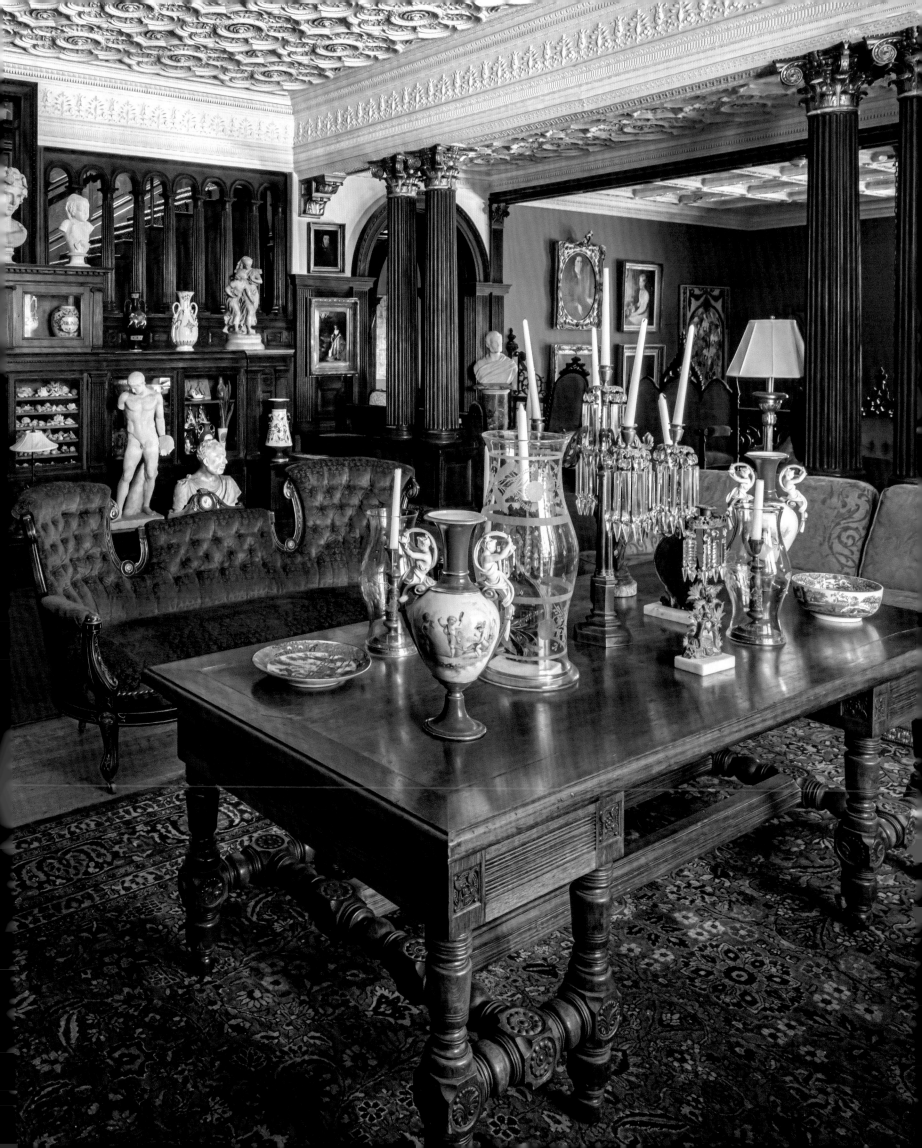

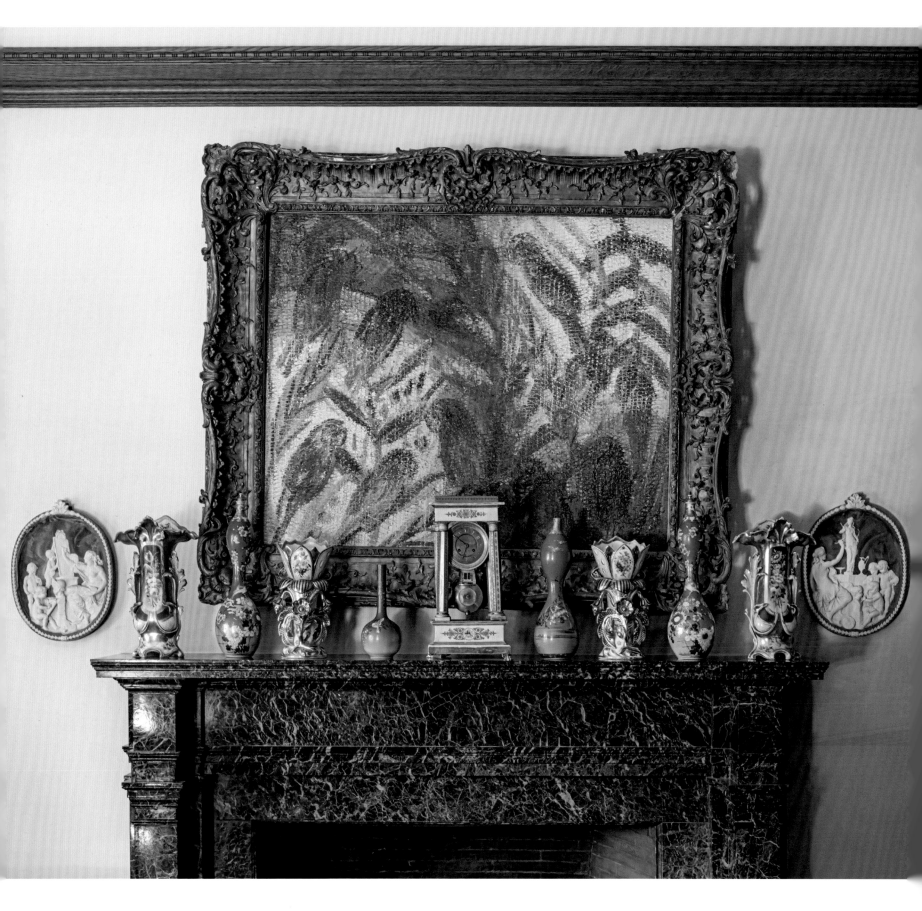

▲ Old Paris vases line the mantel in the Chinese sitting room, with Hunt's *Lories and Heliconia* behind, in a period gilded frame.

▶ A lacquered Chinese chest rests below a collection of Hunt's floral paintings of petunias and cattelayas.

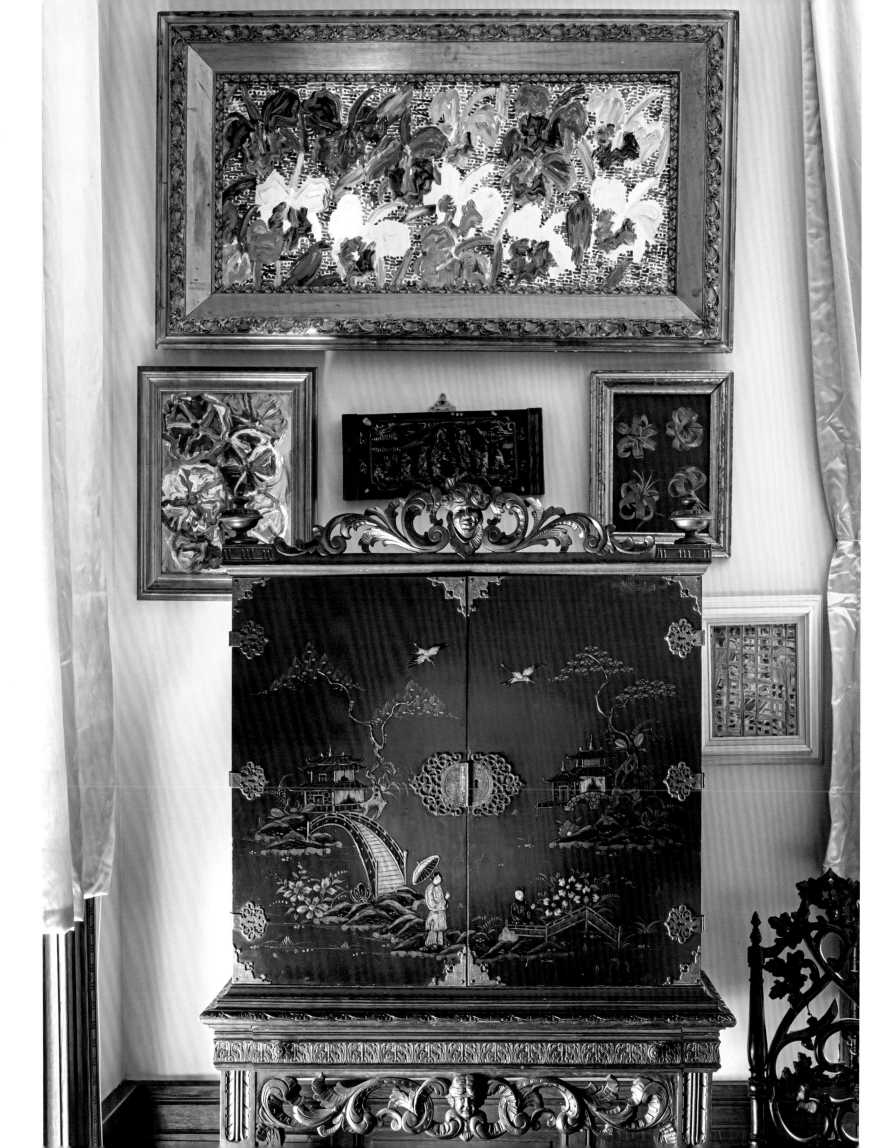

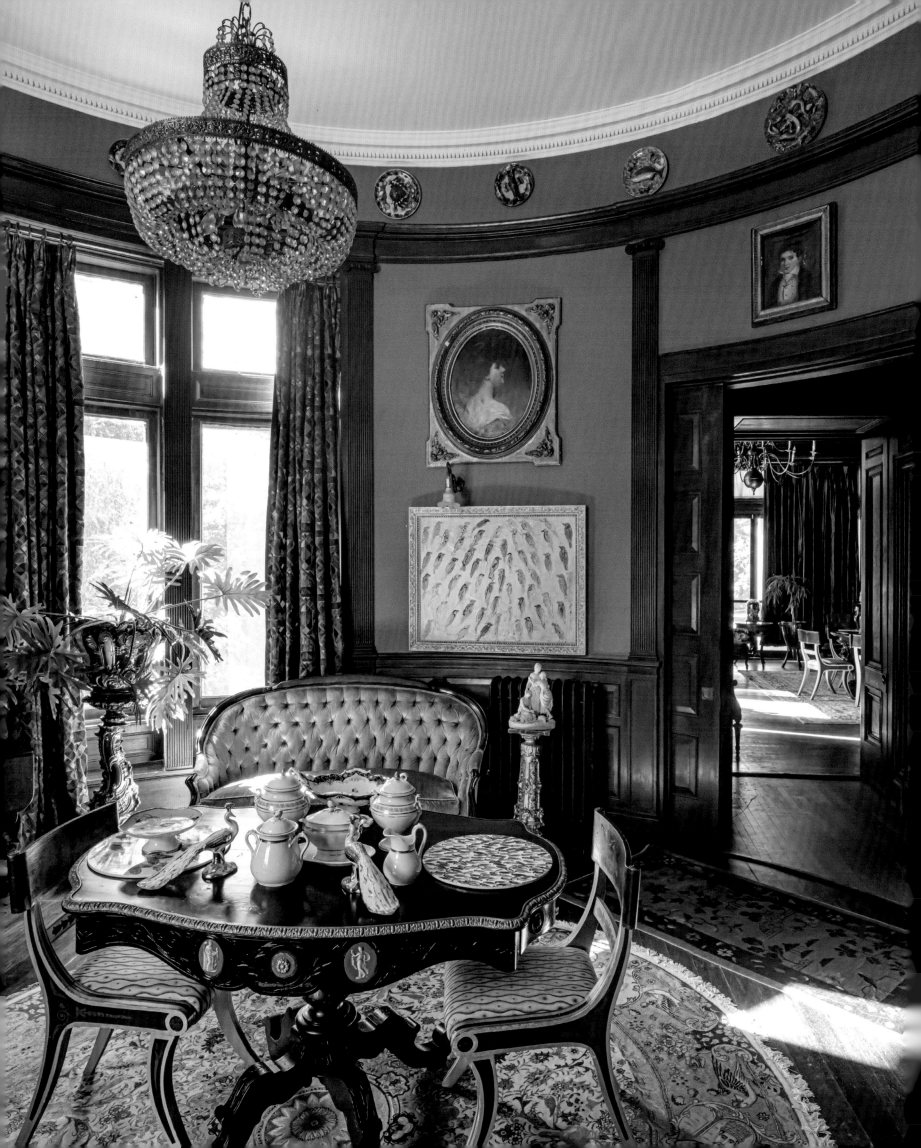

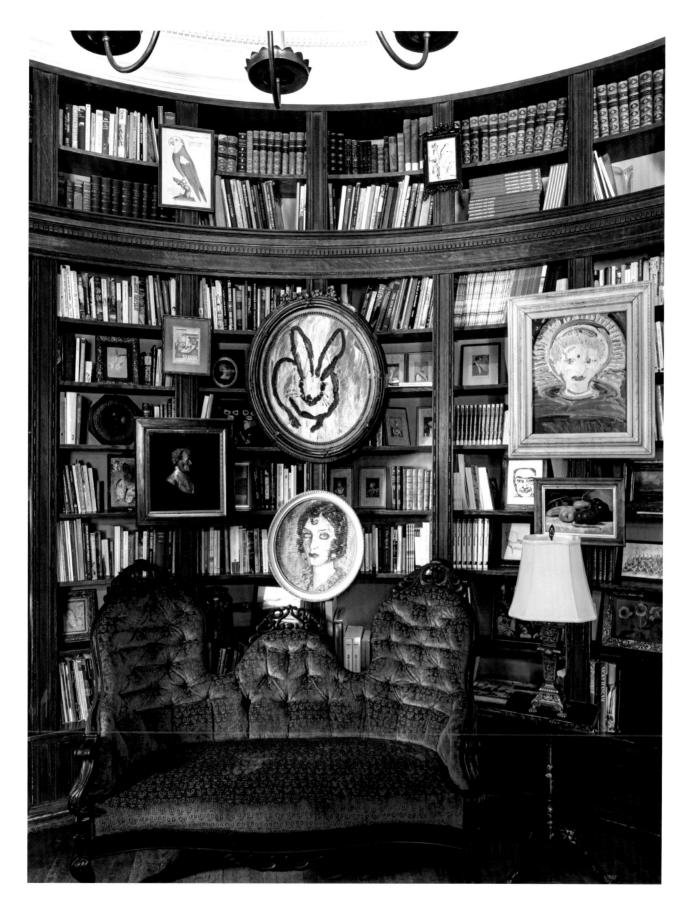

◀ The circular breakfast room, adjacent to the dining room, is set with a Renaissance Revival table with Sevres-style plaques and Hunt's colorful place mats. *Finches* hangs on the wall.

▲ Portraits of Gloria Swanson and St. Francis hang in the circular second-floor library.

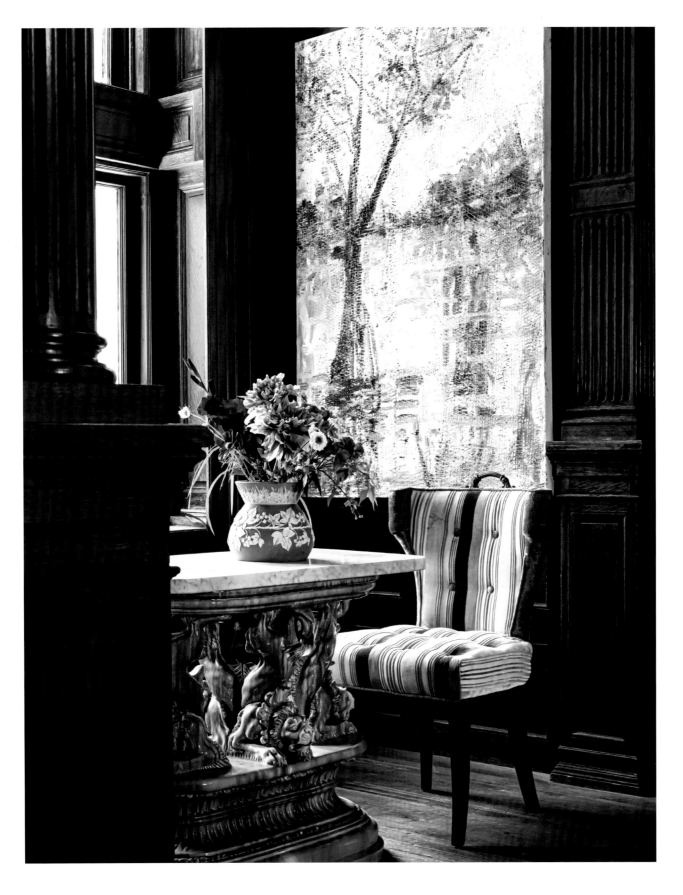

▲ *Bayou* from Hunt's Louisiana home, and a pink and blue, marble-topped majolica pedestal from Windsor Palace rest in a window alcove in the billiards room.

▶ *Archangels* line an upper hallway.

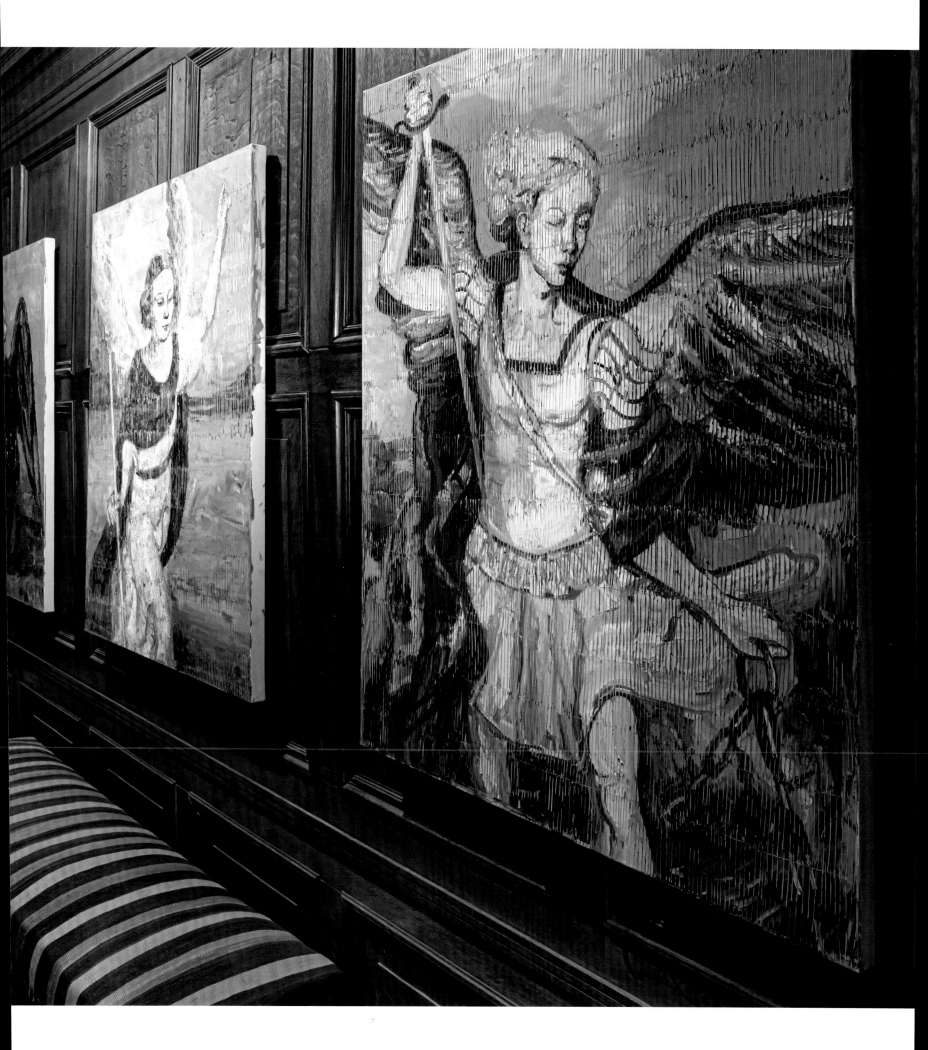

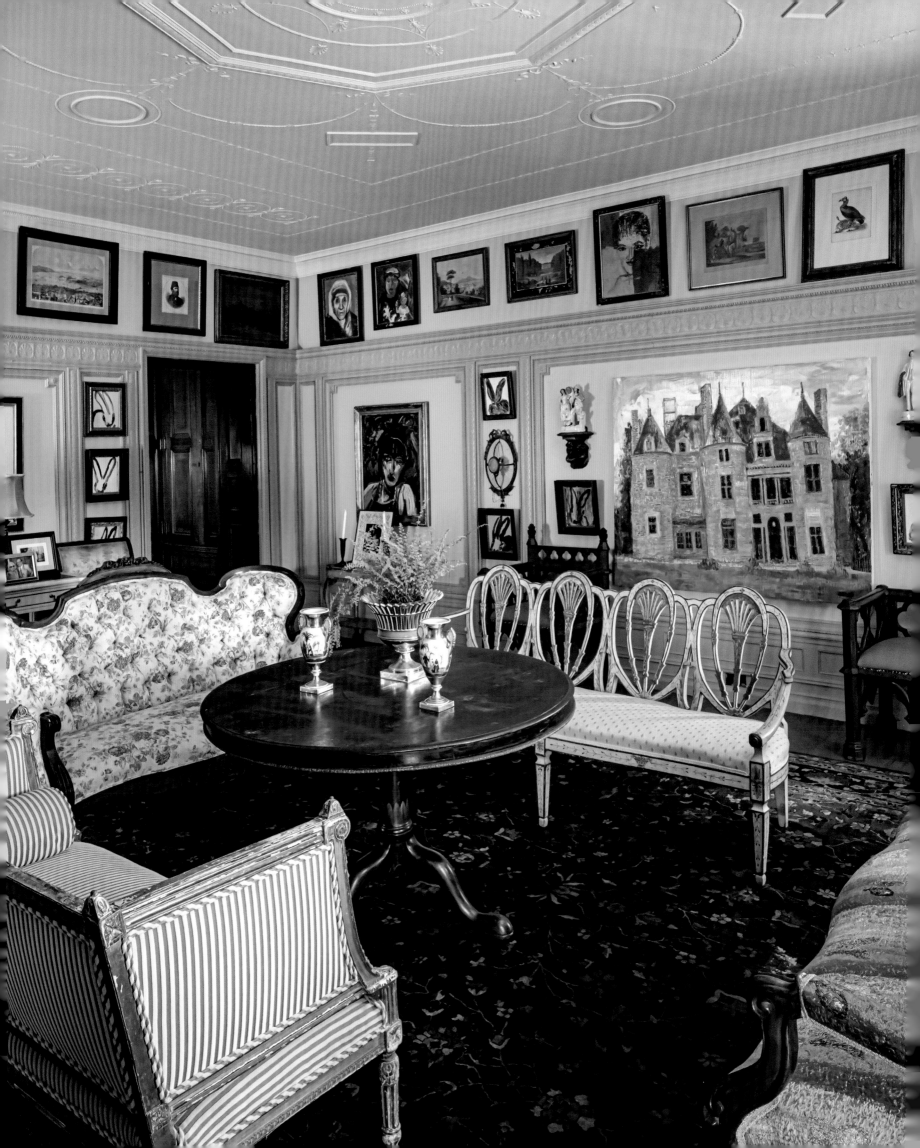

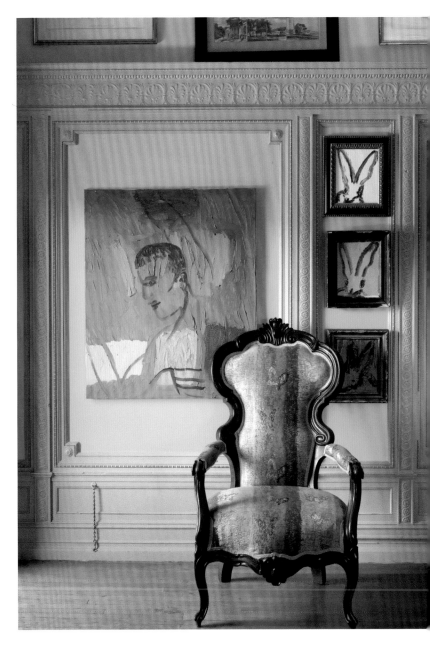

◀ A green and pink sitting room is hung with an assortment of paintings, including *Searles Castle*, *The Countess*, and *Mother Teresa*.

▲ Detail of the original mantel with Hunt's *Oriole* painting and a classic Parian bust.

▶ Hunt's *Rudolph Valentino* hangs behind a Victorian chair upholstered in "Fritillary," for Lee Jofa.

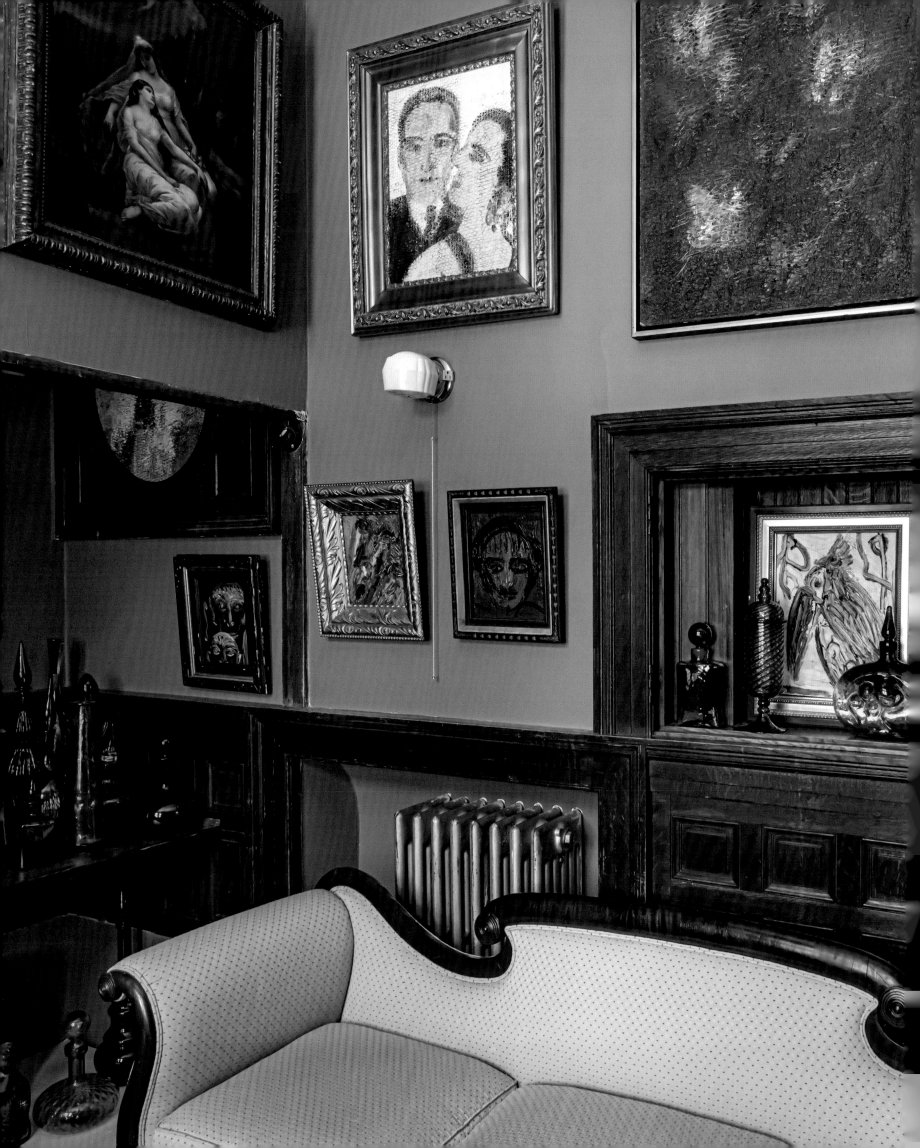

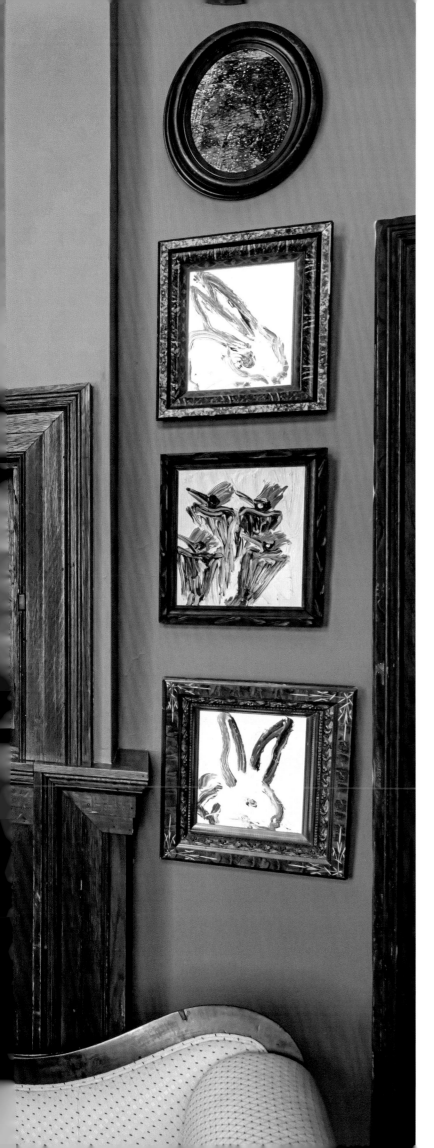

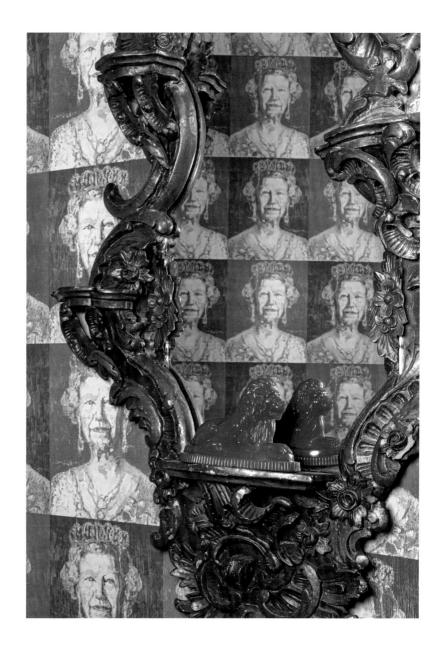

◄ A paneled room is hung with Hunt's paintings, including *Rudolph Valentino* and *The Countess*, and displays colorful Blenko glass.

▲ Hunt's "Her Majesty" Queen Elizabeth wallpaper highlights a powder room.

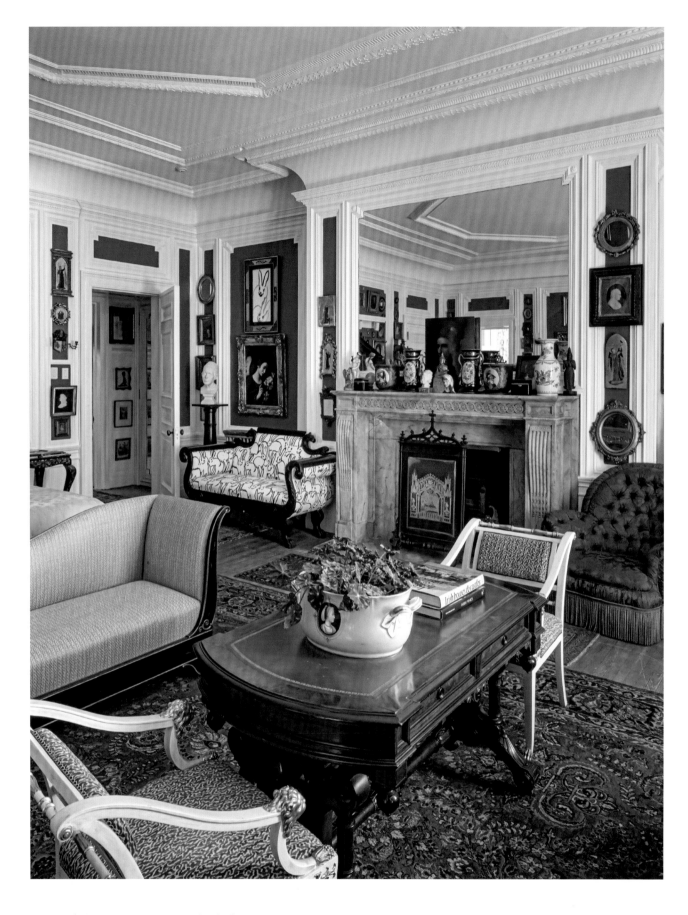

▲ Hunt's bedroom contains a burled walnut, Renaissance Revival center table and comfortable seating, including an Empire sofa upholstered in "Hutch."

▶ A gilded wood religious crown, miniature portraits, and religious paintings reside in Hunt's bedroom.

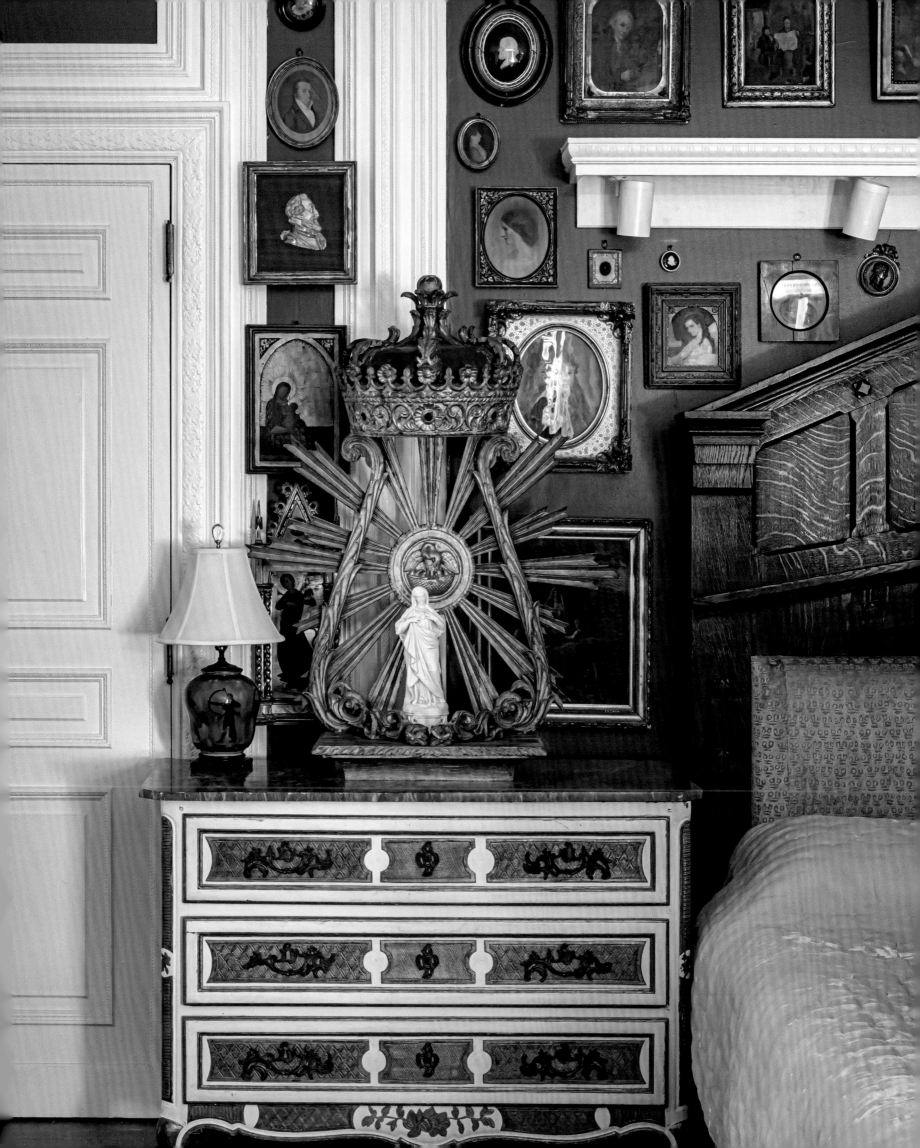

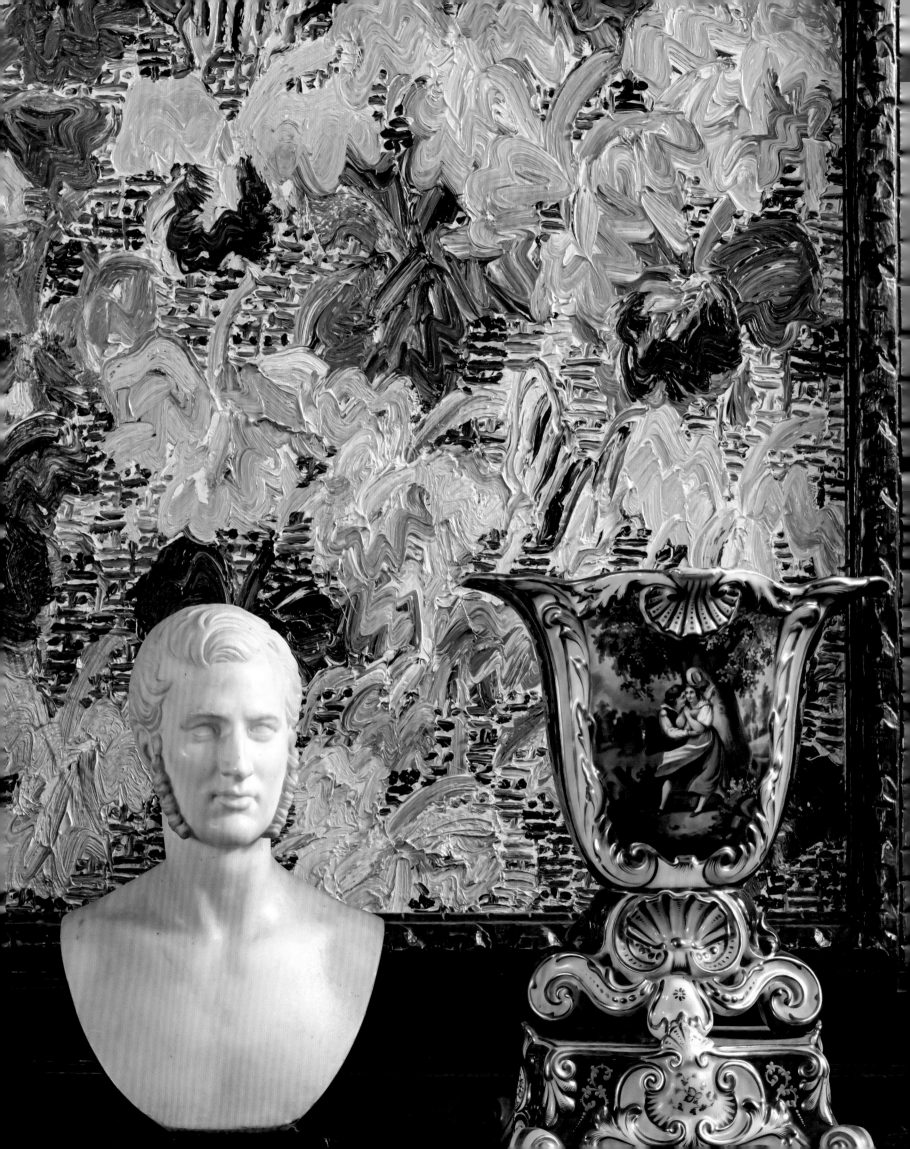

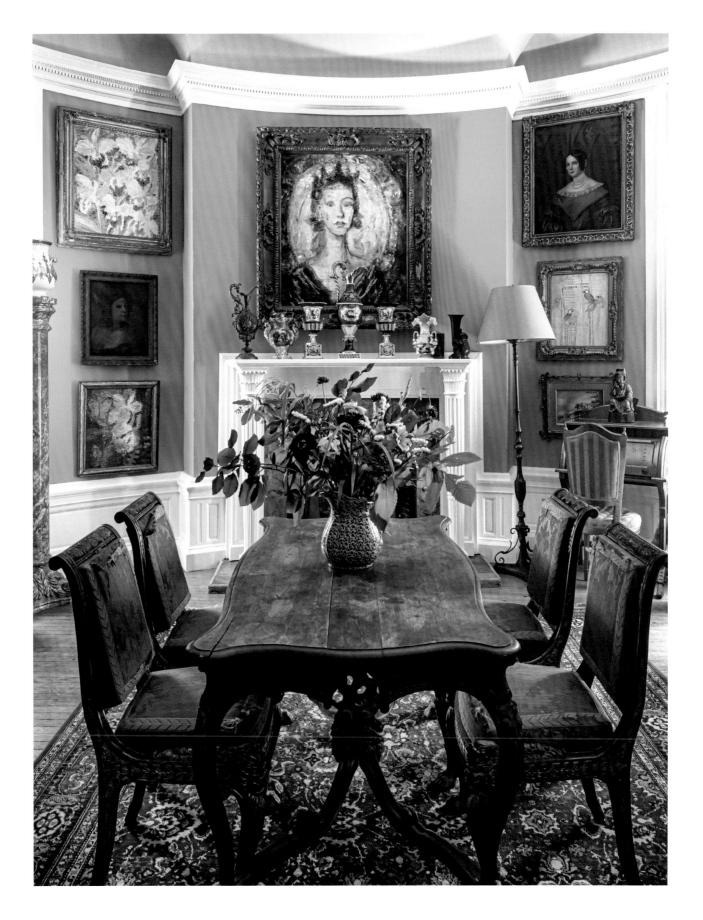

◀ The rich colors of *Cattleyas* are mirrored in an Old Paris porcelain vase.

▲ Flowers from the castle gardens grace a table in a circular sitting room hung with paintings that include *The Countess* and *Cattelayas*.

Overleaf: Front entrance to Searles Castle.

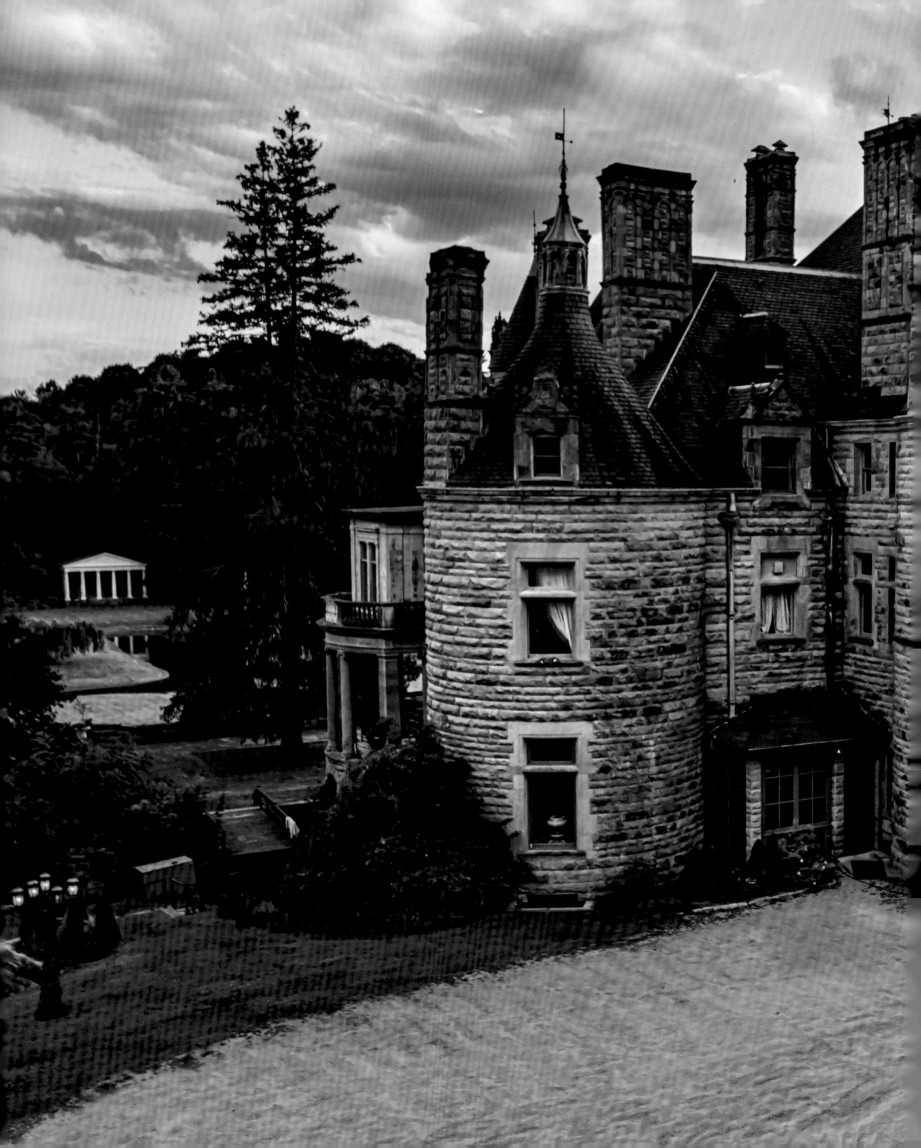

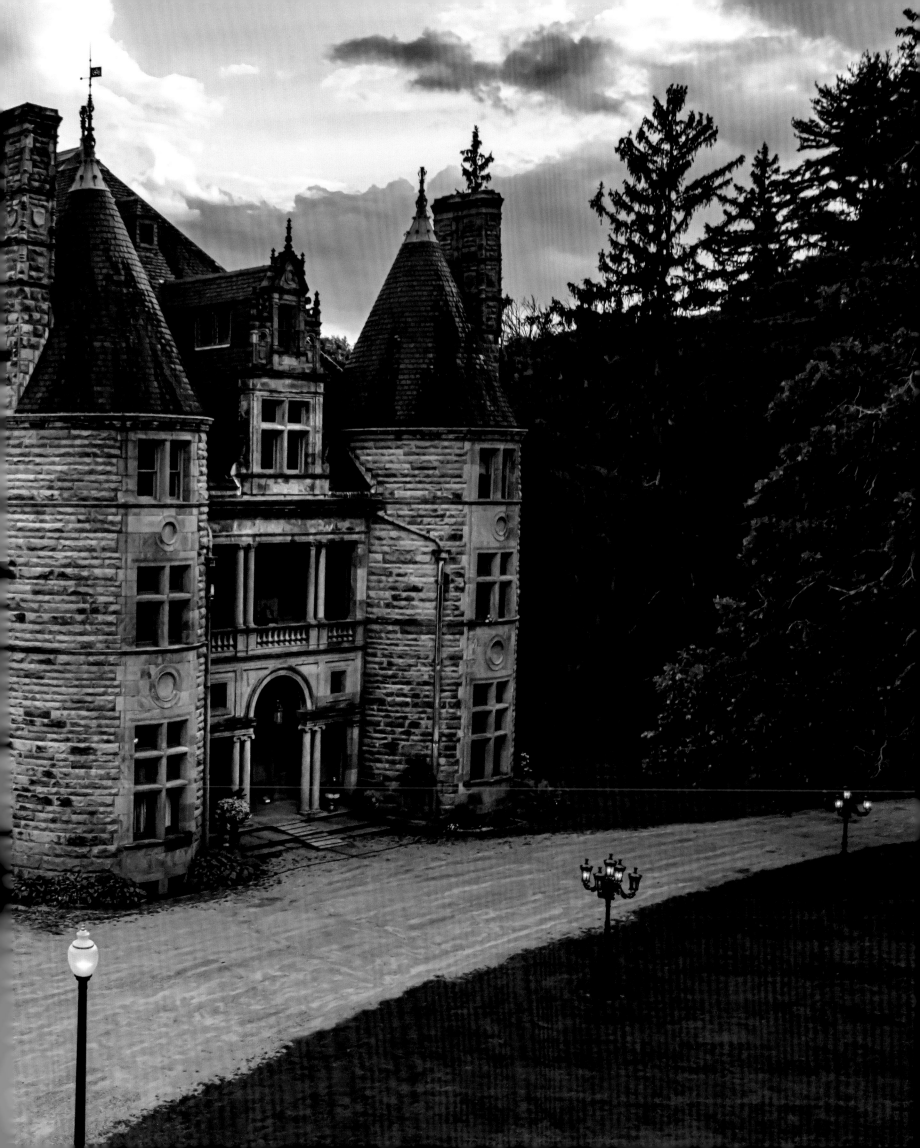

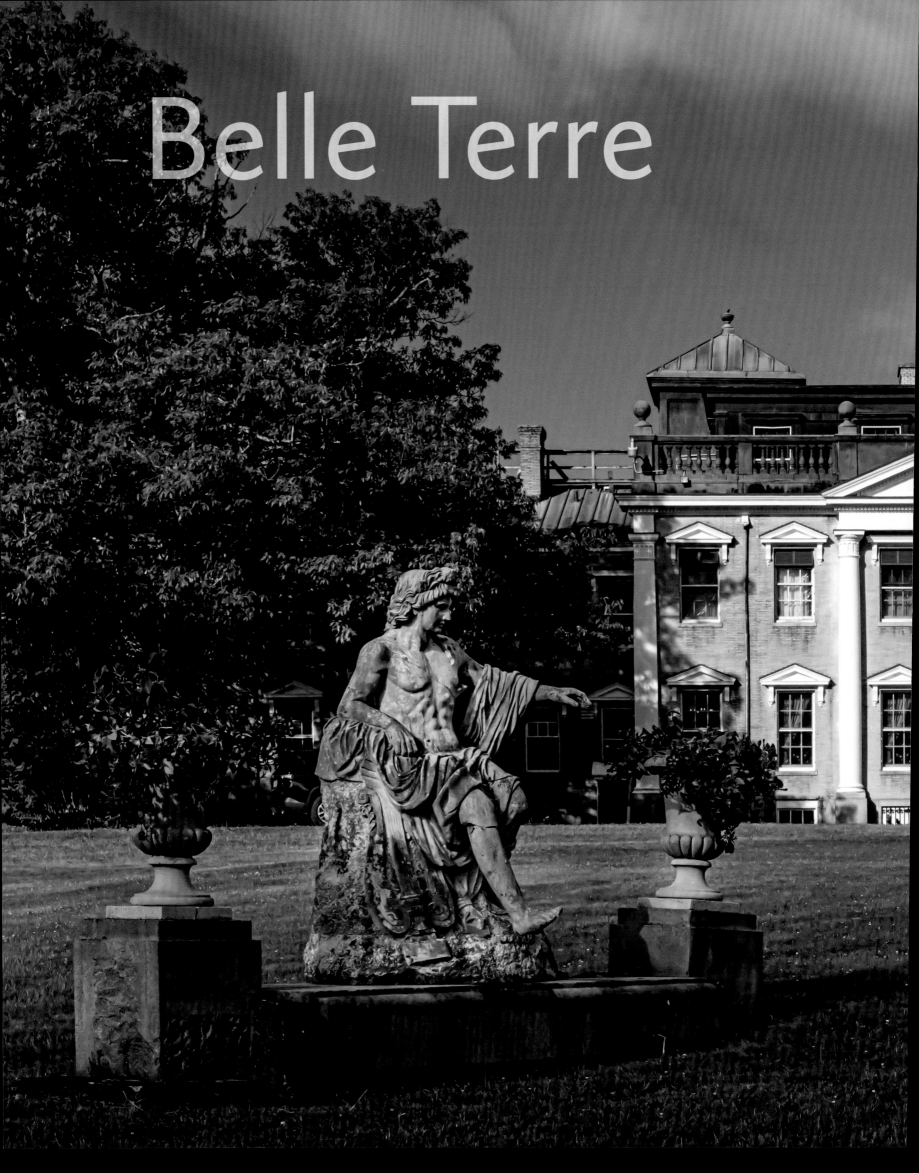

Belle Terre

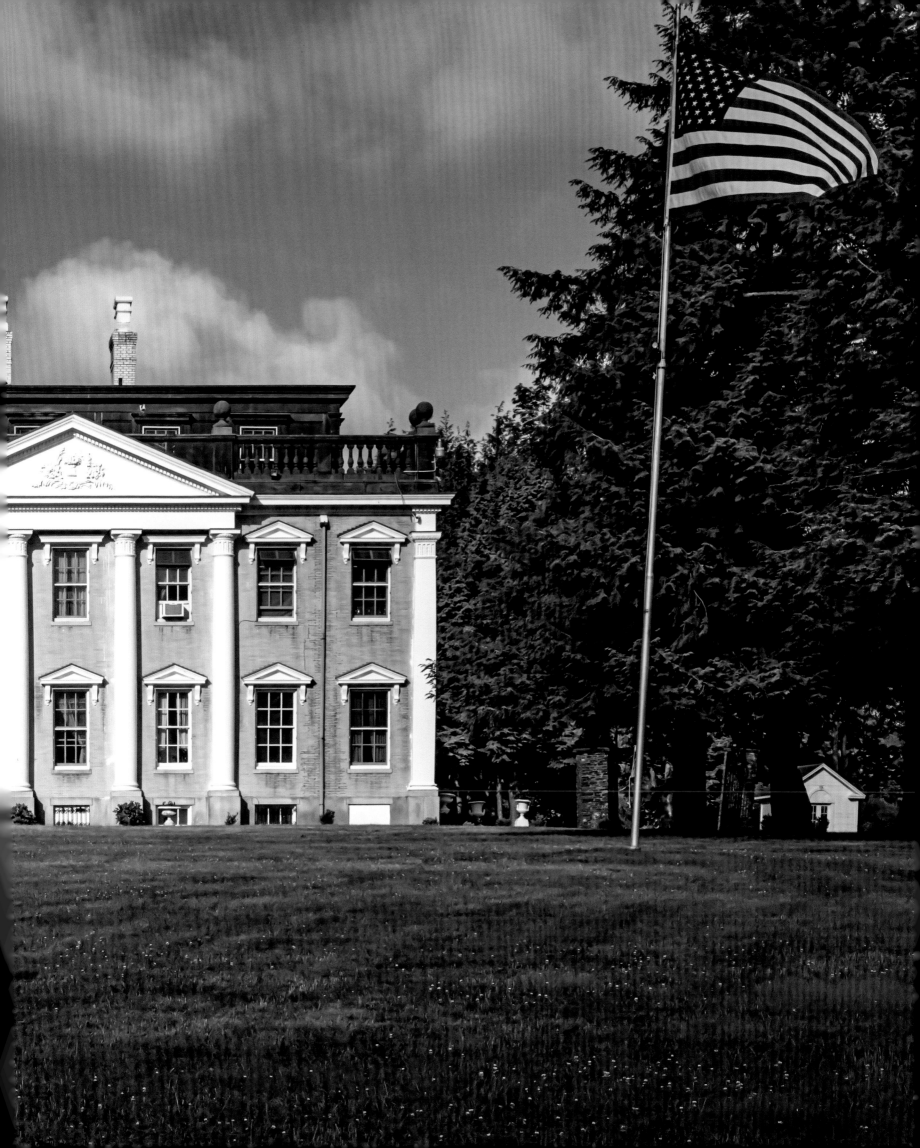

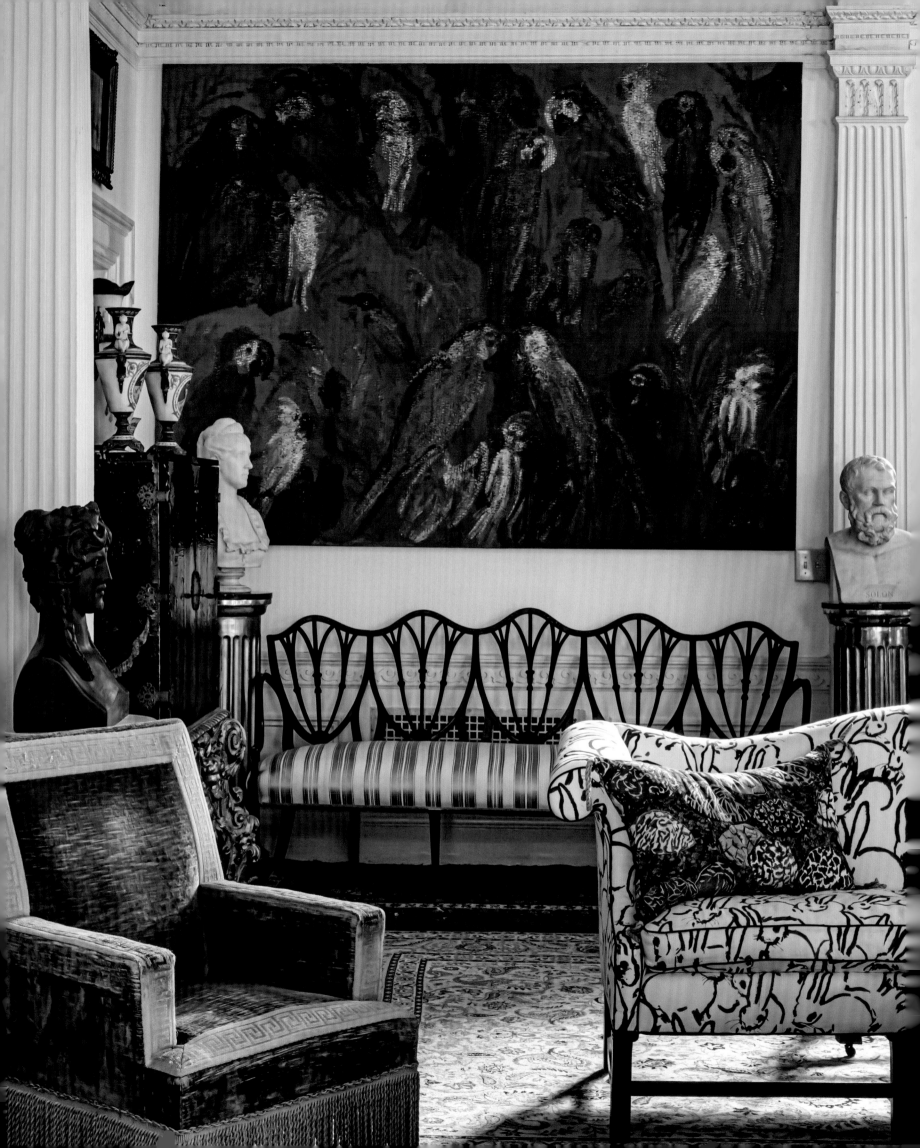

Belle Terre South Kortright, New York

Whenn Hunt heard about a grand 35,000-square-foot mansion in the Catskills that had recently come on the market in 2015, the scale was so unusual that he drove in a snowstorm to see it and was immediately taken by its grandeur. Built in 1906 by copper baron James McLean as a weekend estate for fox hunting, Belle Terre was set on fifty acres, including a private lake in the peaceful, rolling hills of upstate Delaware County, New York. The house presented a commanding façade, the clean lines of its Georgian Revival architecture a reflection of the Colonial Revival movement that was replacing "overly ornate" Victorian design. The interior was equally impressive: a 2,500-square-foot entrance hall ran the width of the house, with classical molding and plasterwork detailing still intact. Original mantels, each unique, had been left in place; the formal dining room's elaborate woodwork and door entablatures had never been altered, and there were sixteen bedrooms for weekend guests. This would be a departure for Hunt, as his previous homes were early nineteenth-century mansions, yet he was intrigued. Negotiations began and he bought the property two weeks later.

Originally named Riverside, the house name had been changed to Belle Terre ("beautiful land"), reflecting its pastoral setting. Many distinguished guests had been hosted there, including Eleanor Roosevelt, a friend of McLean's daughter, Alice. There was room for large events; Eleanor once gave a party at the estate for 6,000 guests (which inspired Hunt to paint her portrait for the home; it hangs in the blue Queen Victoria parlor). Alice maintained Belle Terre after her father's death, organizing an experimental farm for wayward girls on the grounds during World War II. Following Alice's death, it went through many uses, from a church to a dance school, and was boarded up for long periods of time. While the home survived intact, it had been "updated" over the years; unfortunately, the main entry hall had been divided into offices and cubicles, large bedrooms had been separated into smaller rooms, and an institutional kitchen had been installed.

Restoration began with removing the cubicles and wall divisions in the entry hall and bedrooms

Previous overleaf: A classic marble sculpture greets visitors on the drive to Belle Terre.

◄ *Red Picul* with macaws and cockatoos centers a seating arrangement in the entry hall set with antique marble busts and a sofa upholstered in black-and-white "Hutch," for Lee Jofa.

upstairs. Walls and plaster moldings were repaired, the roof and multiple leaks were stabilized, and new pipes and plumbing were added. The kitchen was updated, and its walls were covered with nineteenth-century transferware plates to make it more engaging. Herringbone oak floors were refinished and polished, softened with oriental rugs and carpets. In the dining room (one of the main features that had helped Hunt decide to purchase the house), the original sage-green walls and elaborate moldings were preserved. The entry hall was freshened with Colonial white, accented with a pair of crystal chandeliers, multiple sconces, gilded pedestals, marble busts, and large-scale neoclassical paintings.

Other rooms were glamorized with color—deep ultramarine in the Queen Victoria parlor off the entry hall; teal green in the library; soft, powder blue in the stairwell. Bold color upstairs was begun with a vibrant, orchid purple enlivening the main corridor, which runs the length of the home, and bedrooms were brightened with a rainbow of magenta, yellow, citron, and red. A confirmed collector, Hunt filled the rooms with Staffordshire figurines, gilded porcelains, classic marble and Parian statuary—objects that would have been found in an early twentieth-century interior. Hunt's bright and colorful paintings, often in period frames, were hung alongside eighteenth- and nineteenth-century portraits, accenting the home's classic architecture.

A light-filled passageway with French doors opening to the back gardens was turned into a solarium filled with plants in period jardinières. Hunt's focus on nature was continued with a collection of twenty-two rare, nineteenth-century Fiske aquariums filled with goldfish.

The grounds of Belle Terre were one of the features that attracted Hunt to the property. They were restored to their early twentieth-century elegance with large, planted urns, statuary, and colorful beds of perennials, including native lupines. Chickens and ducks roam the grounds once again, and the private pool—an unsightly garbage dump when Hunt purchased the home—was cleaned and refilled.

After nearly a decade of restoration, Belle Terre is once again what it was designed to be—a grand country estate and peaceful retreat celebrating the beauty and interplay of classic architecture, art, and nature.

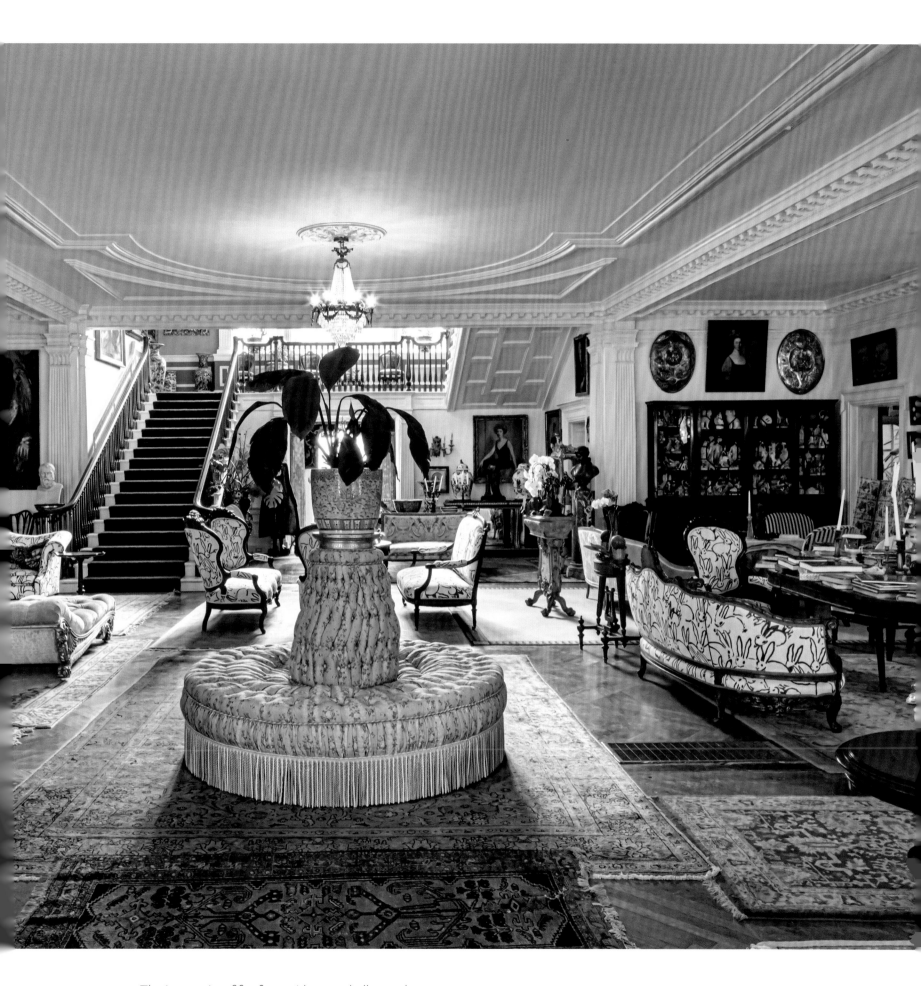

The impressive, fifty-foot-wide entry hall runs the width of the house and is divided into a series of seating areas filled with art and antiques.

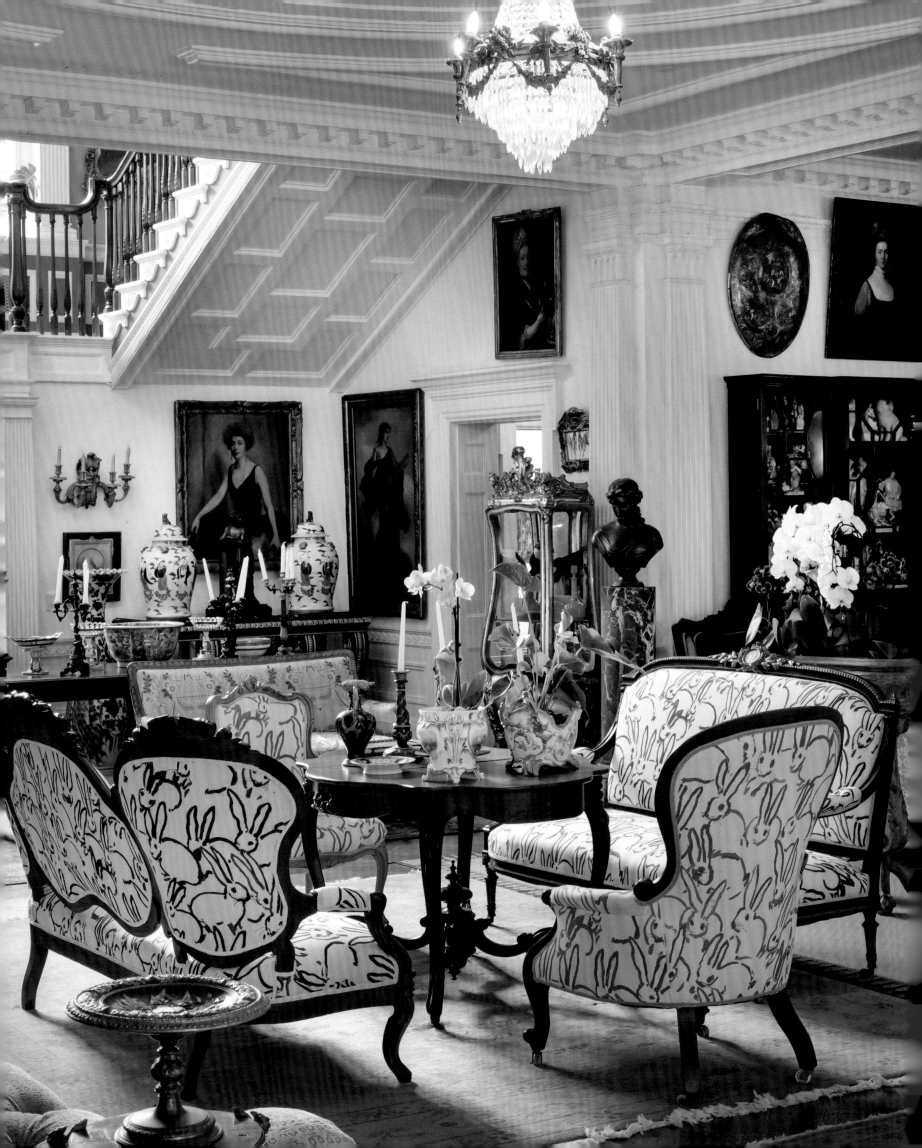

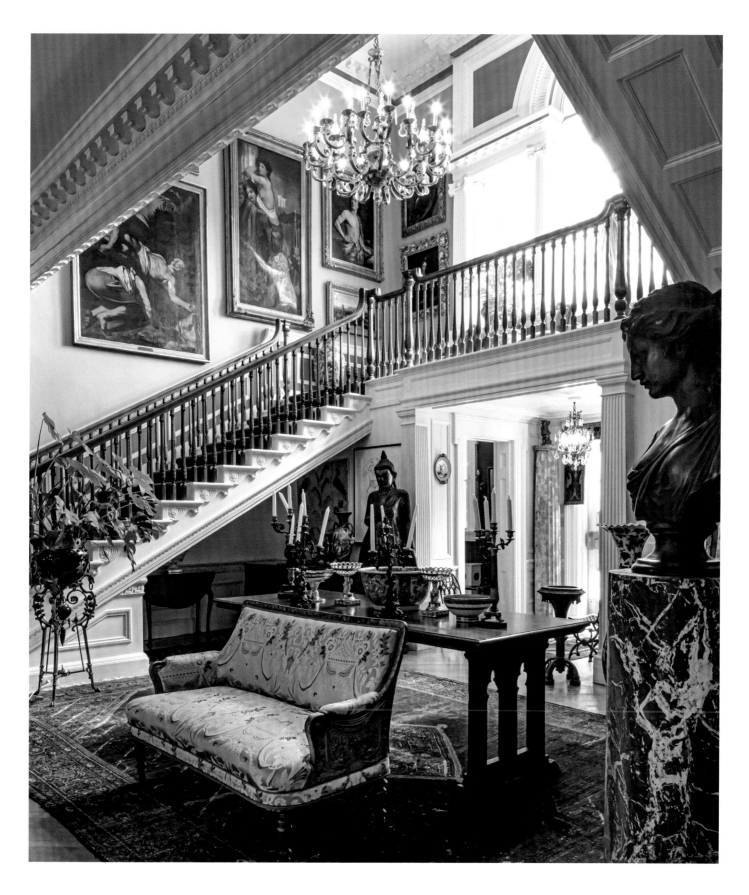

◄ A painting of the Duchess of Marlborough Consuelo Vanderbilt overlooks seating upholstered in Hunt's "Hutch." A glass display cabinet holding a collection of Staffordshire figurines is on the right.

▲ A rare Herter Brothers sofa rests at the bottom of the wide, light-filled stairwell lined with neoclassical paintings.

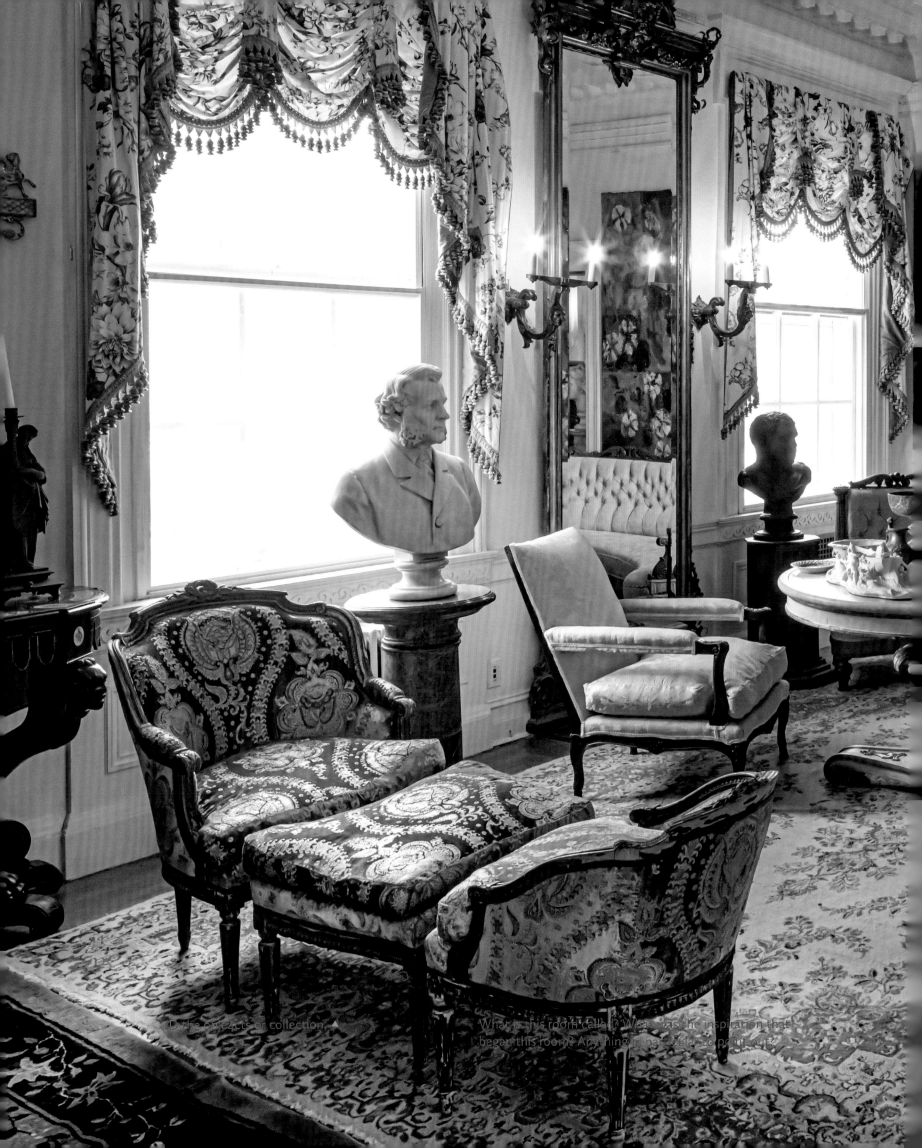

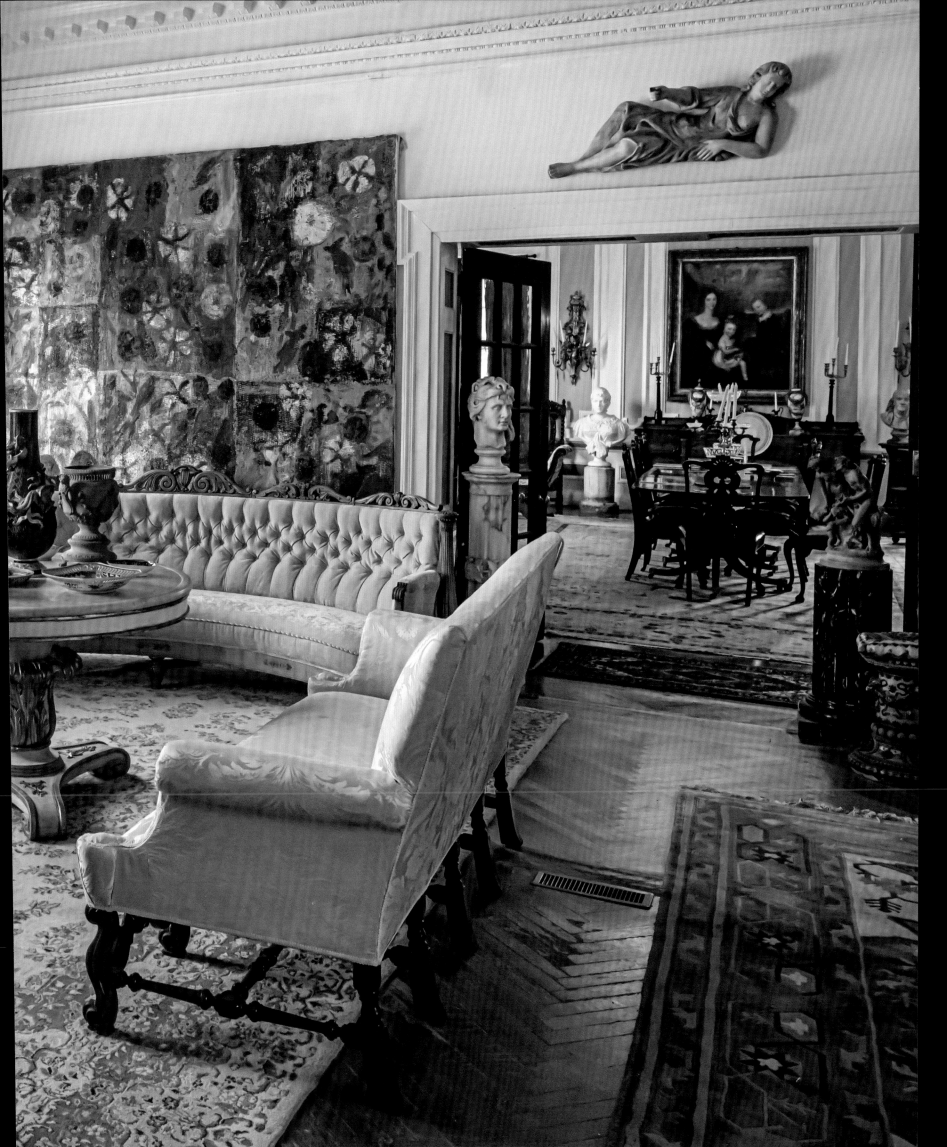

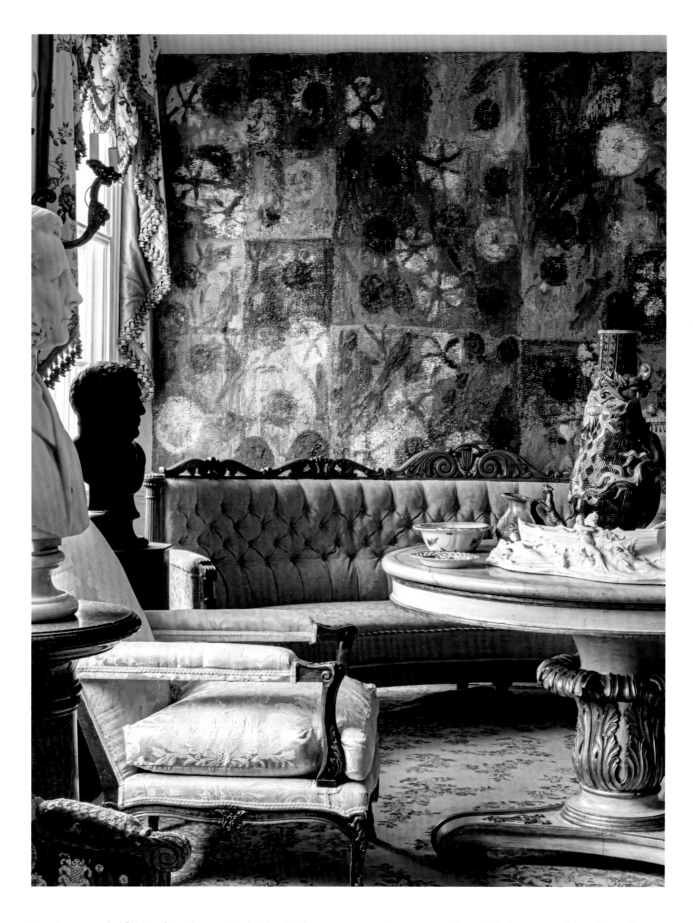

Previous overleaf: Hunt's 77-by-101-inch *Pinwheels* anchors a seating area in the front hall. Marble busts on pedestals, an Italian gilded pier mirror, and oriental ceramics on an Italian gilded center table add to the classic appeal. The dining room is seen beyond.

▲▶Seating area details.

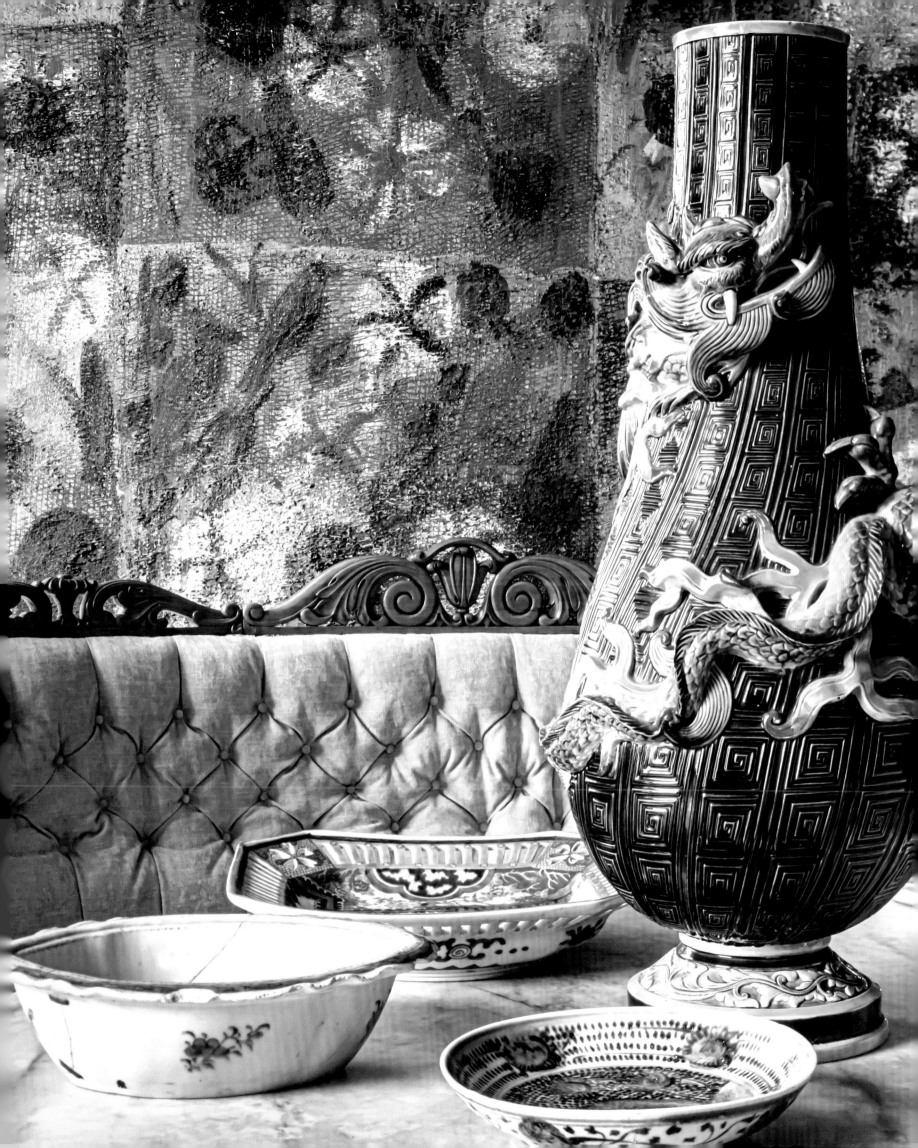

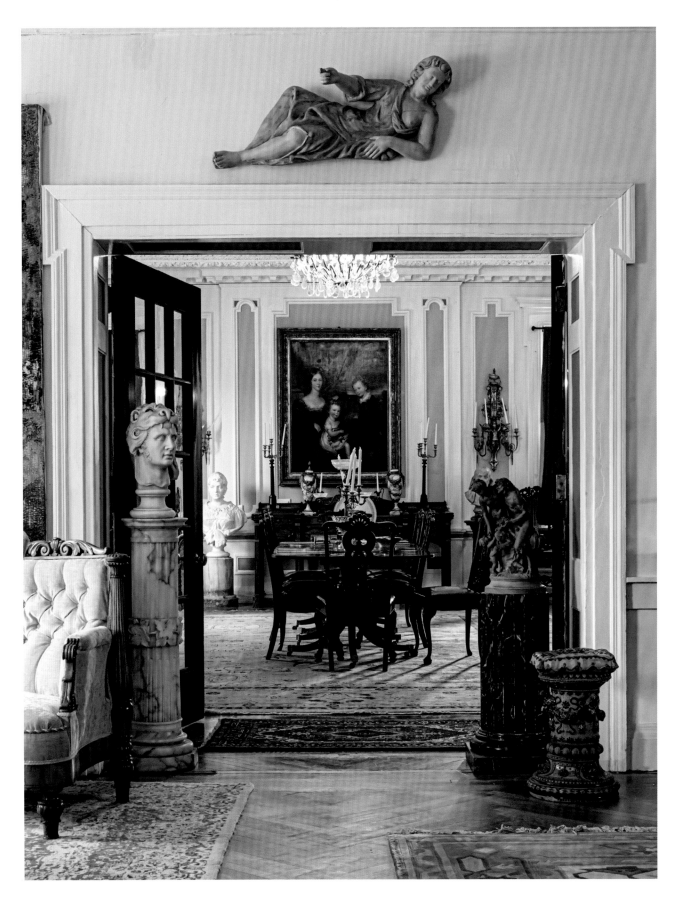

▲ The dining room's classical molding was one of the features that attracted Hunt to the home and was carefully preserved. A carved Baroque figure reclines above the door.

▶ The room is furnished with fine, nineteenth-century lighting, portraits, and antiques.

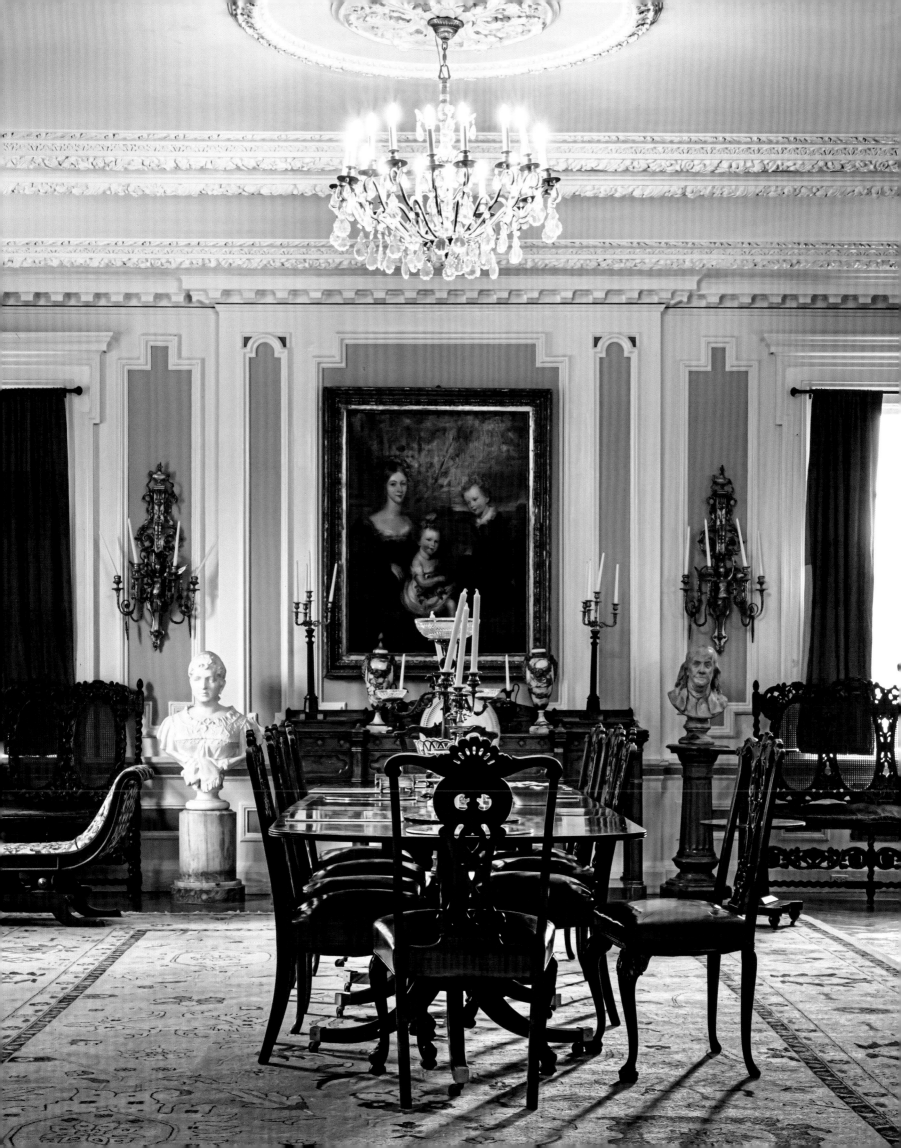

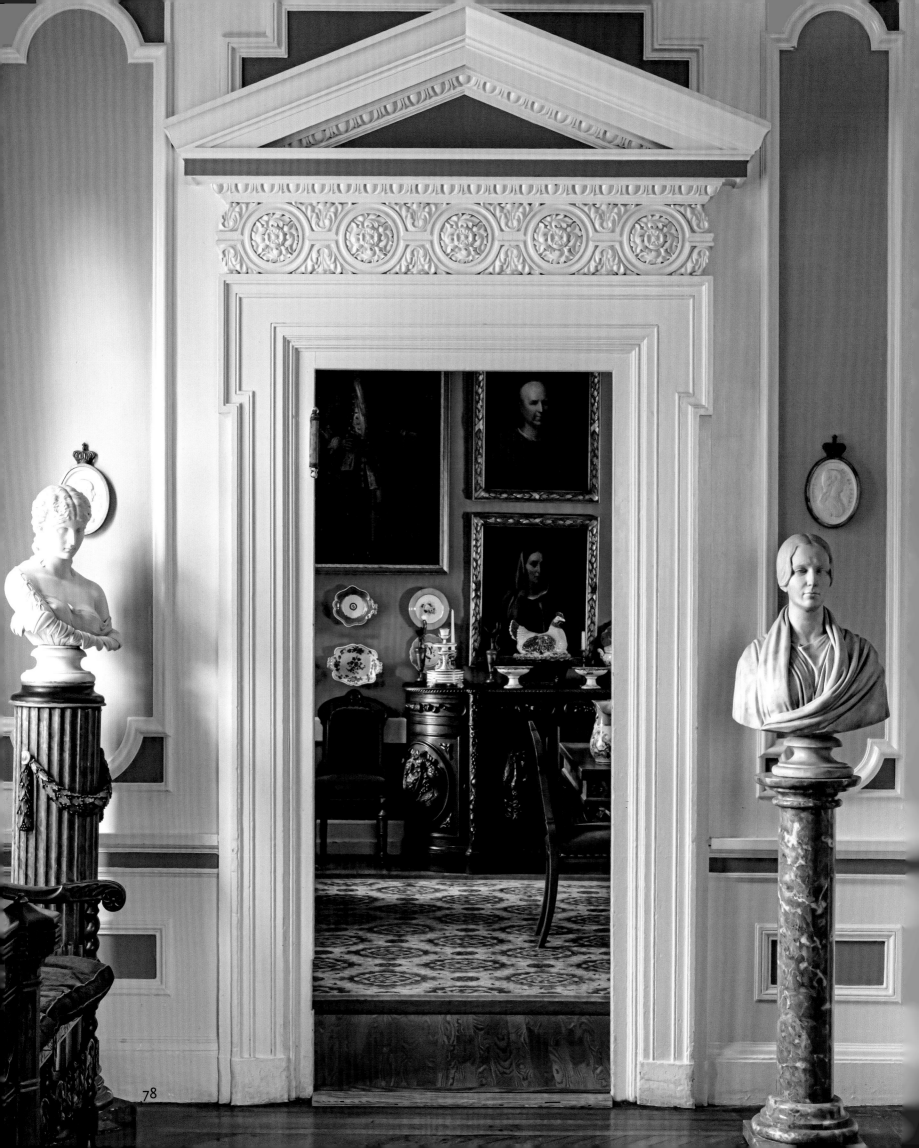

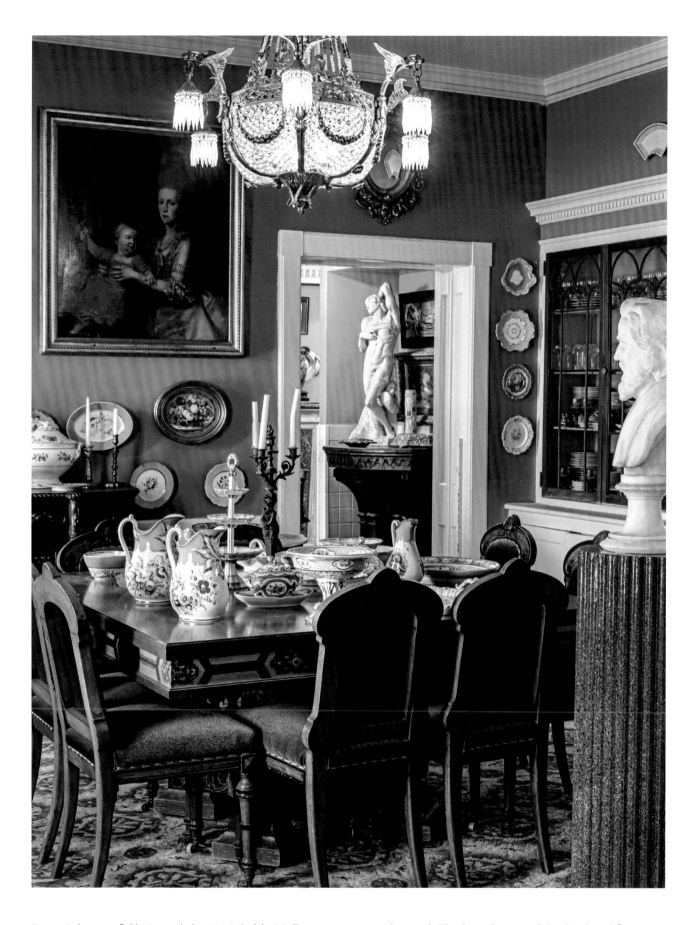

Portrait busts of Clytie and the Unsinkable Molly Brown frame the ornate, grand entablature over the doorway in the dining room, leading to the breakfast room beyond. The heavily carved Gothic breakfront was found in Cincinnati.

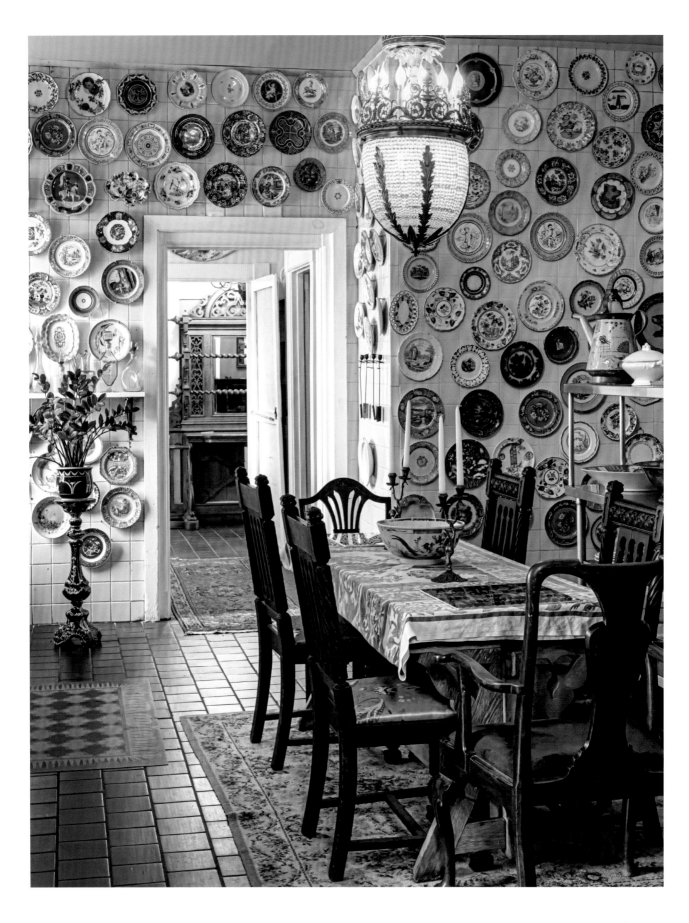

The kitchen walls are hung floor to ceiling with nineteenth-century transferware plates and platters.

Multihued Italian Blenko glass sparkles on a shelf near a window.

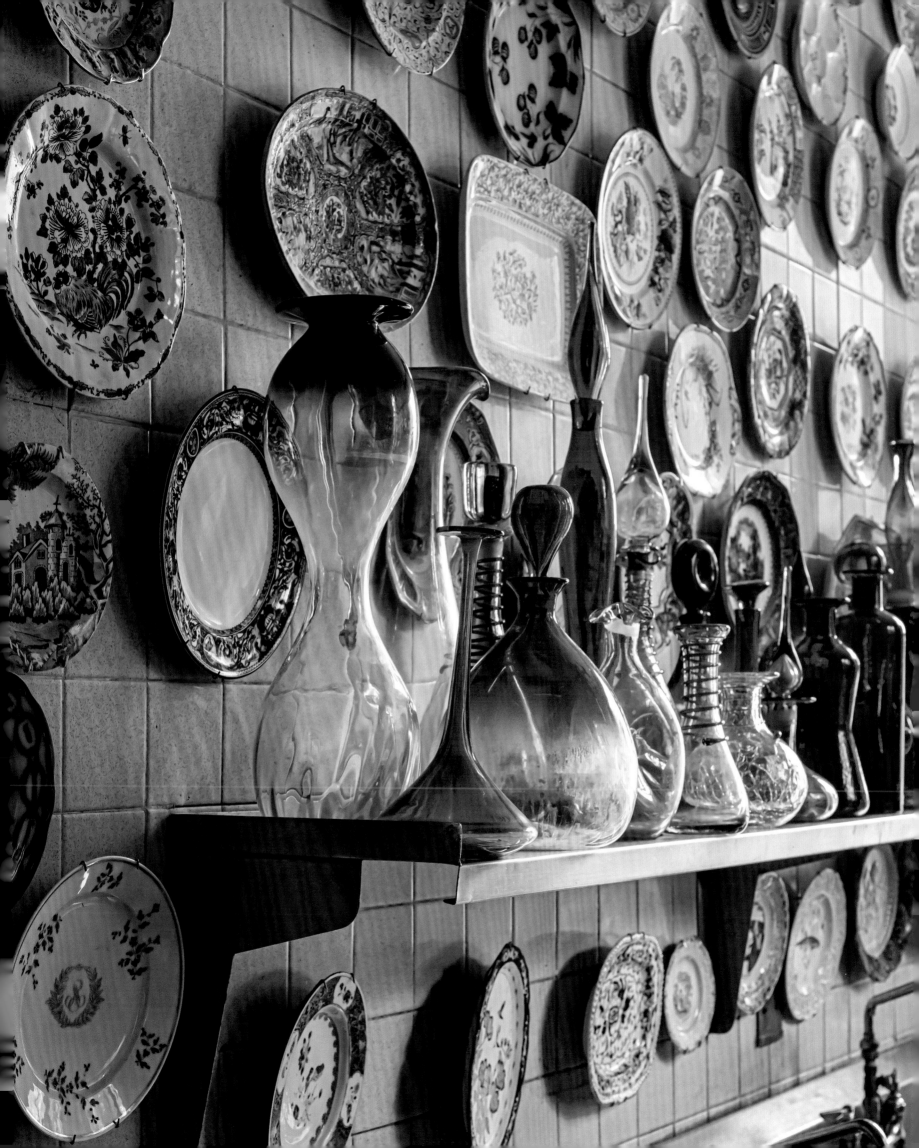

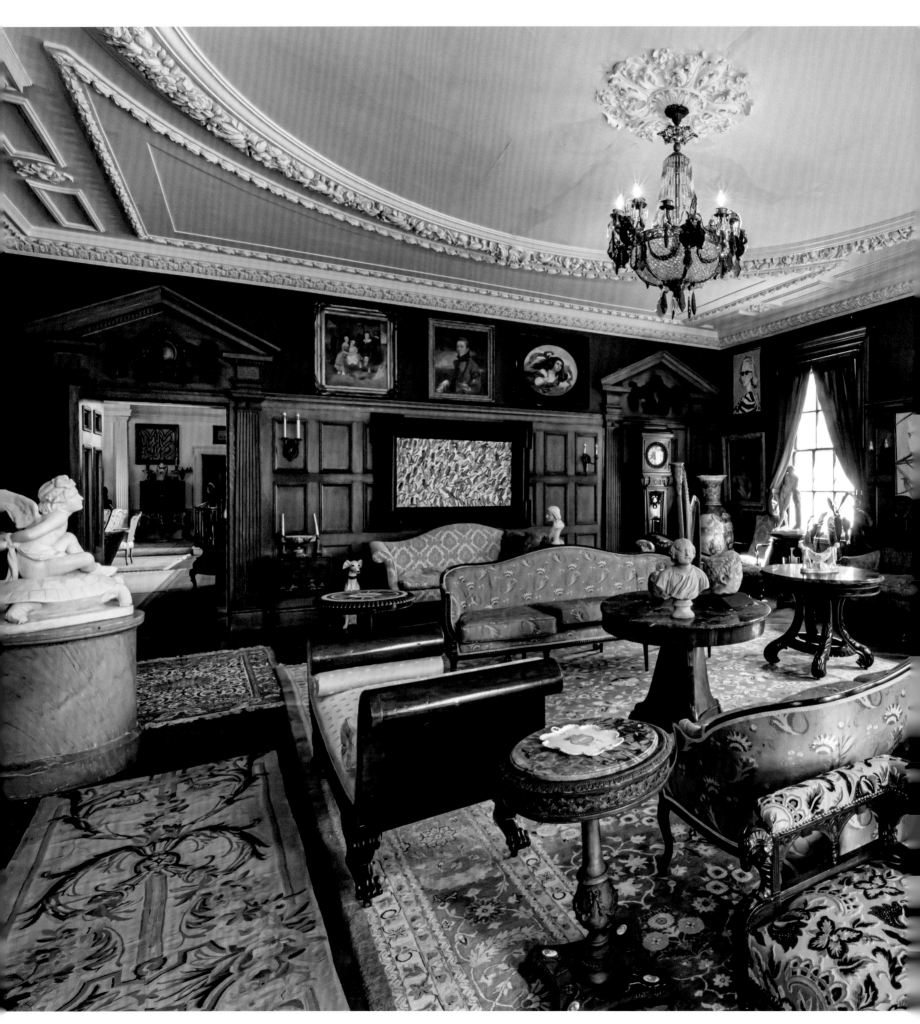

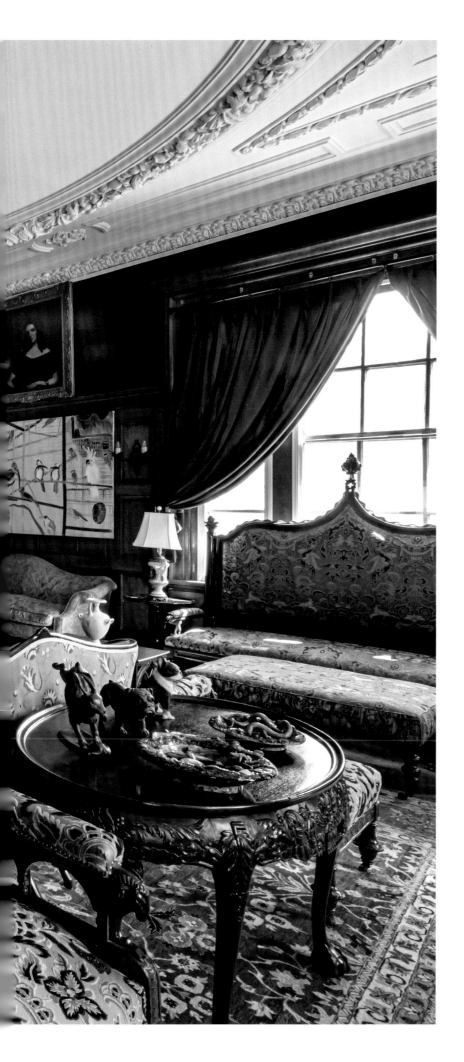

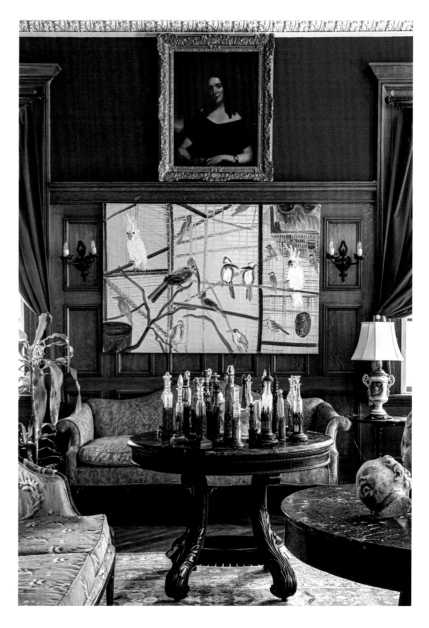

◄ The stately blue parlor features original oak woodwork and fine antiques. A *Finch* series painting is centered on the back wall.

▲ An early aqua *Aviary* painting complements the furnishings.

Overleaf: A collection of scarce Gothic scent bottles.

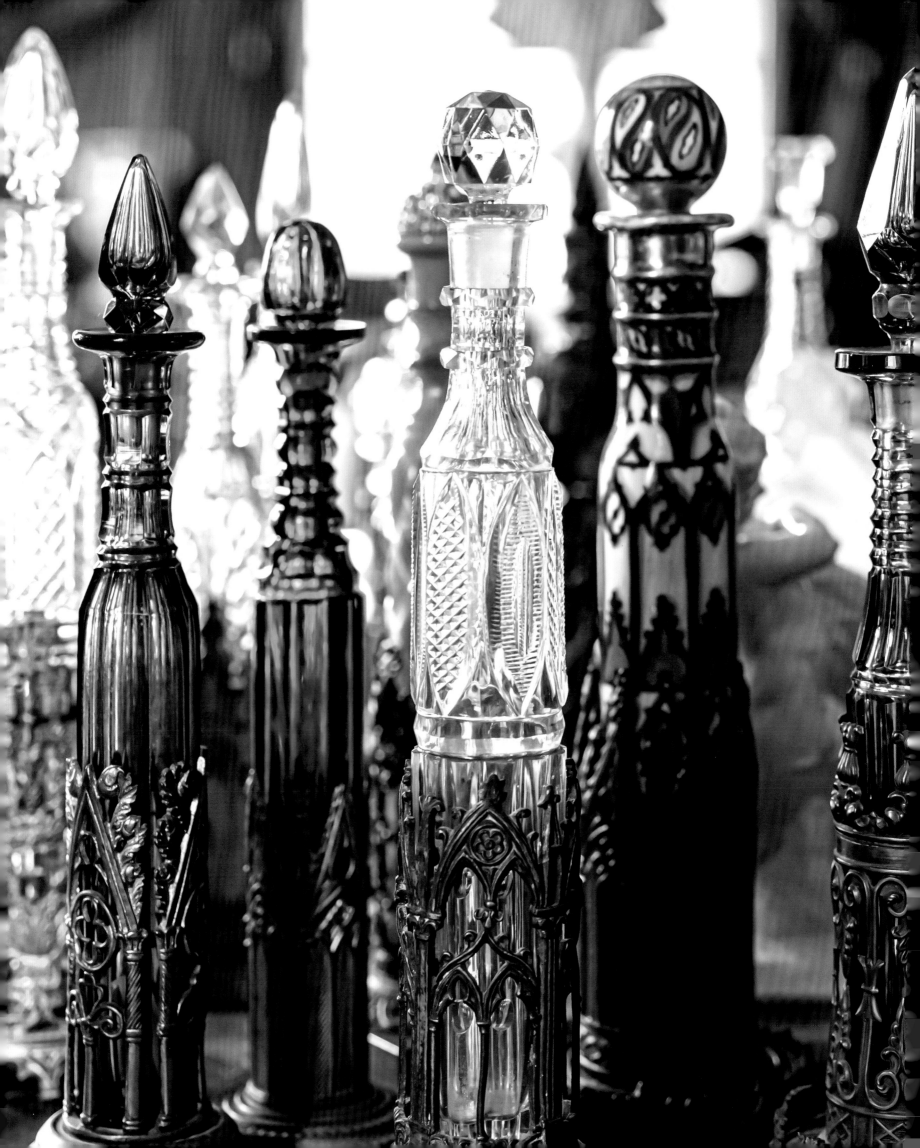

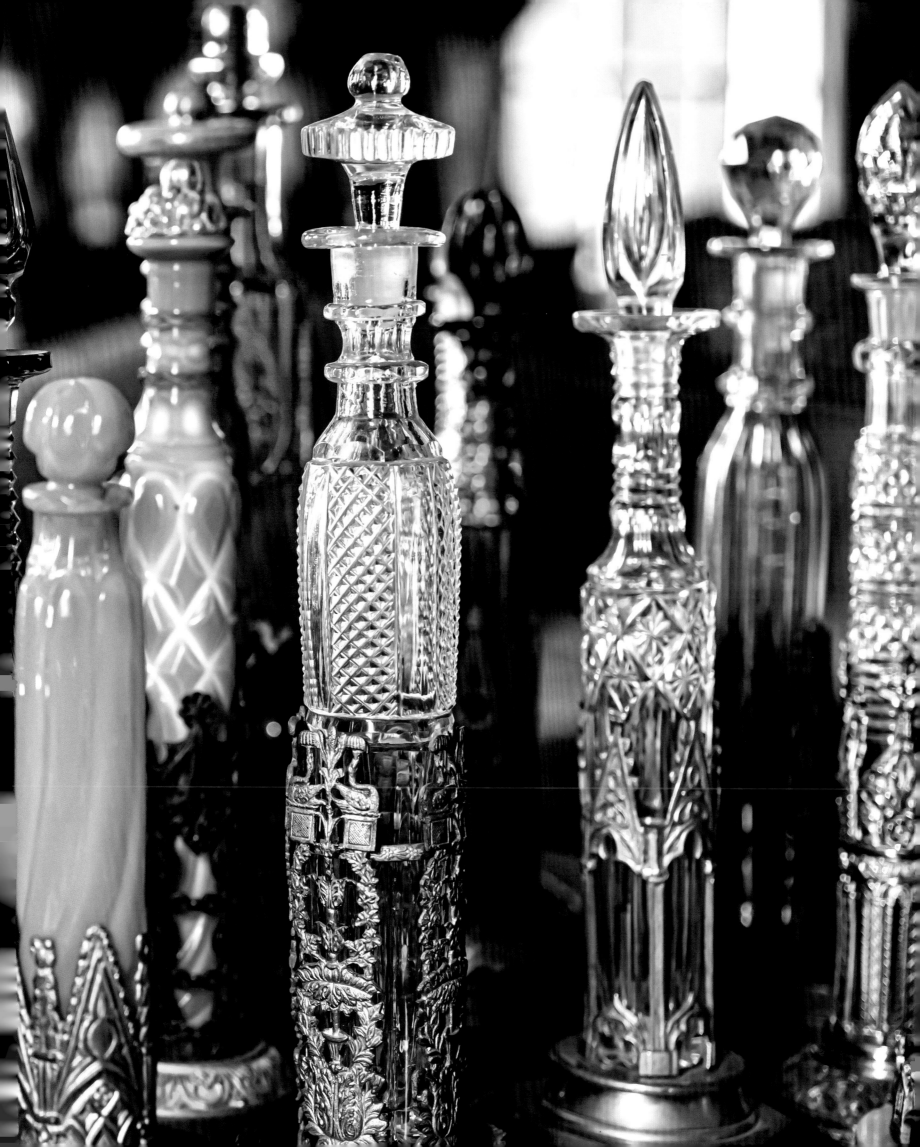

▲ Hunt's *Abraham Lincoln* portrait hangs over the original parlor mantel.

▶ A corner is occupied by a harp and classic statuary.

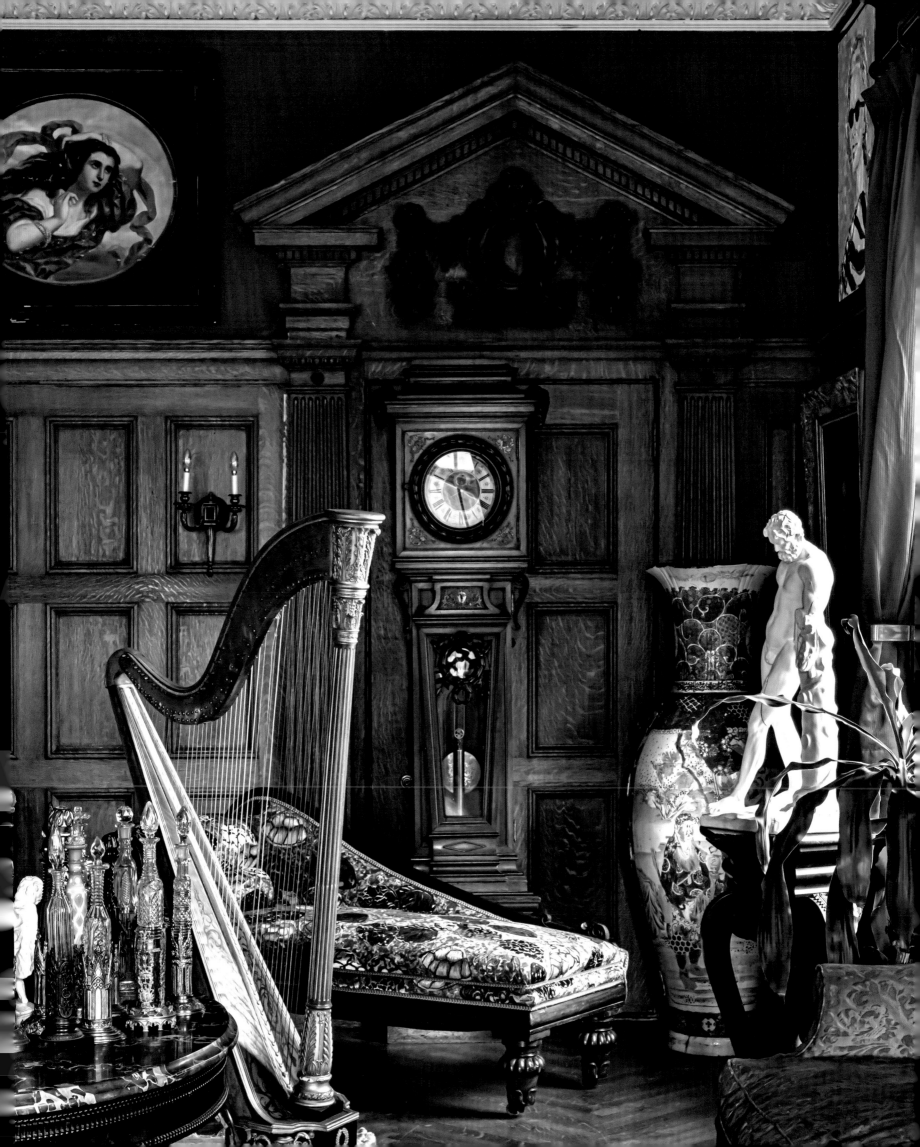

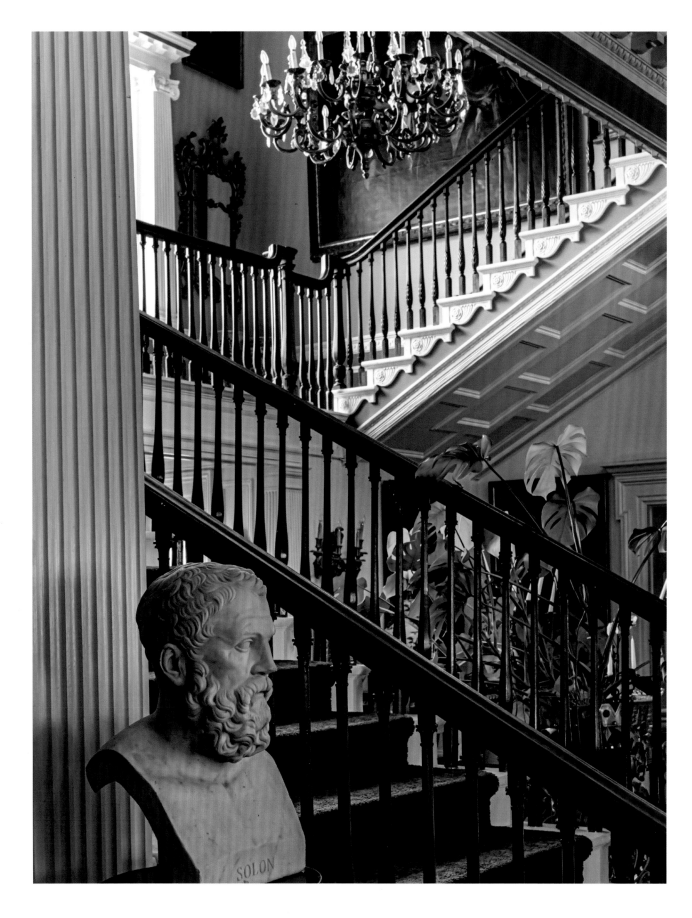

▲ Handsome molding and balustrades highlight the staircase leading to the second floor.

▶ The upper landing is hung with Hunt's *Black Diamond Dust Bunnies*, *Abraham Lincoln*, and a large portrait of Napoleon's wife, *Empress Eugenie*.

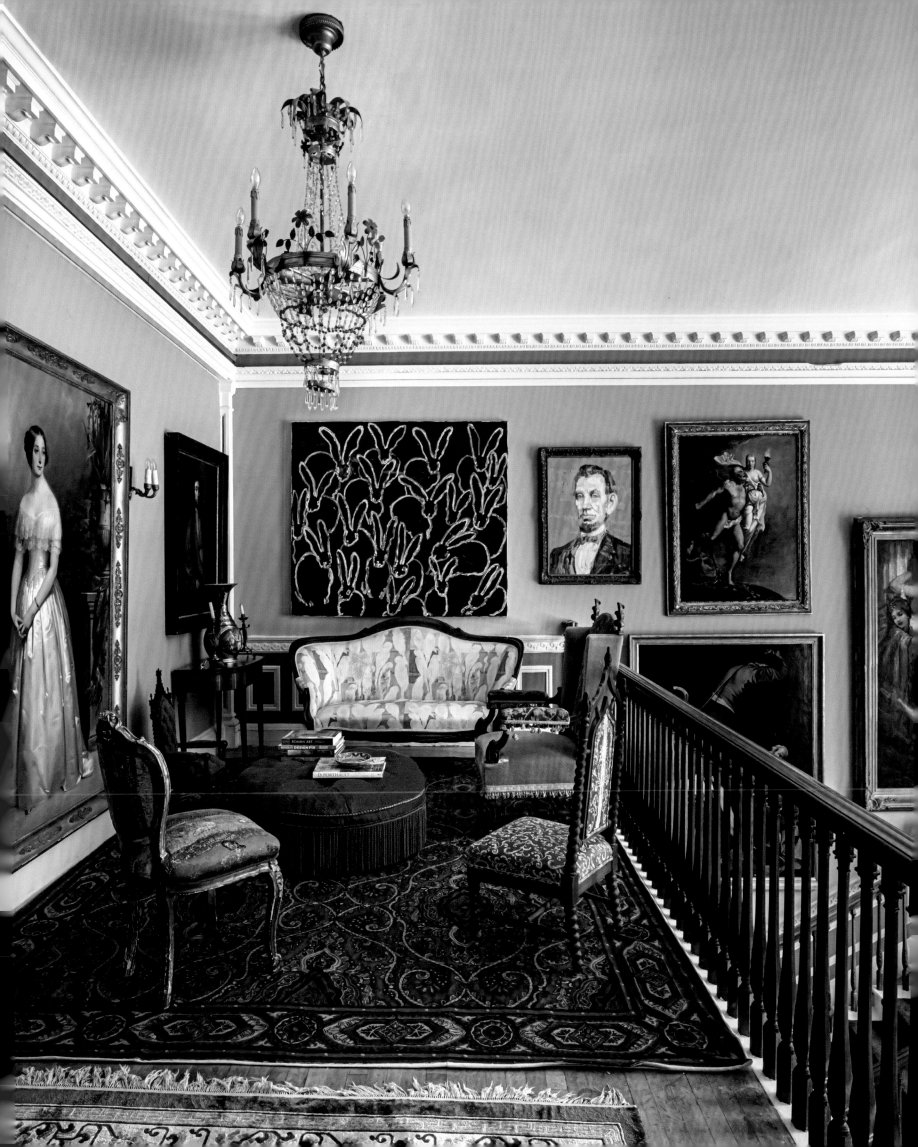

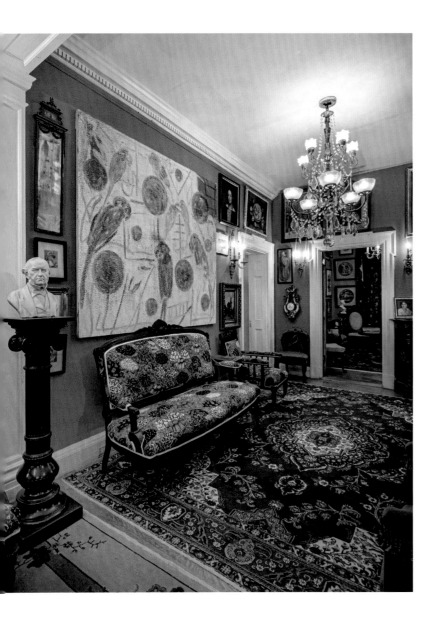

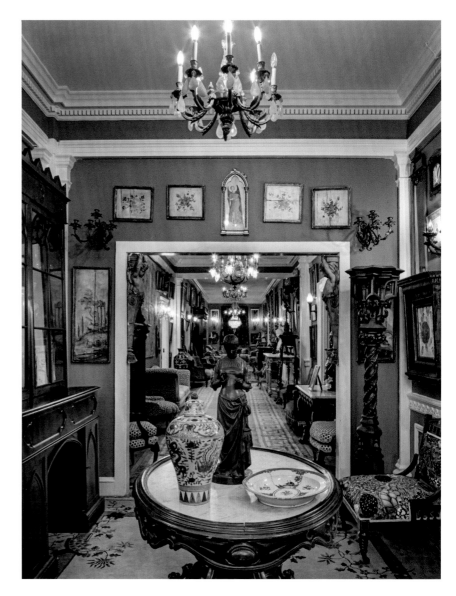

▲ The second-floor hall runs the length of the home and displays an array of marble busts, sculptures, and antiques along with Hunt's paintings, including (left) *Blue Pearls and Hyacinths*, and a sofa upholstered with "Star of India."

▶ *Passenger Pigeons* and an Attic Neo-Grec vase rest along one wall.

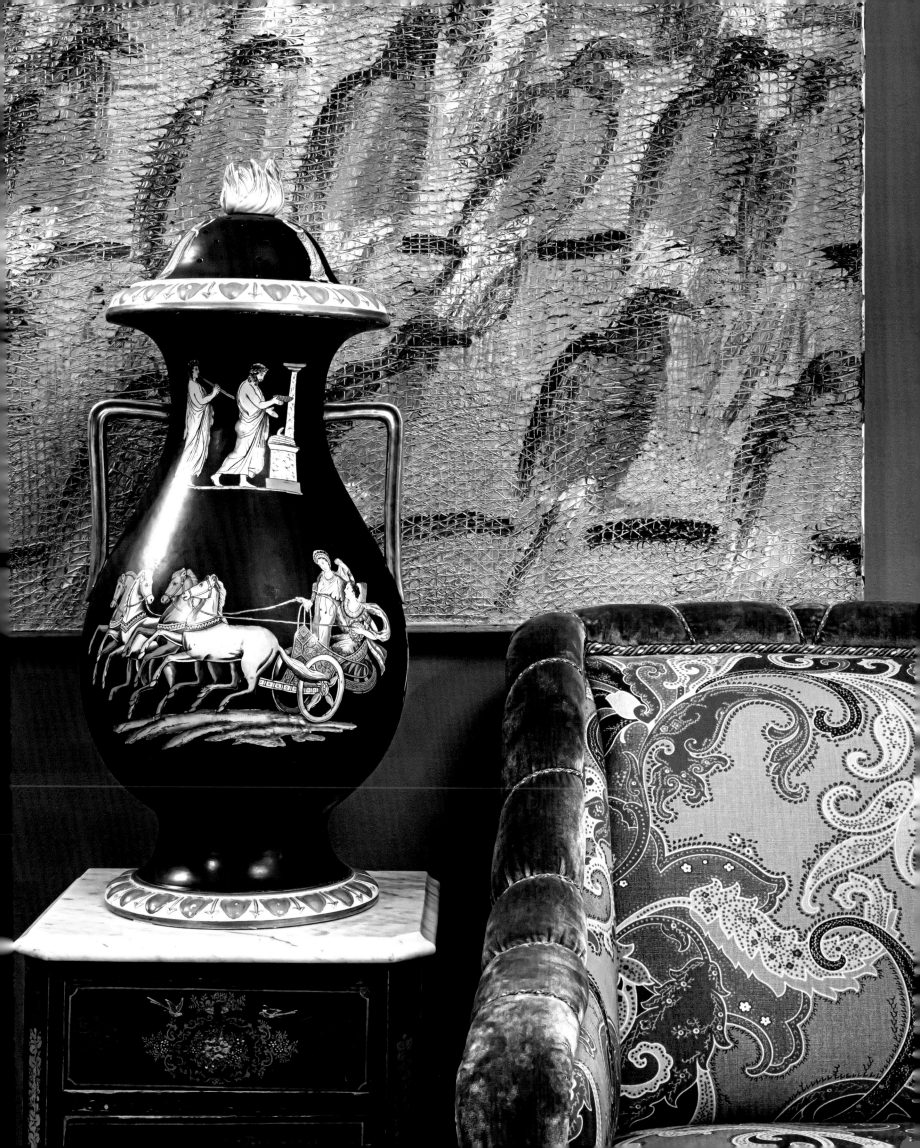

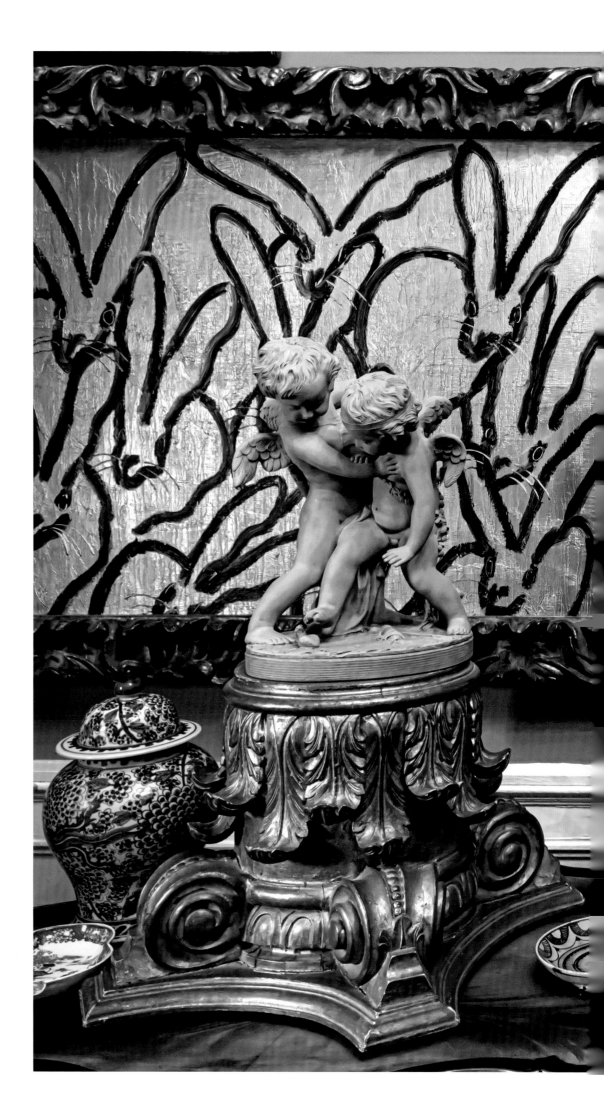

A metallic *Hutch* painting in a gilded Victorian frame is hung among bunnies, butterflies, and a miniature landscape of Mt. Vesuvius. A starburst mirror reflects the rest of the room, and a tooled leather Venetian sofa sits below.

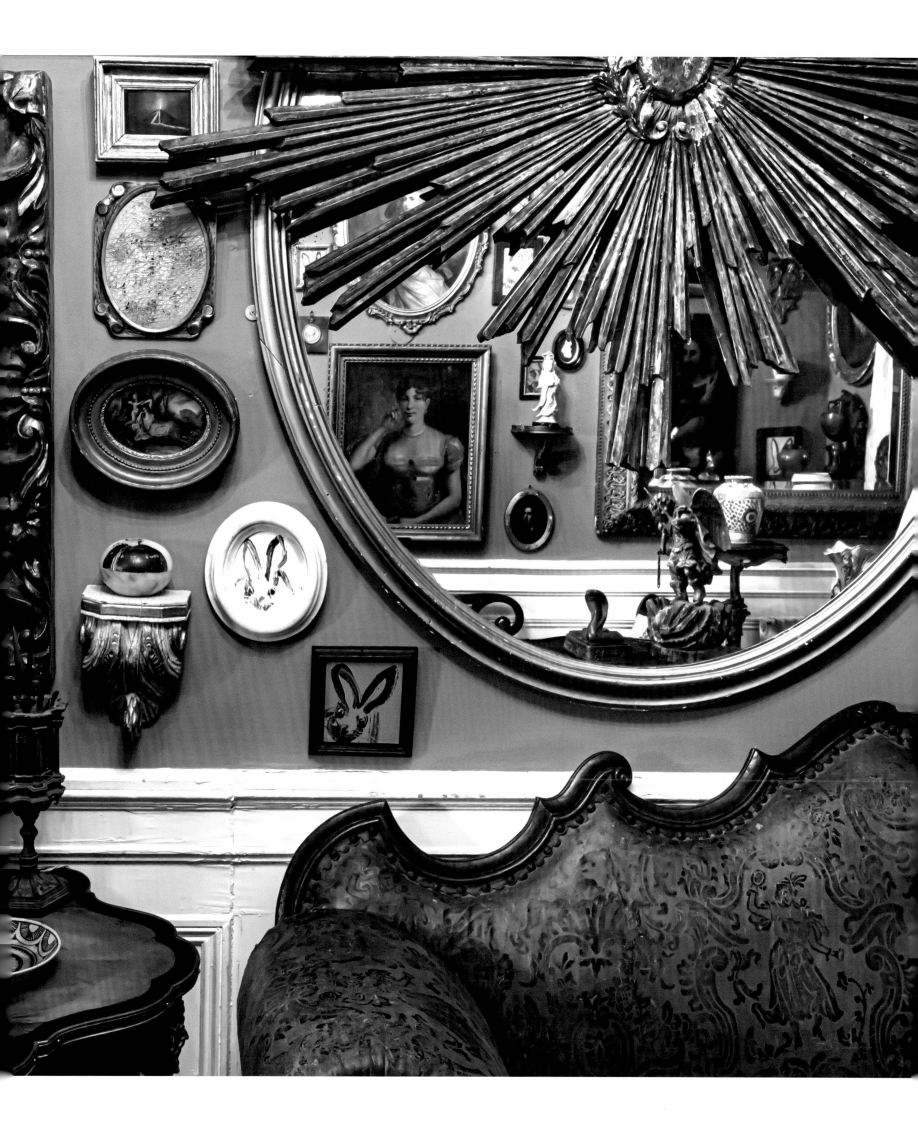

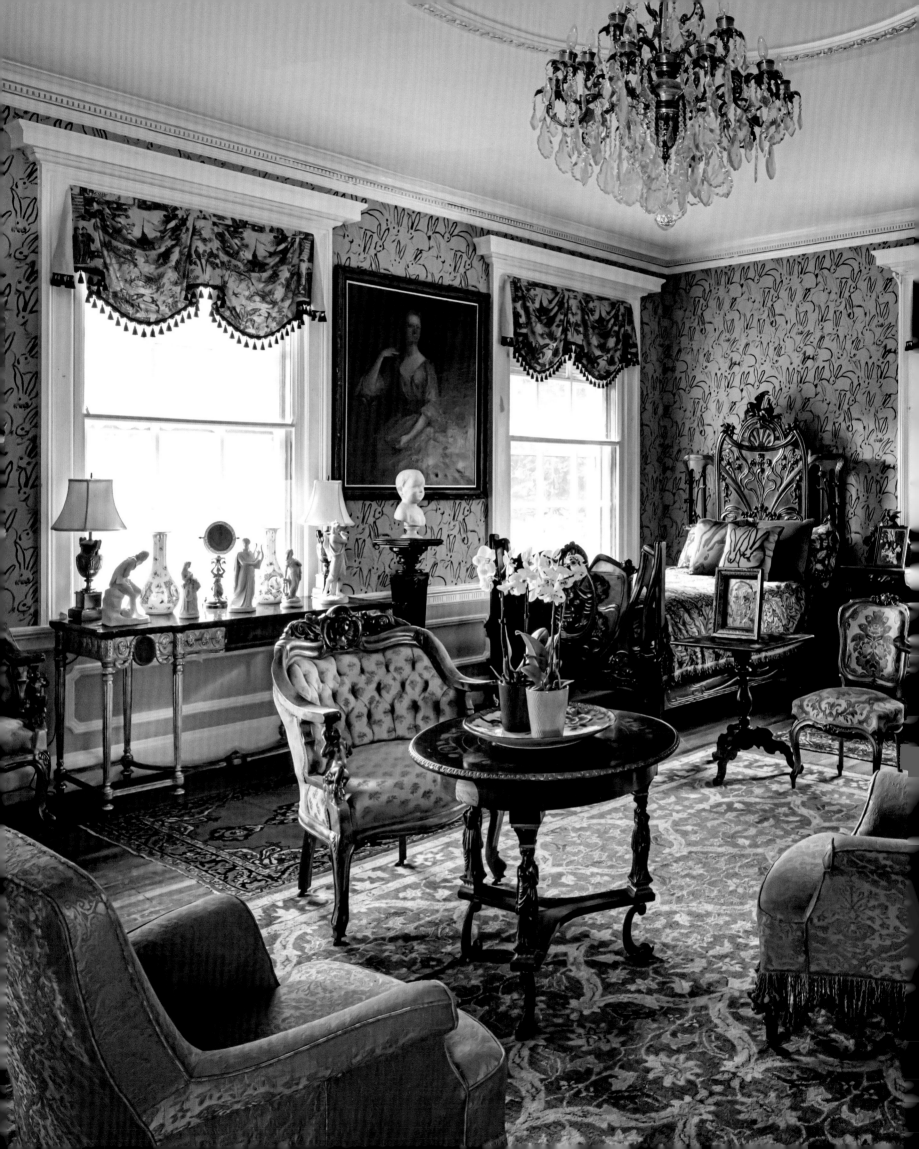

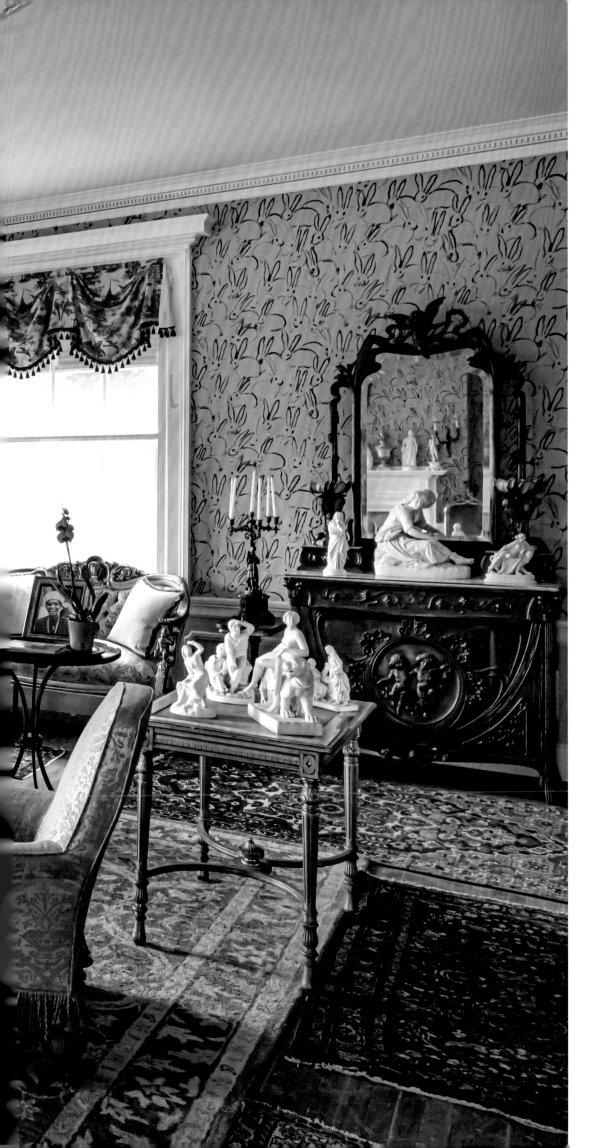

◄ Bunnies in a bright yellow "Hutch" wallpaper, for Lee Jofa, envelop a bedroom. Early twentieth-century antiques include an ornate Art Nouveau bed.

Overleaf: A marble bust of Marie Antoinette rests in front of the bedroom's original mantel, which holds Parian statuary.

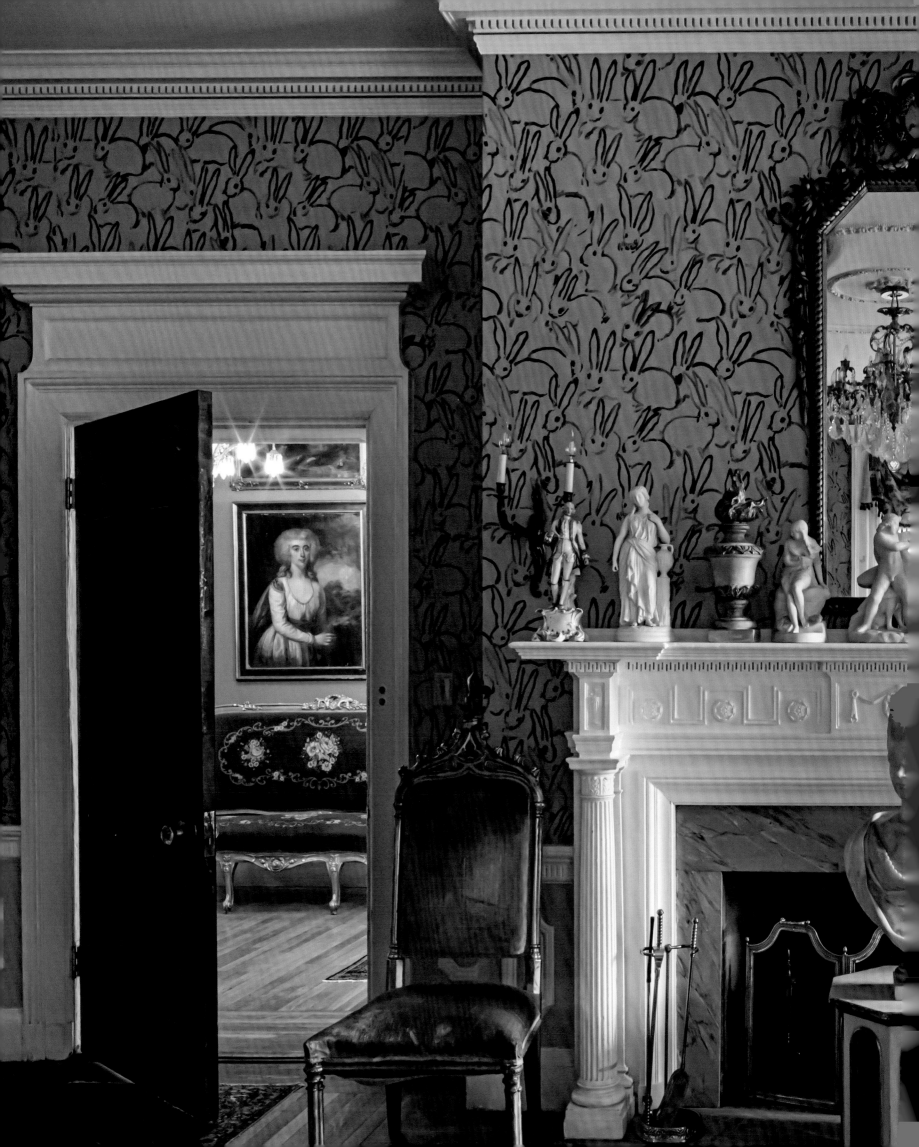

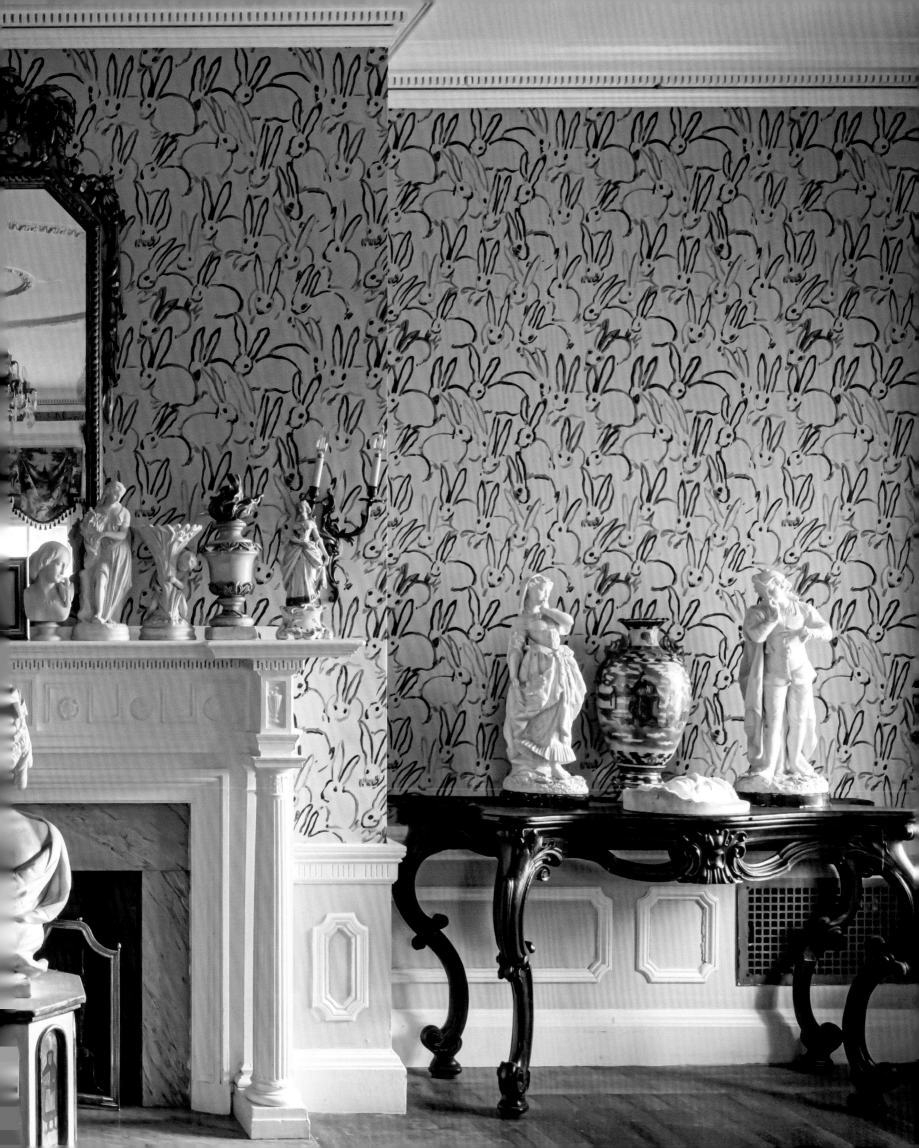

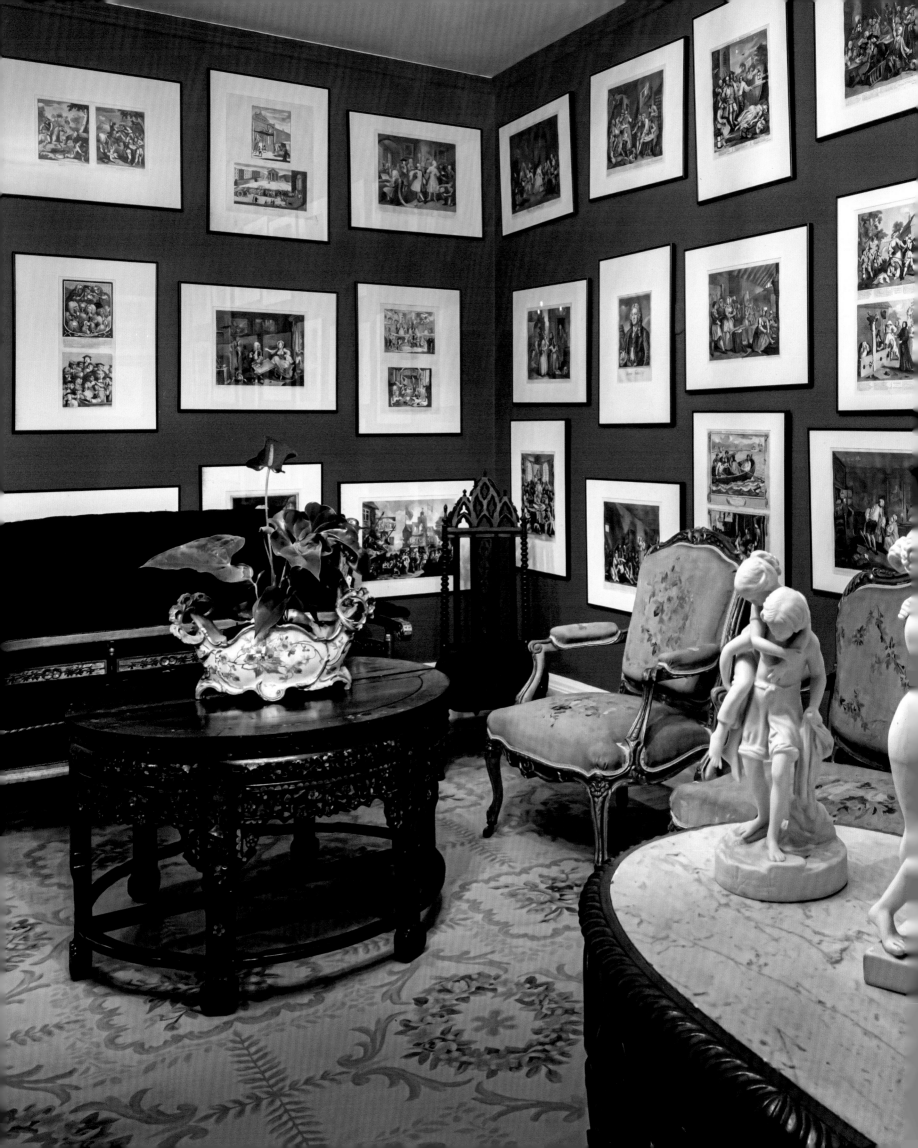

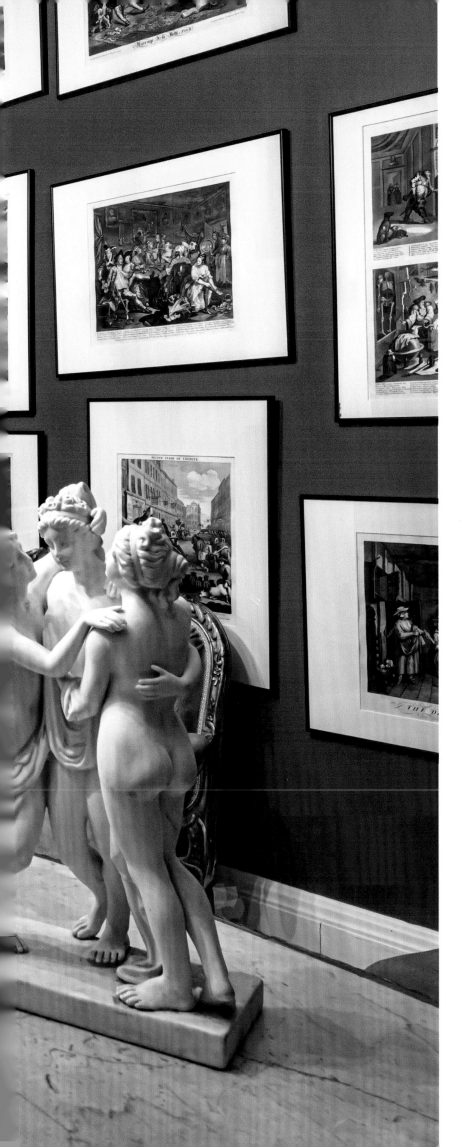

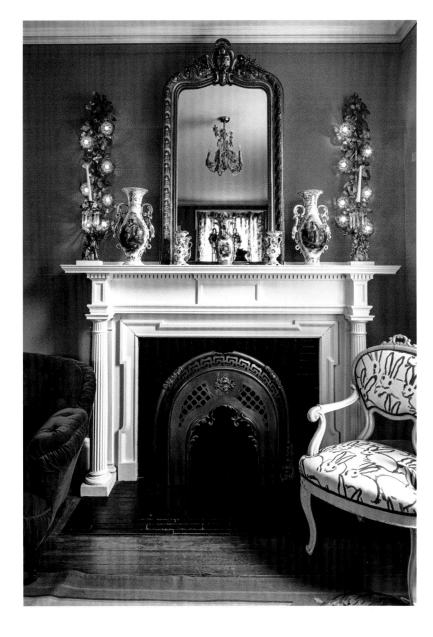

◄ The Print Room, on the third floor, is hung with Hogarth's *The Rake's Progress*.

▲ An original mantel displays Old Paris porcelain.

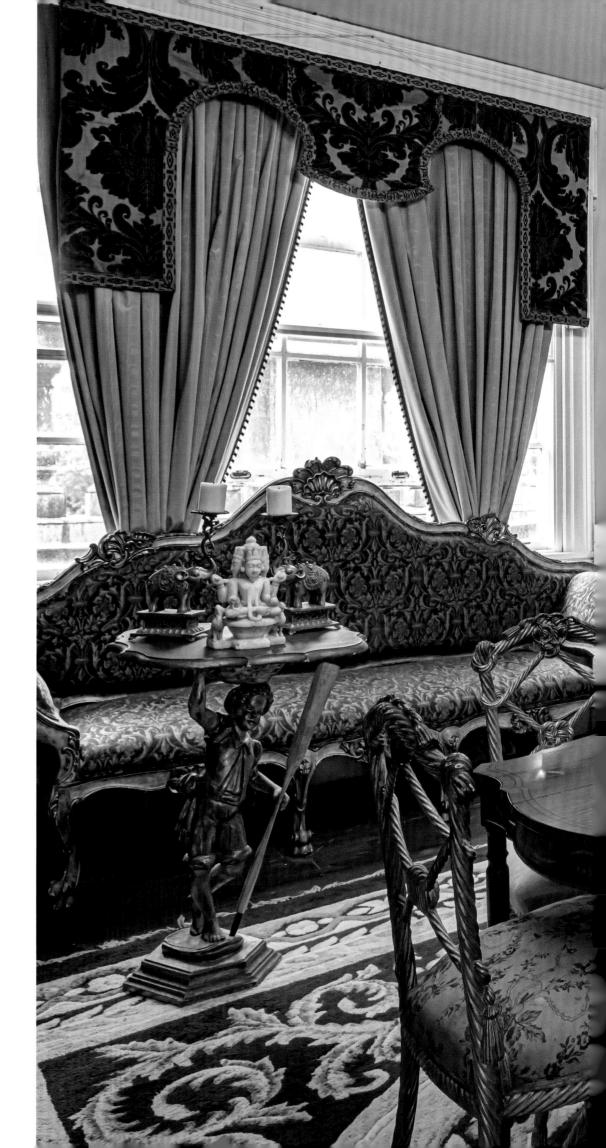

The third-floor room displays paintings *Albania*, one of Hunt's former Louisiana homes, and an earlier painting of *St. Barbara*.

Overleaf: The Magenta Room features an early 1980s painting of cockatoos, macaws, and hyacinths.

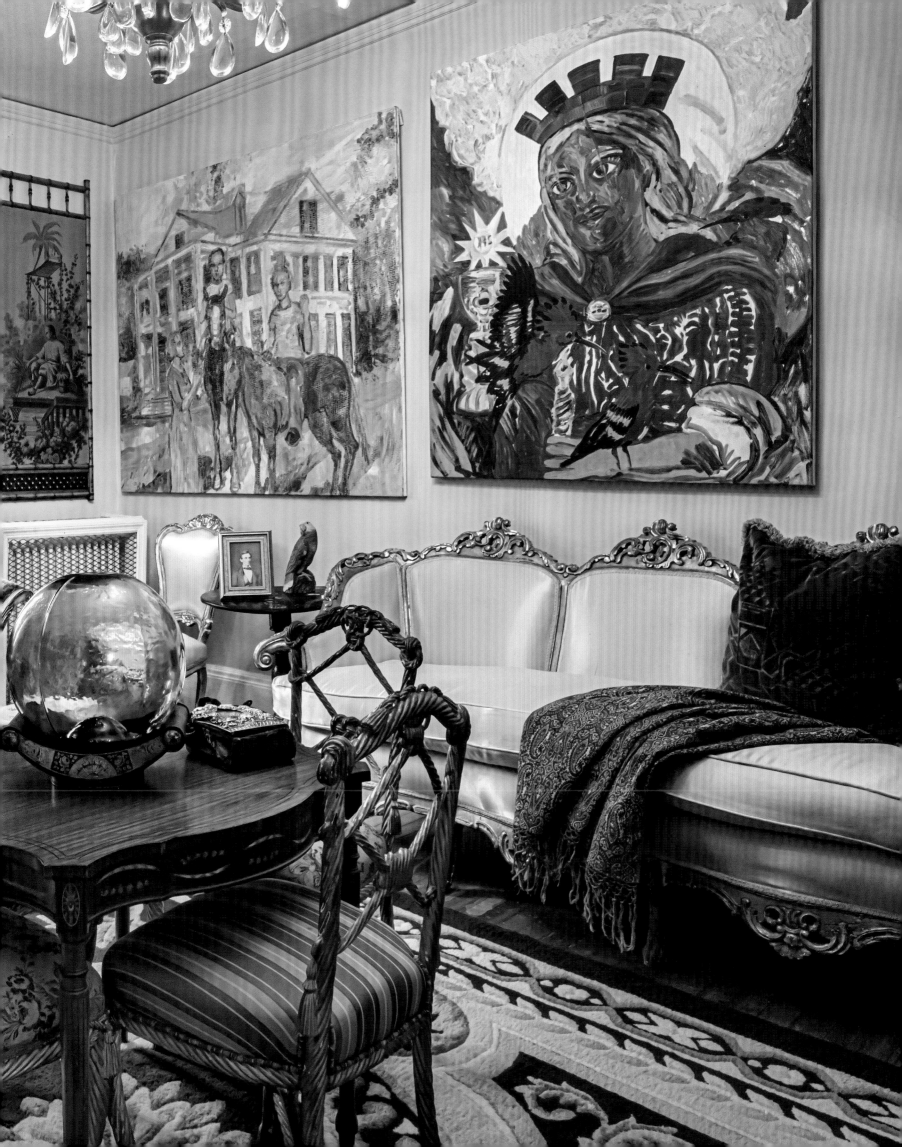

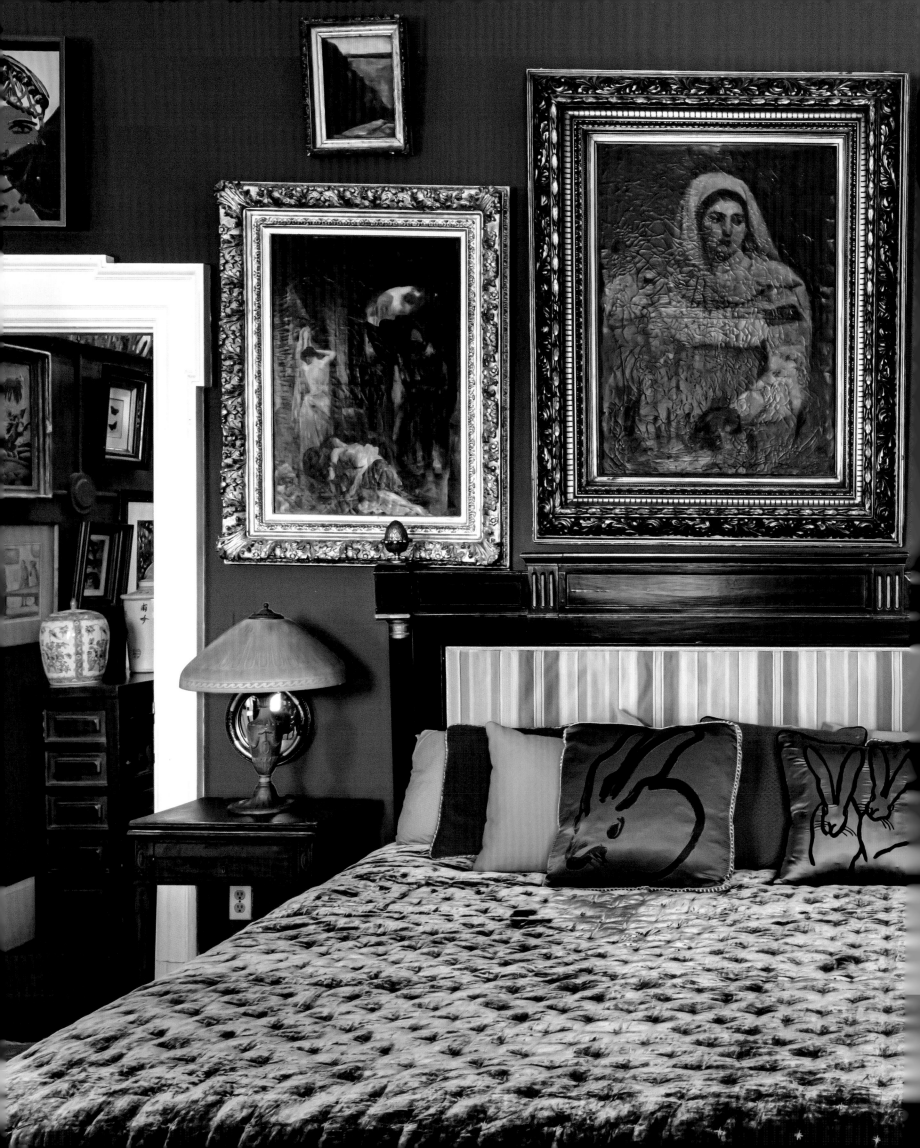

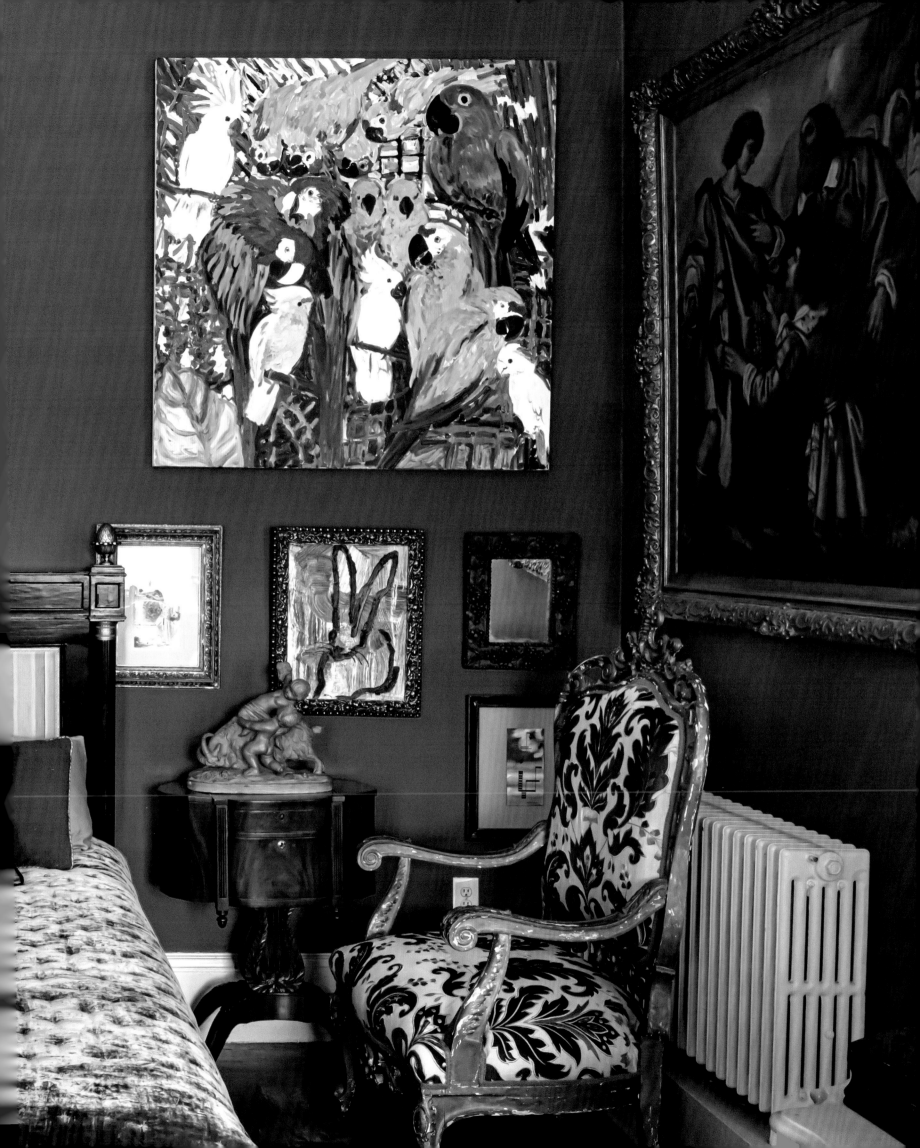

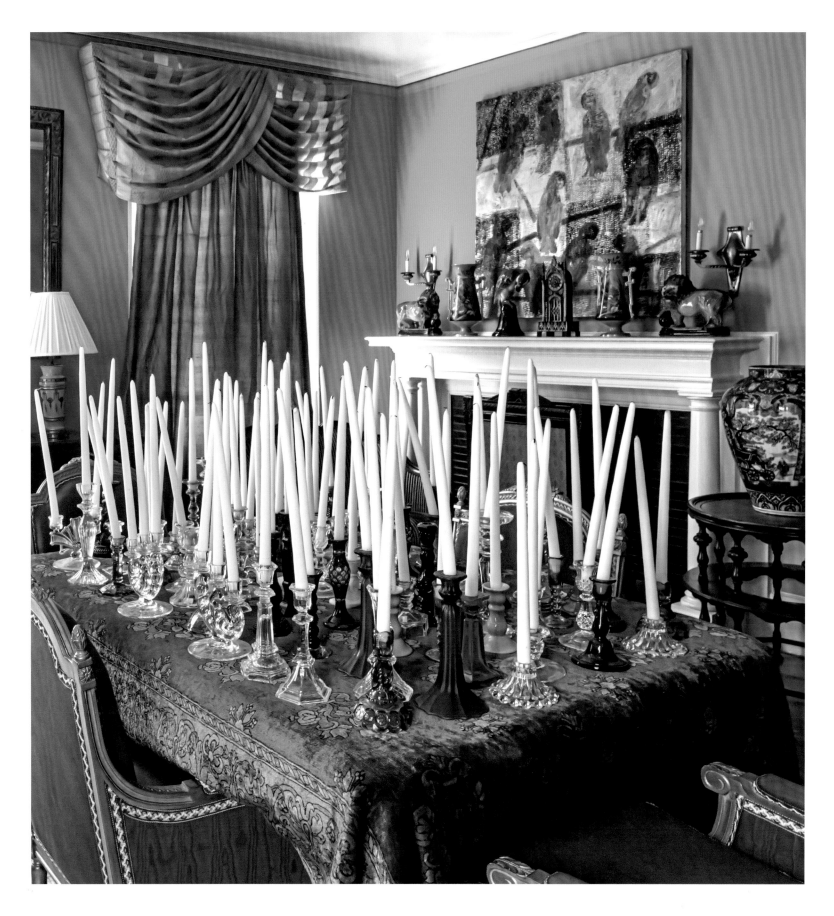

▲ A collection of vintage glass candlesticks is displayed on a table, while *Amazons* hangs above the mantel.

▶ Mantel detail highlights an Aesthetic vase and a Gothic clock.

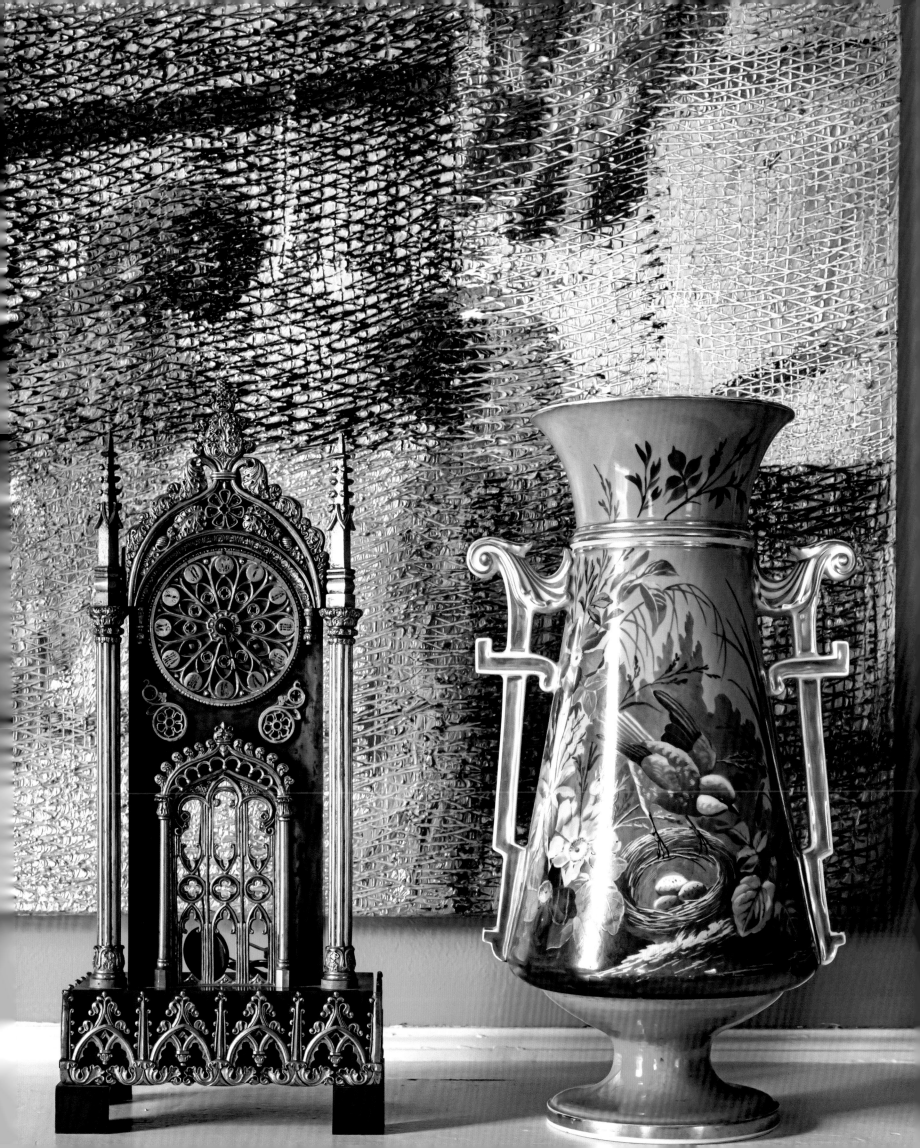

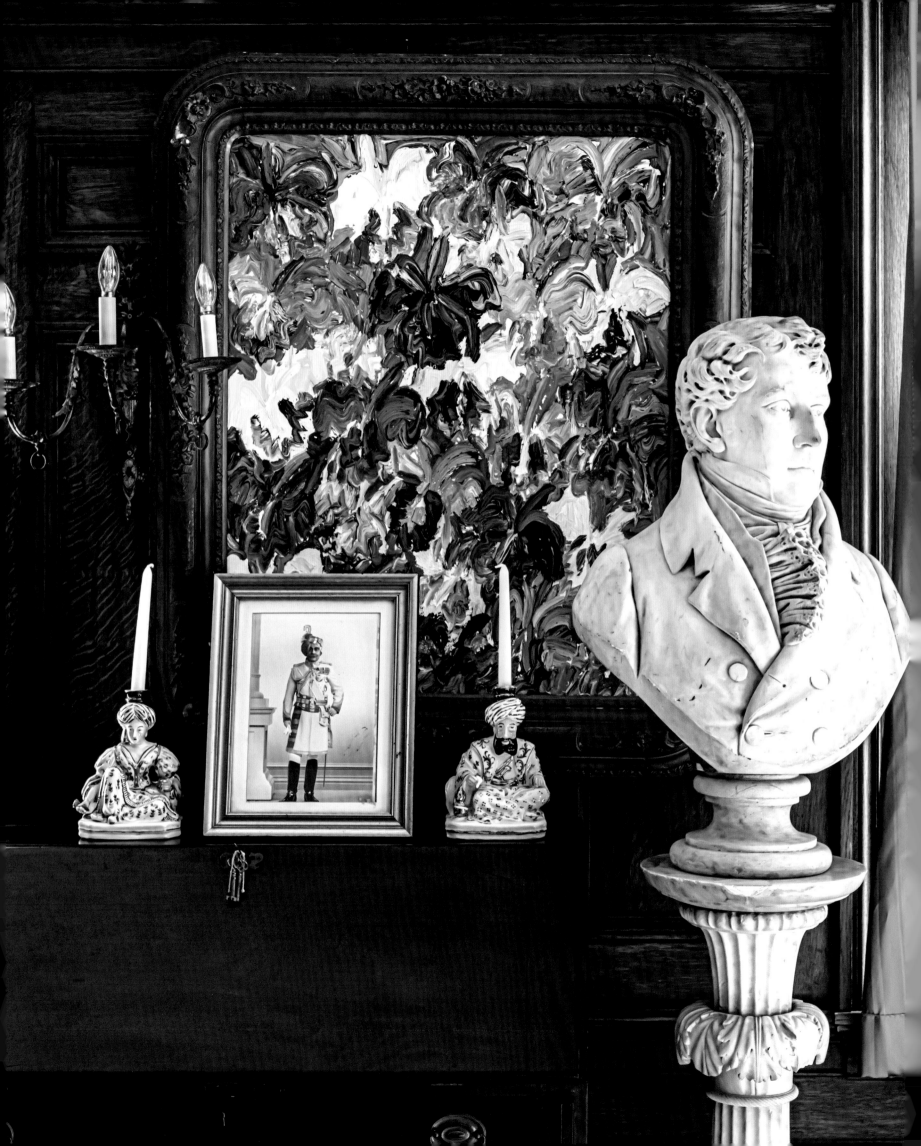

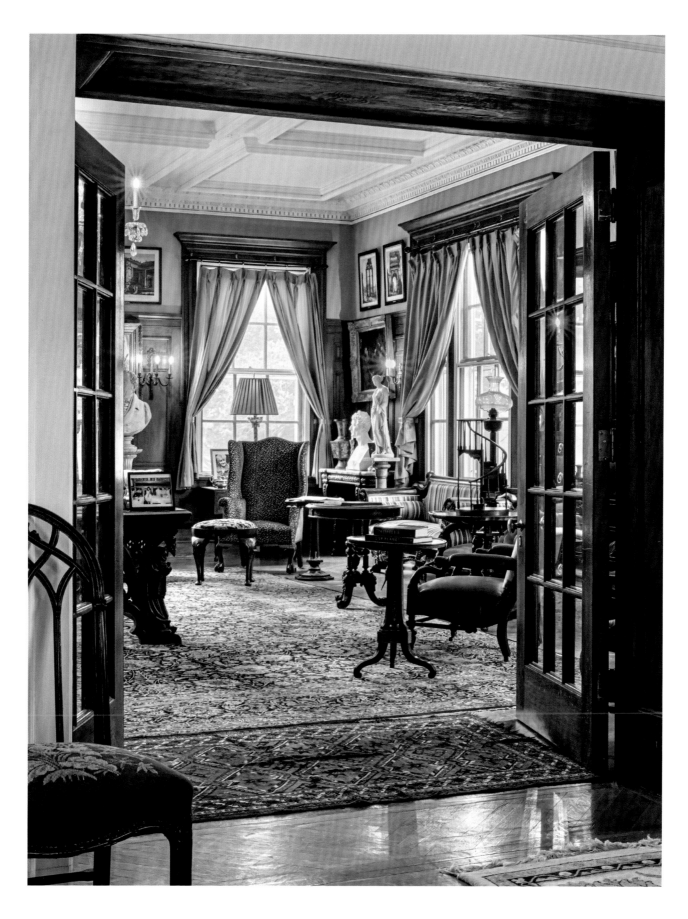

Cattleyas, in a nineteenth-century frame, is backdrop
to Turkish figural porcelain candlesticks in the library
(above), which opens off the front hall.

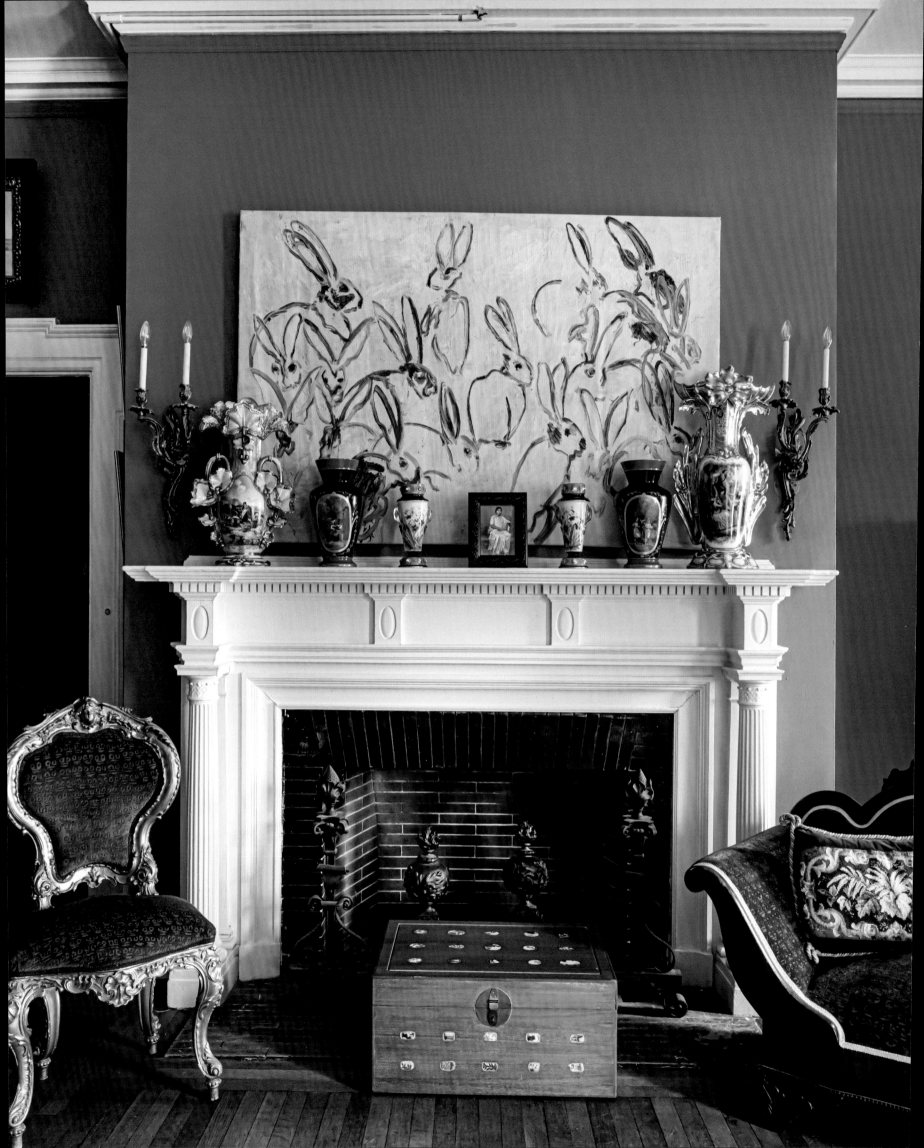

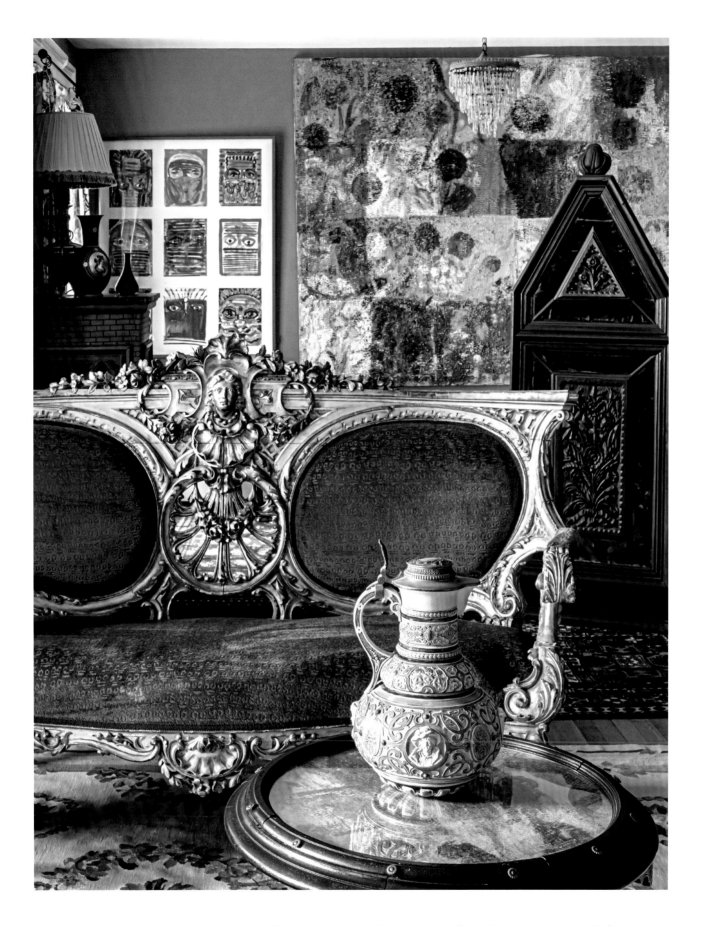

◄ *Hutch* hangs above a bedroom mantel. Gilded Victorian seating is upholstered in blue velvet "Guardians," for Lee Jofa.

▲ A watercolor of Hindu gods and spirits (left) and an oil painting of *Bells of Ireland* are on display.

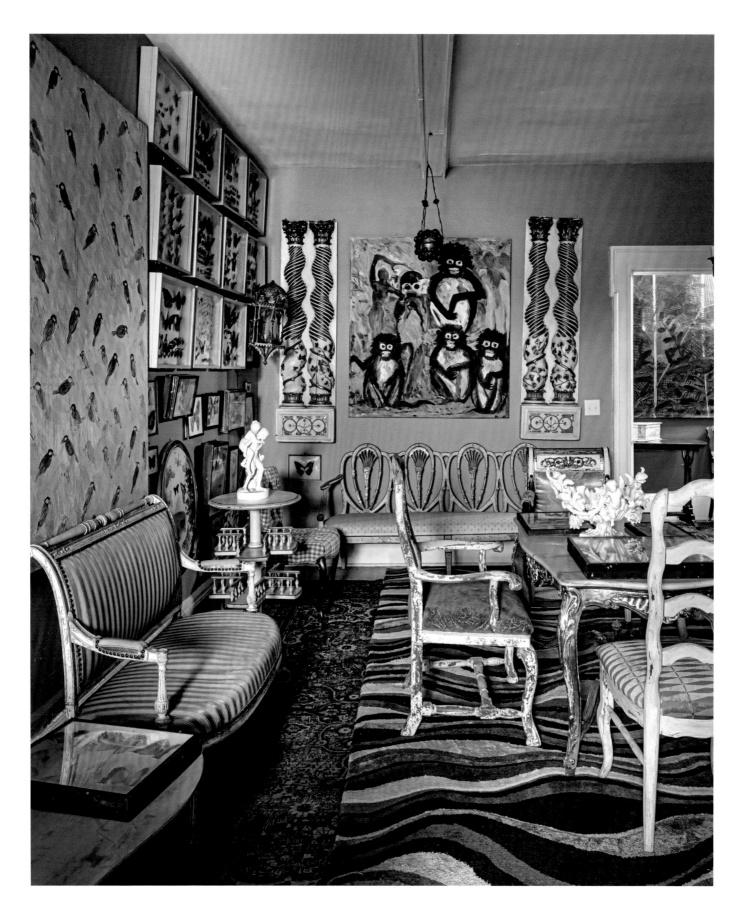

▲ In an orange sitting room with Swedish furniture, *Monkeys* is featured between fragments of carved and gilded columns. On the left is an early *Finch* painting.

▶ *Asian Woodpeckers* hangs above a tansu chest.

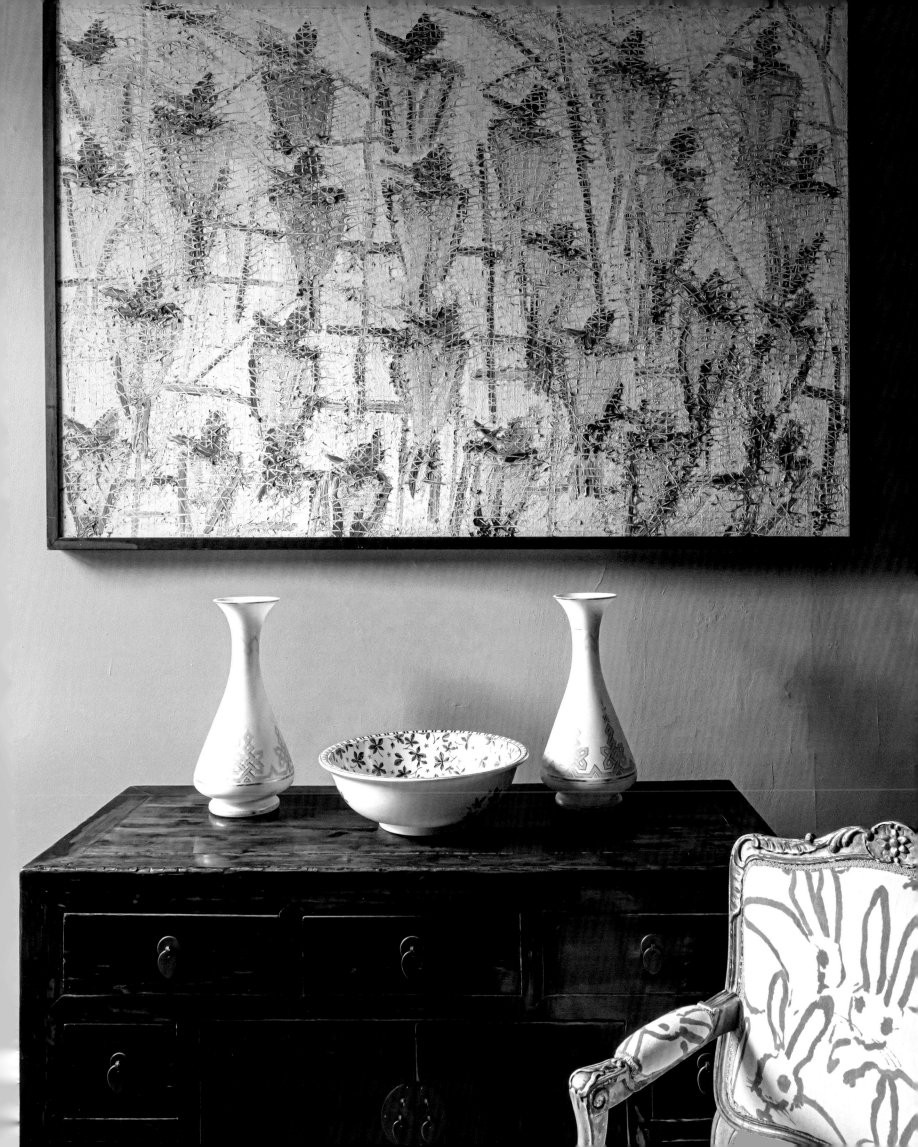

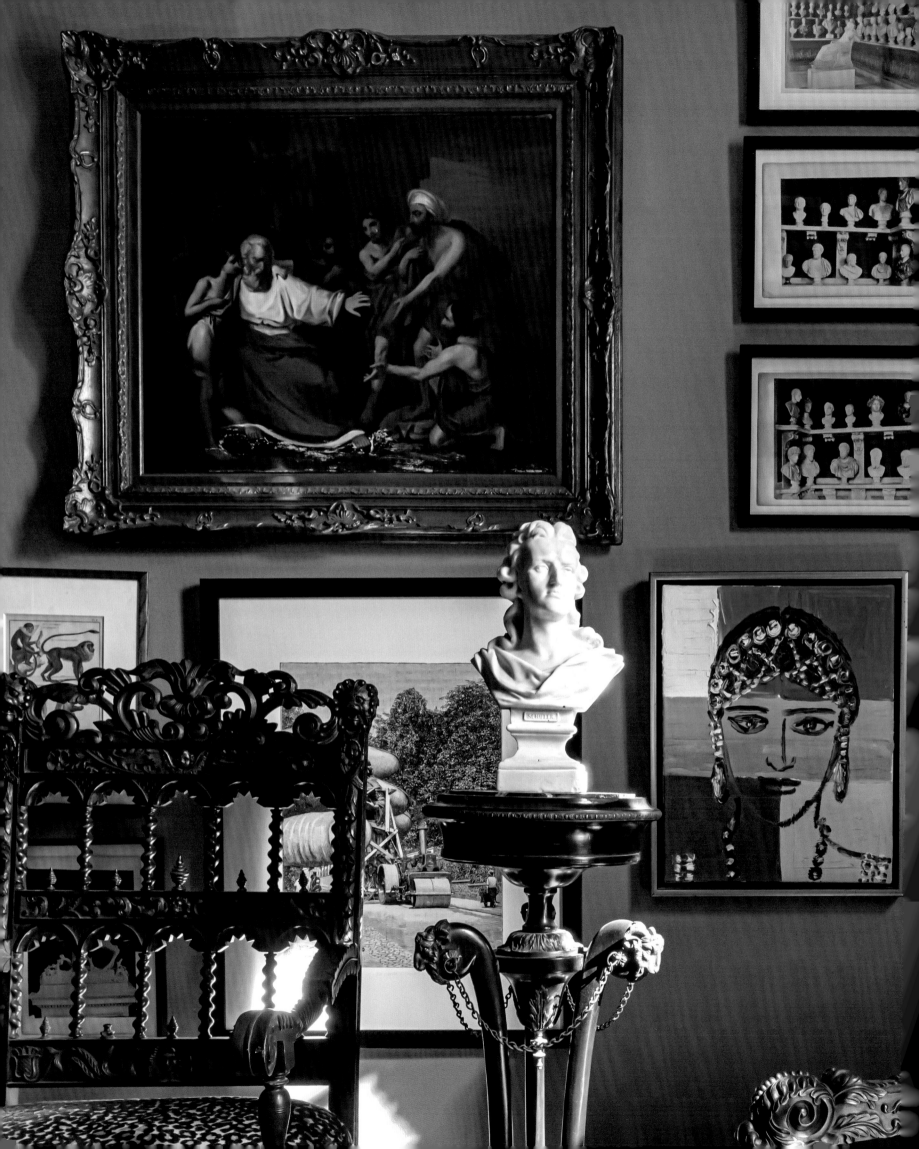

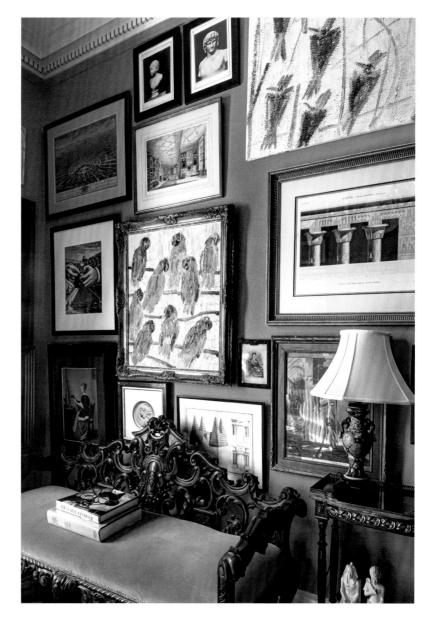

◀ Hunt's painting *The Countess Xacha* centers a wall
hung with prints, photographs, and classical paintings,
including *The Death of Socrates.*

▲ Another room detail.

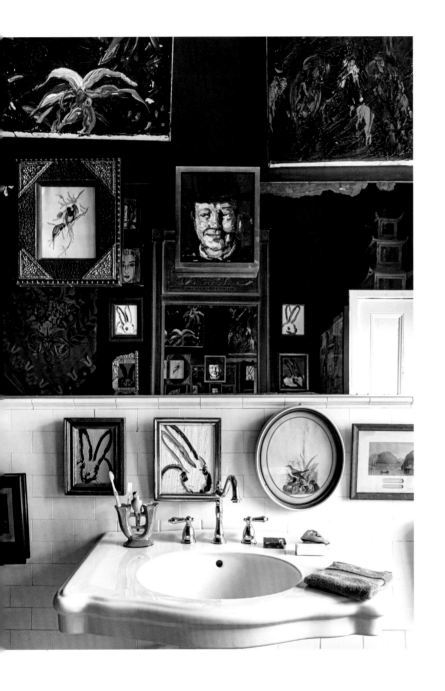

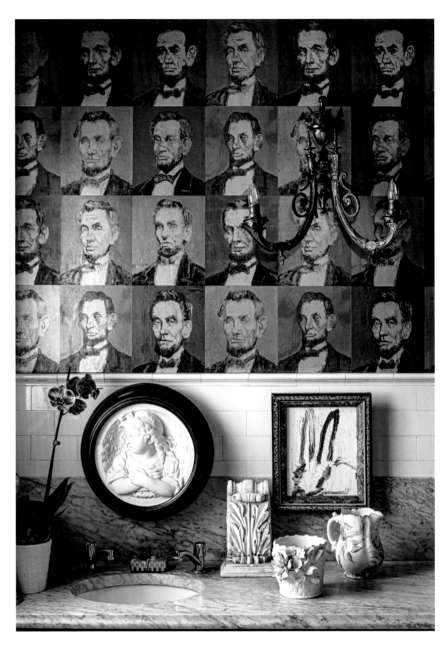

▲ Two powder rooms feature paintings of bunnies and Winston Churchill (left), and Hunt's "Abraham Lincoln" wallpaper for Lee Jofa.

▶ An upstairs hall features paintings *Cattleyas & Guardians* on the left and *Haitian Rope* on the right.

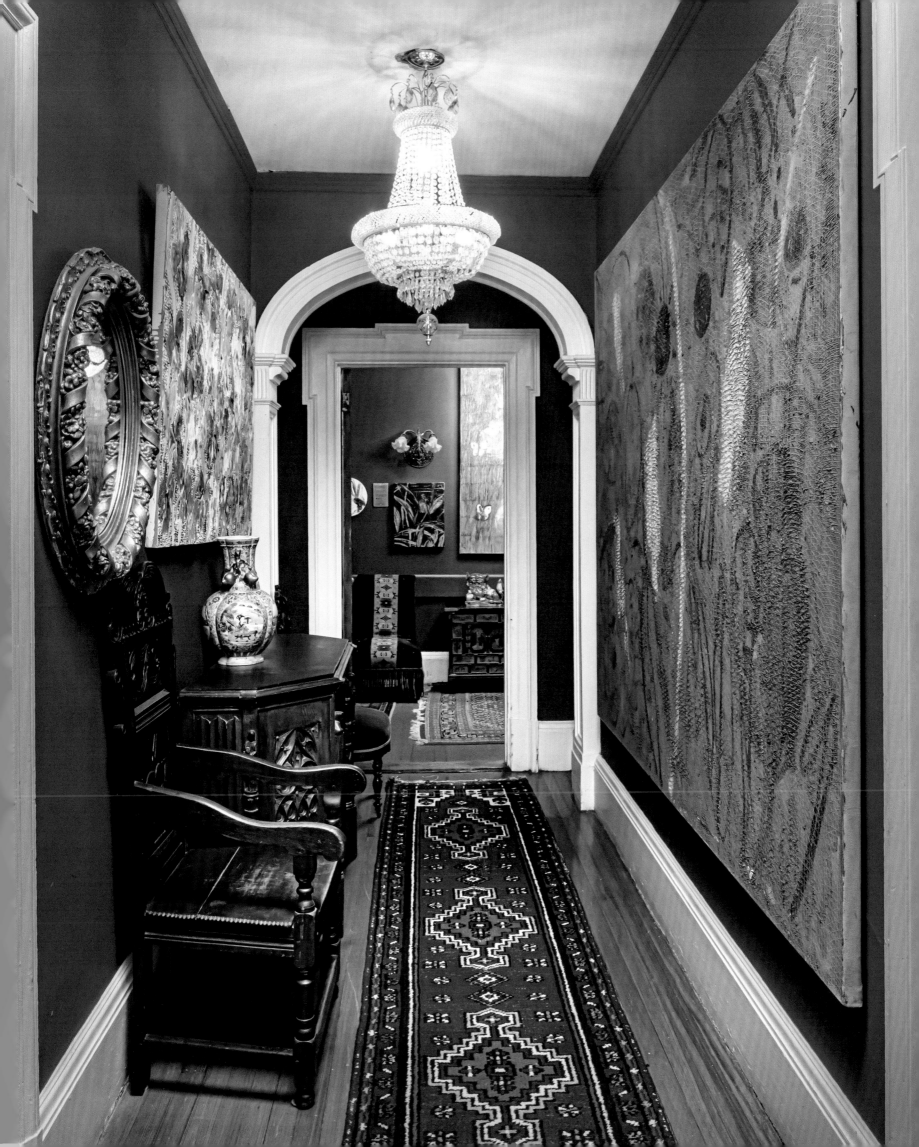

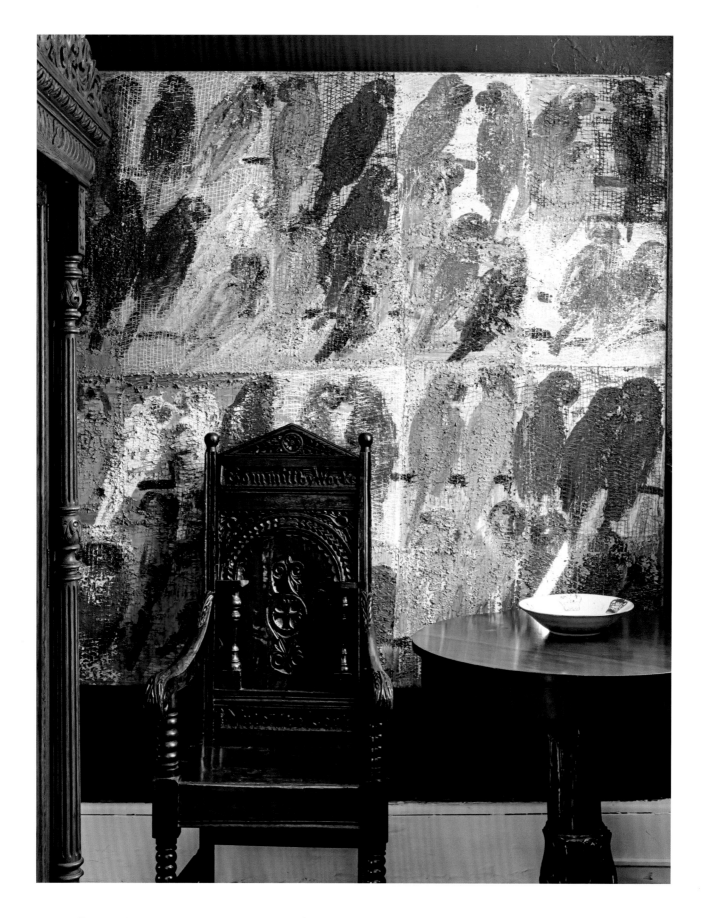

▲ A William and Mary carved hall chair rests in front of a *Lories* painting.

▶ Rare majolica garden chairs, planters and jardinières, and gnomes highlight the plant corridor.

Overleaf: Belle Terre's fifty acres and lake, set in the New York countryside.

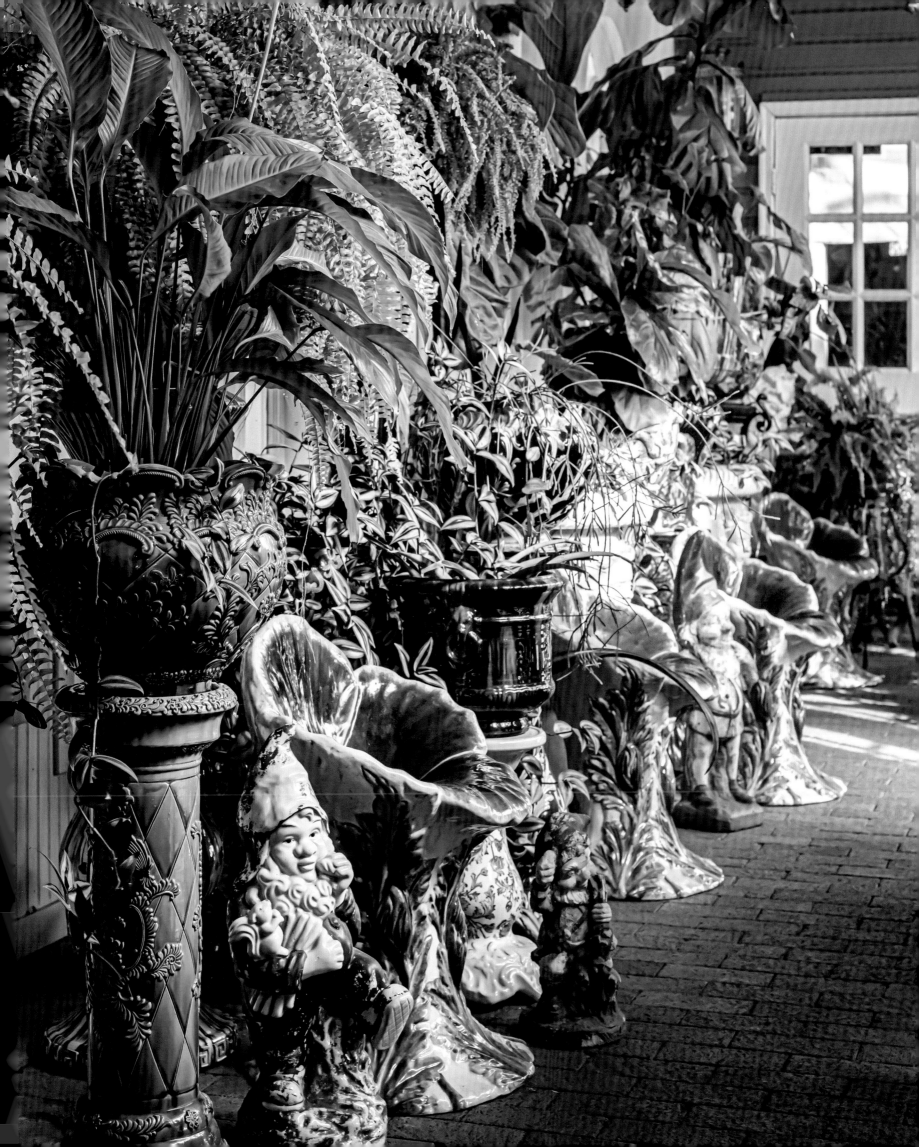

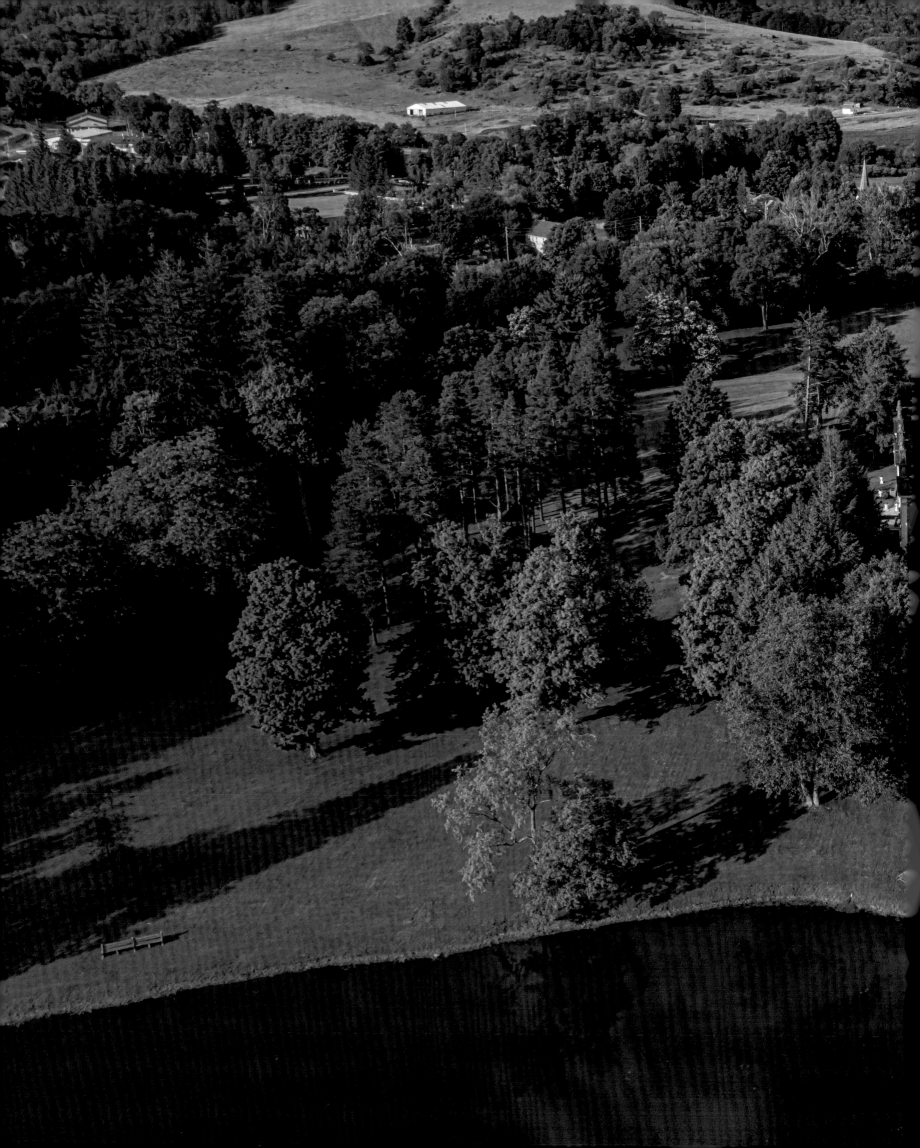

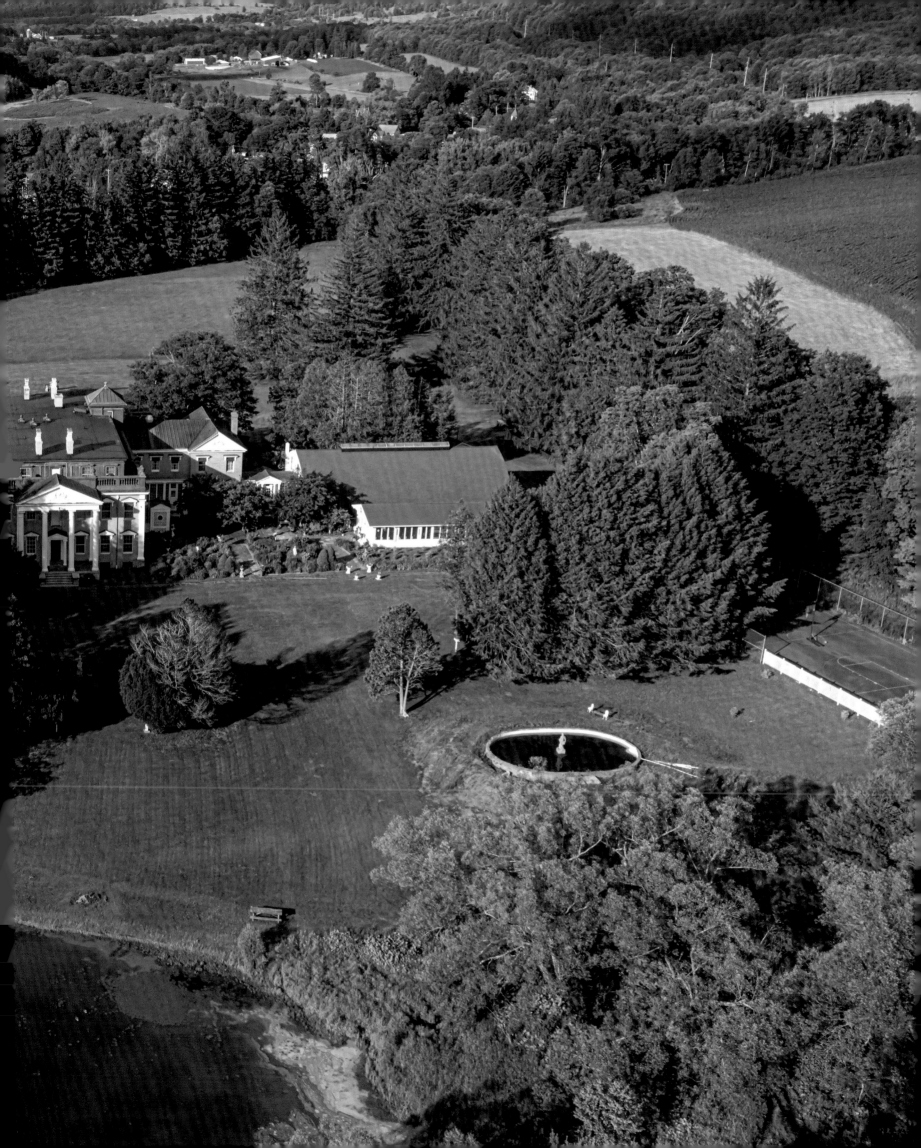

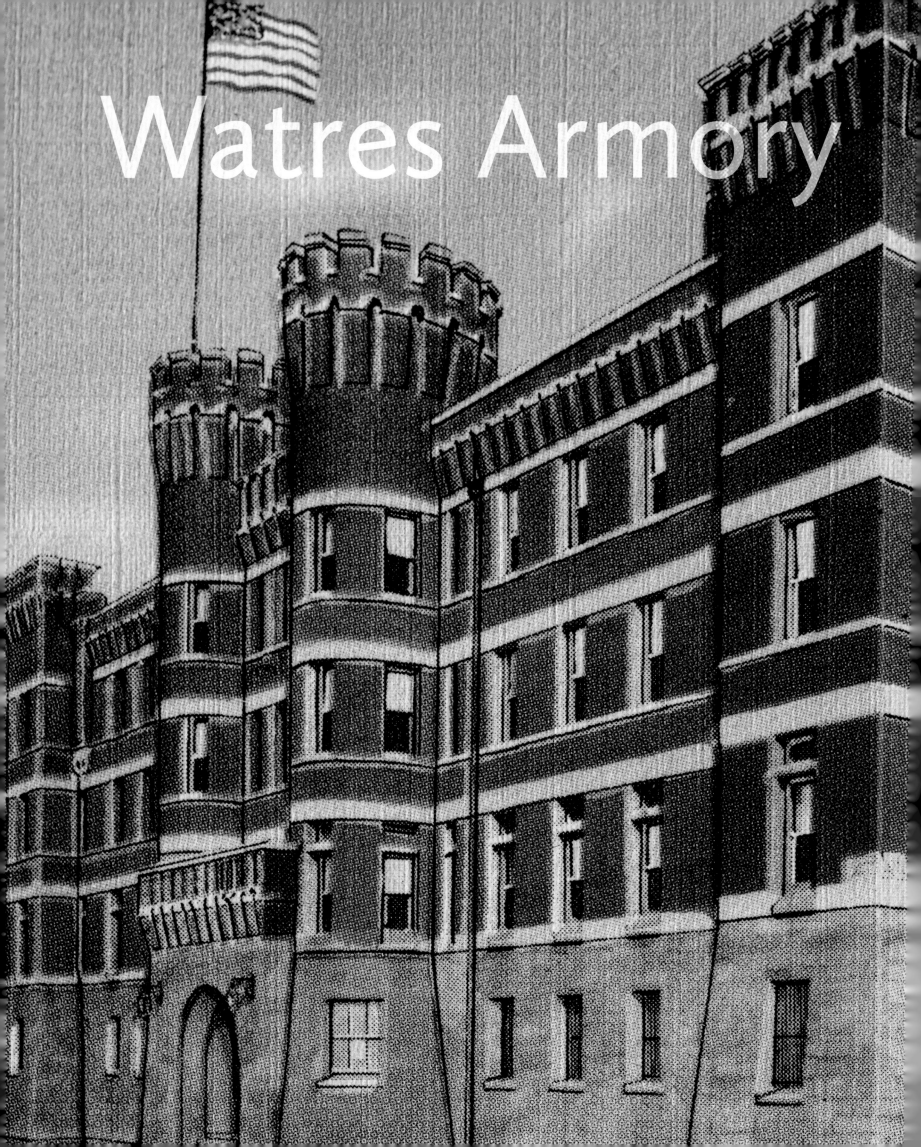

Watres Armory

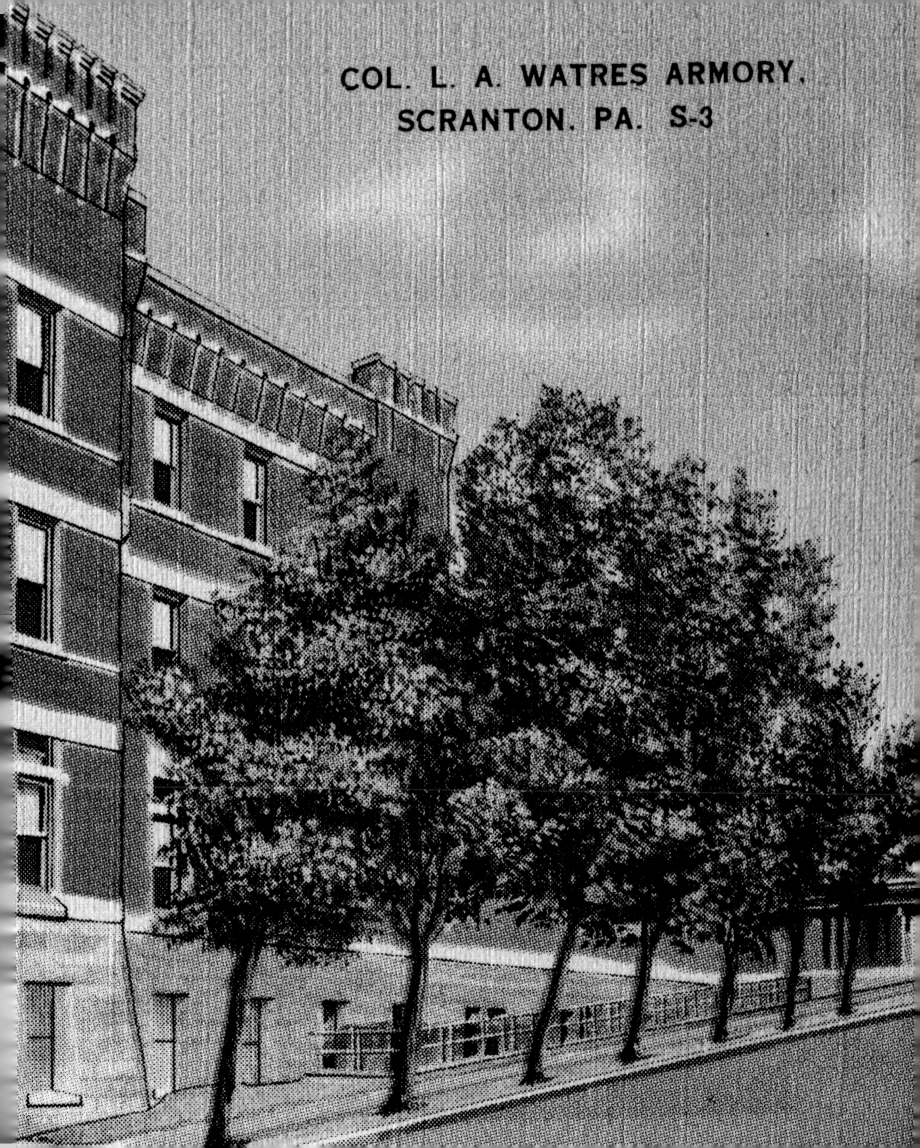

COL. L. A. WATRES ARMORY,
SCRANTON. PA. S-3

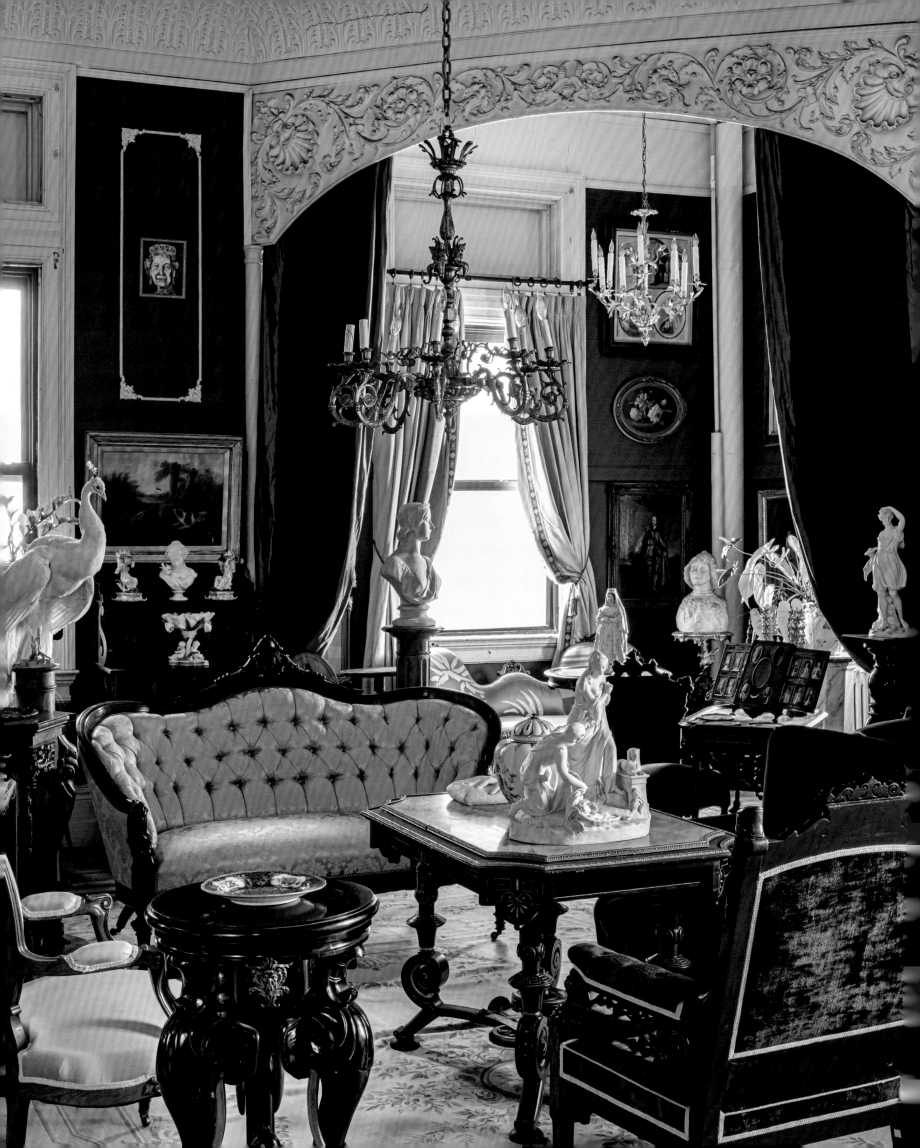

Watres Armory Scranton, Pennsylvania

Hunt wasn't looking for another restoration project when he first heard about the Colonel Louis Watres Armory (aka Scranton Armory) in 2015. He was in the middle of moving studios in New York City and just needed a large space to store his paintings and antiques; the 100,000-square-foot, largely empty armory fit the bill. Hunt had been fascinated with large historic buildings since childhood, when he would dream of constructing a model of the Eiffel Tower in his backyard. His father had been a naval officer, and Hunt grew up in shipyards and officers' quarters around the country. As soon as he stepped inside the Armory, he felt at home and realized he needed to save this building. The Romanesque Revival structure had been built in 1873 as headquarters of the 13th Regimental Infantry (today, the National Guard) and played an important part in American history. Five presidents, including Woodrow Wilson and John F. Kennedy, had delivered campaign speeches in the drill hall, and Rachmaninoff had given a recital there. Occupying a whole city block, the turreted, brick-and-stone structure had been considered one of the finest armories in the country, but now, having been mostly vacant for several years, it was a white elephant in danger of being torn down for a parking lot. Hunt immediately saw the possibilities. Wide corridors ran the length of each floor and would be perfect to hold his collections of classical busts and pedestals; a 35,000-square-foot drill hall would provide a home for his plants in period jardinières; the open, central staircase with broad landings could display his early paintings, many of which had been rolled up and in storage for thirty years; and scores of rooms gave opportunity for period room arrangements.

He began by consulting his long-time psychic advisor, who had been born in Scranton and, it turned out, knew the Armory well—she had ice skated there as a child. She advised him to proceed, telling him he would be happy but would not spend much time there. The building had seen its share of history, and Hunt's psychic cautioned it was still filled with more than a century of spirits, which required several ghost bustings to clear it for the new occupants.

A *Queen Elizabeth* painting presides over the Queen's Room, richly furnished with upholstered Victorian seating and an ebonized Aesthetic Movement center table. Hunt uncovered the decorated plaster arch during renovation.

123

Hunt then rolled up his sleeves and began what would be an intensive, two-year renovation and move. Inside, he took down later divisions between rooms, removed dropped ceilings, repaired damaged plaster walls, and brought the wiring and plumbing up to code. As work progressed, beautiful details began to emerge: button-patterned plaster dados in the hallways; mythological white plaster friezes of *Hannibal Crossing the Alps* in sunlight-filled rooms on the second floor; and luxurious oak floors hidden beneath old linoleum covered with decades of dirt and debris.

Color was the key, Hunt explains, in turning the formerly drab, military warehouse into a mystical and magical setting. He had walls painted in azure blue (suggested by Gershwin's "Rhapsody in Blue" portrayal of early twentieth-century Jazz Age New York City), rich siren red, elegant amethyst purple, and cadmium yellow—the latter inspired by channeling Jackie Onassis, who advised Hunt she liked his use of yellow.

When Hunt begain furnishing the building, Hunt's goal was to recapture the opulence and elegance of past eras through the furnishings. More than 500 truckloads of antiques and paintings were delivered, including Hunt's early work and Victorian antiques—thousands of busts and pedestals, tufted and upholstered sofas and chairs (many in fabrics Hunt designed), and ancestorial portraits of distinguished Victorians.

Hunt let the spaces talk to him, traveling through time and allowing the energy of each room to unfold: a Chinese room with lacquered and carved furniture, dozens of opulent Victorian parlors, seven dining rooms, nine round tower rooms—one a Kuan Yin meditation room with a bodhisattva statue and center table of crystals.

On a grand and monumental scale, Hunt accomplished what every artist dreams of having—a tableau for his paintings and collections, a work of art in itself.

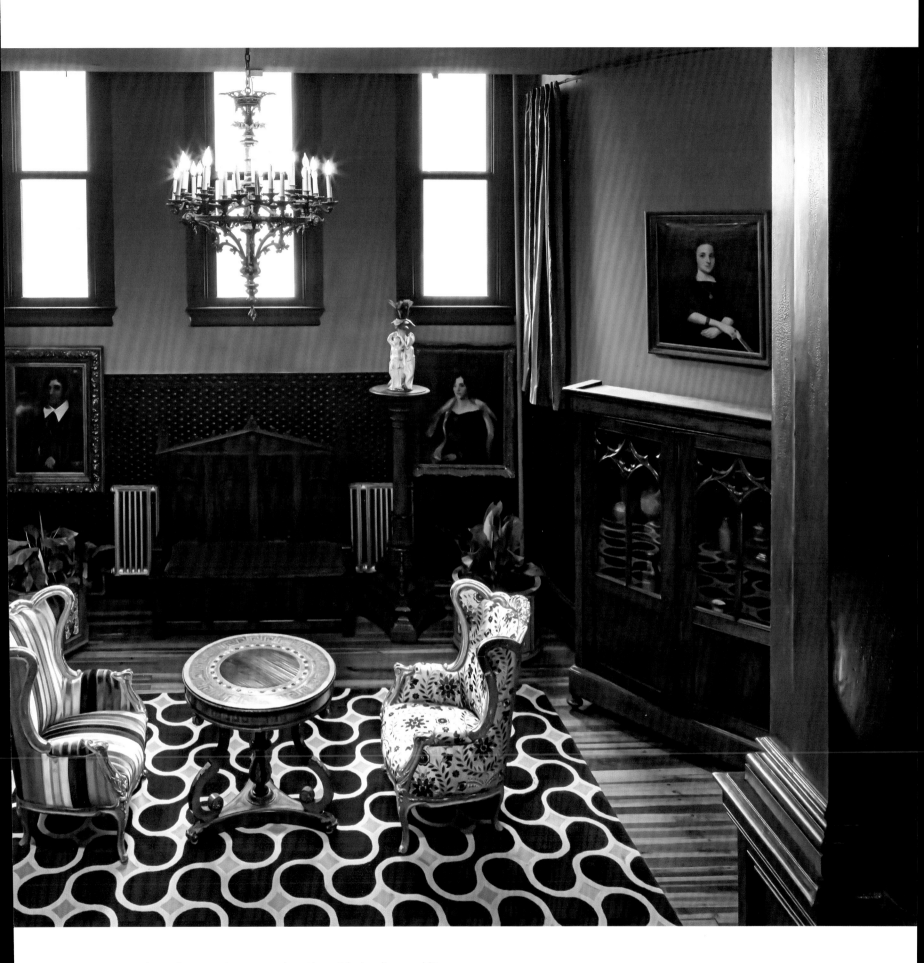

A seating area is arranged on the wide landing and lit
by a bronze Gothic chandelier.

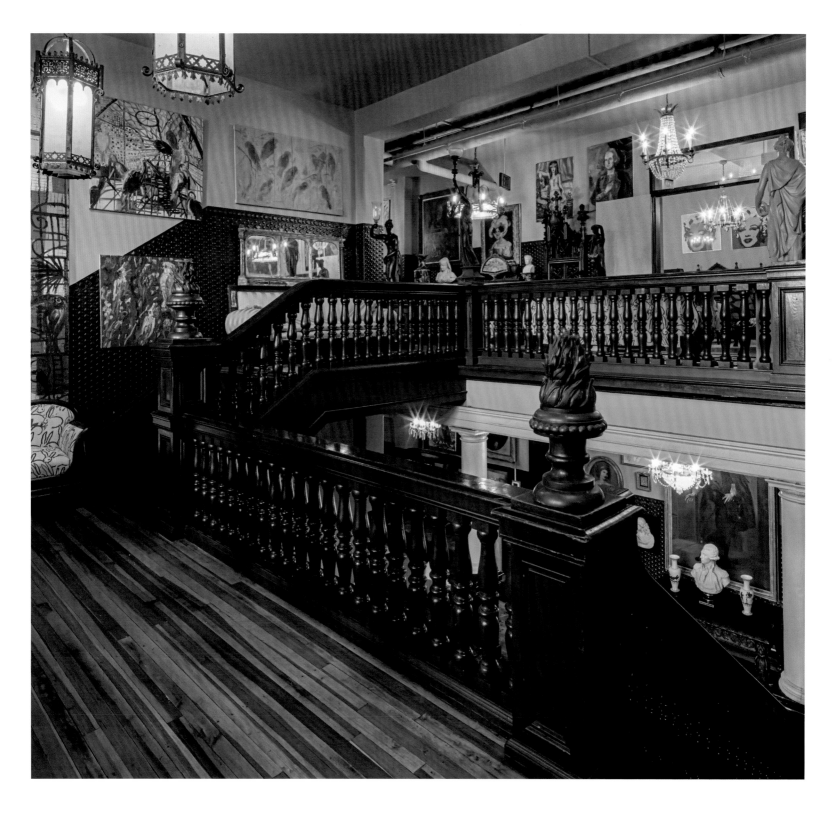

▲ Antique newel post caps hand carved in the flames style were added to the bannisters on each landing. The stairwell is a gallery of Hunt's paintings.

▶ Bird paintings include a 12-foot aviary of toucans.

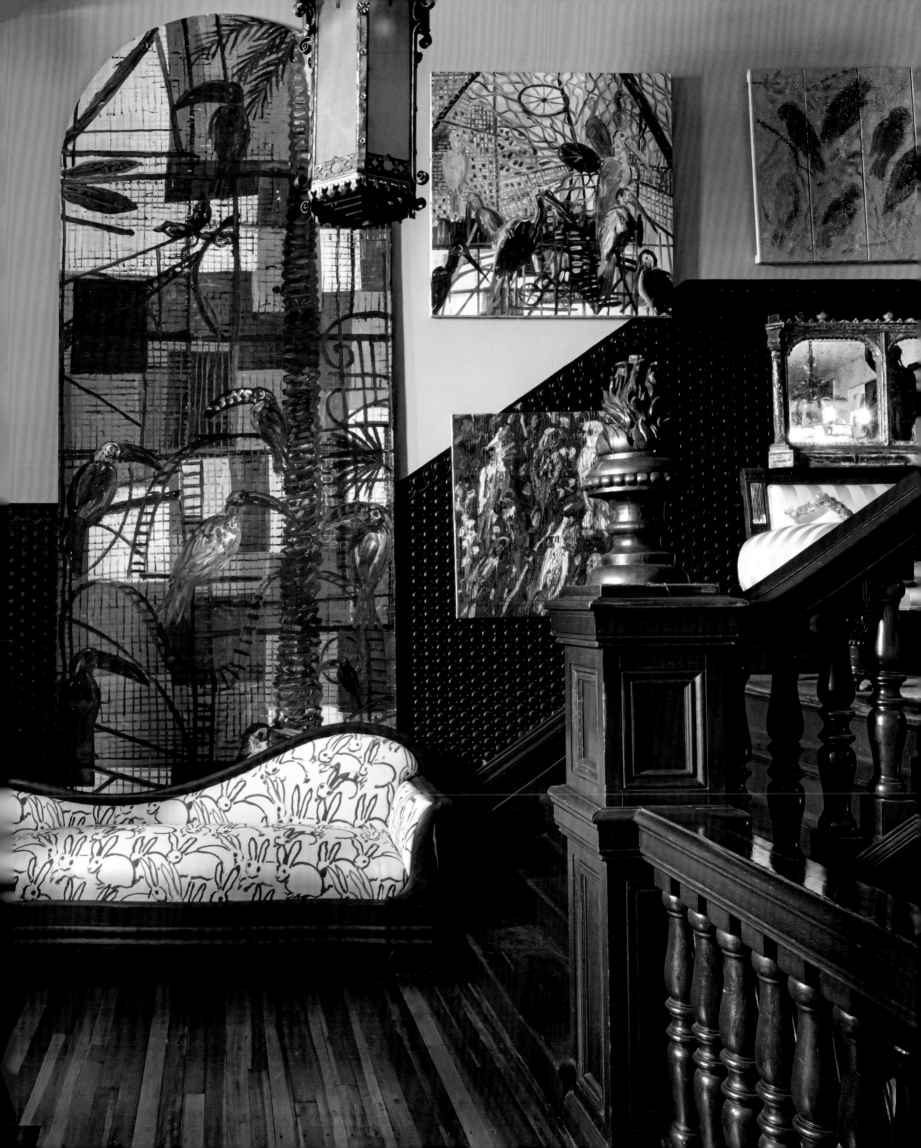

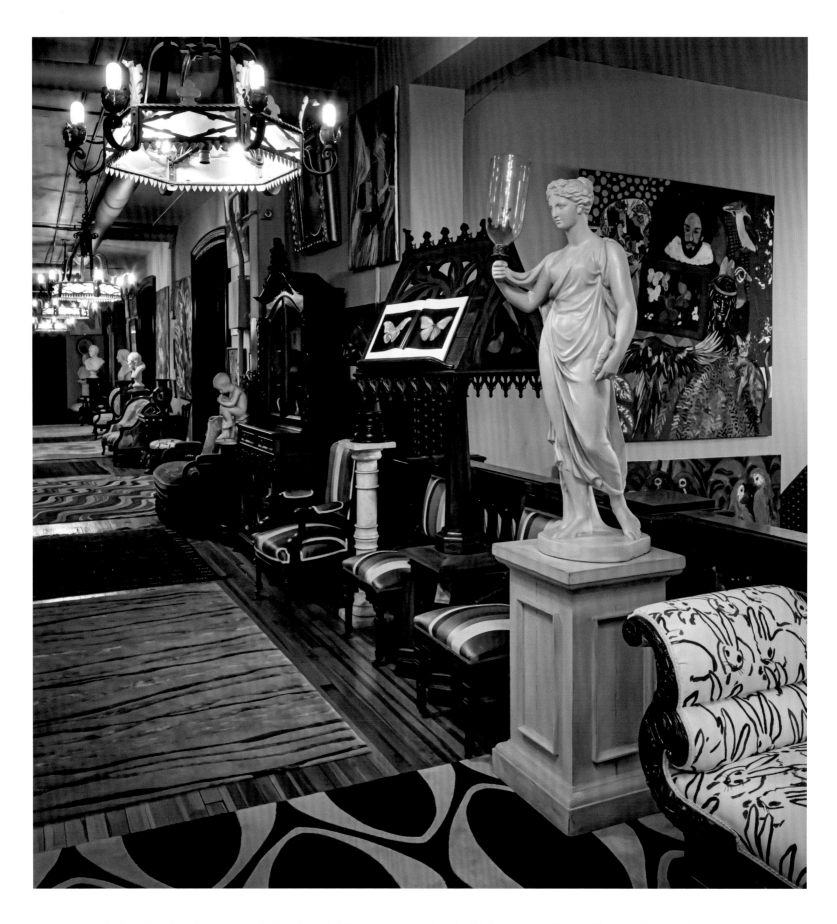

A Victorian Grecian maiden lights the third-floor hallway. Paintings include Hunt's *Abraham Lincoln*, *Shakespeare*, and an early jungle scene.

Overleaf: The second-floor hallway is lined with paintings, plaster and marble busts on pedestals, and nineteenth-century sofas and chairs.

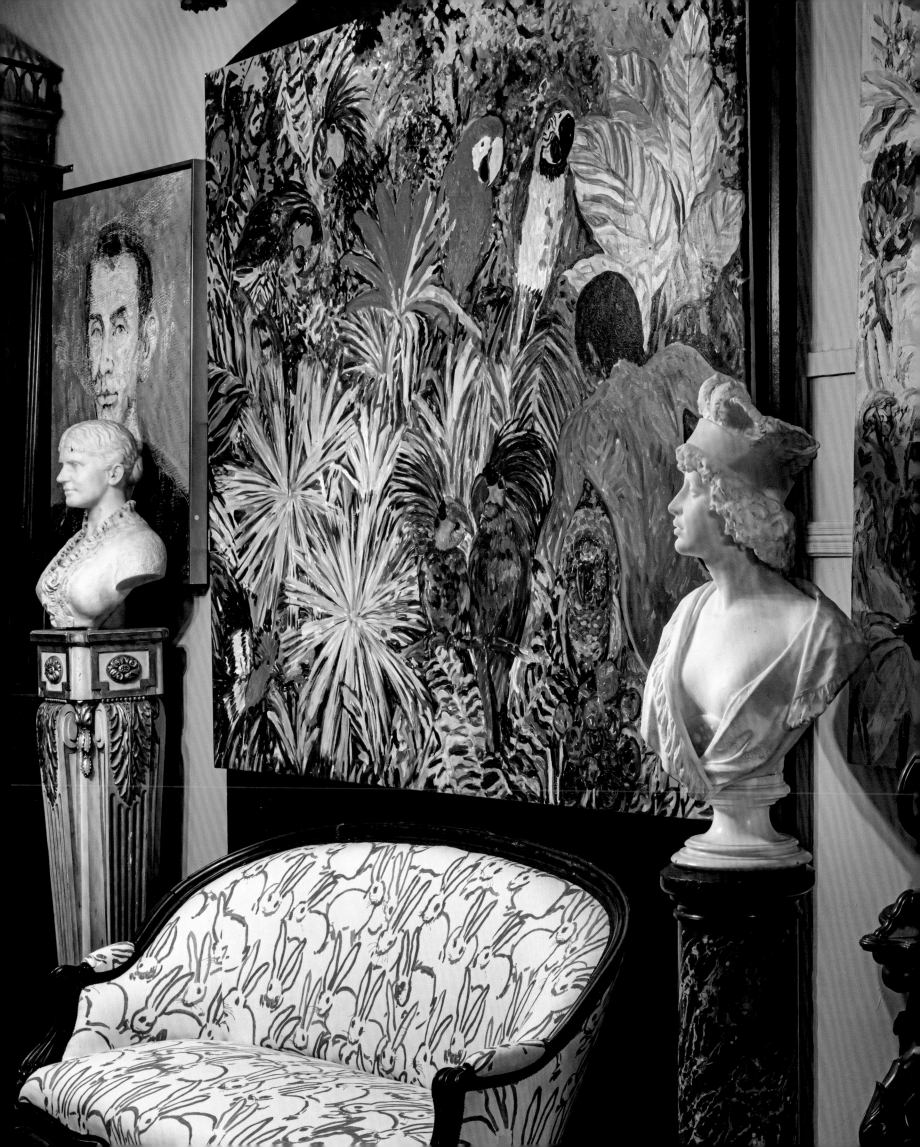

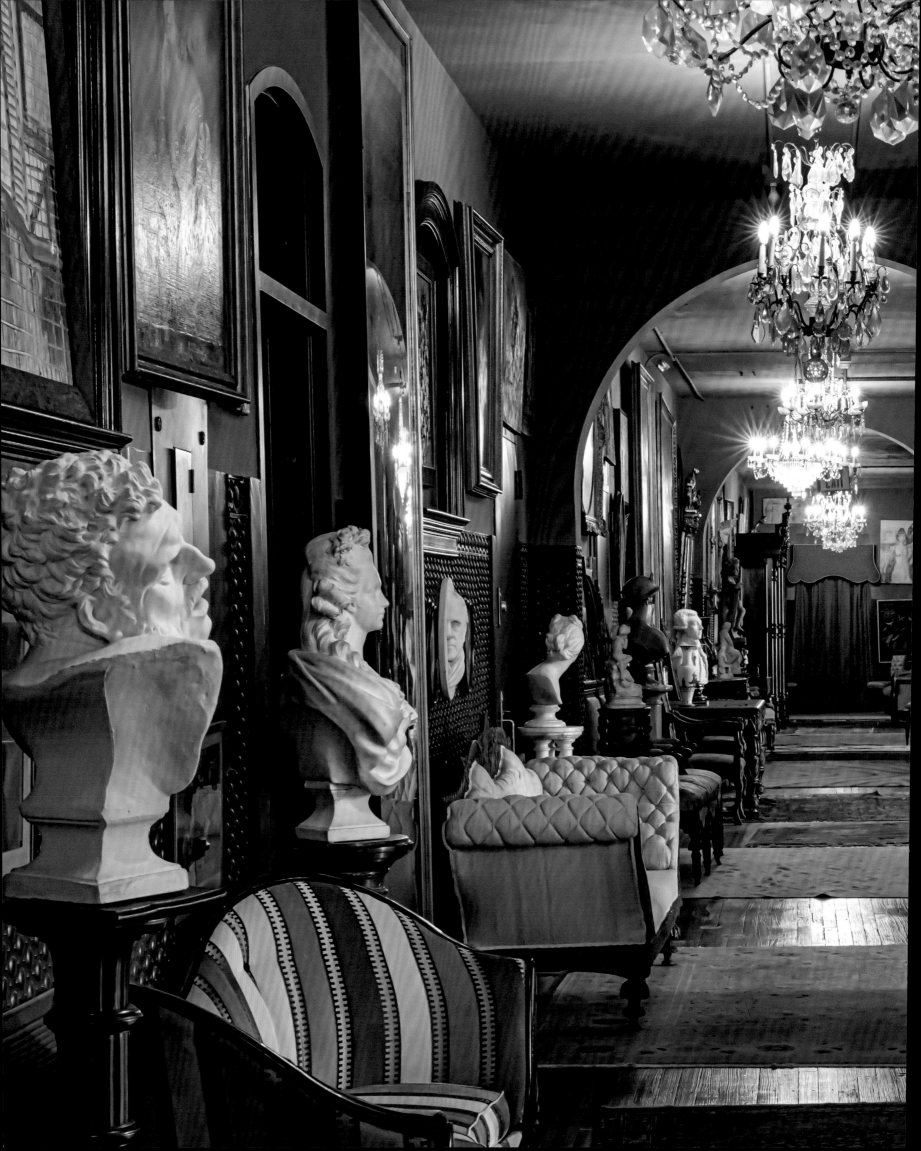

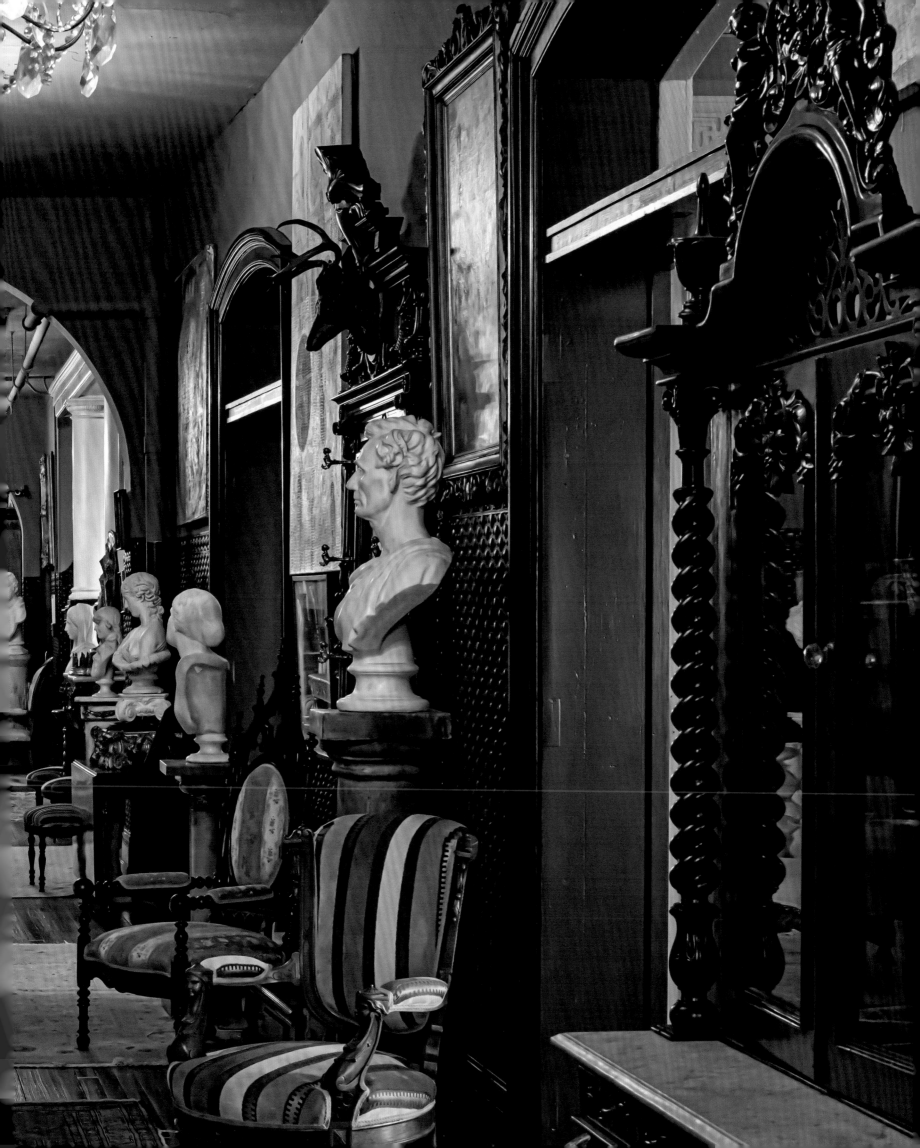

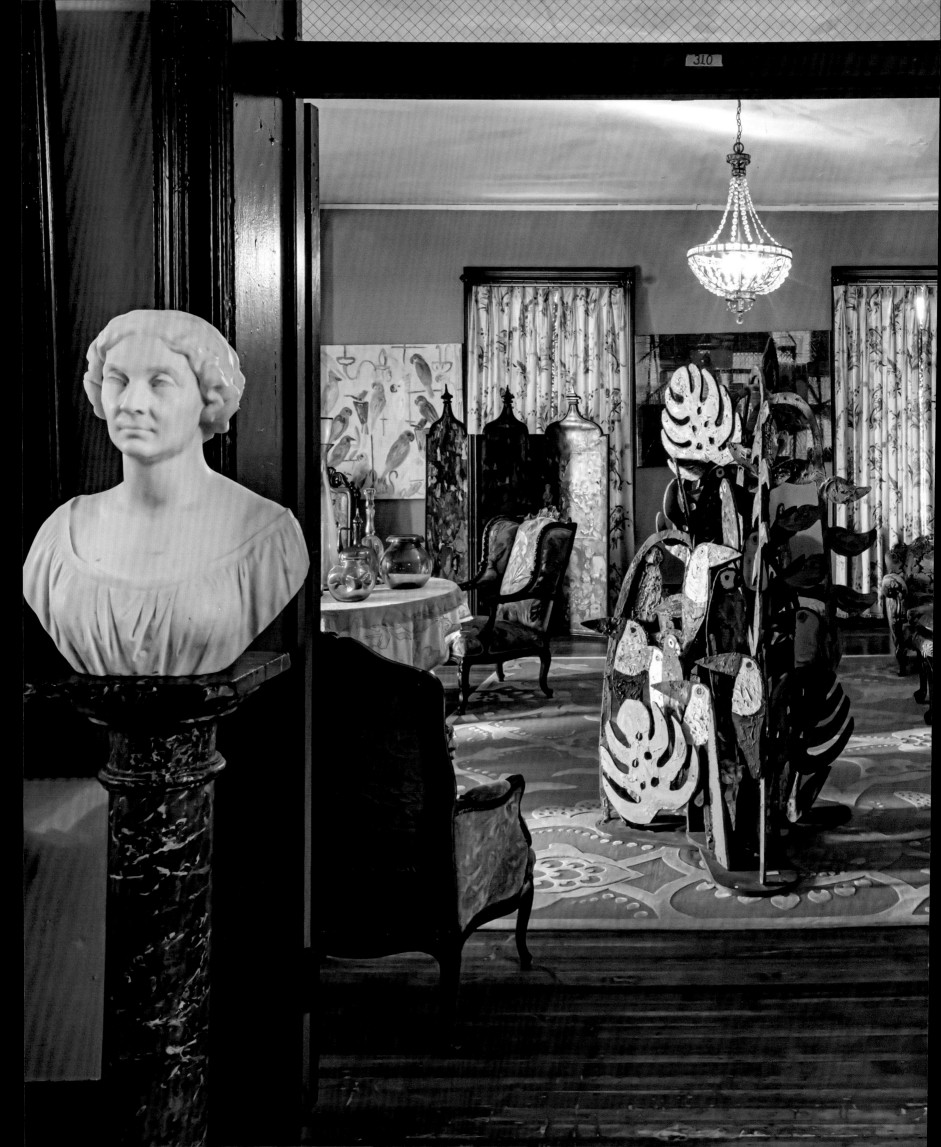

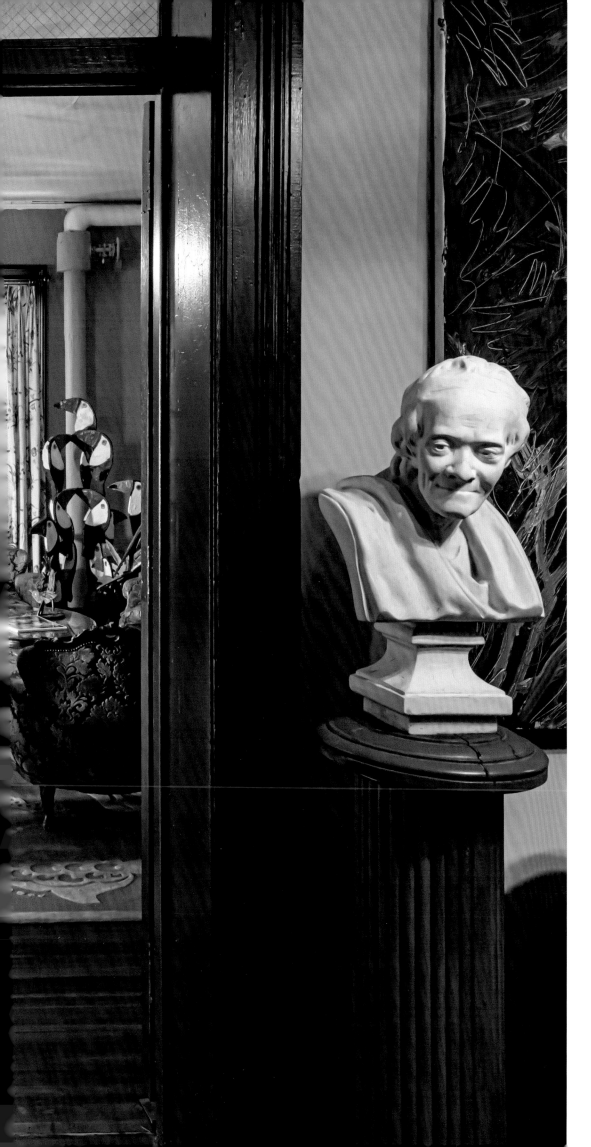

A pair of marble busts guard the entrance to a third-floor orange sitting room with wooden sculptures of toucans, plants, and parrots.

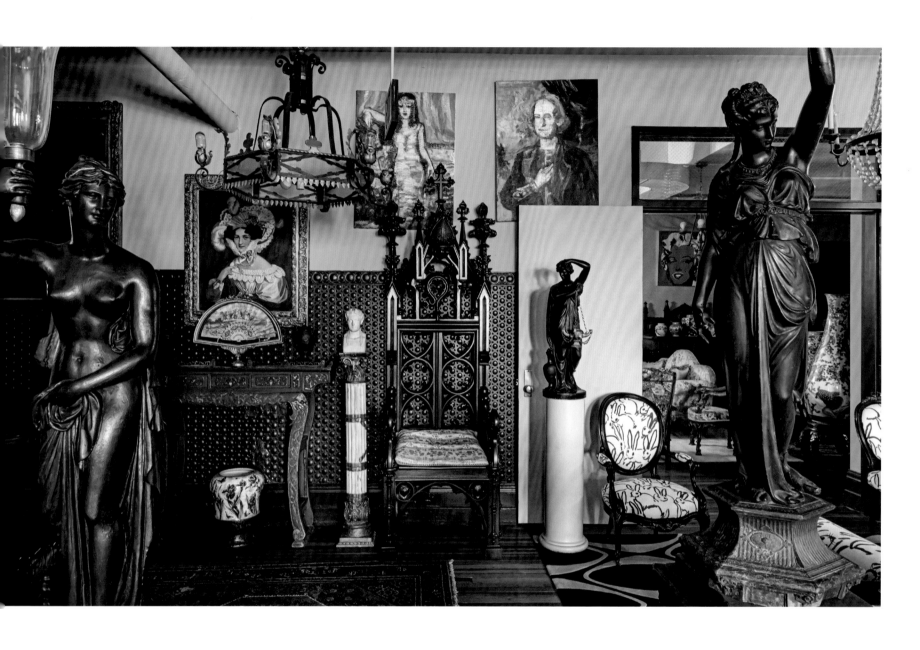

▲ *Cleopatra* and *George Washington* above the door overlook bronzed-plaster, English Regency maidens holding lanterns.

▶ Seating upholstered in Hunt's "Hutch" fabric for Lee Jofa lines the corridors.

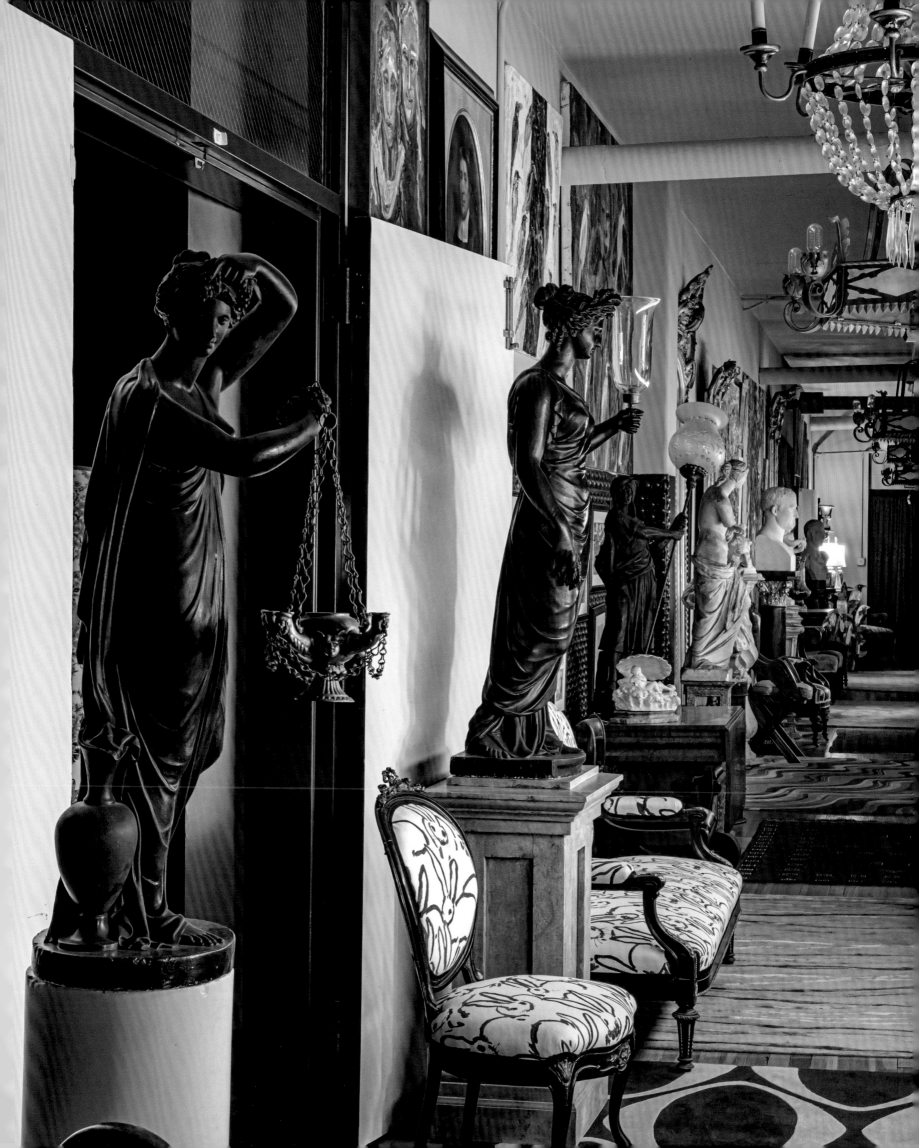

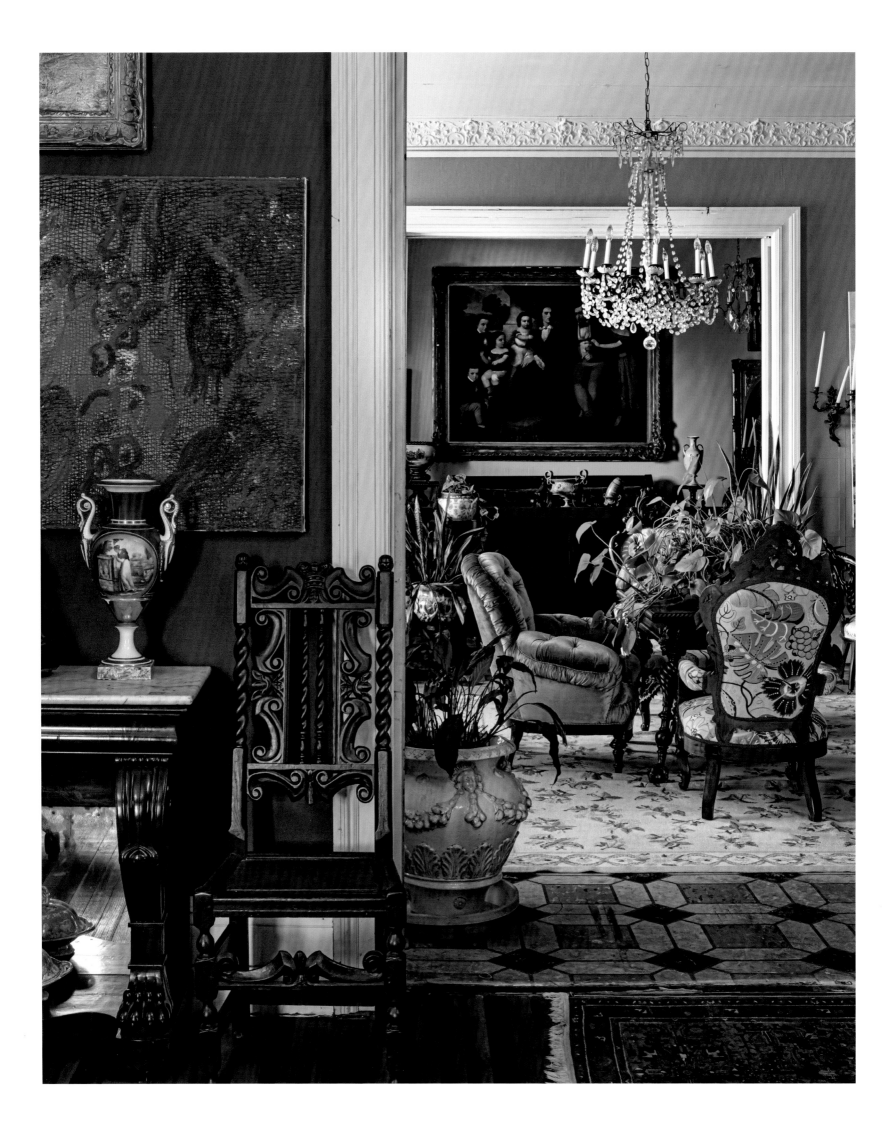

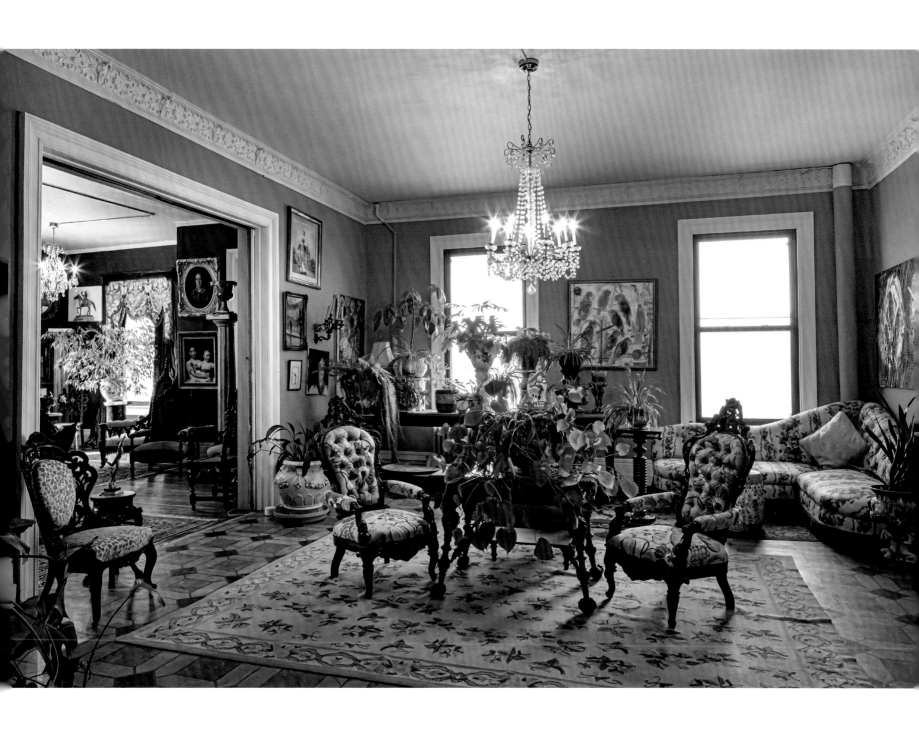

◀ A view from a red parlor, through a purple sitting room, and into a green parlor beyond, where hangs a portrait of John Davis Jones, contractor of the historic Philadelphia Academy of Music, and his family.

▲ Original linoleum was conserved and can be seen beneath the rug in the sitting room.

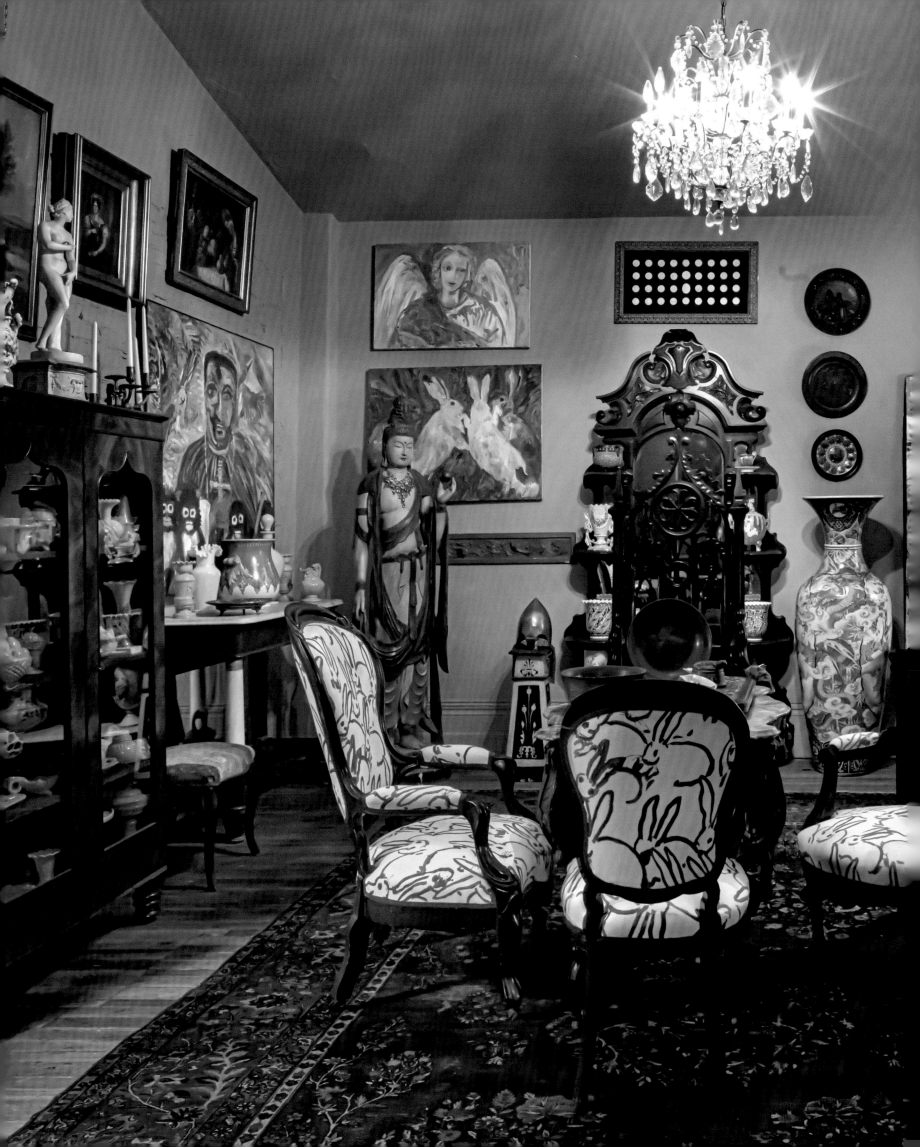

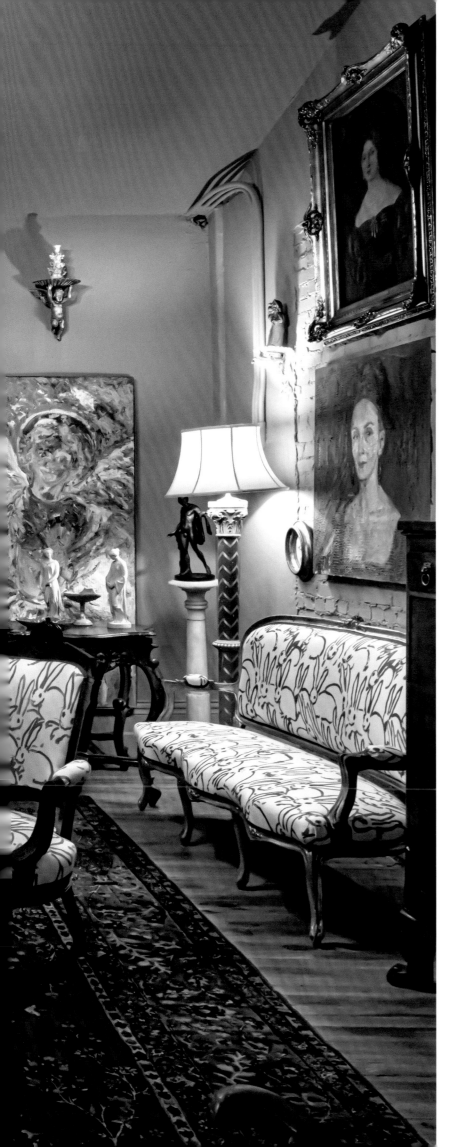

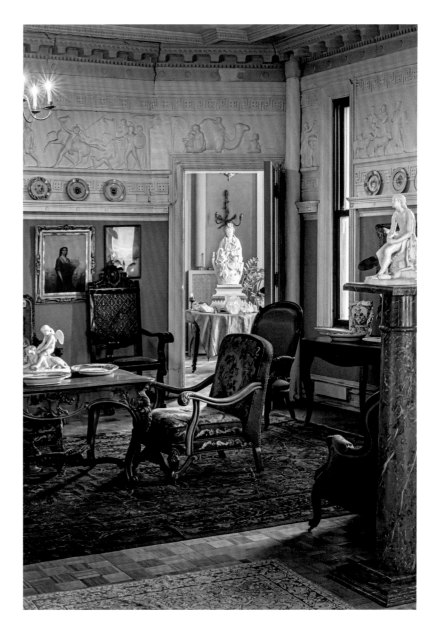

◀ Seating upholstered in "Hutch" centers a first-floor sitting room that features some of Hunt's religious paintings and objets, including *St. Martin de Porres* (left wall) and *Archangel Michael*, above left. A carved statue of Kuan Yin stands in the corner.

▲ A third-floor dining room looks into the Kuan Yin meditation room, set in a front turret.

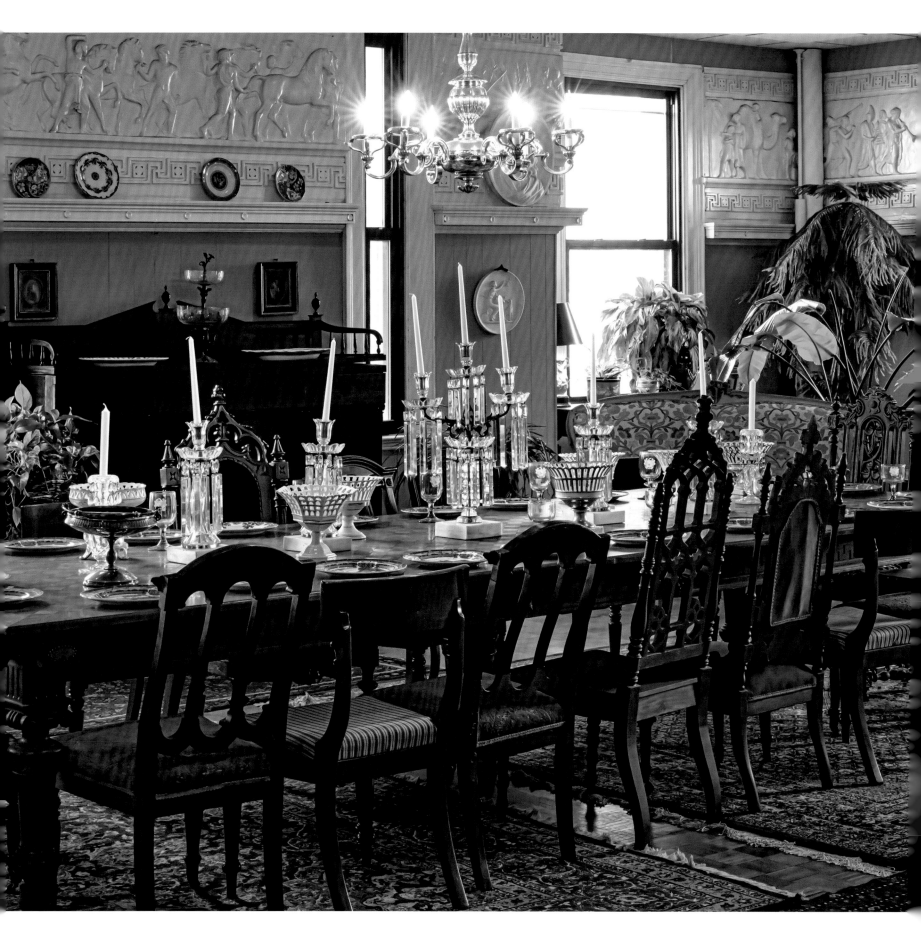

▲ The third-floor dining room table is set with Chinese export armorial china and crystal candelabras.

▶ The original plaster frieze of *Hannibal Crossing the Alps* was, fortunately, intact; Hunt's *Valentino* painting rests on the table.

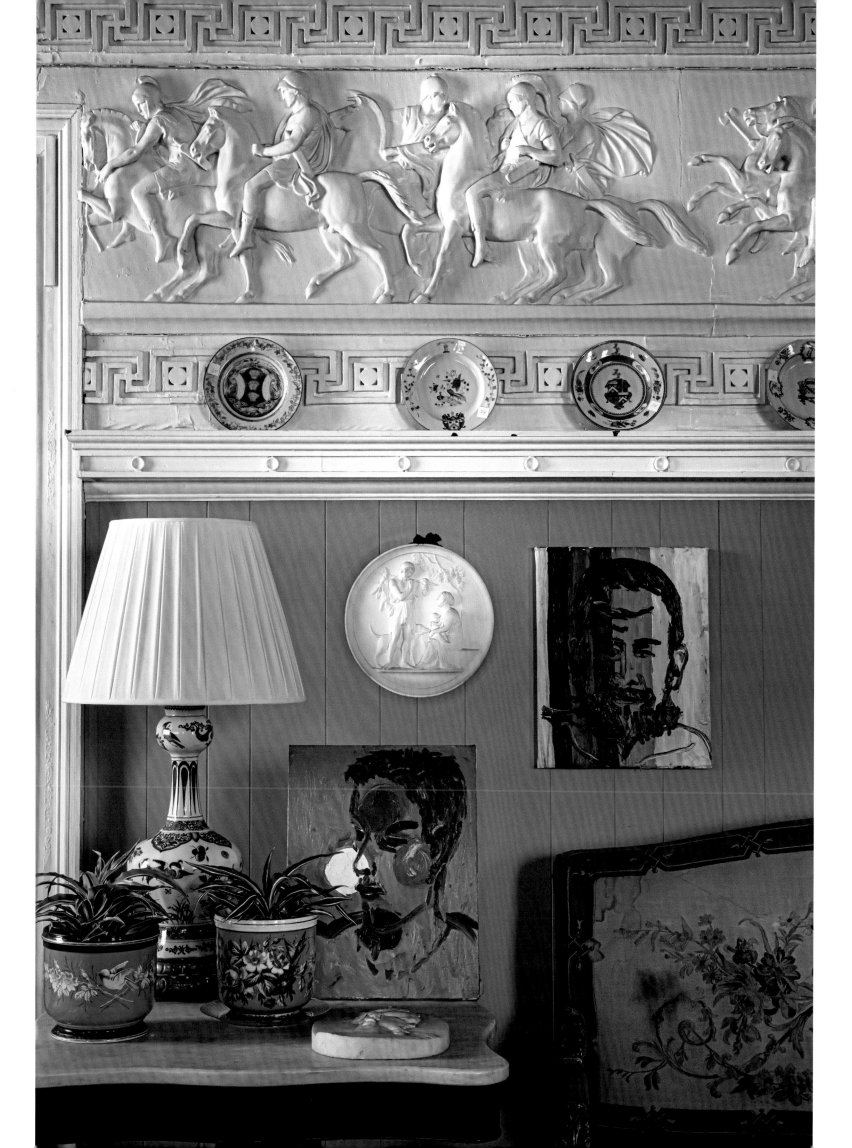

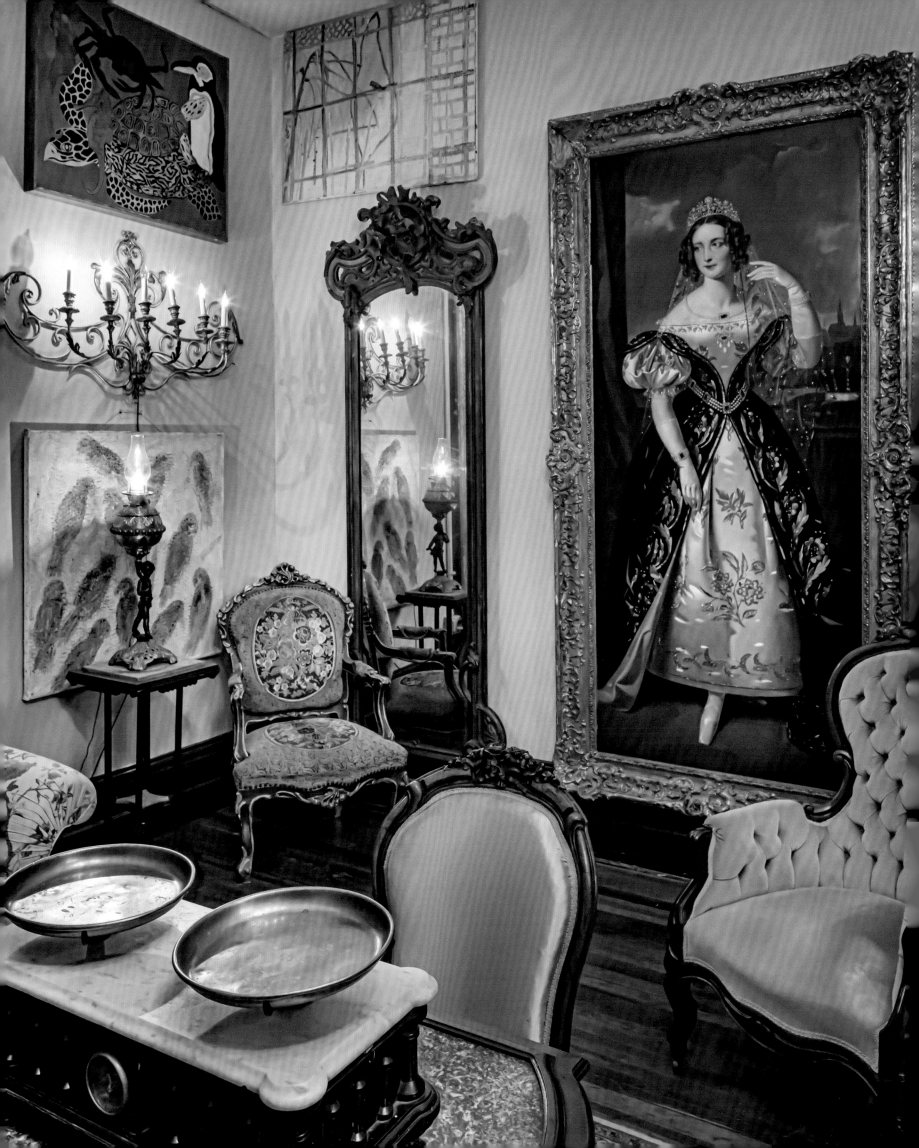

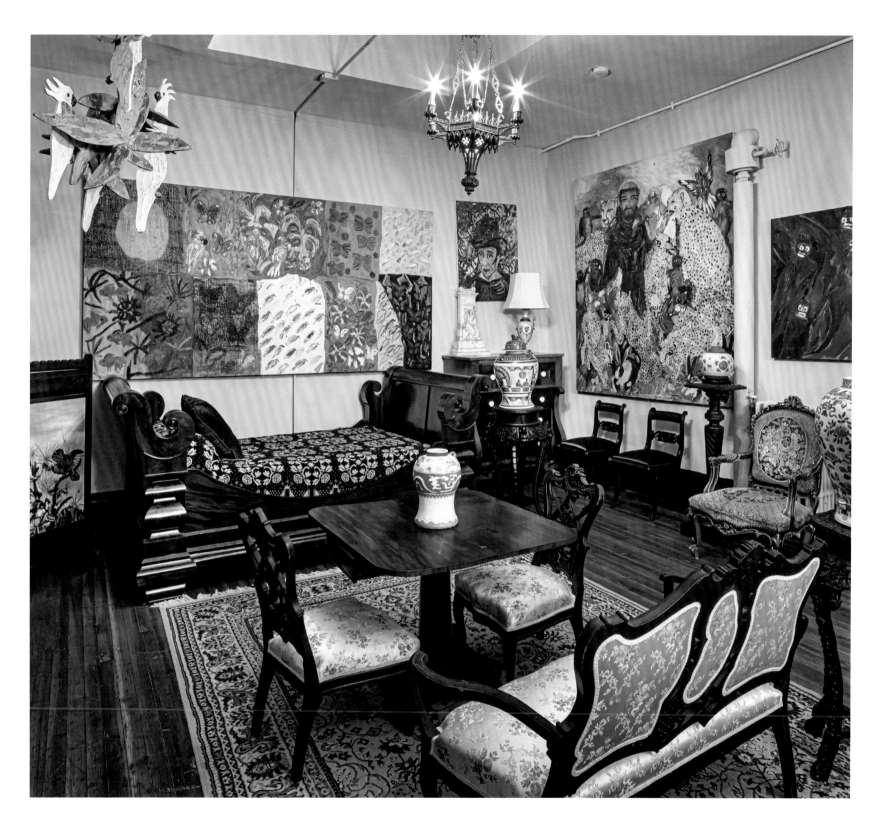

◀ *Maria Theresa of Austria*, the Queen of the Two Sicilies, looms large in the yellow parlor.

▲ Hunt's paintings of birds and butterflies intersect a wall grounded by a large painting of St. Francis of Assisi.

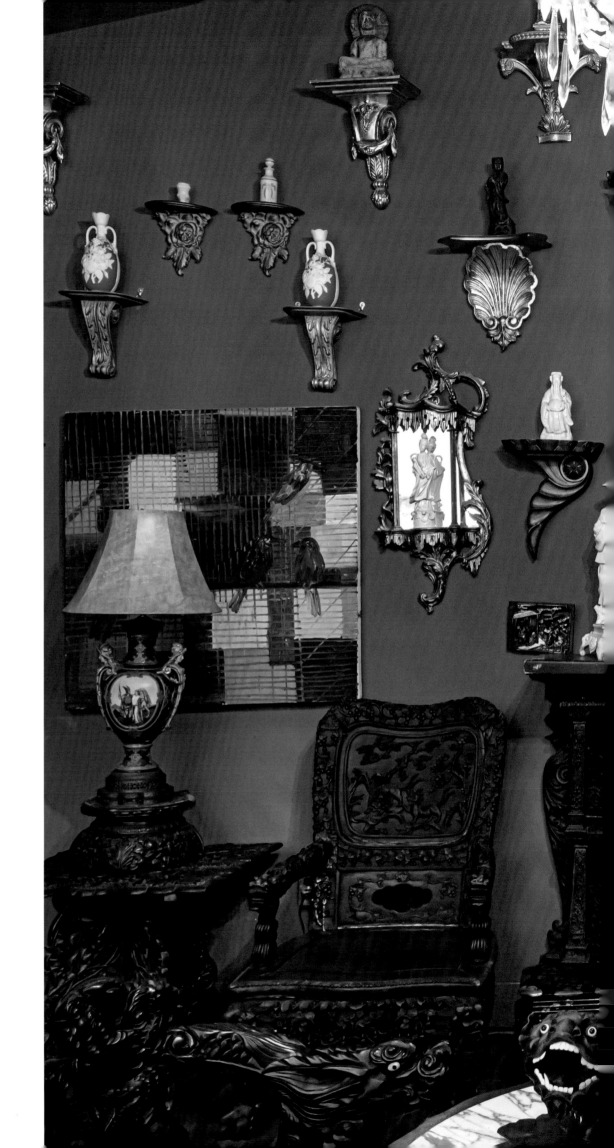

The Chinese room on the first floor is hung with carved-and-gilded wooden brackets displaying oriental ceramics. A richly carved Tiffany mantel centers the room; a pierce-carved, gilded panel inset with porcelains and reverse-painted glass from a Chinese wedding bed rests above. Hunt's early painting of St. Catherine in her tomb is on the right.

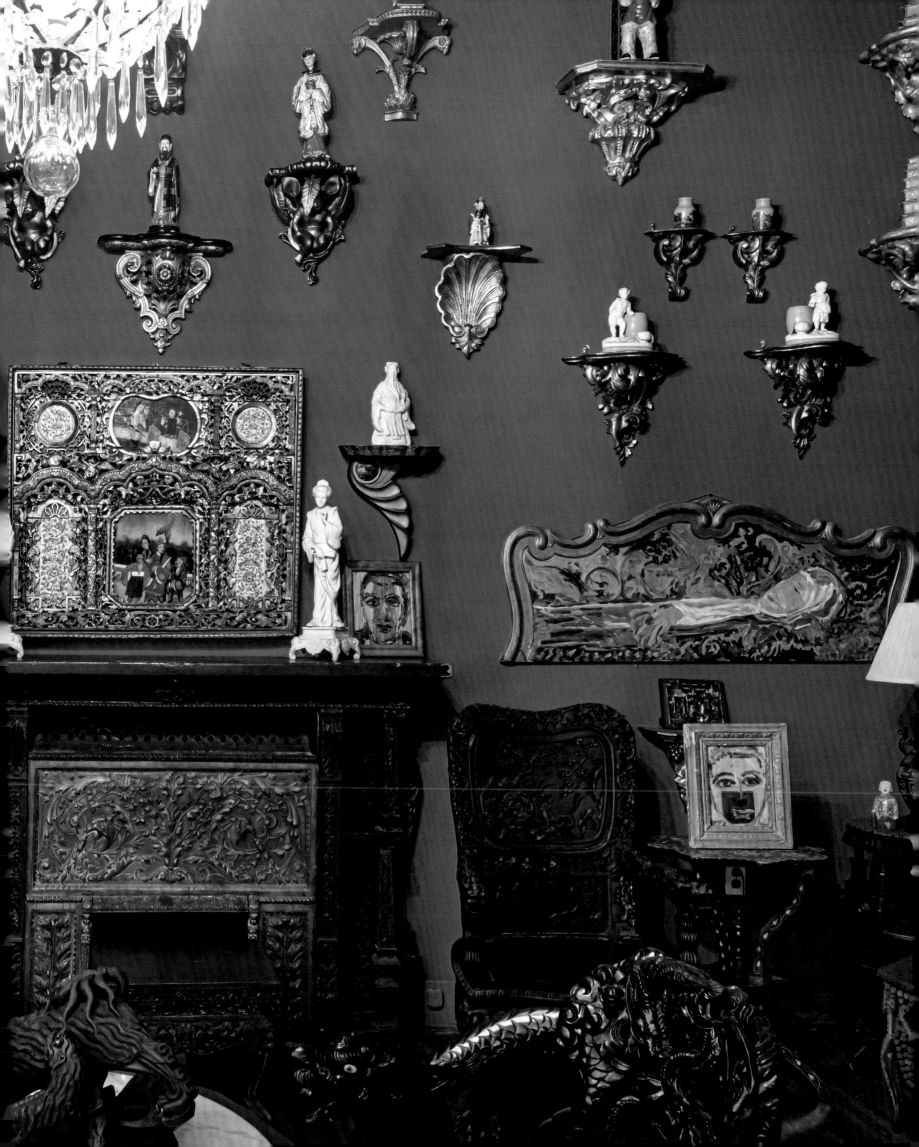

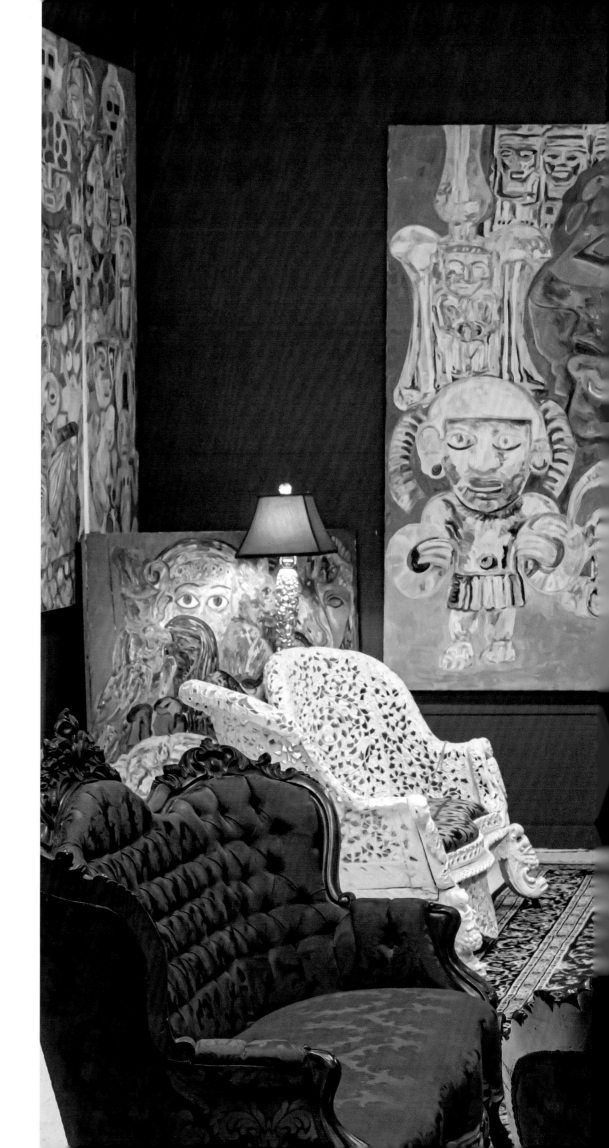

A red reception room on the second floor features carved teak furniture and Hunt's early mythological works, including *Inca Gold*.

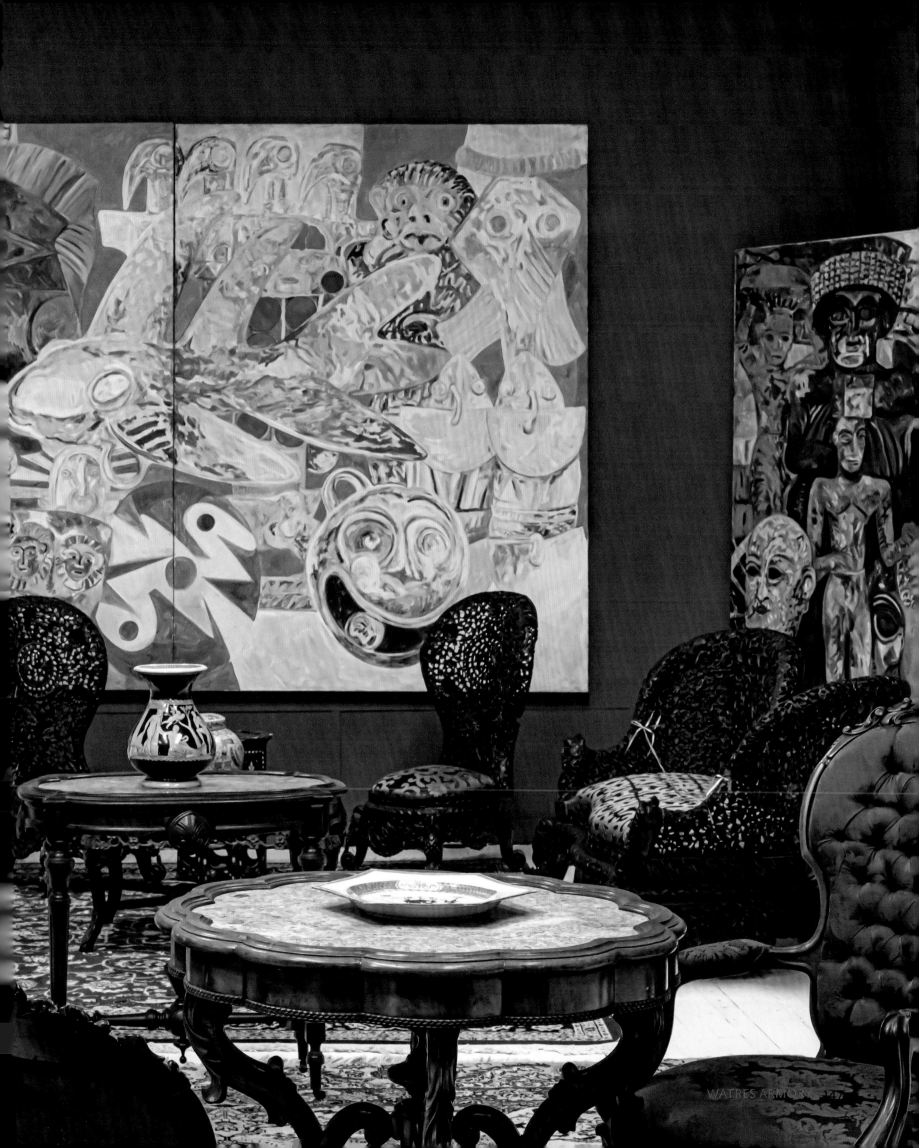

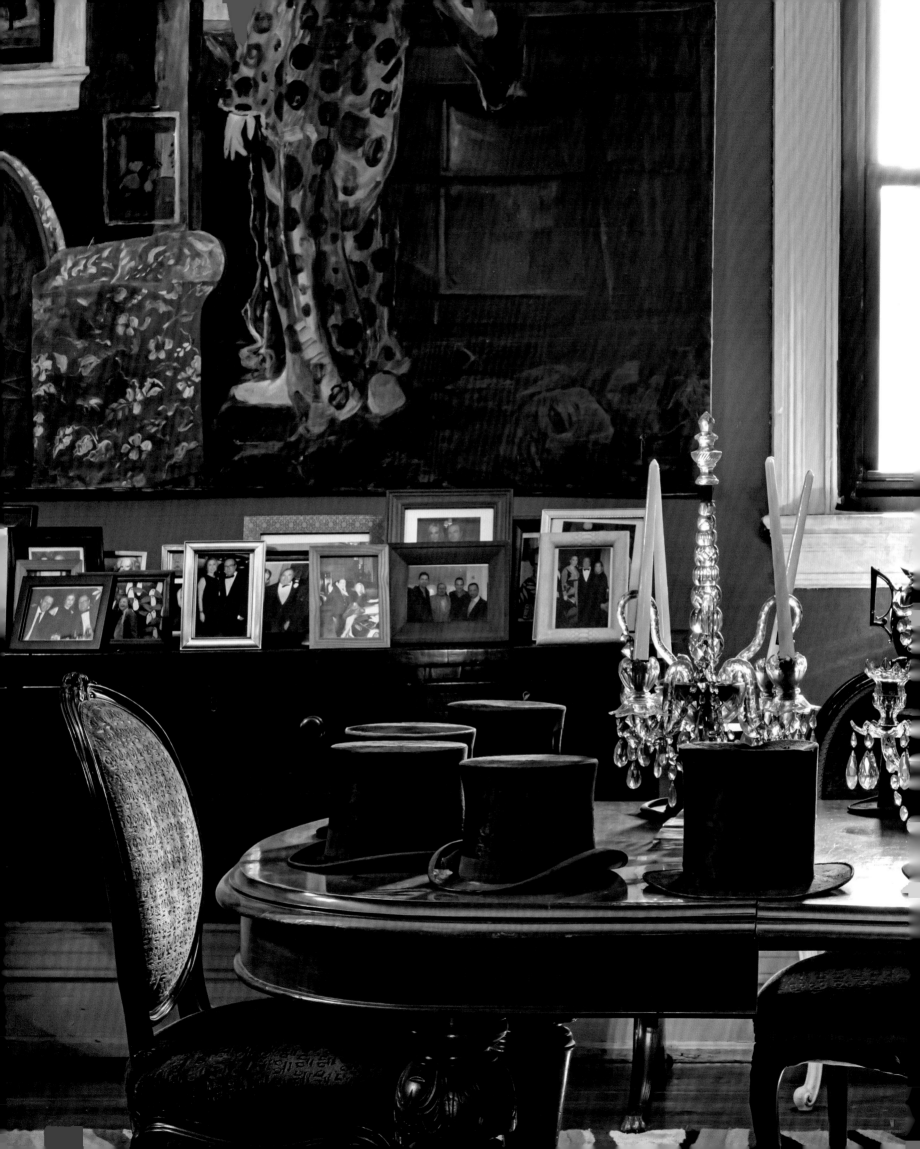

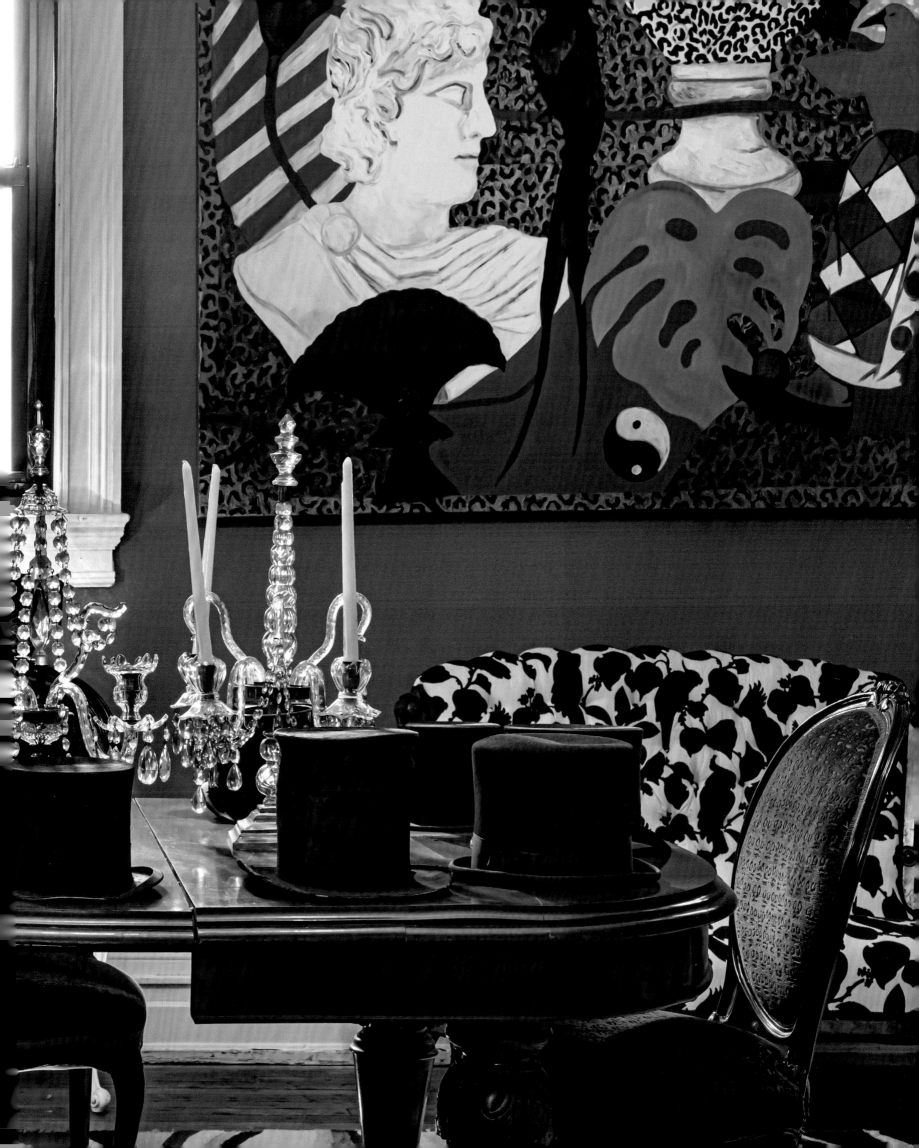

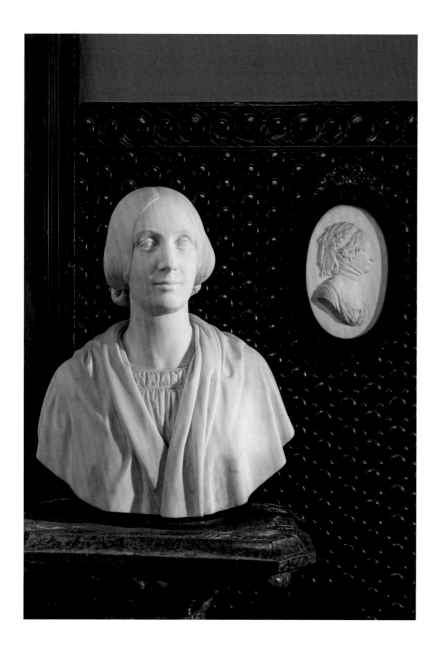

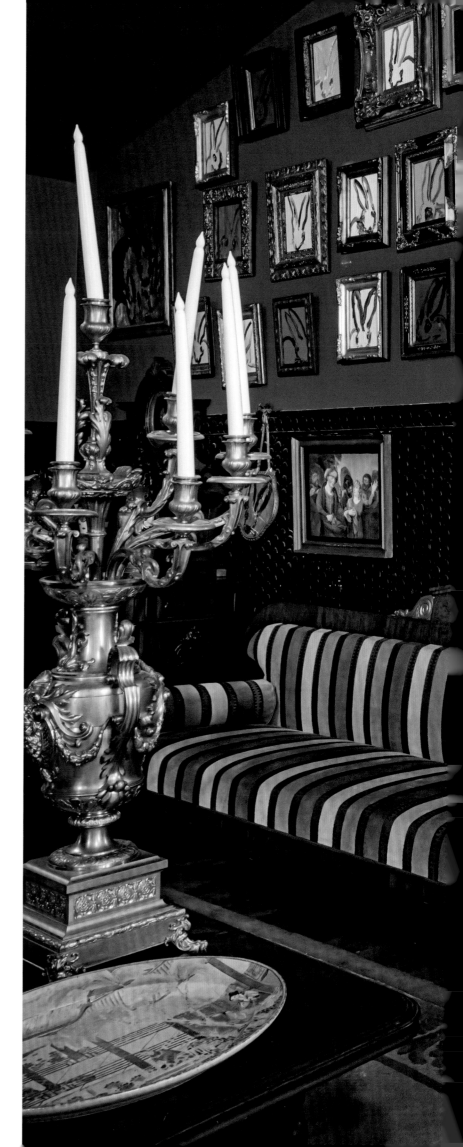

Previous Overleaf: A collection of top hats in a third-floor sitting room, which is hung with very early works.

▲ The original button-patterned plaster dado provides a handsome backdrop for Hunt's antiques and paintings.

▶ A suit of armor and a wall of early bunny paintings above a Biedermeier sofa greet visitors at the entrance.

Overleaf: Marble busts and statues, a carved Victorian chair upholstered in colorful "Bayou Casino," for Lee Jofa, and a "Guardian Eyes" rug are set outside the only white room in the Armory.

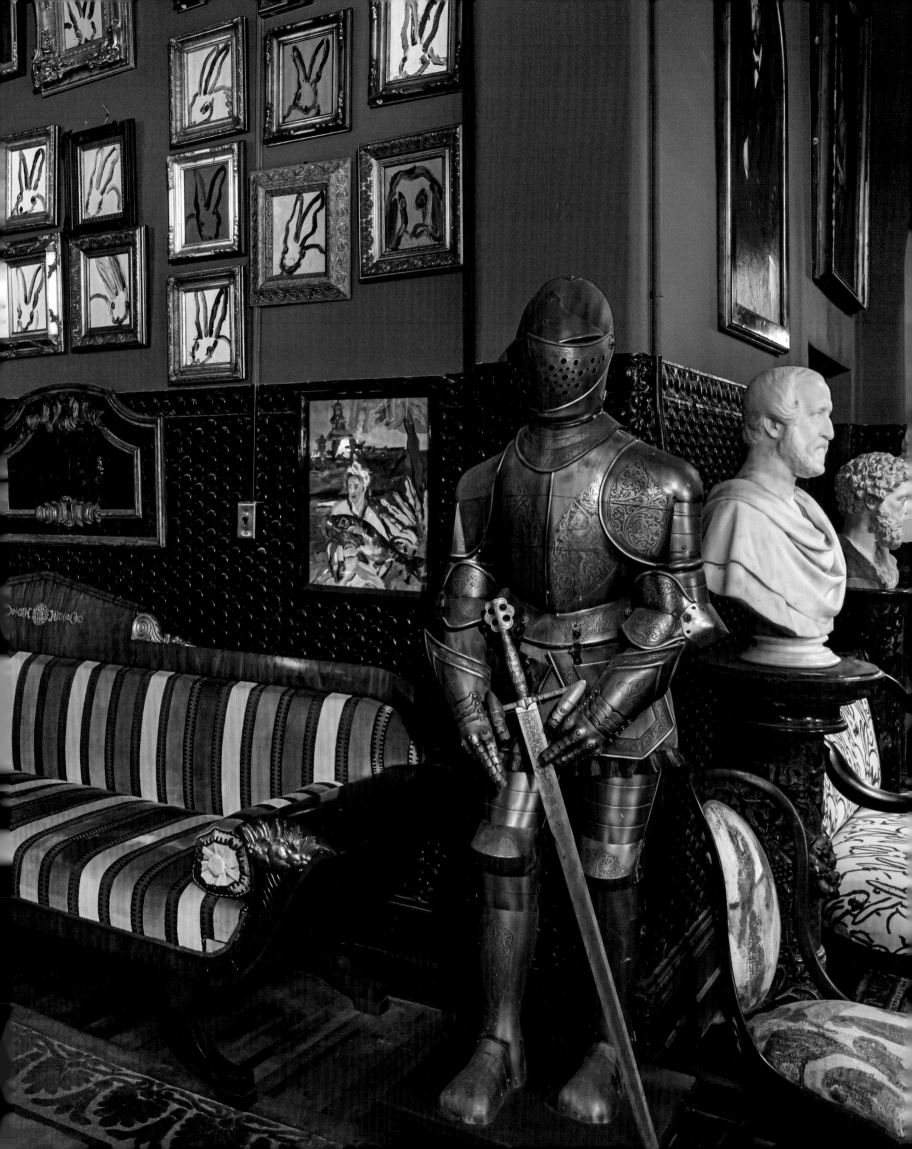

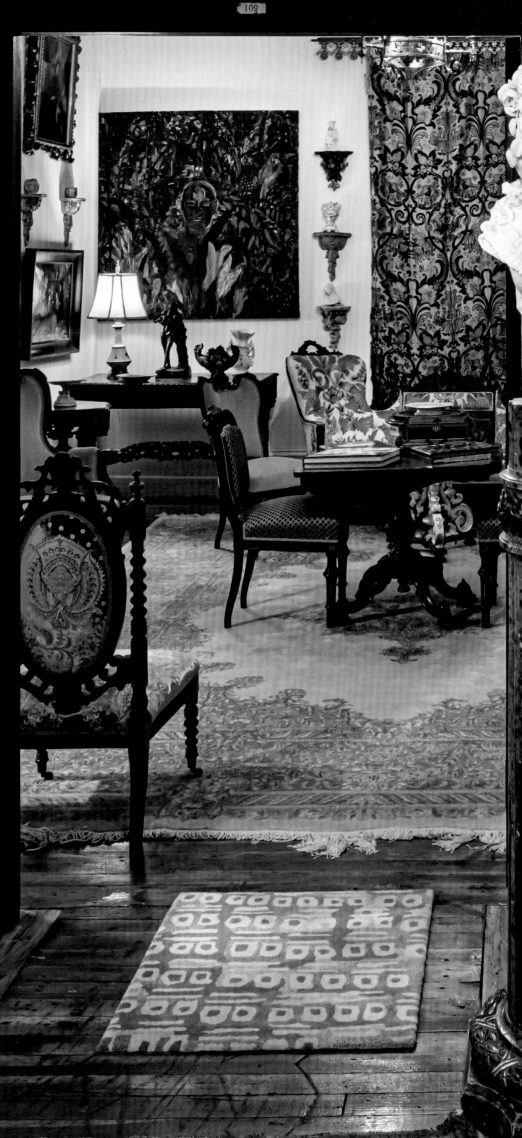

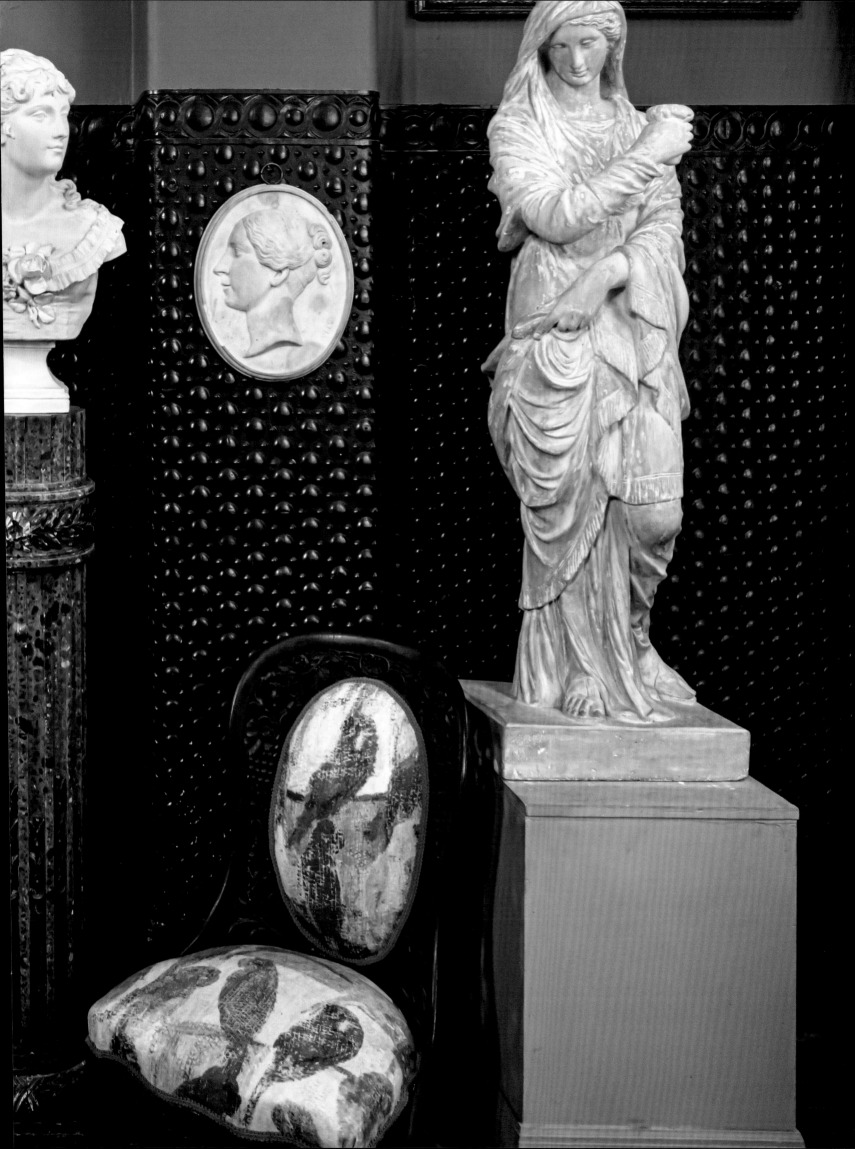

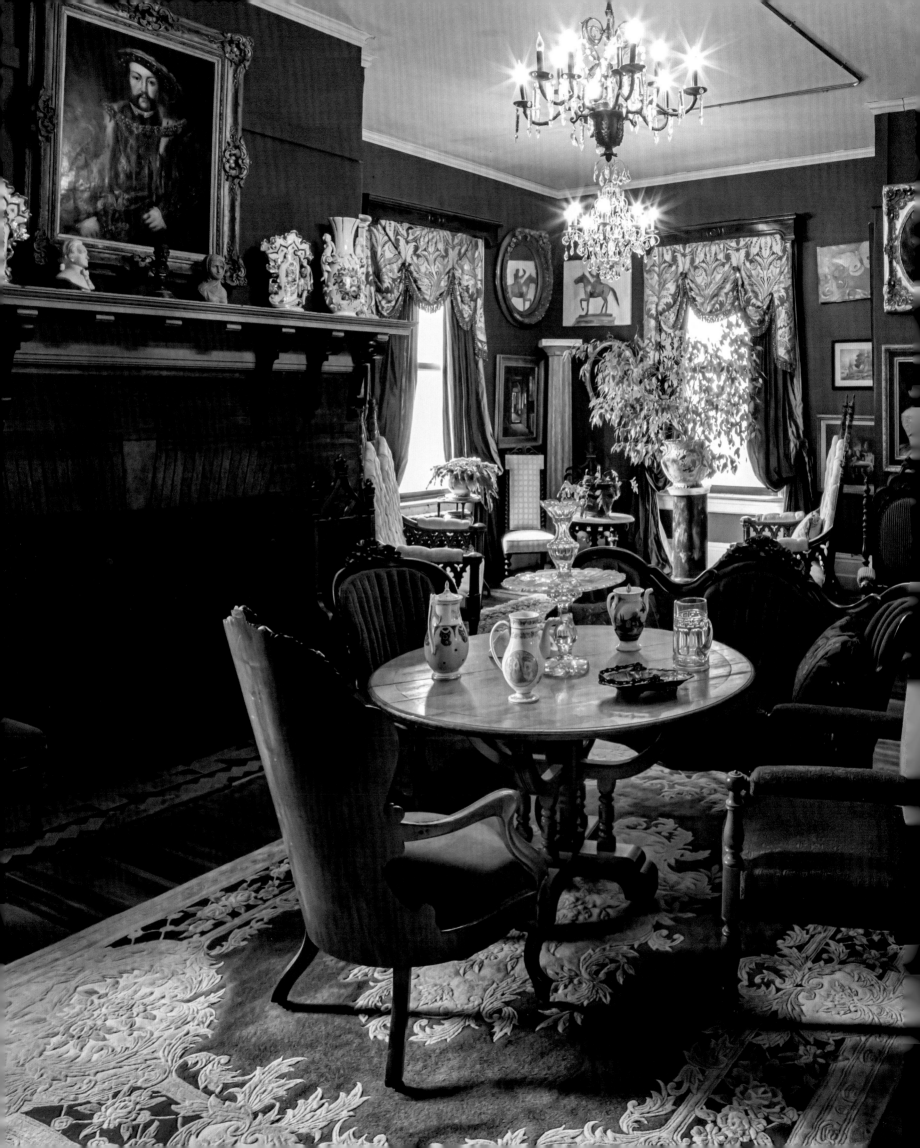

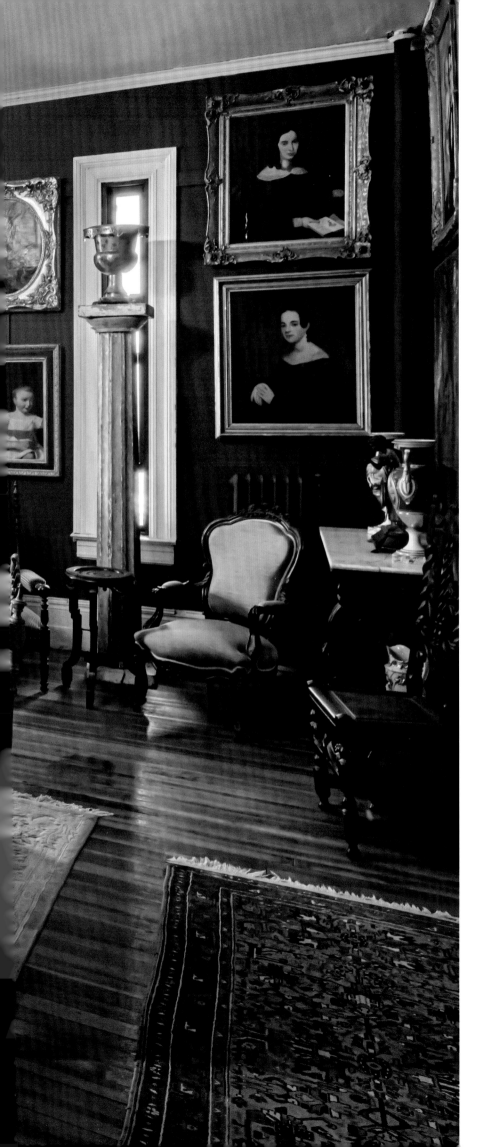

Victorian oil portraits, including Henry VIII (above the mantel), line the sitting room.

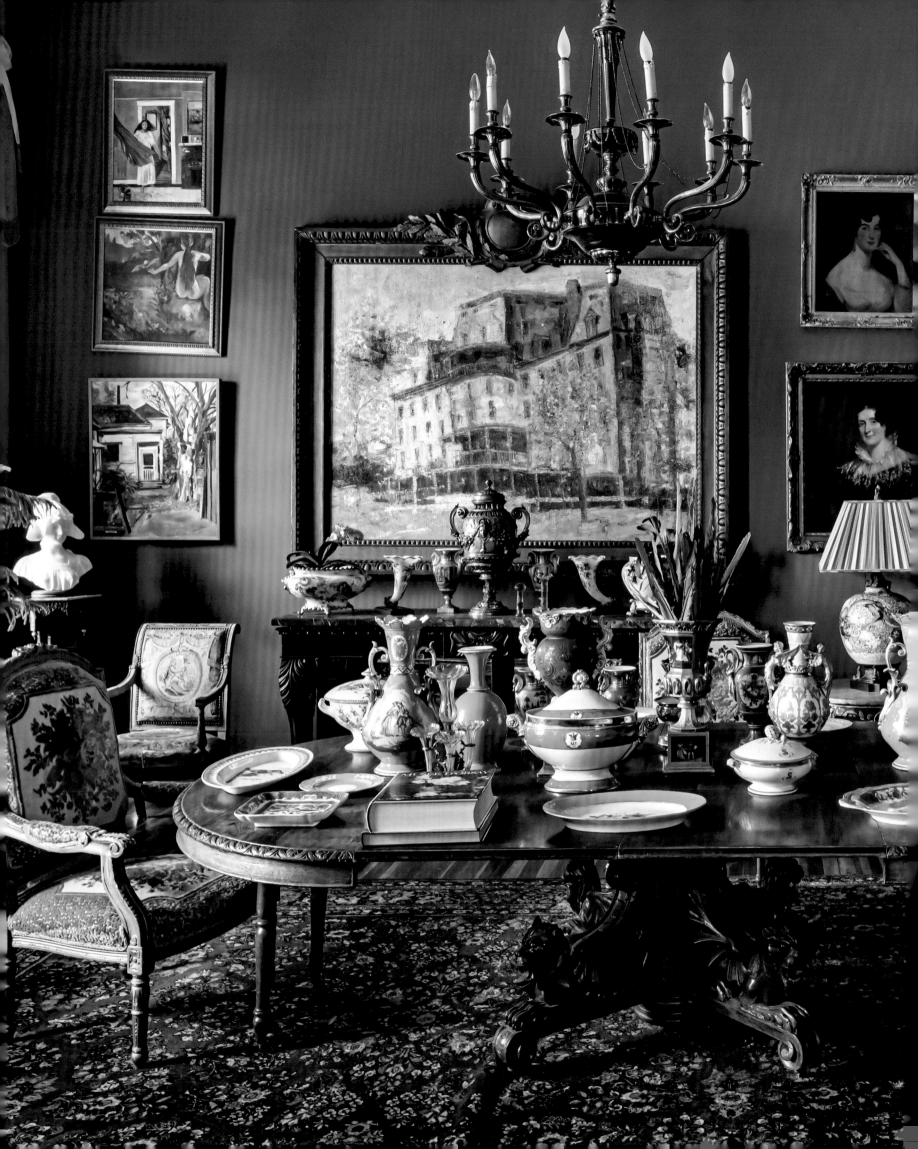

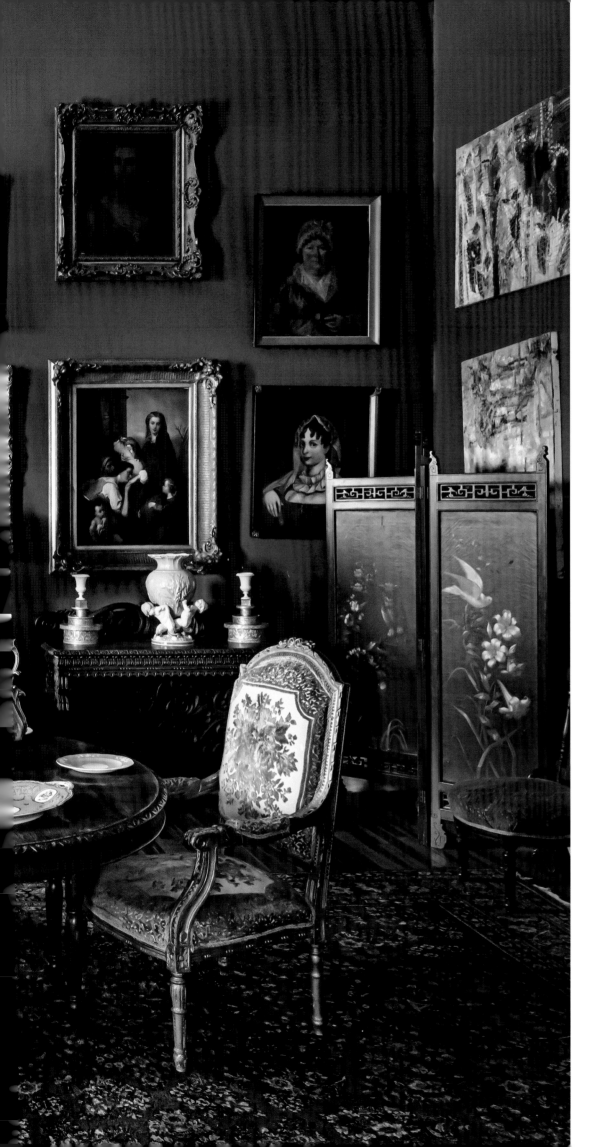

The green dining room table is set with Old Paris porcelain and china; paintings include *The Rexmere Hotel*, a historic hotel in Stamford, New York.

Overleaf: A light-filled sitting room on the first floor is furnished with plants, nineteenth-century furniture Hunt collected on trips, and some of his *Abraham Lincoln* portraits, as well as Victorian portraits.

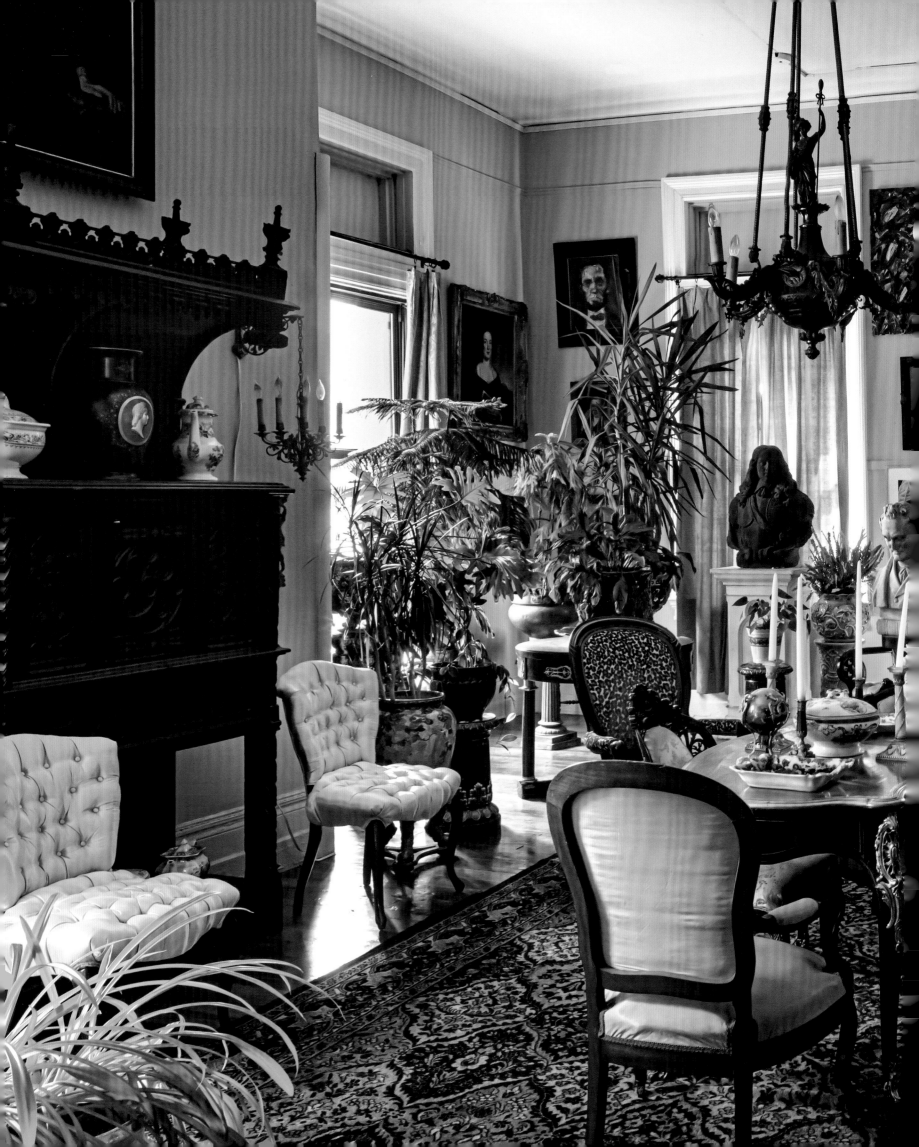

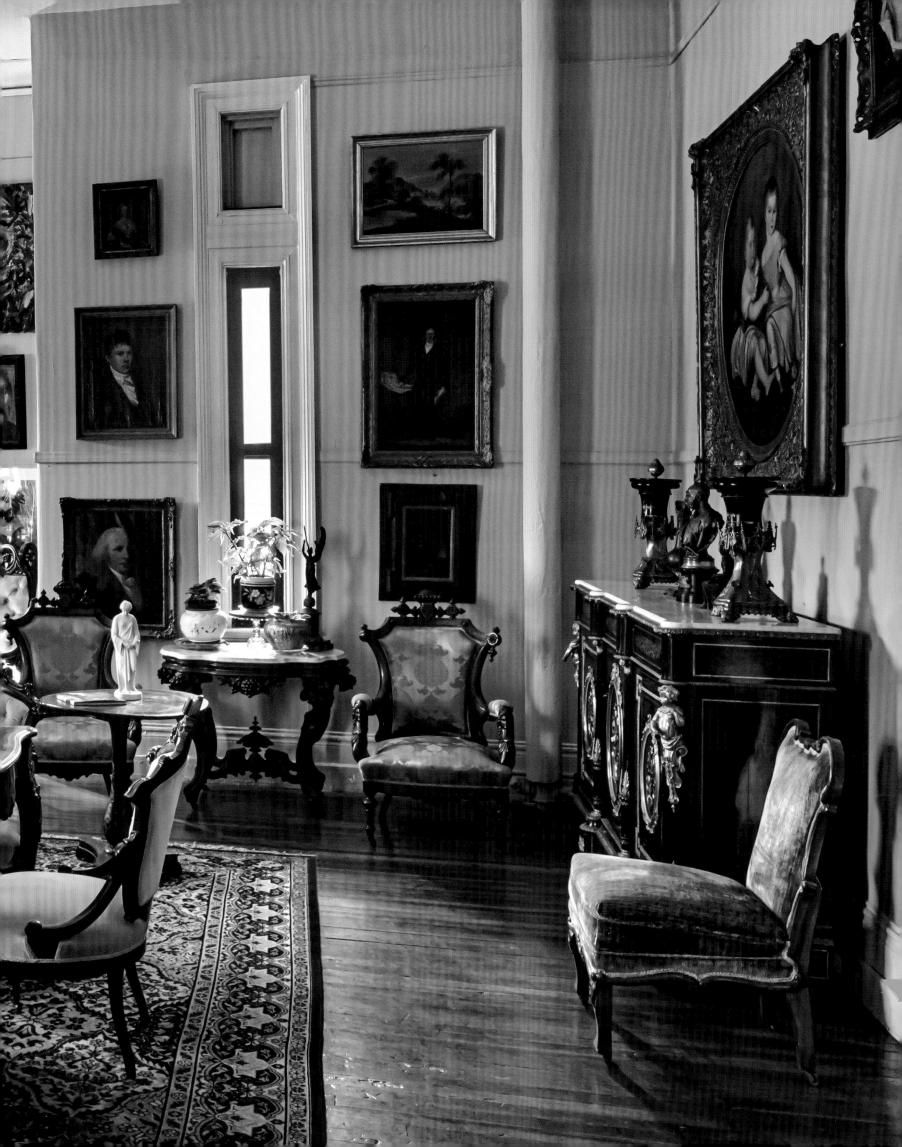

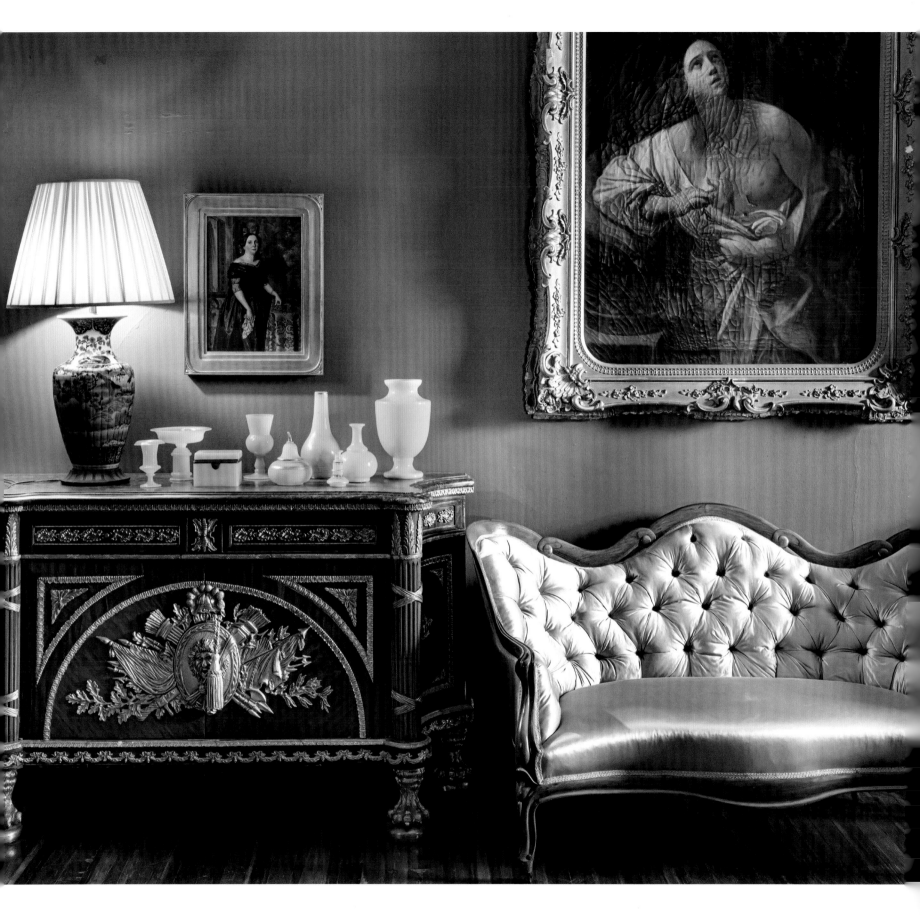

▲ A collection of green opaline glass catches the light on a French Louis XV gilt commode embellished with gilt bronze and marquetry in a first-floor sitting room.

▶ Carved Gothic chairs surround a marble-topped table set with an Old Paris tea set. Hunt conserved the room's original green woodwork and trim.

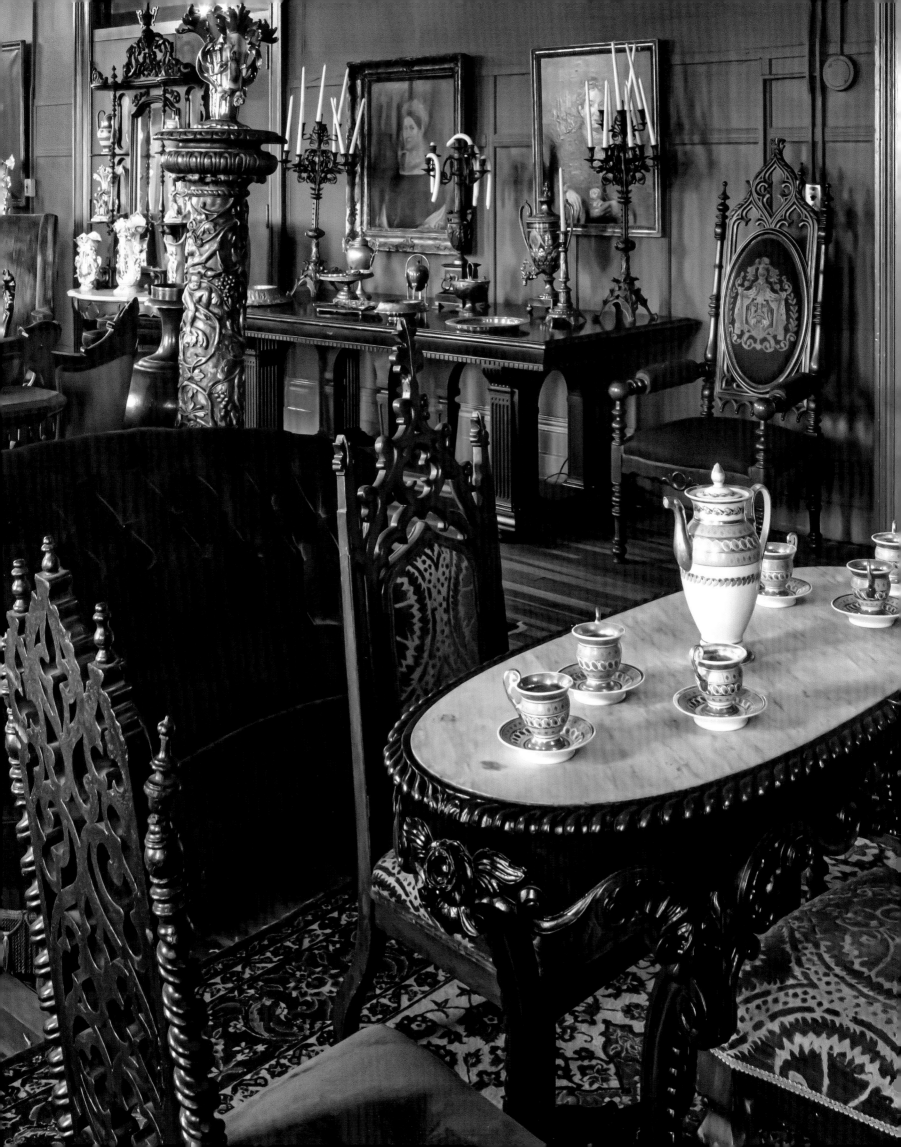

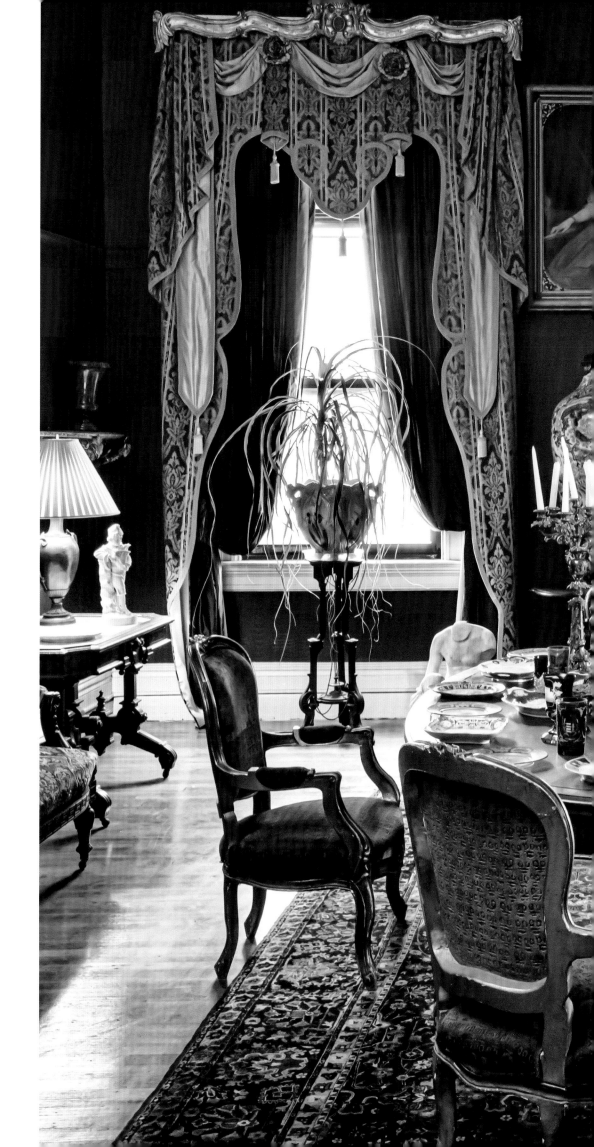

The table in the dining room adjacent to the Queen's Room is set with Old Paris porcelain, Bohemian glass, and gilded candelabras. The elaborately swagged and tasseled, antique tapestry curtains were found in Natchez; A bust of Hercules stands in front.

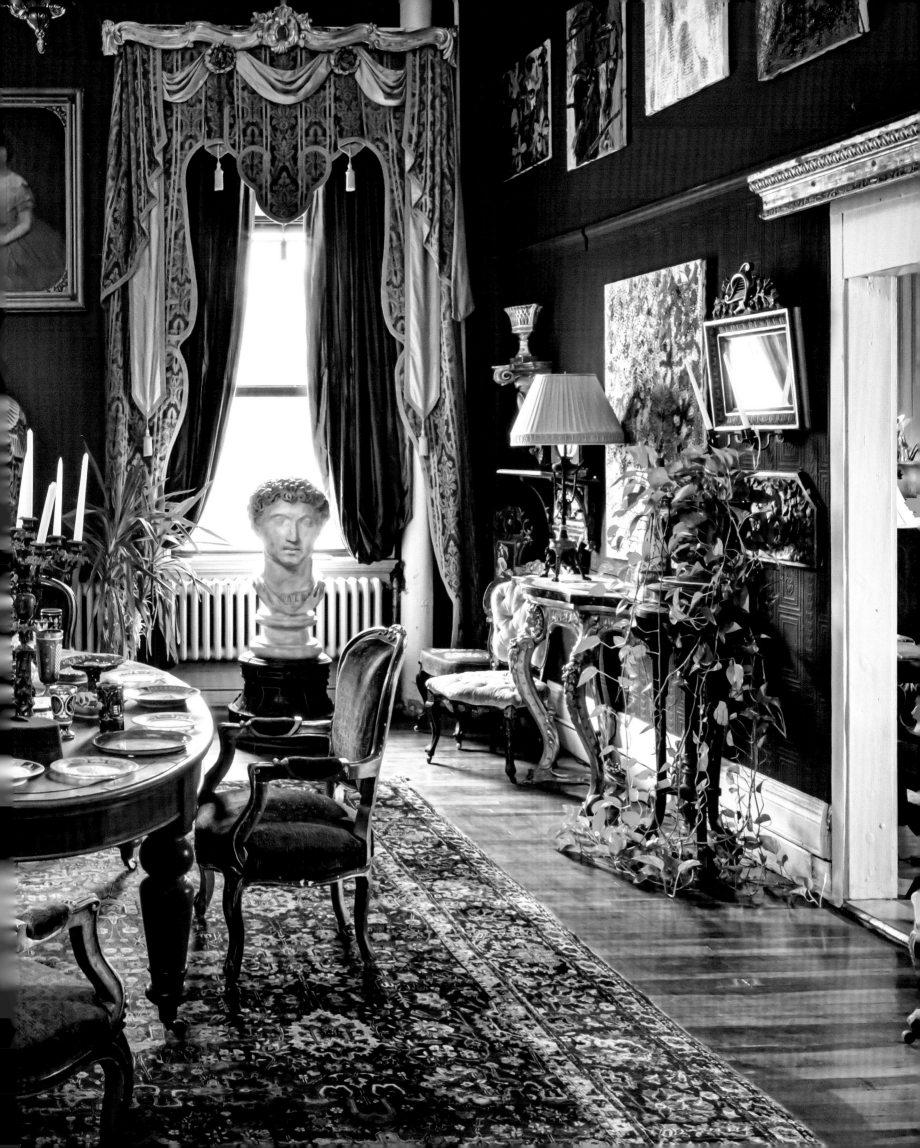

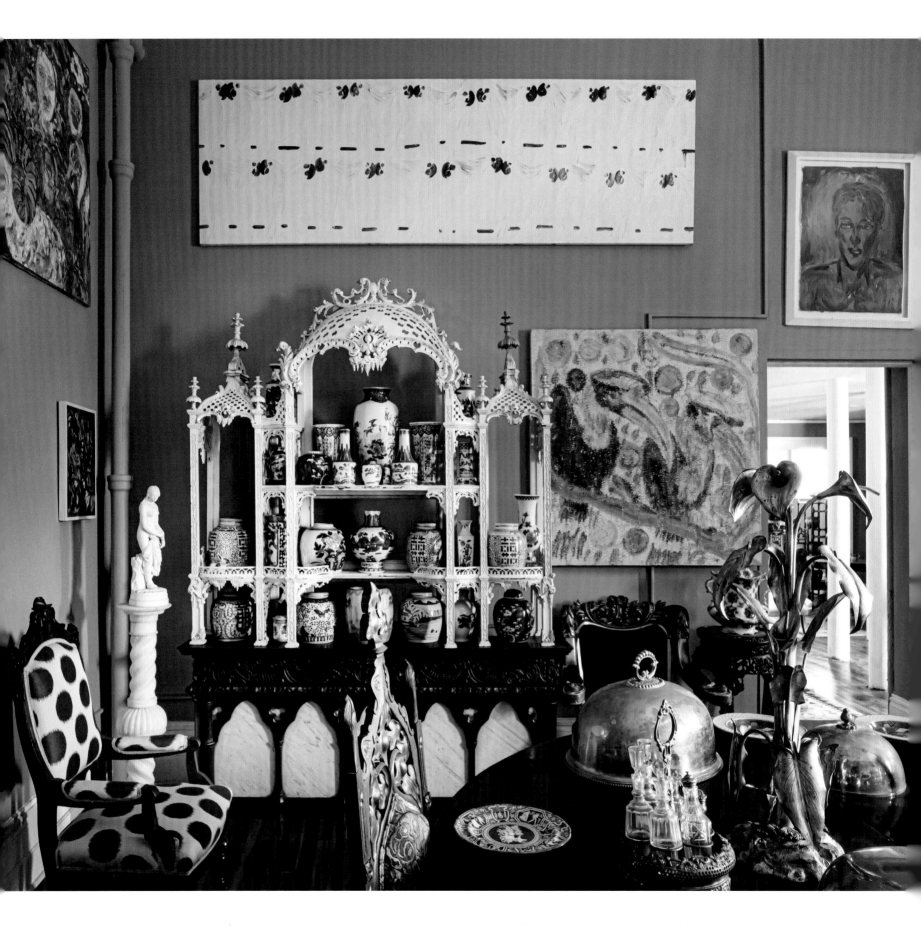

▲ A lavender dining room on the first floor displays a collection of blue-and-white china on a painted Georgian chinoiserie étagère. Hunt's *Cockatoos* (above) and *Hornbills* hang alongside.

▶ Hunt's *Vandas* is set above a lavendar-upholstered sofa. One of a pair of Elkington centerpieces in the form of lilies graces the dining table.

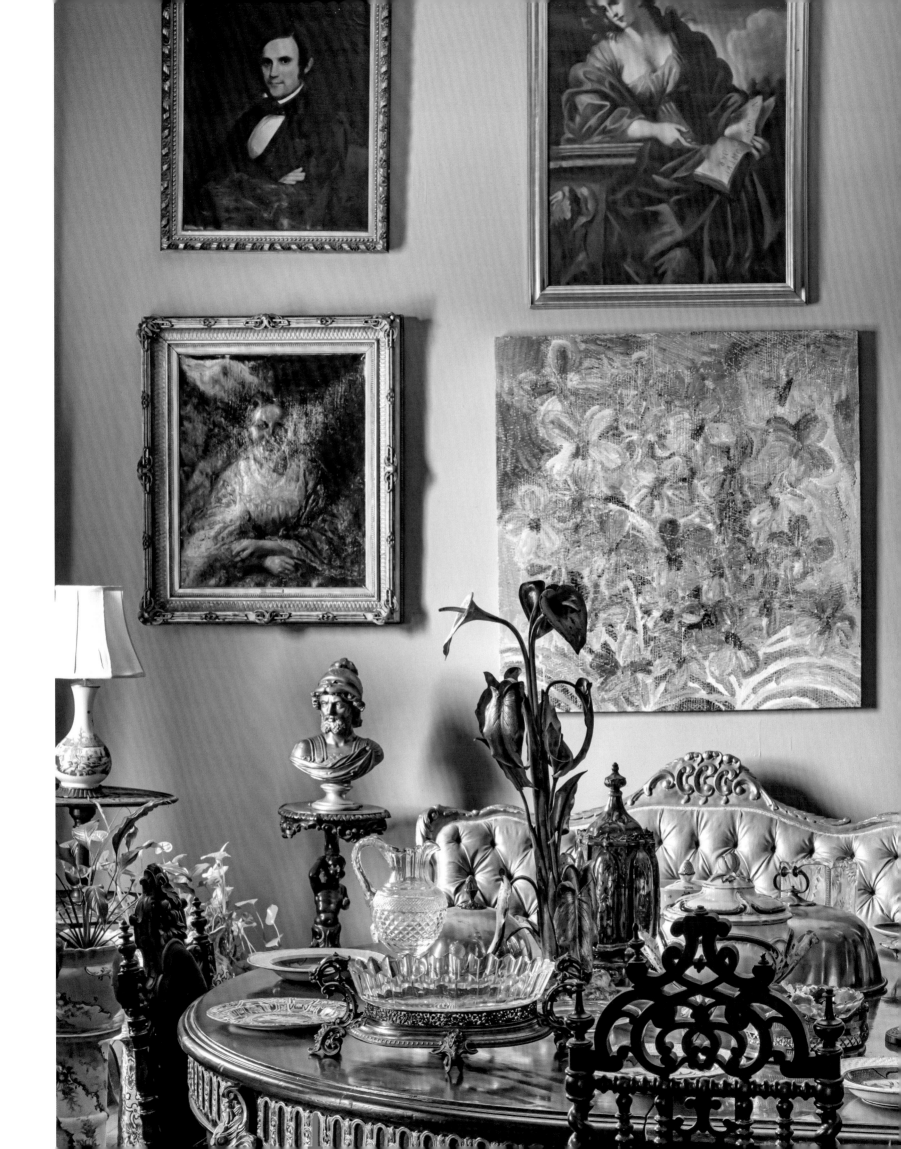

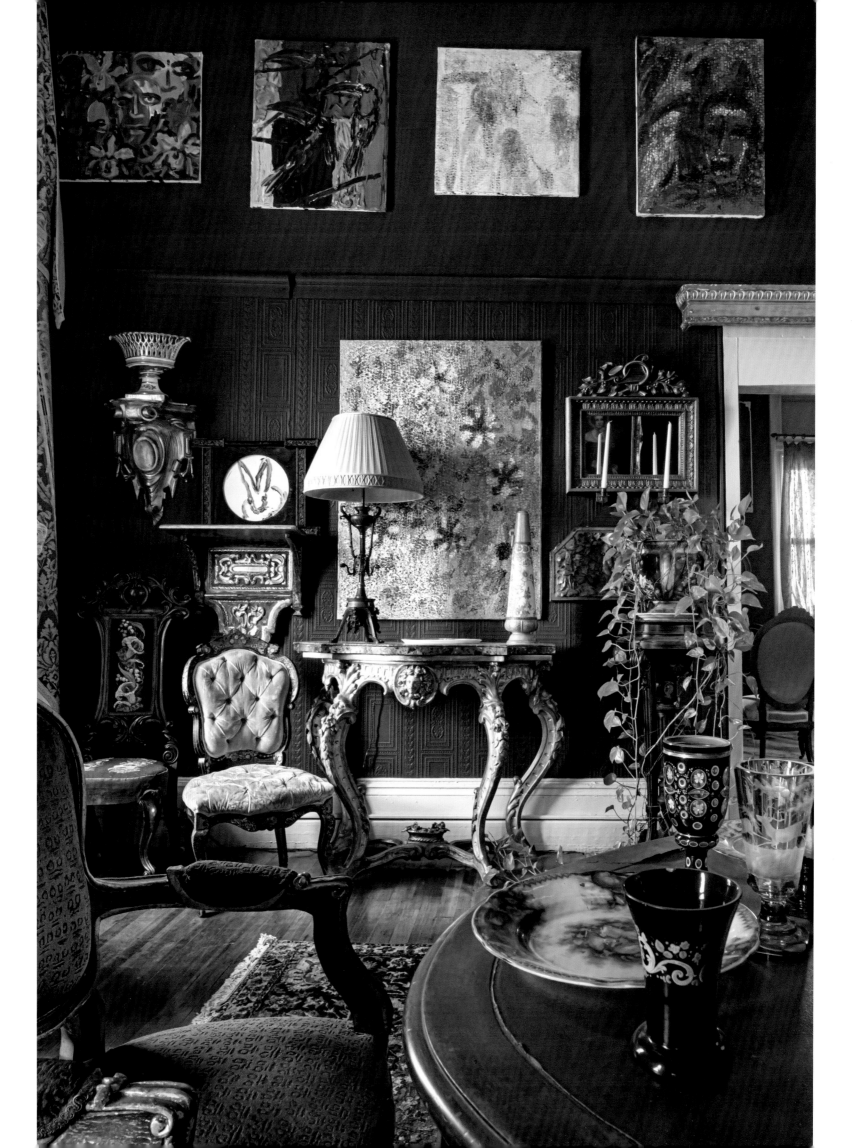

◀ Bohemian glass goblets sit on the table in the first-floor red room, where paintings include *Pinwheel*, bunnies, and birds.

▲ A Chinese figural vase is juxtaposed with toucans, lories, and macaws.

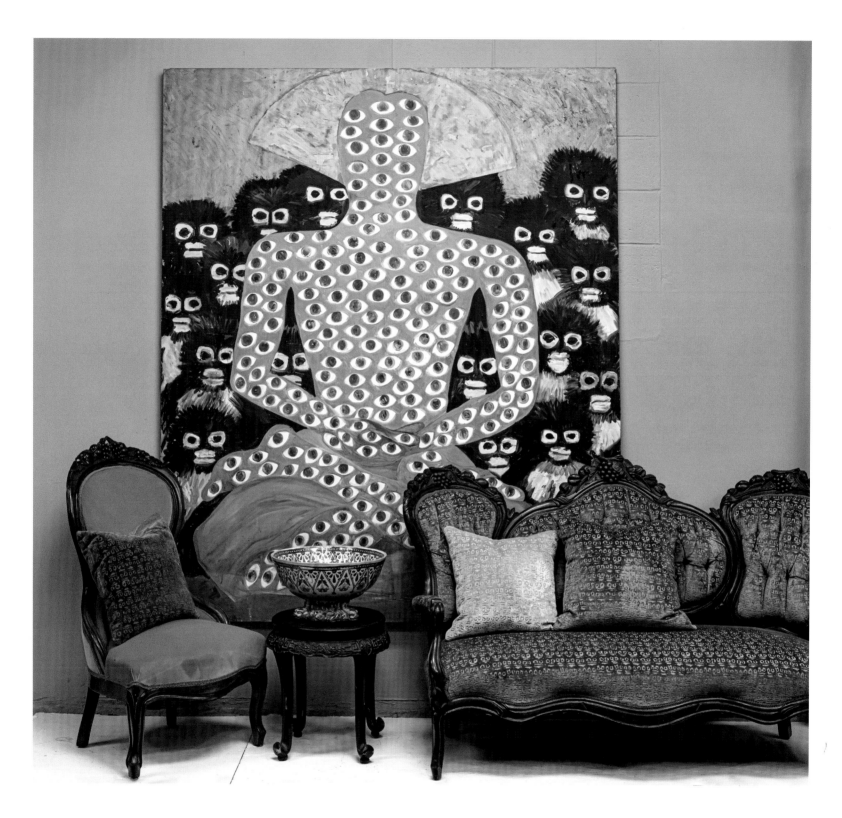

Hunt's large portrait called *Mahavatar Babaji* hangs
behind a sofa and pillows covered in "Guardians" fabric.

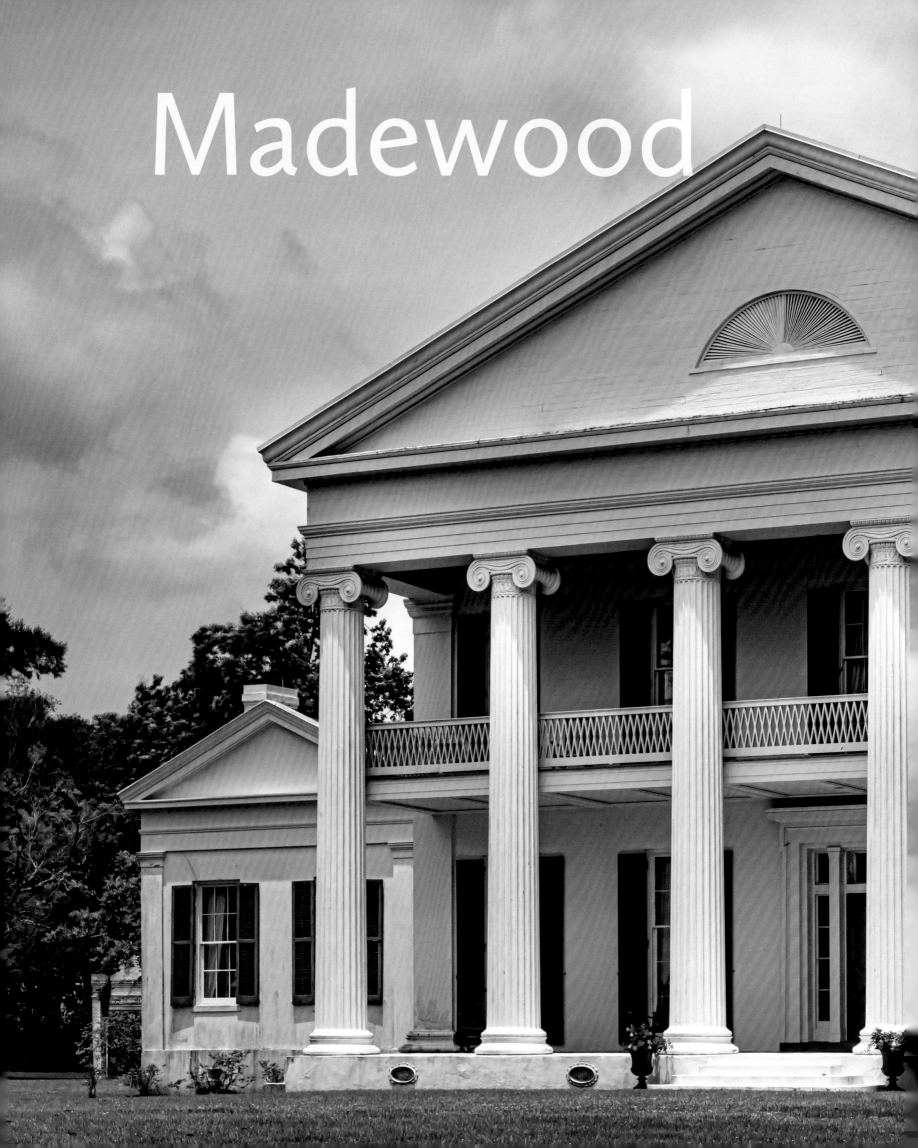

Madewood

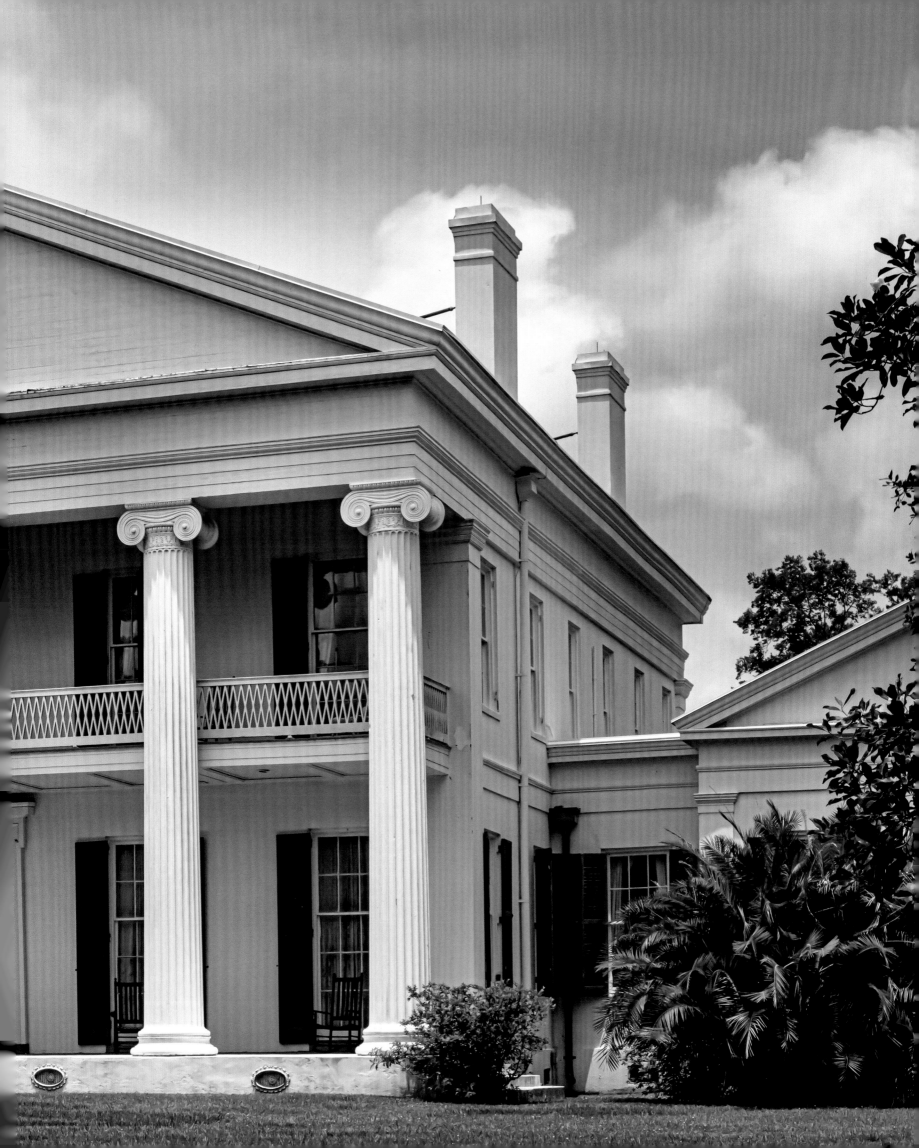

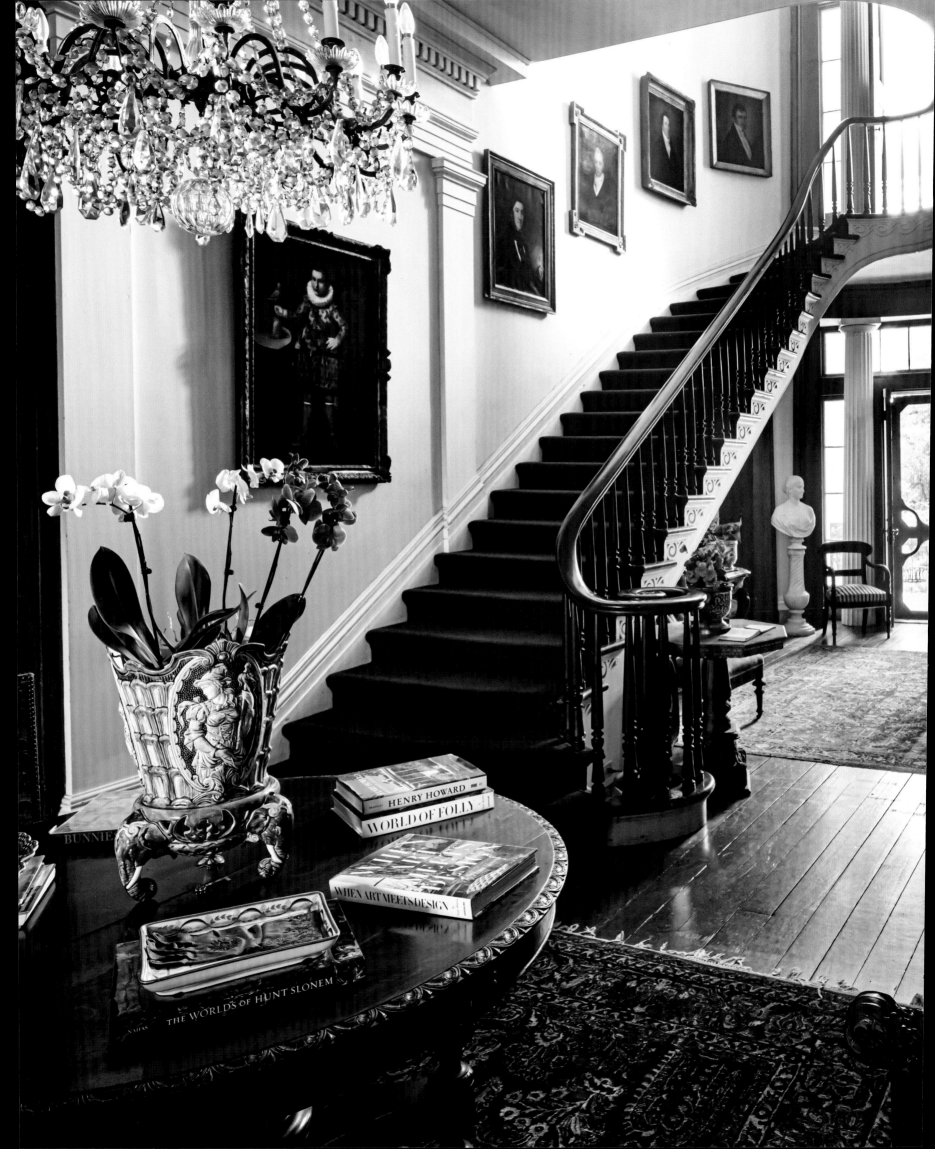

Madewood Napoleonville, Louisiana

Hunt Slonem couldn't get Madewood out of his mind after he first visited it as a student at Tulane University in the 1970s. Considered one of the finest Greek Revival mansions in the South, Madewood was built in 1846 by New Orleans architect Henry Howard for Colonel Thomas Pugh as the center of Pugh's 10,000-acre sugar cane business. The setting was idyllic, nestled among oak trees along Bayou LaFourche in southeastern Louisiana. Hunt was drawn to the grand interiors and architectural detailing, from the fourteen-foot ceilings to the elaborate entablatures over the interior doors and hallways. Rooms were large and filled with light, and there was even a grand ballroom, unusual for a home of this period.

Over the years, the house saw its share of celebrities (with guests from Brad Pitt to Faye Dunaway) and had been in magazine shoots and films—from *Sister, Sister* (1987), written by Maya Angelou, to *The Beguiled* (2017), written and directed by Sophia Coppola. And in 2016 Beyoncé filmed her popular music video *Lemonade* seated in a rare, Stanton Hall Gothic chair in the central hall.

This would be a chance, Hunt thought, to own a well-known home he had admired since college, a place where he could create a magical setting for his art and antiques. After consulting his spiritual advisor, who had a vision of him waving from the front porch, he knew it was meant to be.

The architecture of Madewood was impressive and one of the main features that attracted Hunt to the house. Local materials and woods (primarily pine and cypress) had been used throughout its construction, giving rise to its name, "Madewood." Thick brick walls were finished with stucco then scored to resemble stone blocks, and the spacious interiors were finished with faux graining and marbleized detailing. Six massive Ionic columns supported a Greek Revival temple front with a broad entablature and pedimented gable, giving it a commanding, classical appeal. A wide entry hall ran the width of the house to allow breezes to flow through. The hall was divided midway by a pair of fluted Corinthian columns framing a semicircular staircase leading to bedrooms and sitting rooms

Previous overleaf: Broad lawns sweep up to the front façade. Classic Greek architecture is celebrated with two-story Ionic columns, a fully pedimented gable, and broad, open verandas. The main structure is augmented with ells on either side. Note the rare Senegal date palm on the right.

◄ Sweeping stairs in the hall are lined by Louisiana period portraits.

upstairs. Wings on either side of the main floor formed ells for public rooms, including double parlors to the right and a library, dining room, and grand ballroom to the left. A kitchen was attached beyond the ballroom—unusual for homes of this period as cooking was typically done in outbuildings to minimize the risk of house fires.

Madewood survived unchanged over two centuries, but time was not kind and it had badly deteriorated by the time it was bought by the Marshall family in 1964. They spent the next several decades restoring it to its original grandeur, and the house was registered a National Historic Landmark in 1983. Hunt was able to purchase it when the Marshalls retired in 2018, fifty years after he first saw it as a young student.

He approached the home as an artist, with the goal of recreating visions of nineteenth-century magnificence. He updated structural elements from the roof to the wiring and added new life to the interiors with bold color. He combed antique shops and auctions throughout the South and filled the rooms with collections of fine Antebellum and nineteenth-century antiques and Victorian paintings. He dressed the windows with ornate swagged and draped treatments. After two years of restoration, Madewood was ready to welcome guests as Hunt's artistic vision of a grand and elegant Southern home.

The front hall runs the width of the home and is divided by a pair of Corinthian columns and a gently curving staircase leading to the second-floor bedrooms.

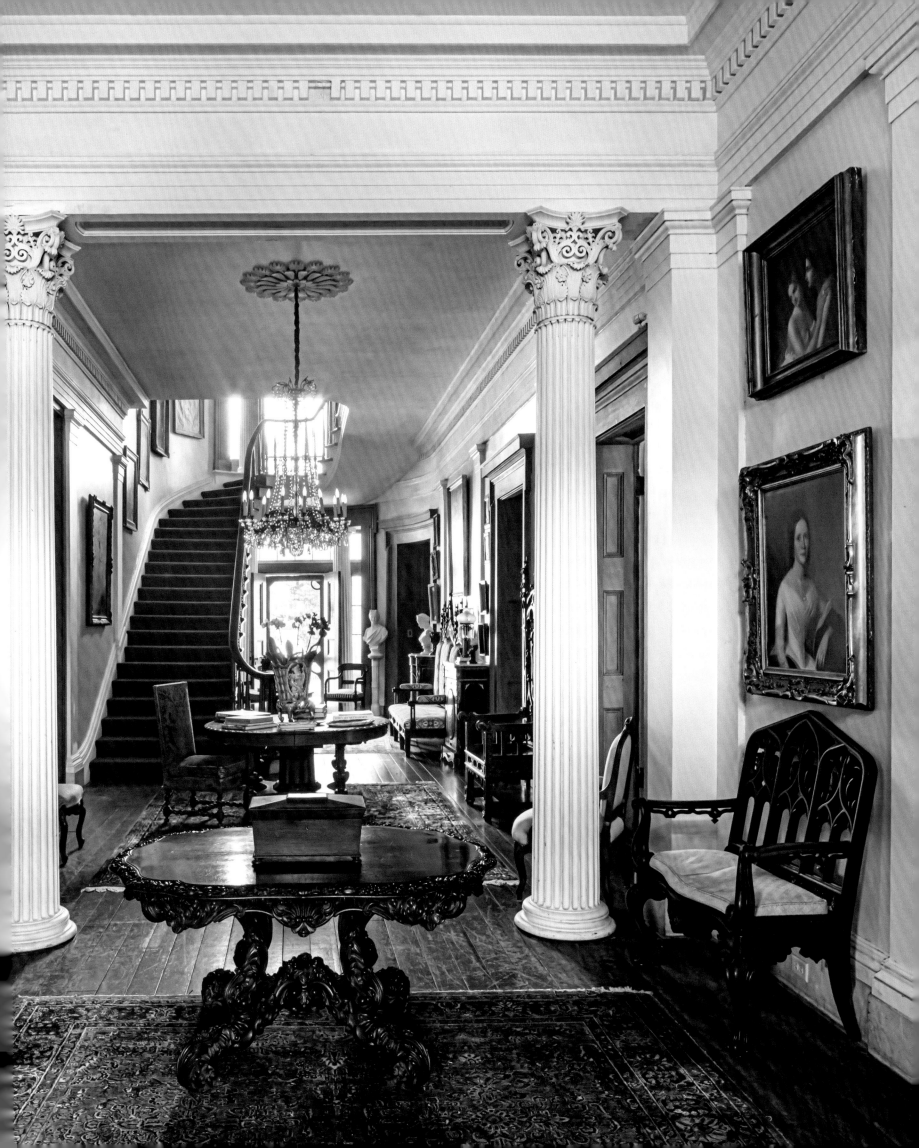

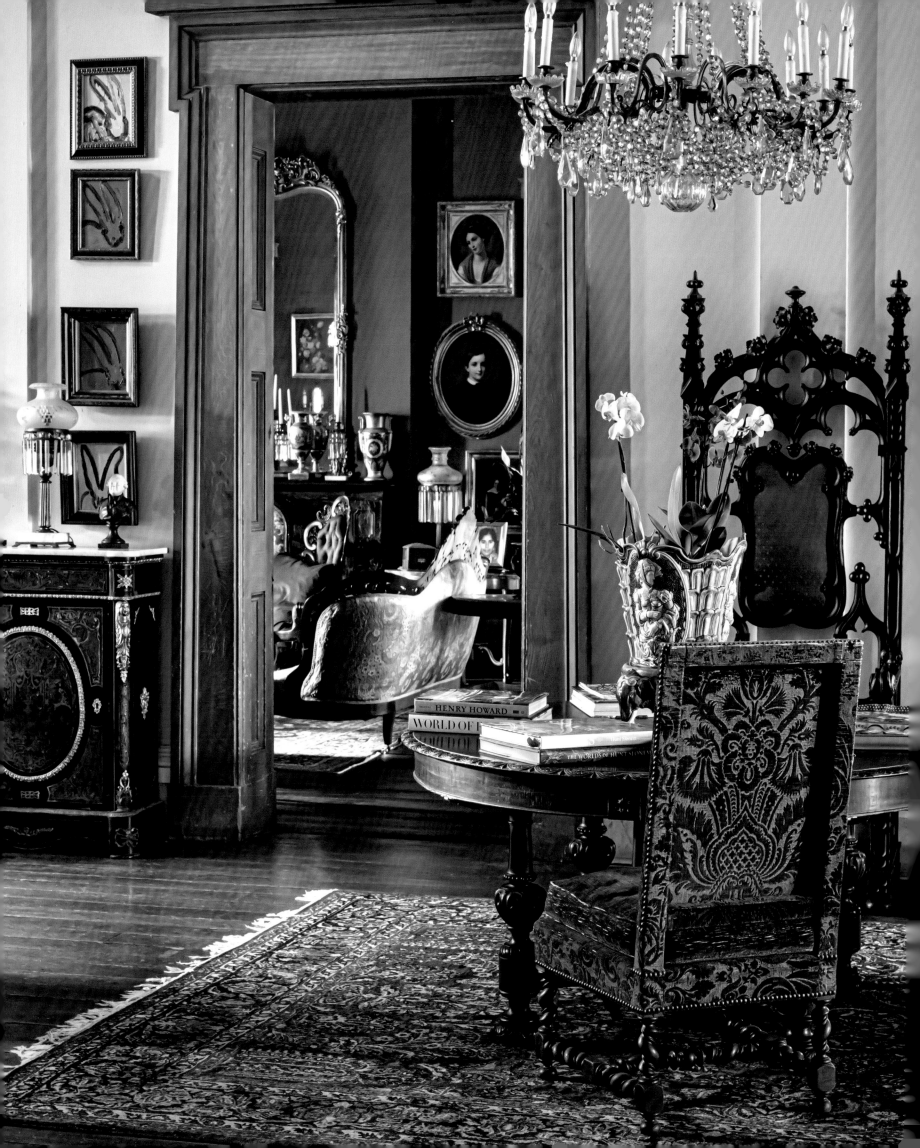

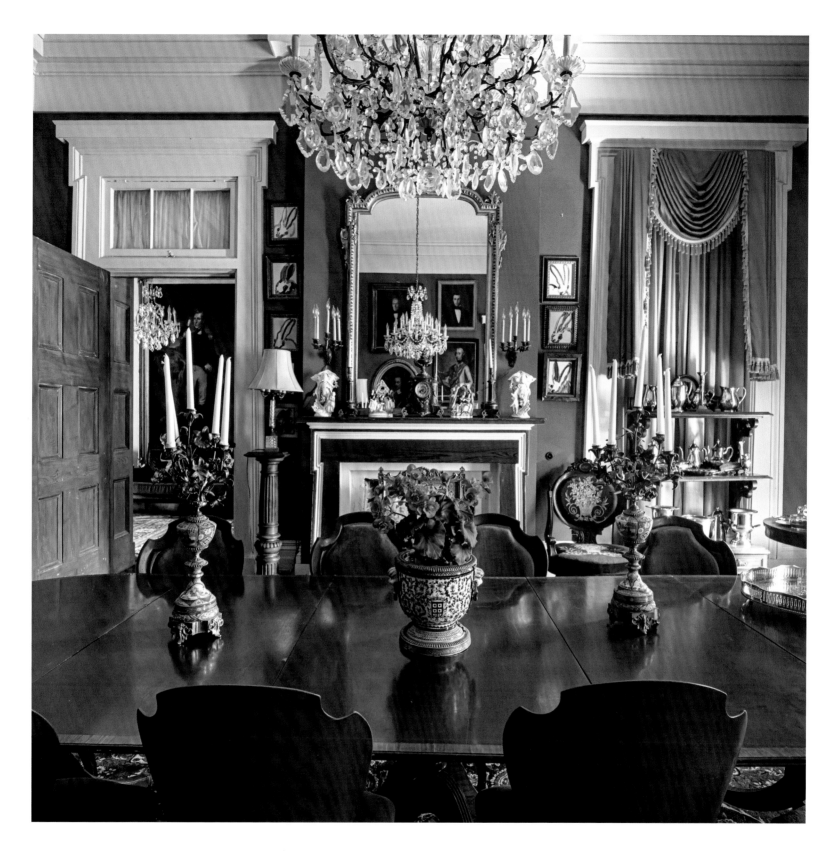

◀ A center table piled with books welcomes guests into the entry hall, the double parlors glimpsed beyond. An ornately carved, mahoganized oak Stanton Hall side chair, circa 1850, is an icon of American Gothic Revival. (Of special note: Beyoncé filmed her 2016 visual companion to her album *Lemonade* at Madewood, seated in this chair.)

▲ Paintings of rabbits are a counterpoint to Louisiana portraits and the more formal furnishings in the dining room. The mantel is original.

Overleaf left: A marble-topped side table in the dining room rests beneath elaborately swagged and draped curtains by Les Wisinger. (Draperies throughout were designed by Wisinger.)

Overleaf right: Morning sunlight highlights the gilded furniture and picture frames in Hunt's sitting room, furnished with antiques, mementos that include a circa 1960 family photograph, and his *Red Picul* series painting.

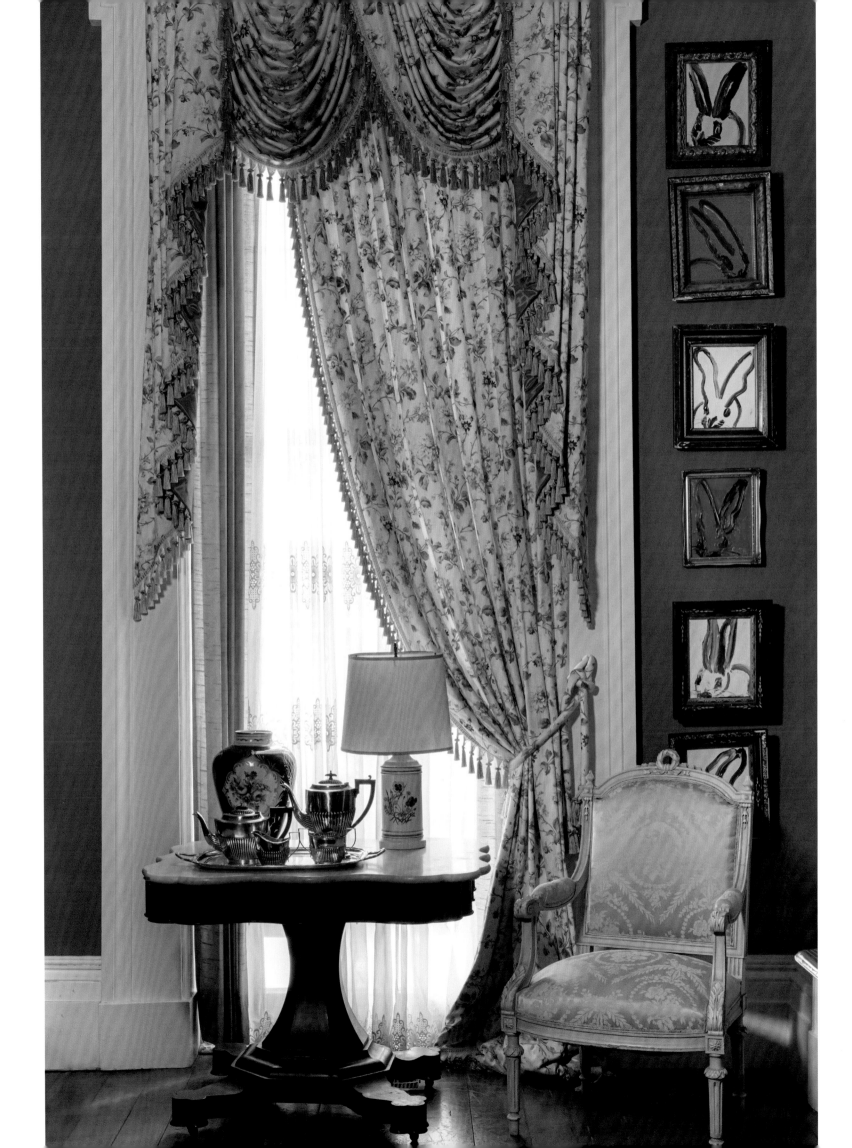

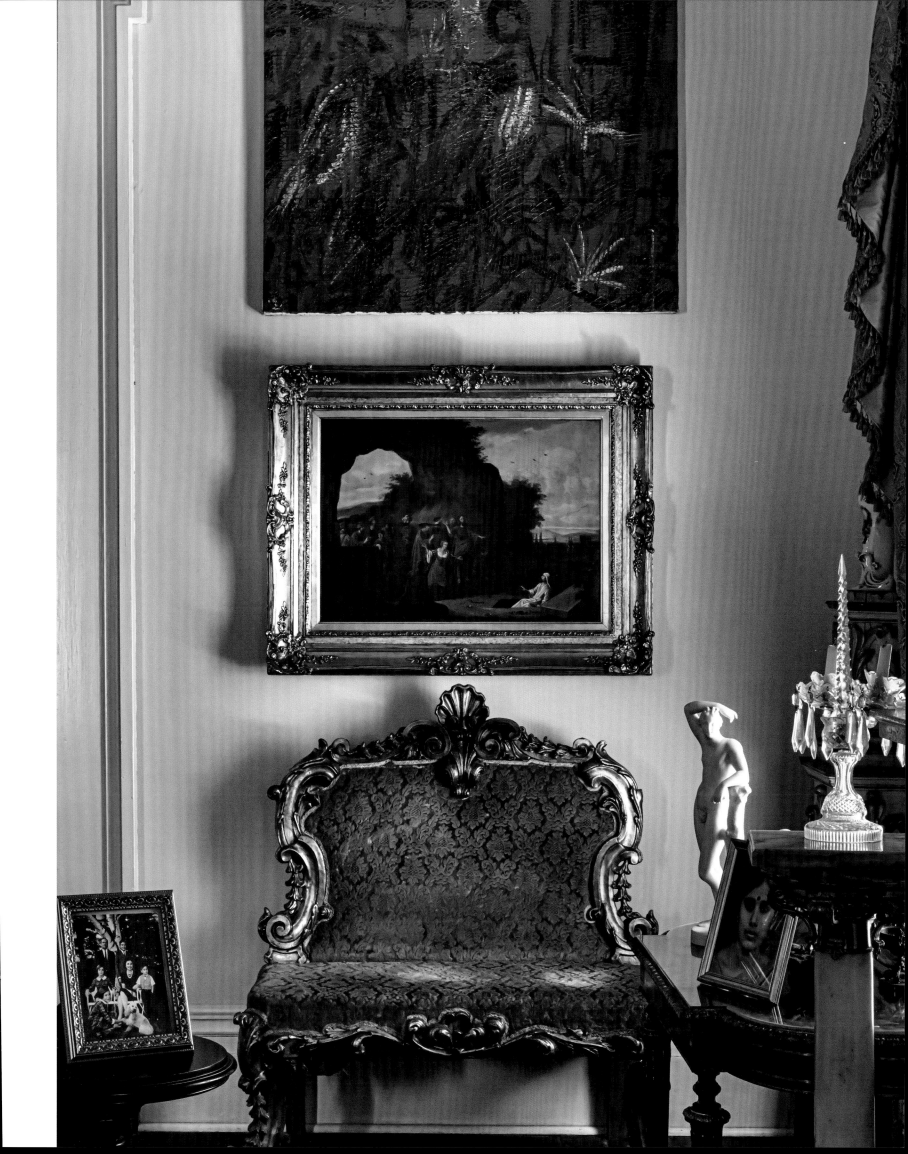

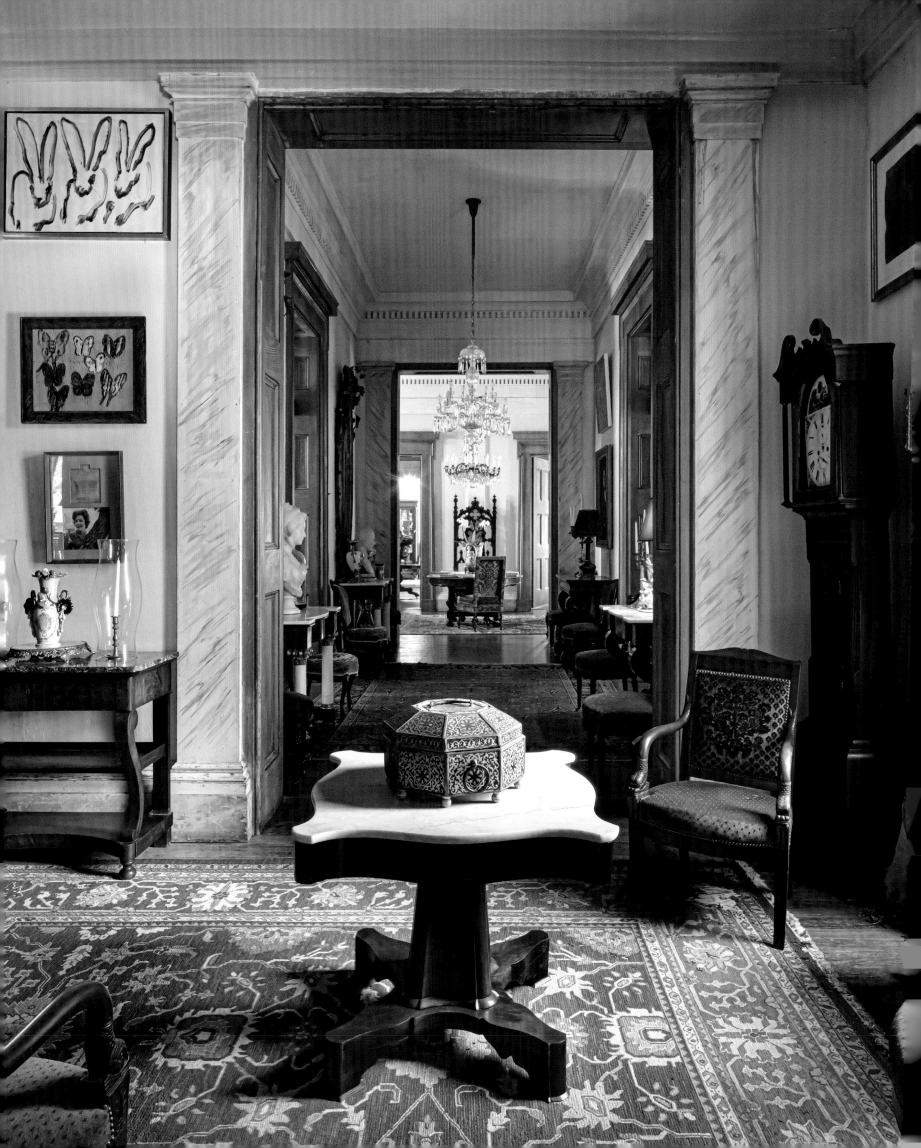

◀ Faux marble pilasters frame the corridor leading from the music room to the main entry hall.

▲ Hunt's portrait of Colonel Thomas Pugh hangs in the front hall; a Gothic Revival side chair rests alongside.

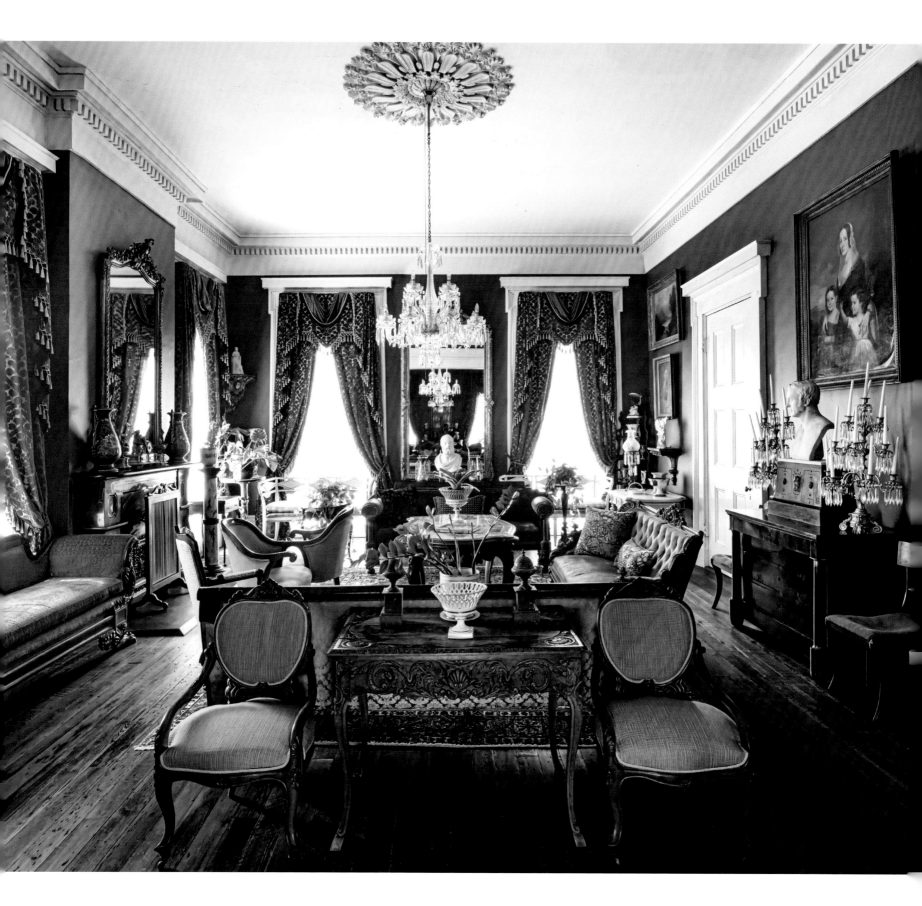

▲ The front parlor is furnished with classic pieces, including an Empire settee upholstered with "Guardians," a velvet designed by Hunt for Lee Jofa.

▶ The repeating eyes and mouths of monkeys—symbols of protection—make a rich cut-velvet pattern.

Overleaf: Two rare Belter Rococo Revival settees in the shell and bird patterns face each other in the second parlor, looking into the front parlor. Note the beautifully faux-grained door entablature.

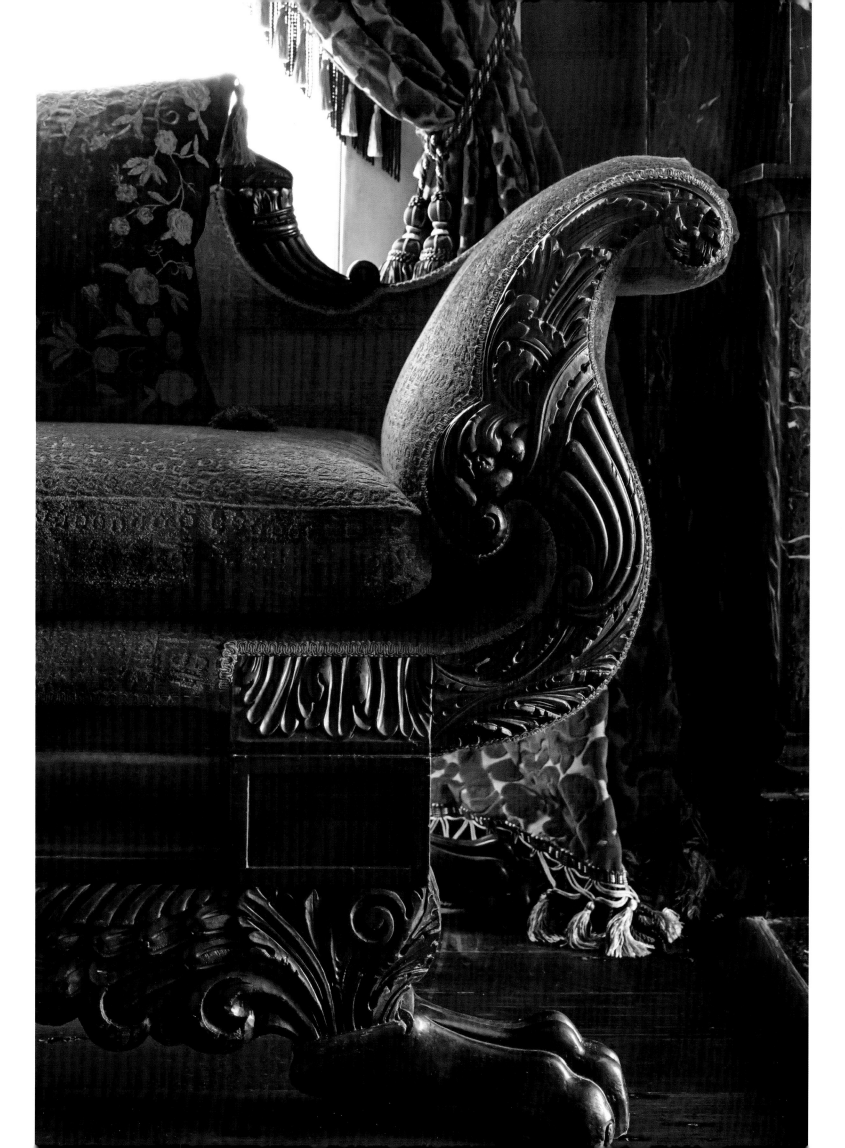

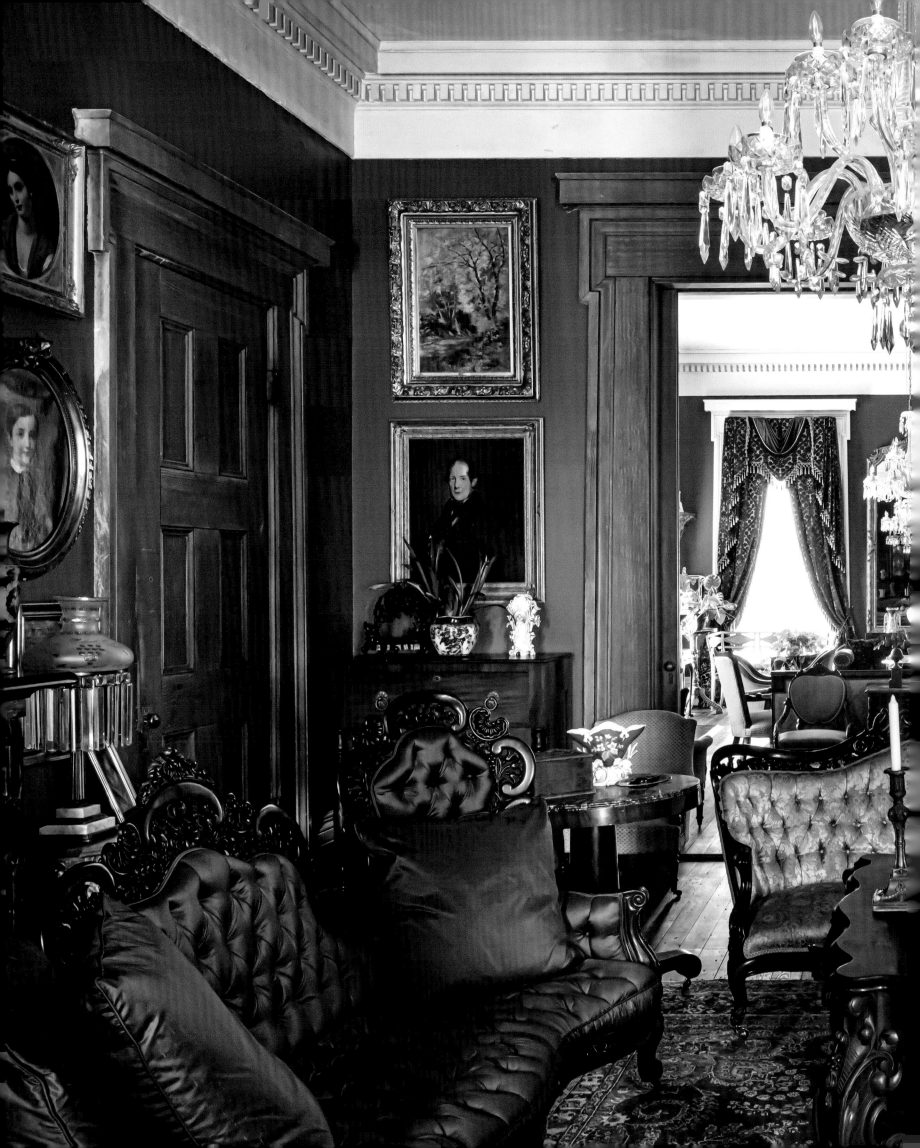

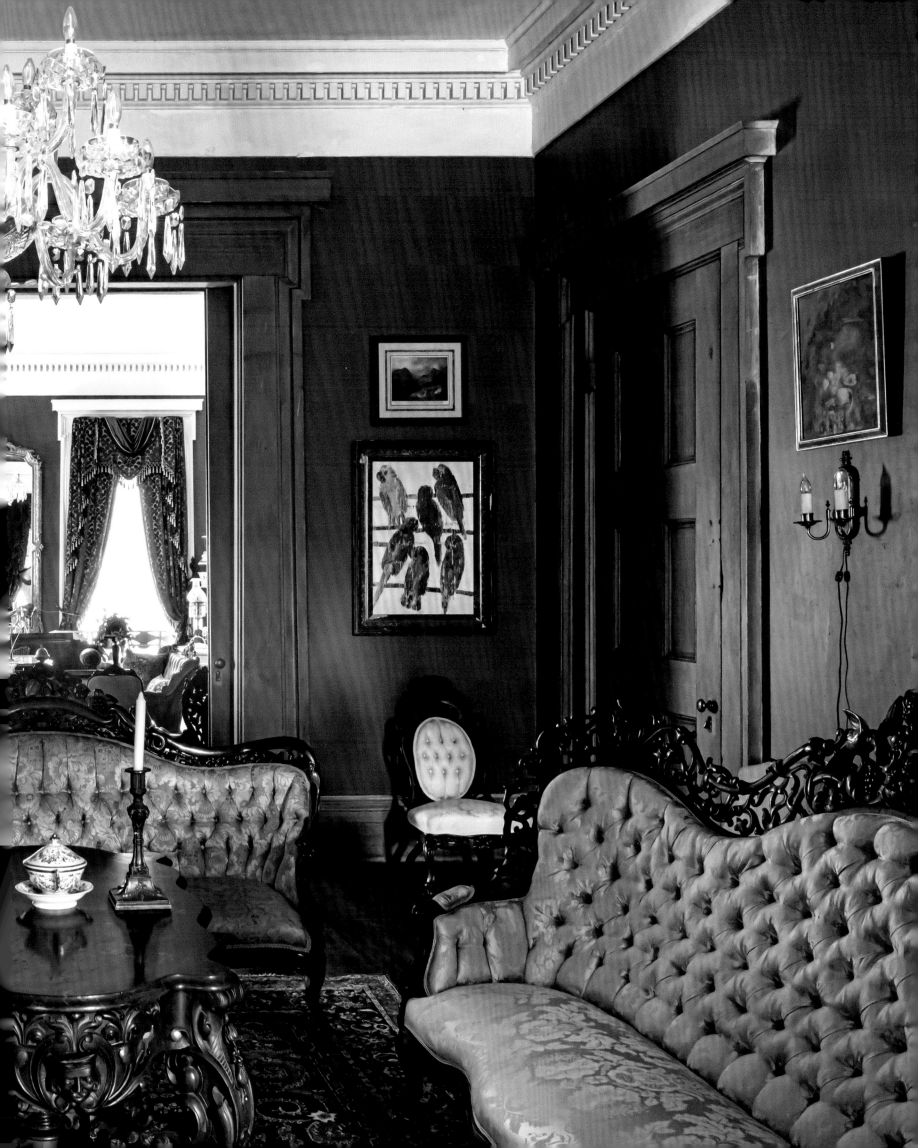

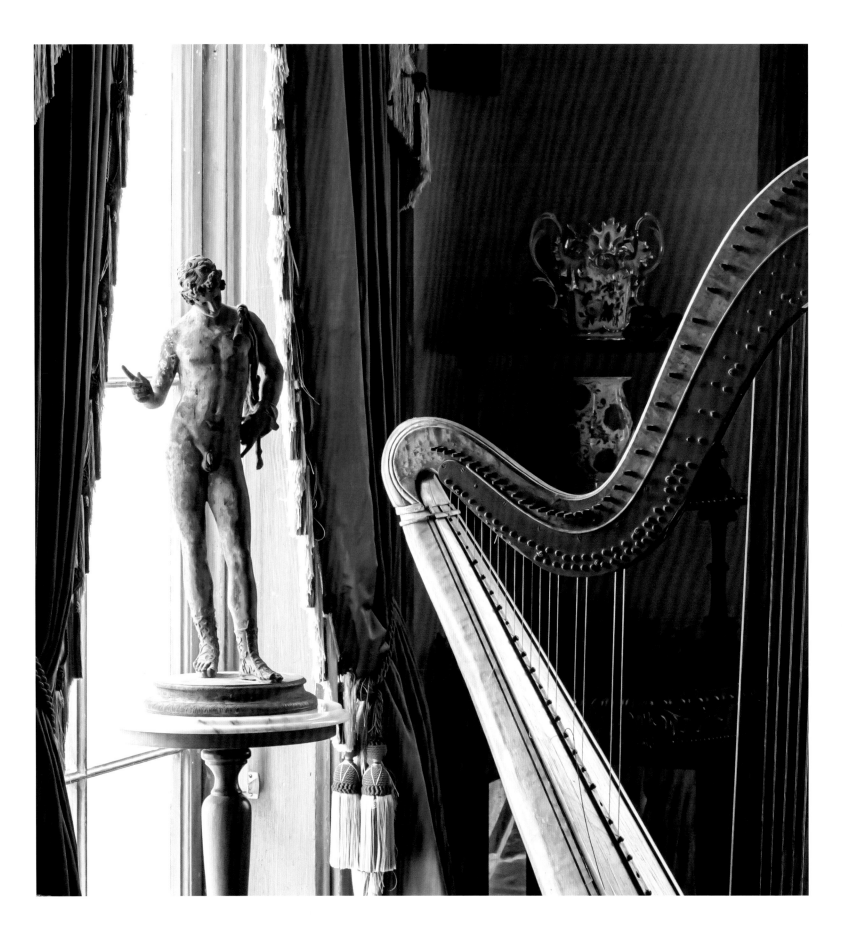

Sunny yellow walls and richly draped windows embellish the music room, which is furnished with a Meeks rosewood parlor suite and Louisiana portraits. A classical sculpture and an antique harp rest by a window in the music room.

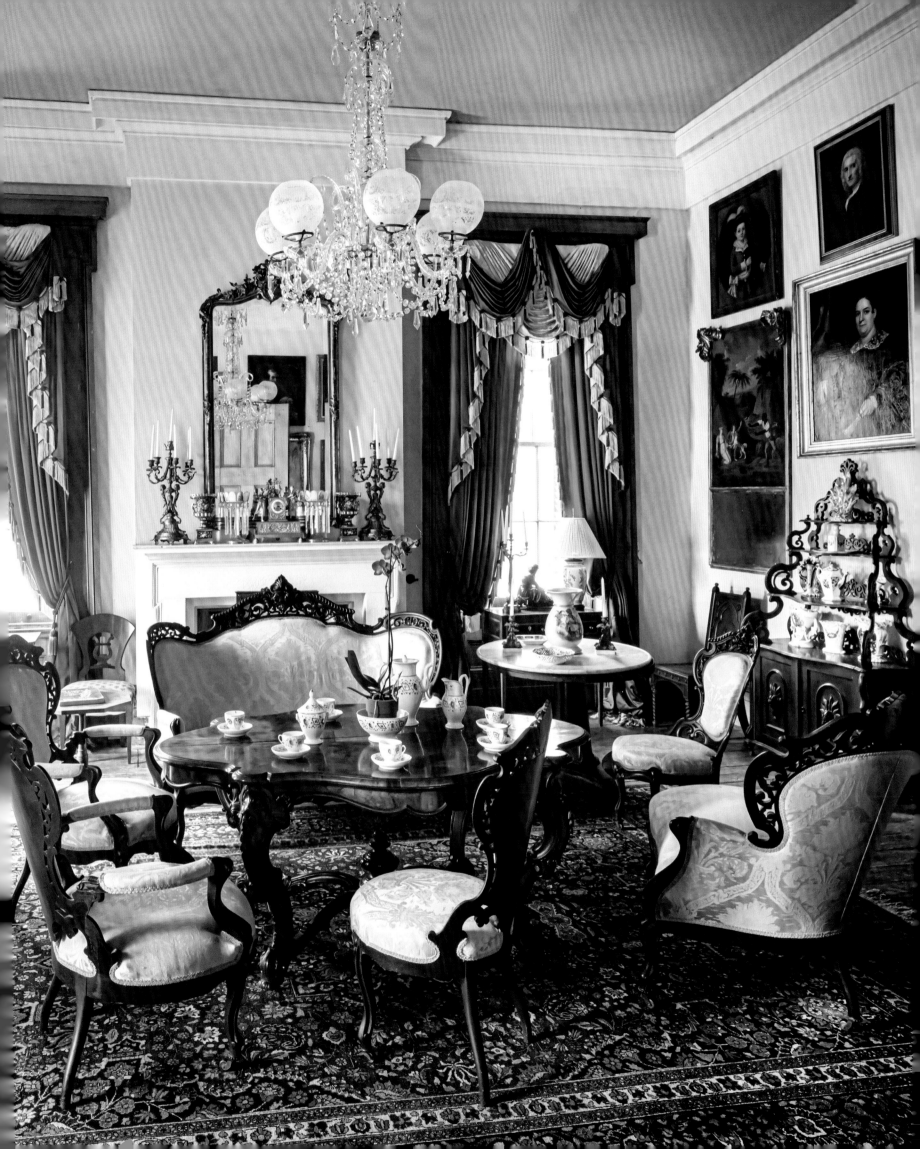

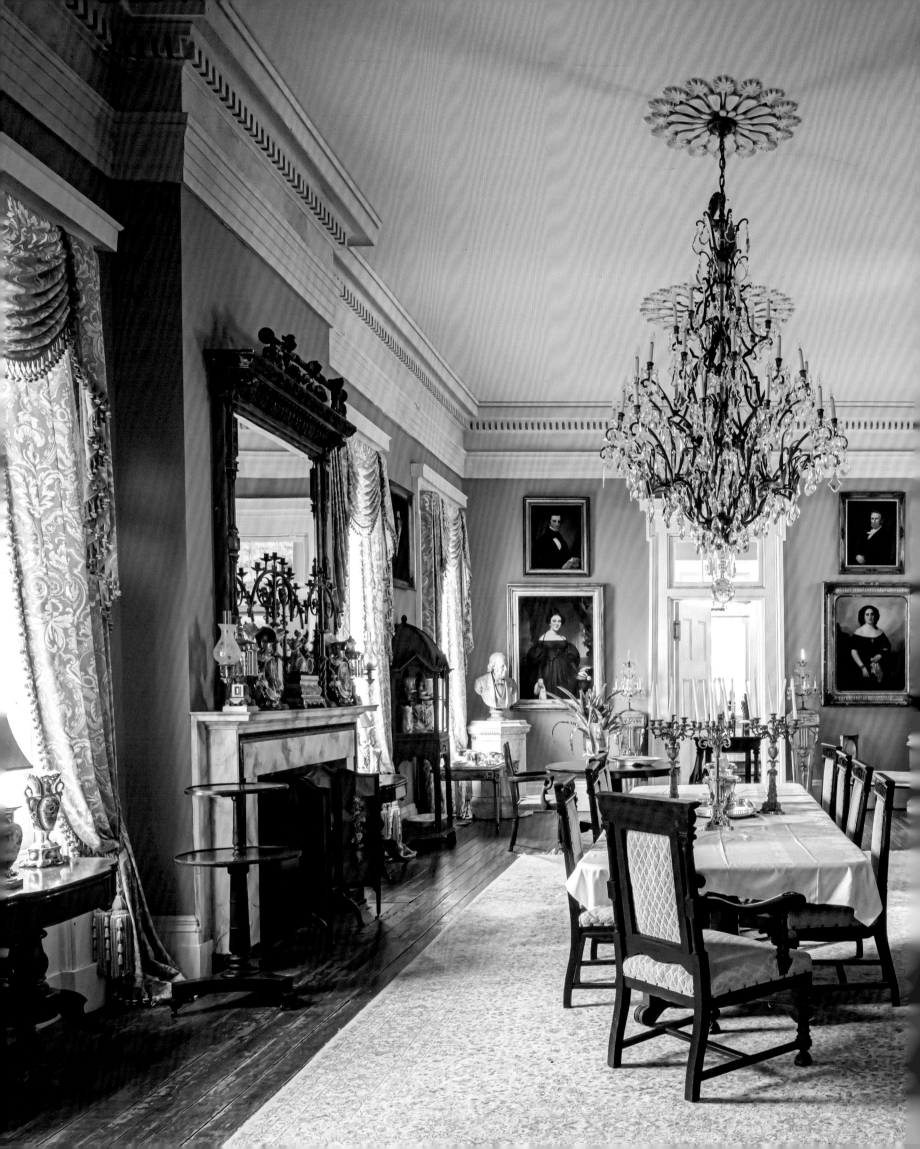

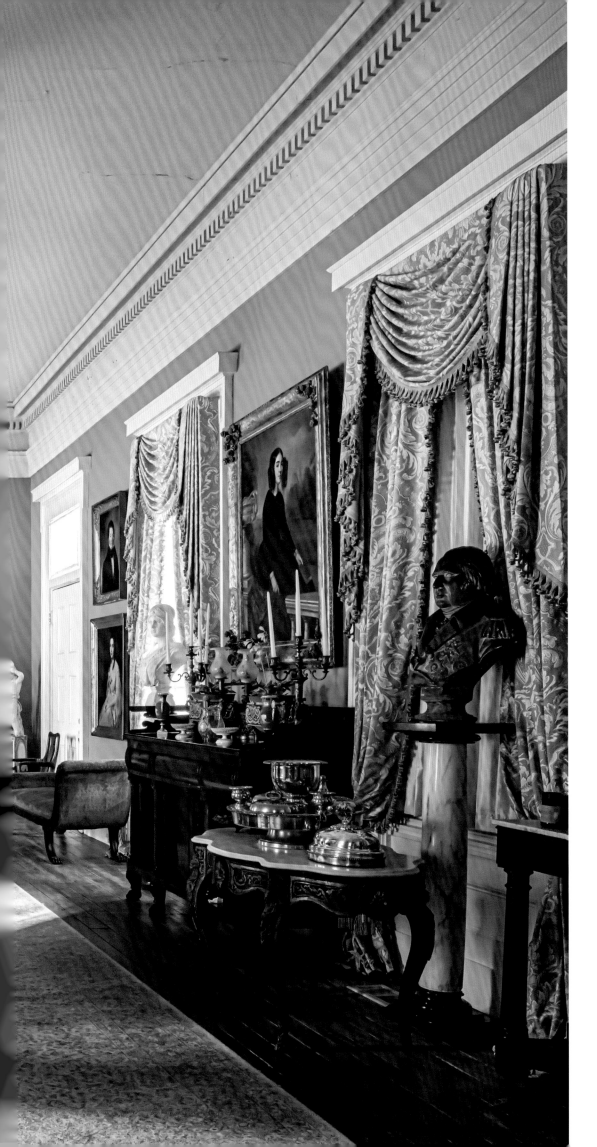

The grand ballroom (unusual for homes at this time) was one of the features that attracted Hunt to the home. He freshened it with deep blue walls, elaborate gold silk curtains, and nineteenth-century portraits. An immense, nineteenth-century crystal chandelier was found to center the room and required additional support beams to accommodate its weight.

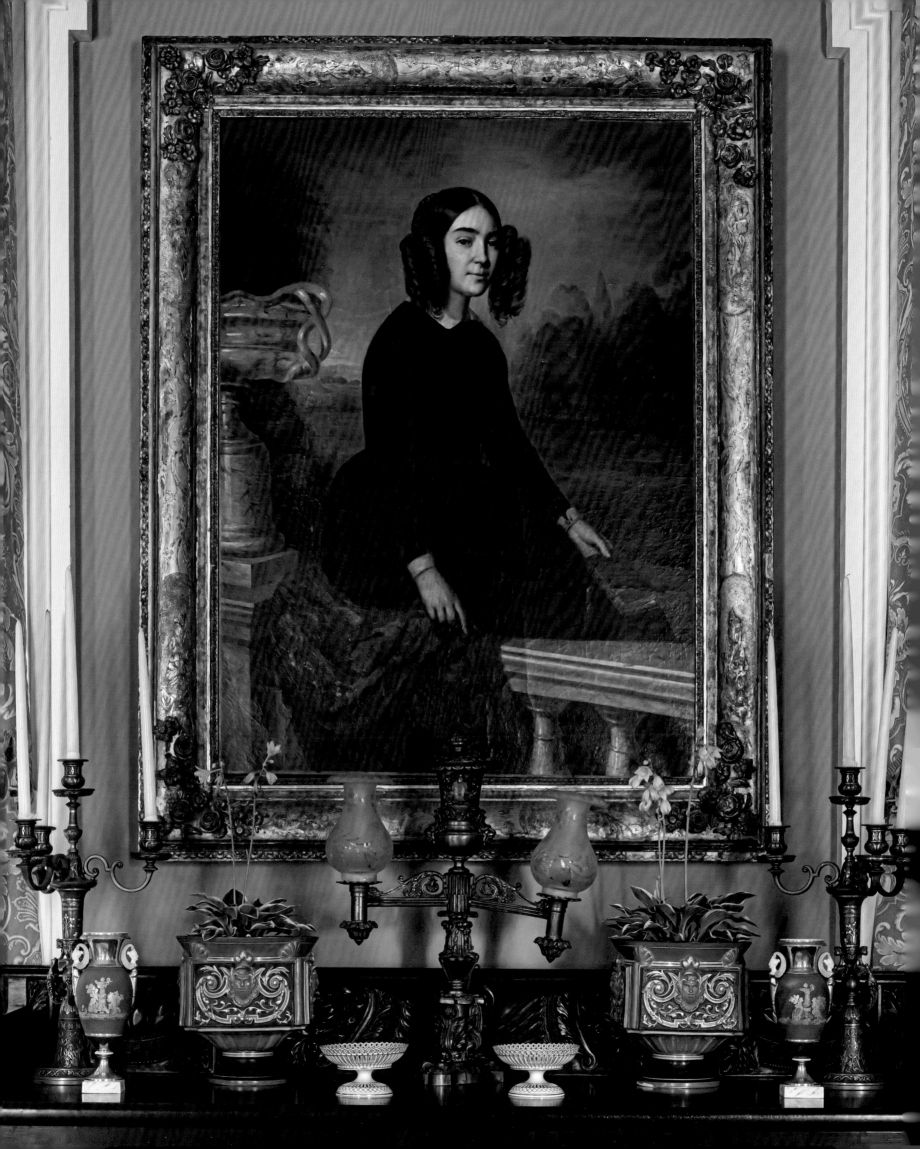

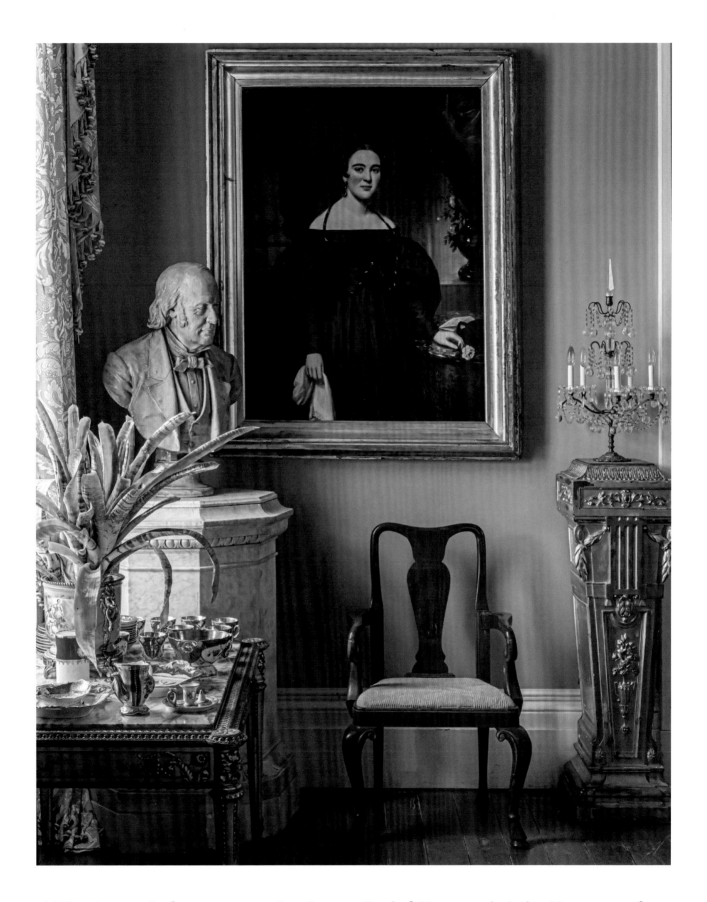

◄ A Victorian portrait of a young woman, circa 1840, overlooks a collection of cerulean blue Old Paris porcelains.

▲ A nineteenth-century oil portrait, pedestals holding busts and candelabras, and a porcelain tea service set on a marble and gilded table fill a corner of the ballroom.

Overleaf: Mauve, popular in the 1860s, was one of Queen Victoria's favorite colors and was chosen for this guest bedroom, furnished with a period half tester bed, nineteenth-century paintings, and Hunt's artwork, including a portrait of Countess Xacha Obrenovitch, a famous seer of the 1920s.

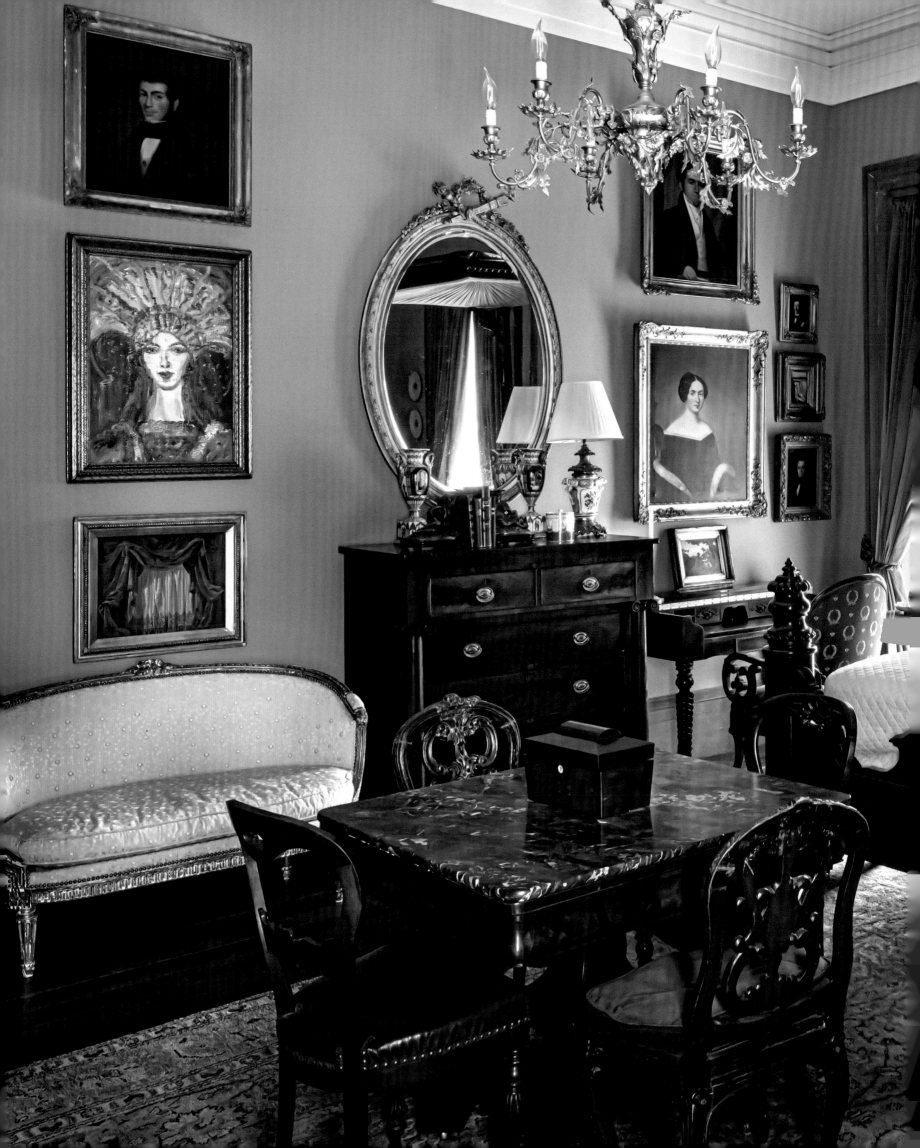

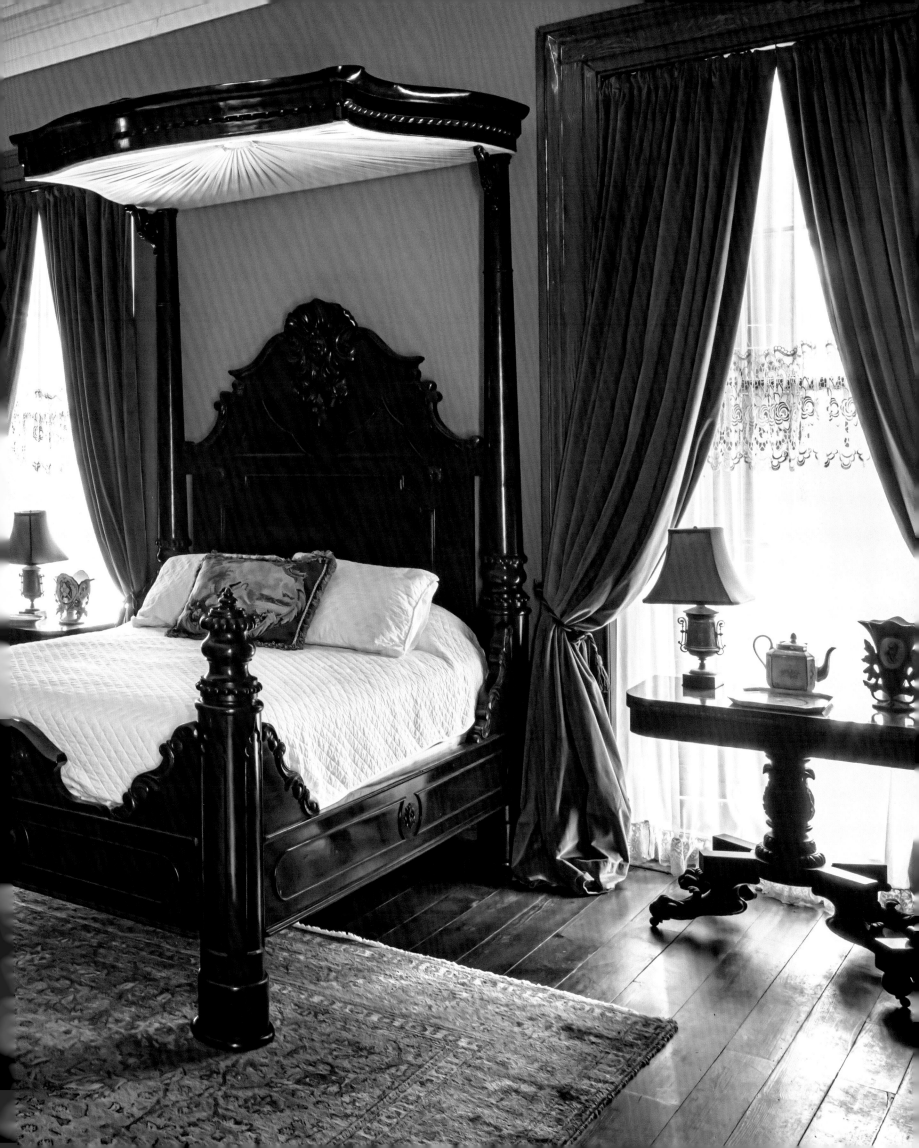

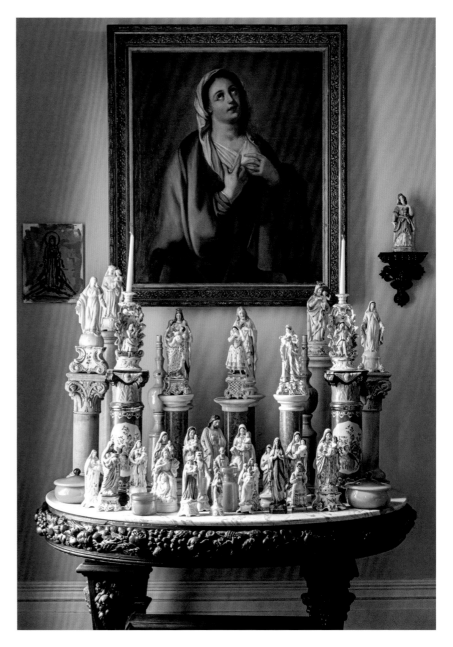

◄ A gilded Regency sofa and a *Hutch* rabbit painting occupy a corner of Hunt's bedroom.

▲ Virgin Mary statuettes collected on trips are displayed on a side table, the tableau set for a moment of reflection.

▶ A Prudent Mallard Rococo Revival four-poster bed centers the room, which is also furnished with Andy Warhol's *Marilyn*, Hunt's *Toucan* sculpture, and religious paintings.

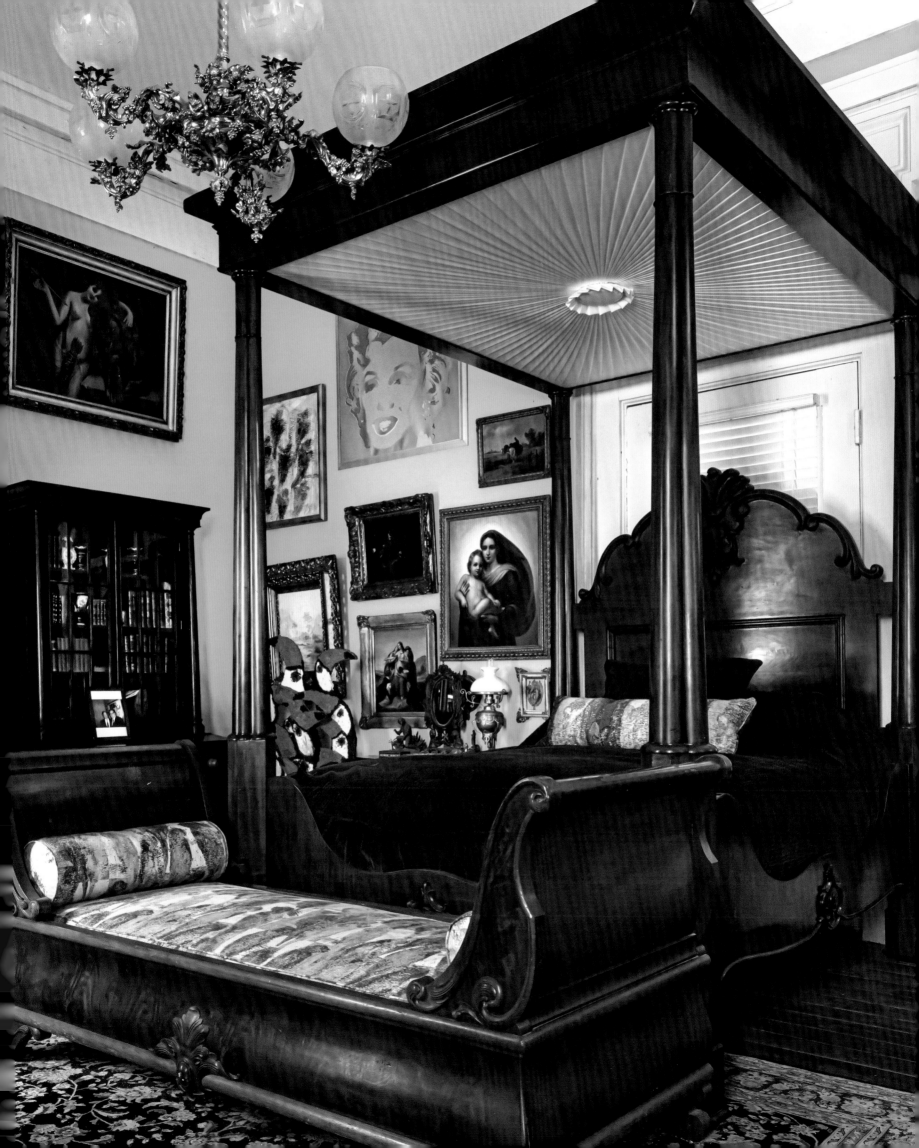

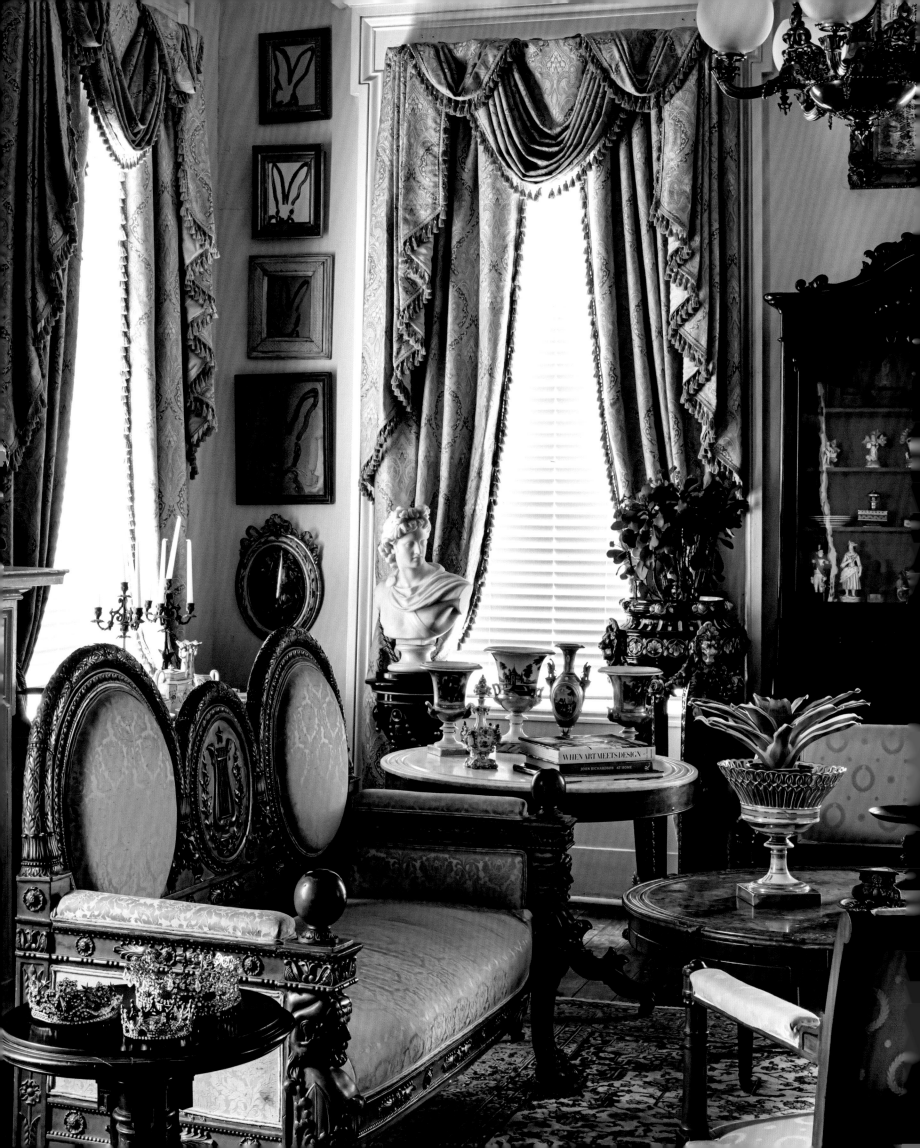

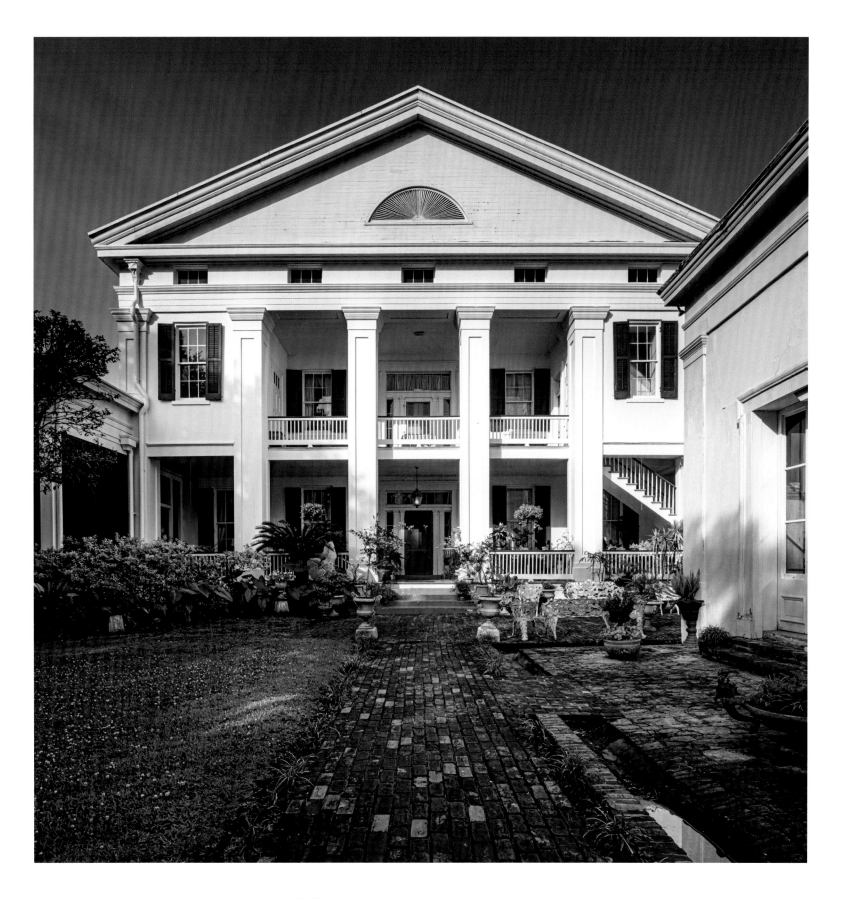

◀ A carved Renaissance Revival sofa from the Cornstalk Mansion in New Orleans (designed by Henry Howard, the architect of Madewood) holds court in the sitting room adjacent to Hunt's bedroom. A line of bunny portraits contrast classical busts and porcelains.

▲ Two-story brick piers frame the rear porch and galley, which look out onto the rear gardens. Wings projecting from either side of the main house contain parlors, a dining room, a library, and a large ballroom. The kitchen, on the right, is connected to the main house, an unusual feature for homes of this period.

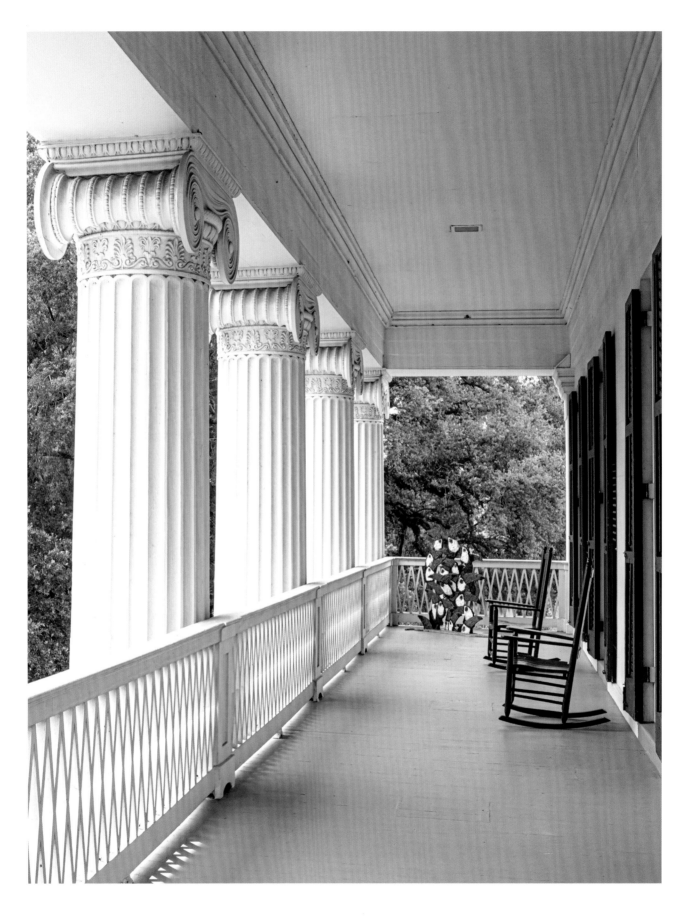

▲ A wide veranda runs the length of the front of the house. Hunt's postmodern *Toucan* (resin and acrylic on wood) sculpture is an engaging accent.

▶ Brick parterres and fountains ground the rear gardens, which feature Hunt's ever-growing collection of mid-nineteenth-century cast-iron planters.

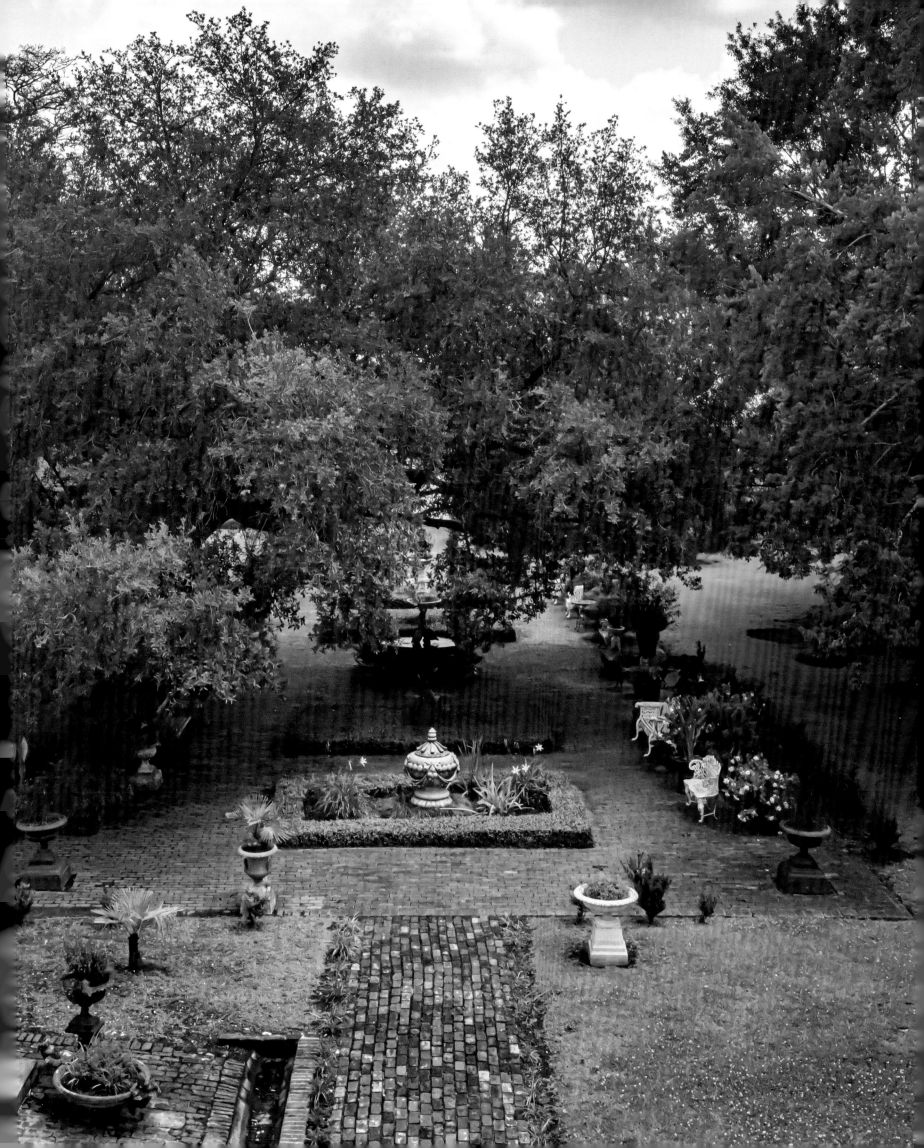

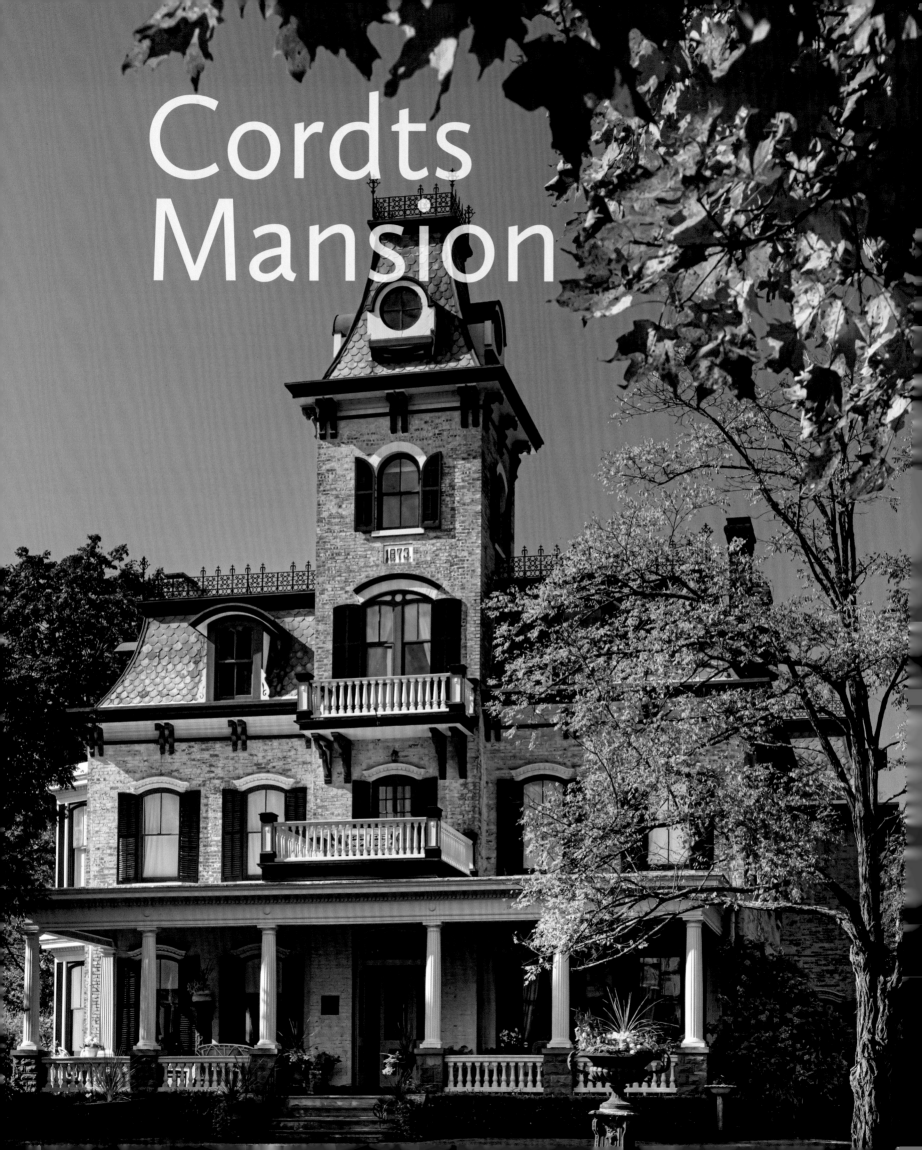

Cordts
Mansion

1873

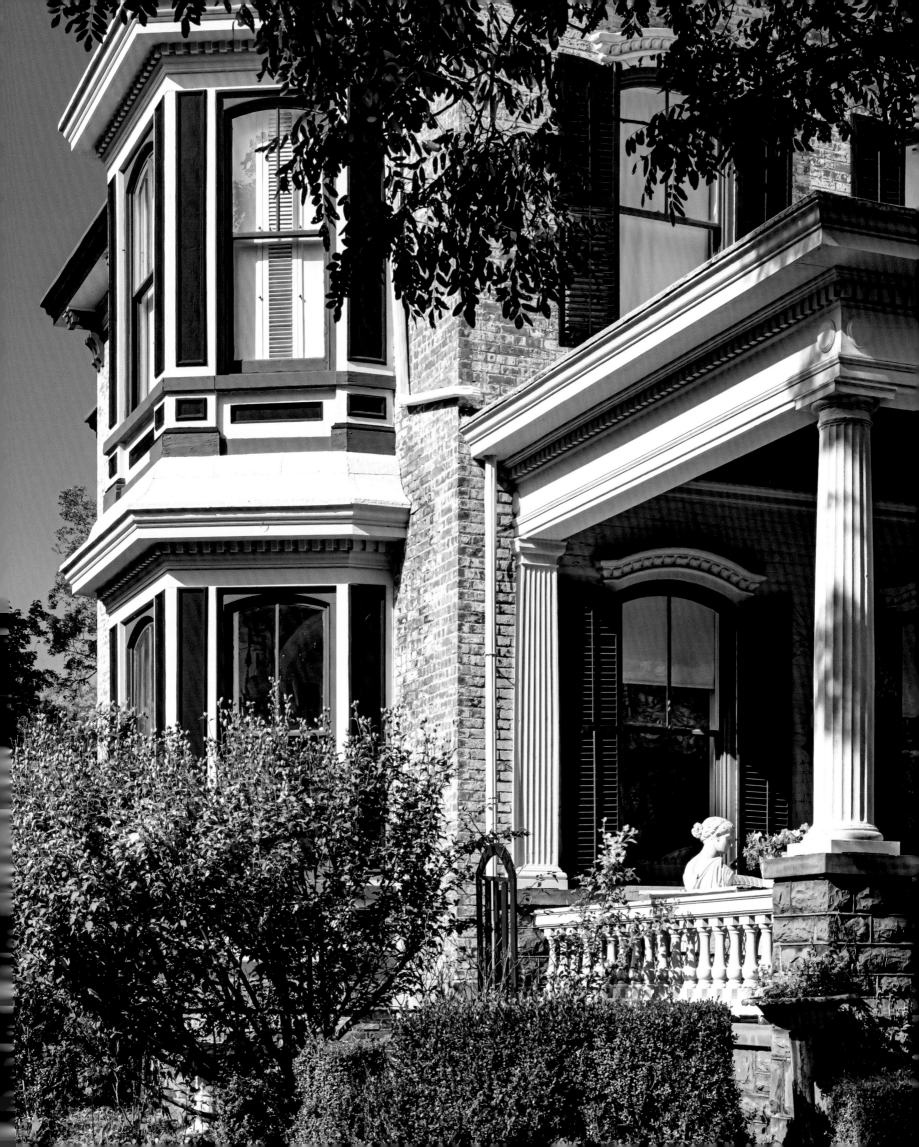

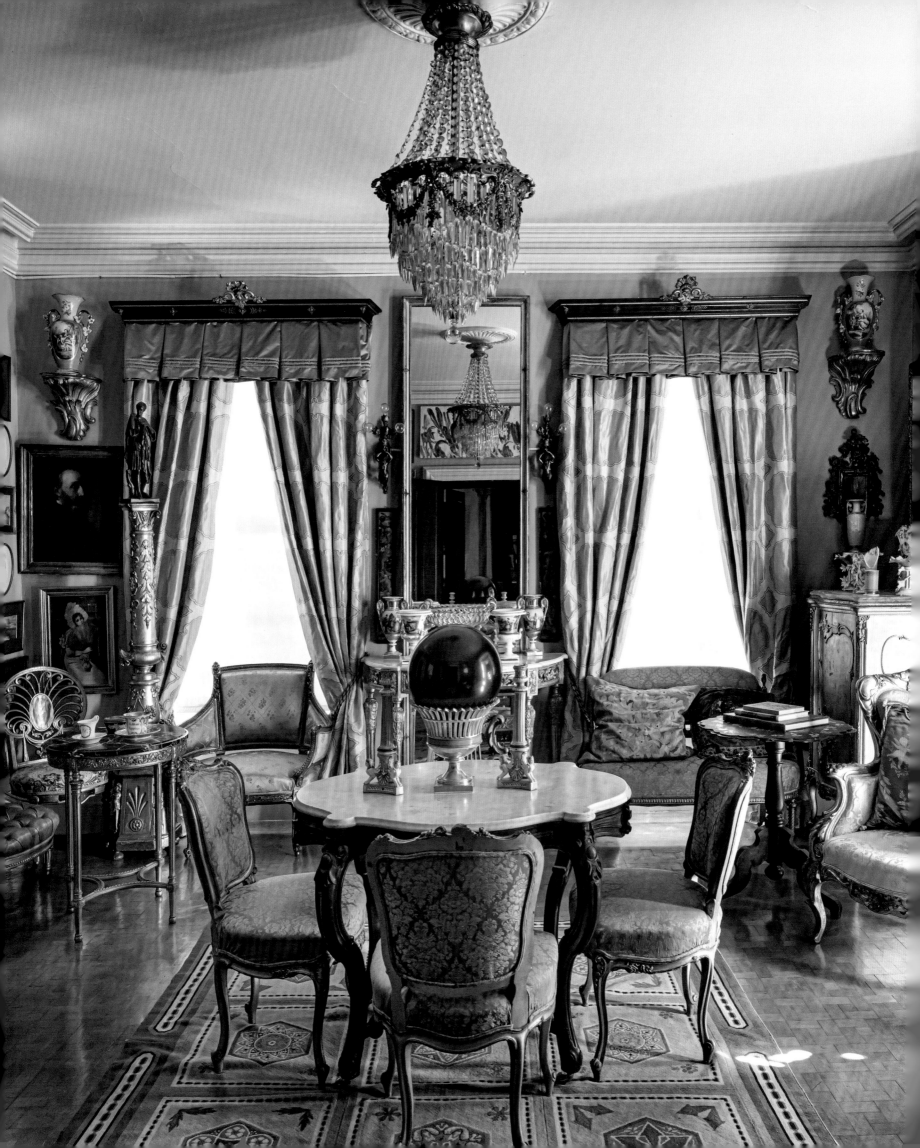

Cordts Mansion Kingston, New York

Hunt had not been planning on buying a country home in 2001, but when friends told him about the Cordts Mansion in Kingston, New York, he was interested. A Second Empire (or Napoleon III) Victorian, the mansion was one of the grandest homes in the area. Built in 1873 by successful merchant John H. Cordts and originally set on ninety acres, it was solidly constructed of brick (Cordts owned local Hutton Brickyards). Centered on an imposing tower, it had more than twenty-two rooms, a slate mansard roof punctuated with dormer windows, iron roof cresting, and heavily bracketed balustrades and cornices. It had remained in the Cordts family for more than a century, and not much had changed.

The original interior detailing was still intact—intricate molding and plasterwork, wainscoting, slate mantels, wooden floors, and a pair of rare, elaborate, cast-iron mantel covers in the double parlors. There was even a carriage house with its original horse stalls untouched.

With nine bedrooms, servants' quarters, and an uncompleted third floor, there was room for expansion. The owners were contacted, and Hunt was able to purchase the Cordts Mansion in 2001, his first home and one that he would keep for the next twenty-two years.

Previous Overleaf: The Second Empire home has a commanding presence, with a central tower soaring four stories and affording views of the countryside.

◀ The blue sitting room on the second floor is centered on an original pier mirror and furnished with gilded furniture and Old Paris porcelains. The parquet floors are original.

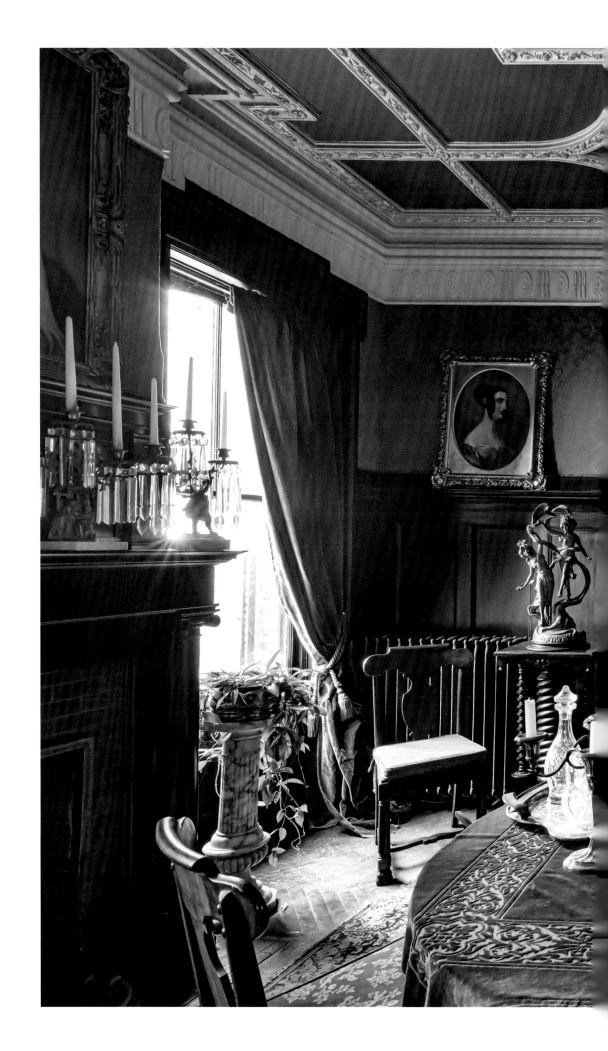

The dining room features fir wainscoting and elaborate ceiling plasterwork. A large, nineteenth-century marble bust by Italian sculptor A. Cipriani sits on a marble pedestal. Furniture by A. H. Davenport includes a round dining table set with Limoges tiered dessert stands and tazzas.

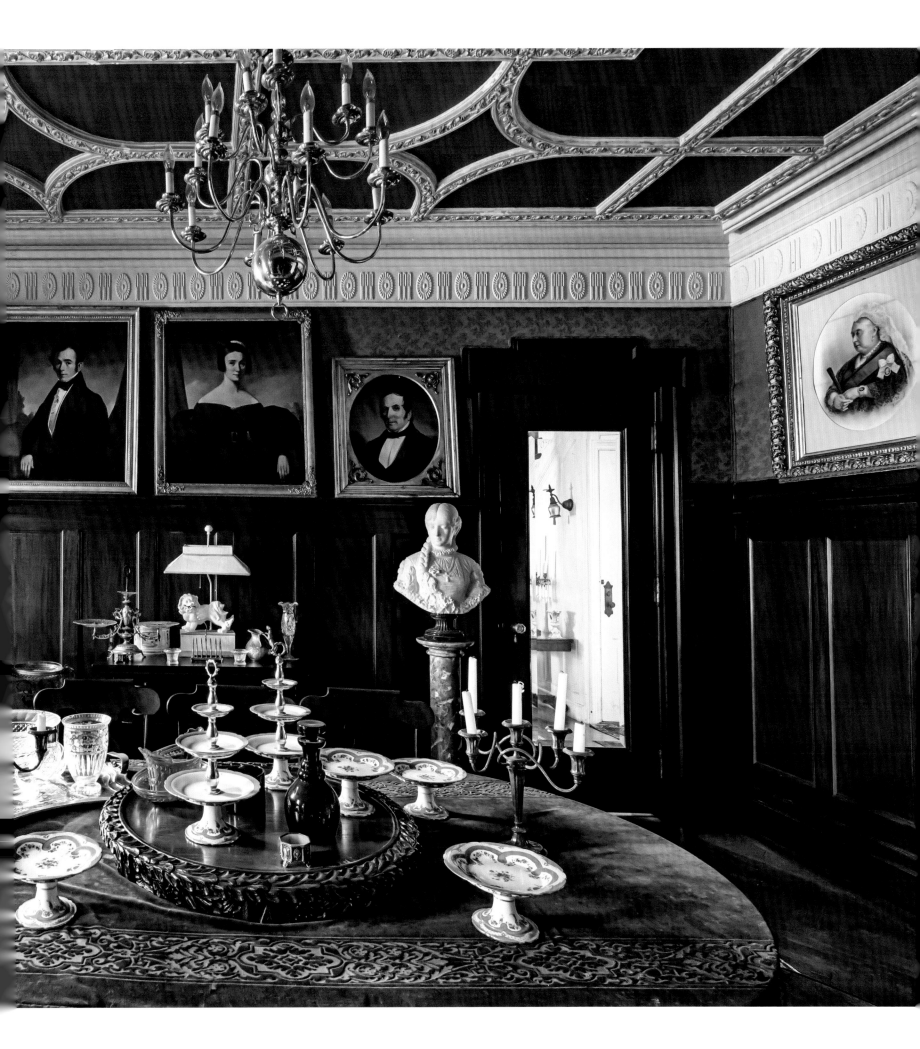

▲ Finely carved balustrades outline the stairwell to the second floor.

▶ The hallway is crowded with Grand Tour bronzes. The vintage wallpaper frieze was found at a flea market.

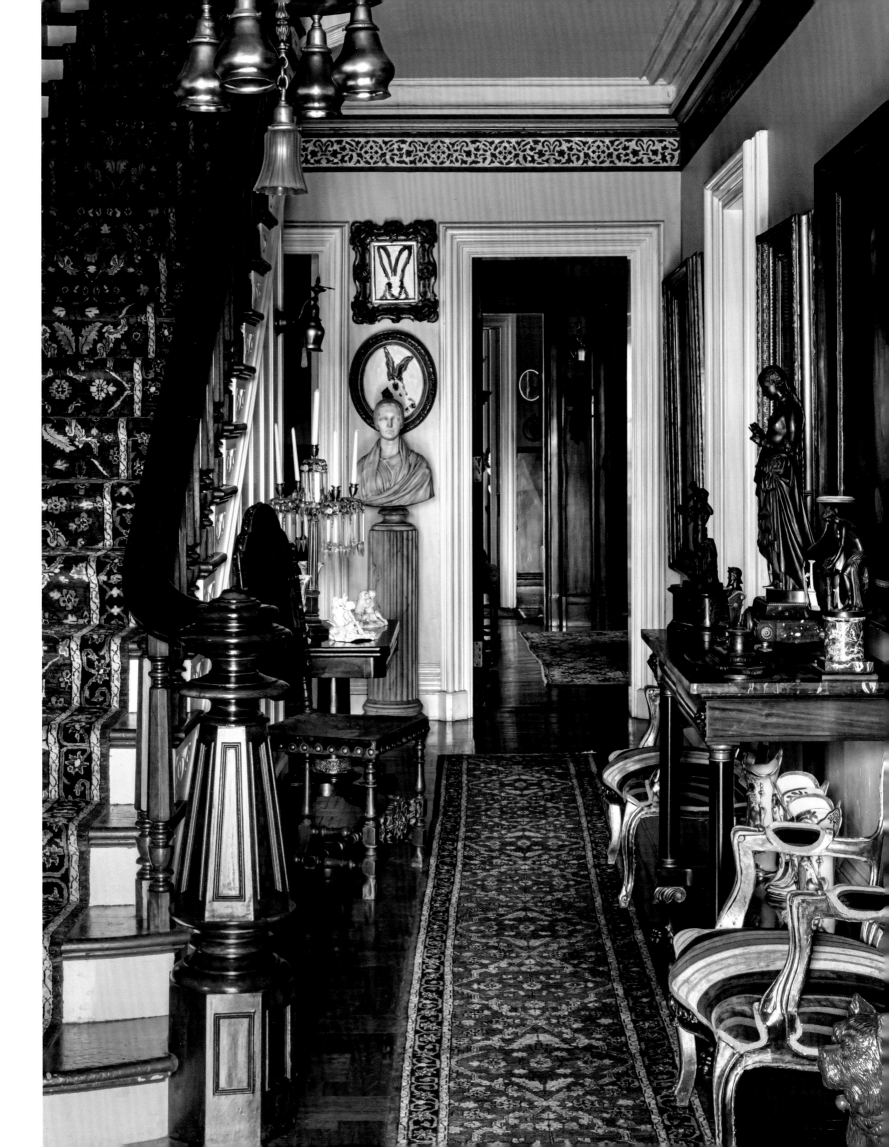

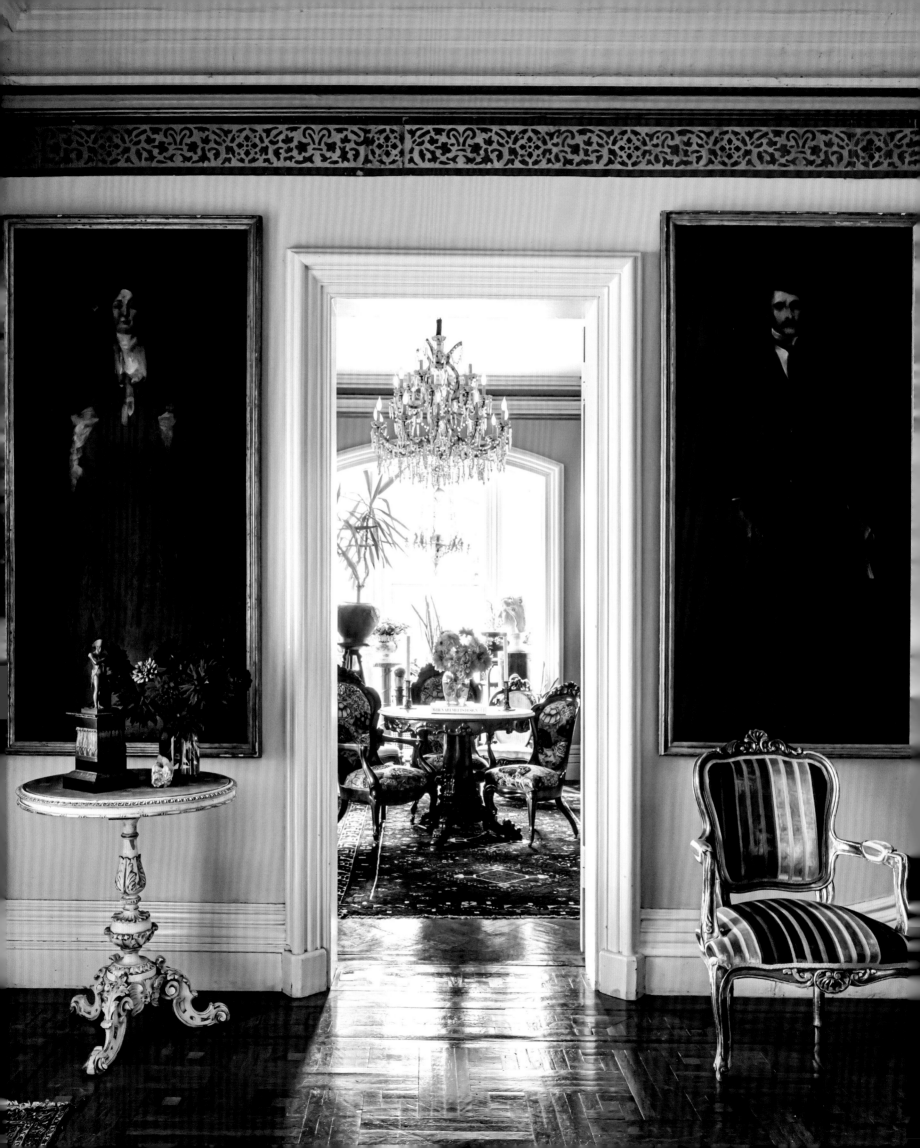

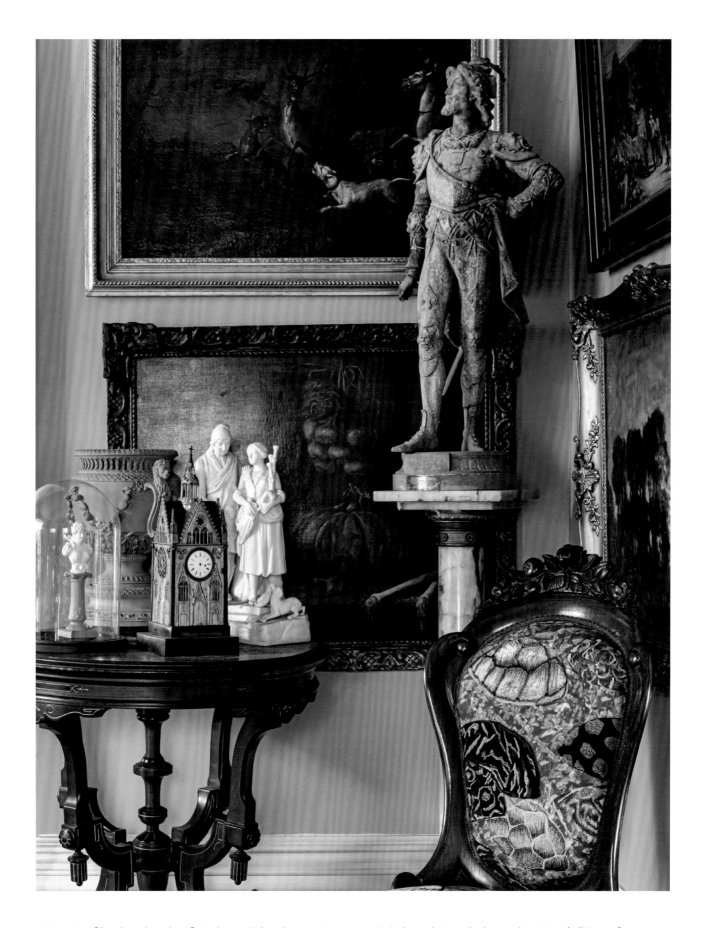

◄ A pair of husband and wife Ashcan School portraits in the front hall frame the entrance to the parlor.

▲ A Belter chair upholstered in Hunt's "Star of India," for Lee Jofa, rests in a parlor corner hung with nineteenth-century landscapes.

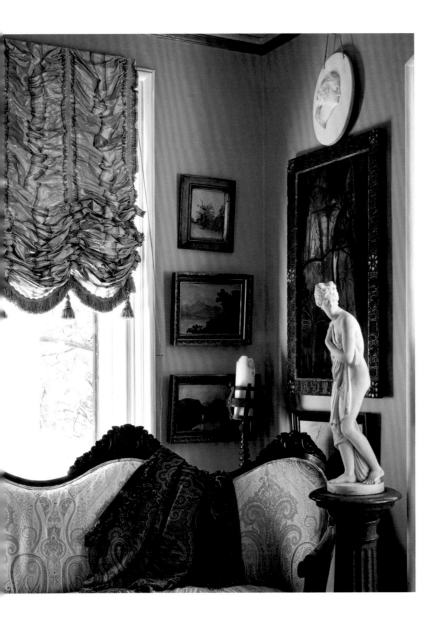

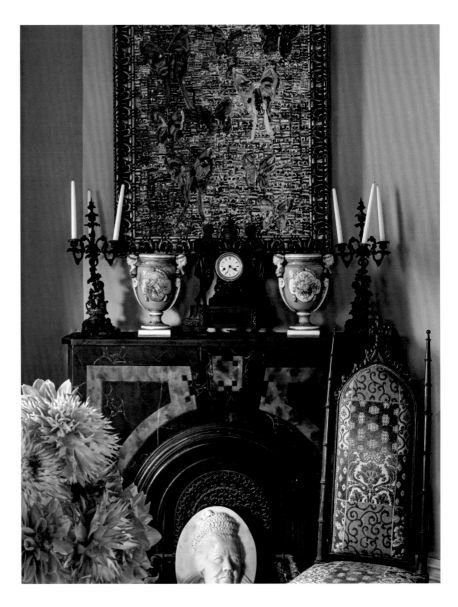

◀▲▶ Paintings in the parlor include nineteenth-century landscapes and Hunt's *Butterflies and Guardians*, one of his favorites.

Overleaf: The second parlor is centered on a full-length portrait of *Empress Eugenie*, wife of Napoleon III, by Claude-Marie Dubufe. A bust of Benjamin Franklin rests below. The windows are accented with ebonized and gilded valences attributed to Jelliff. Original, rare cast-iron mantel covers are found in both parlors. A Rococo Belter méridienne sits in the corner.

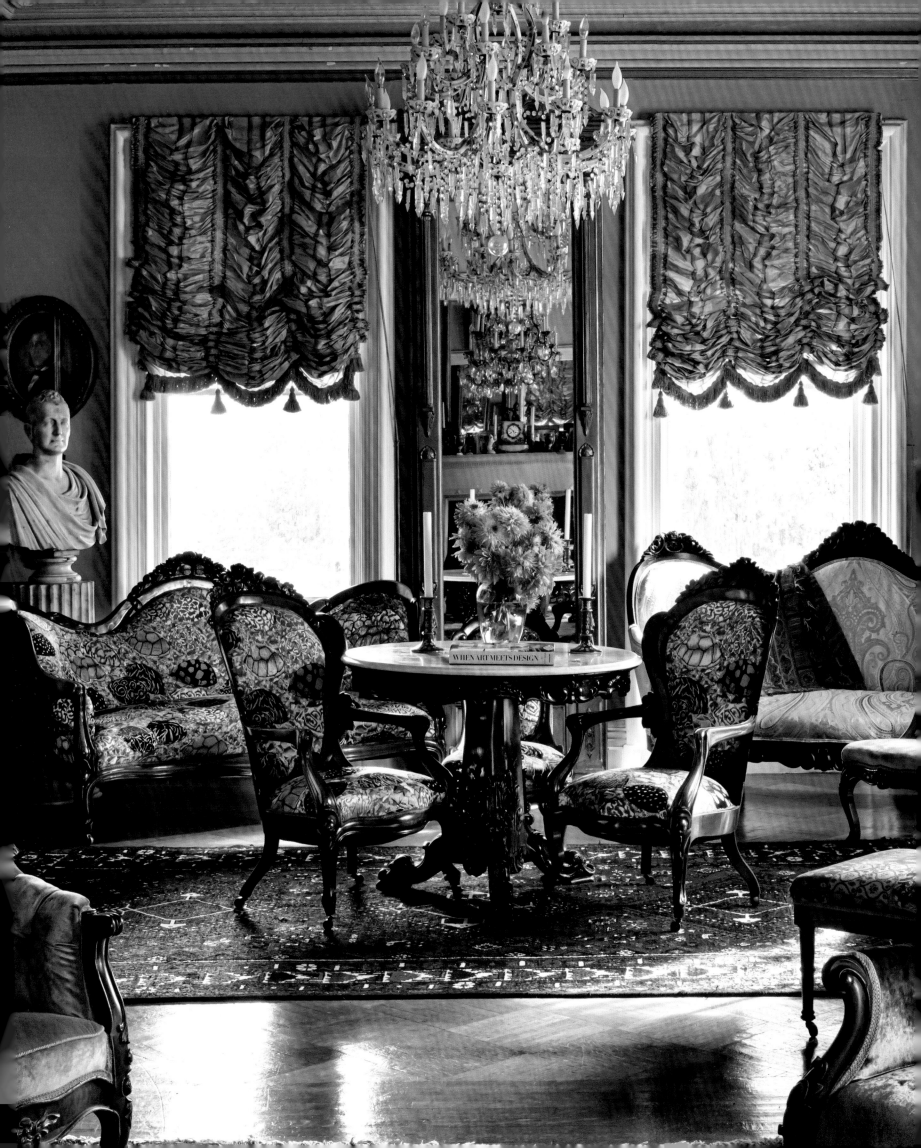

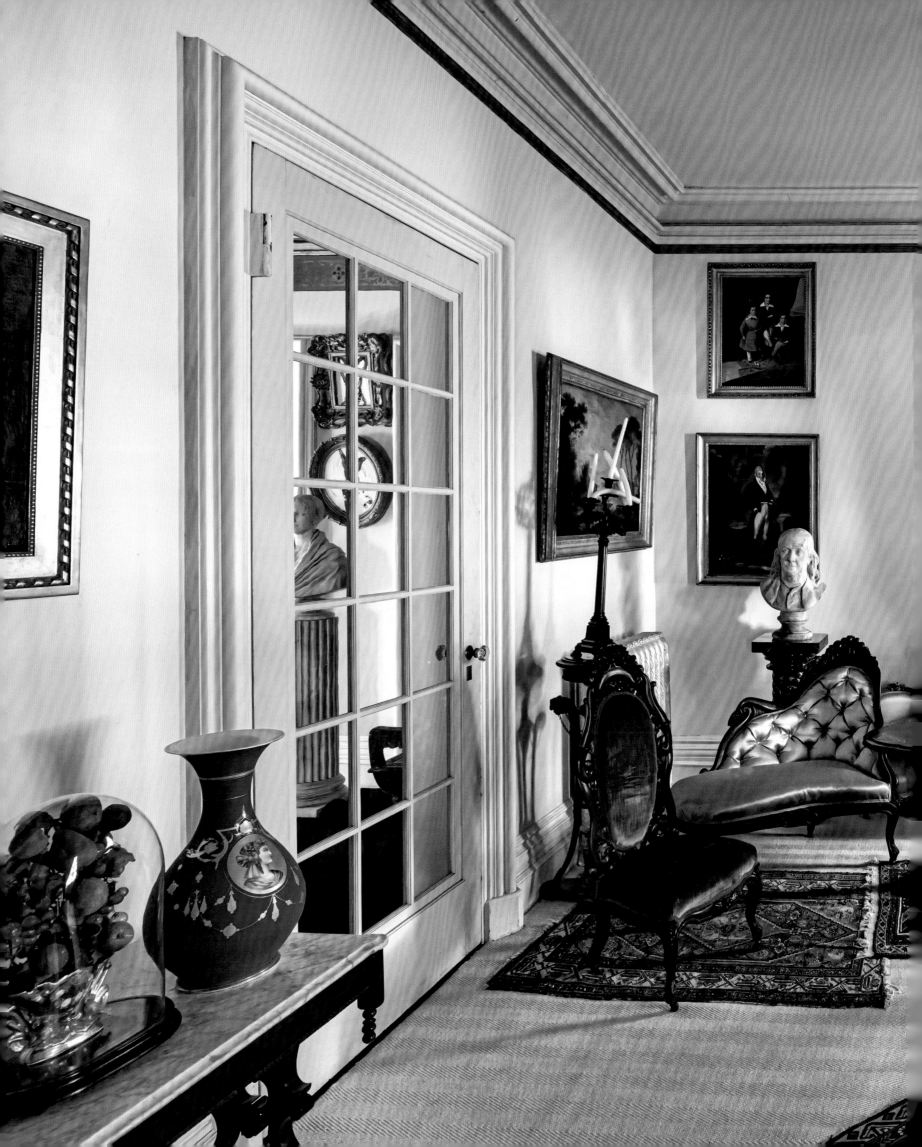

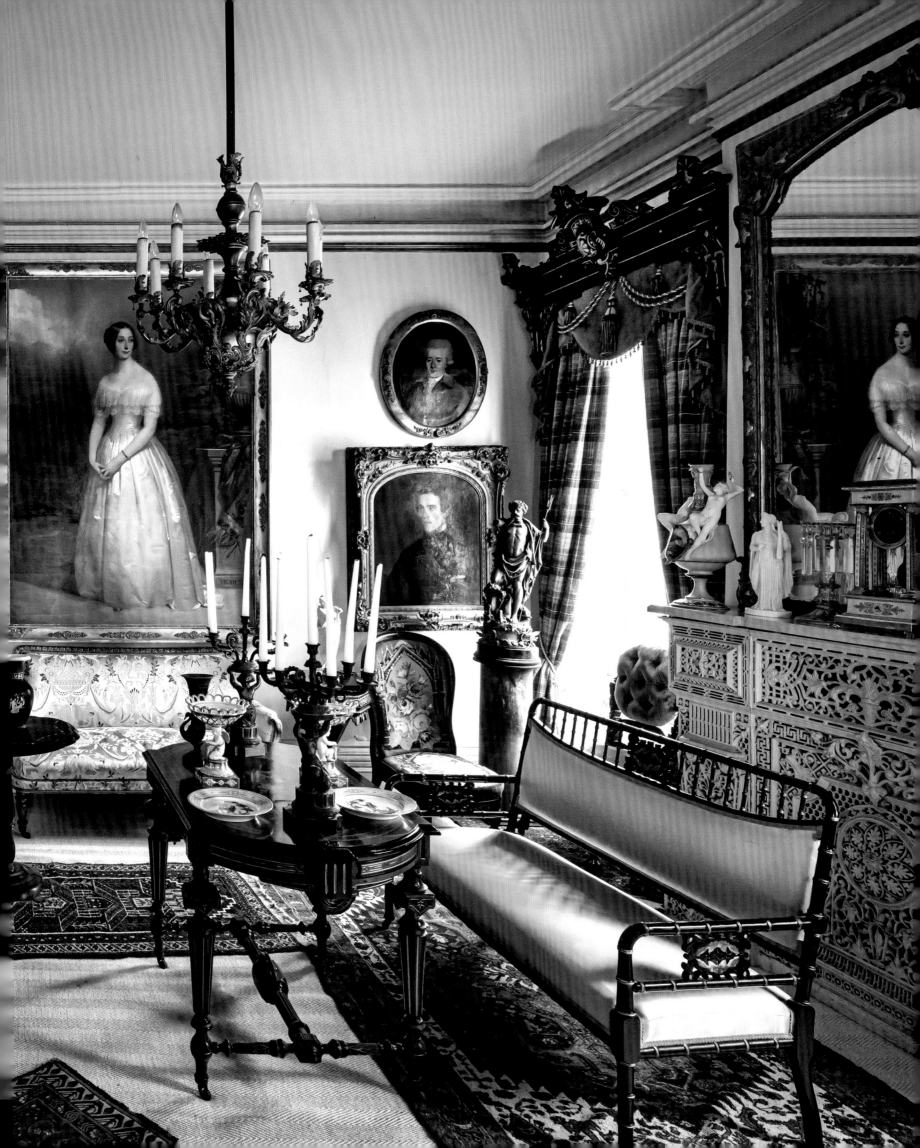

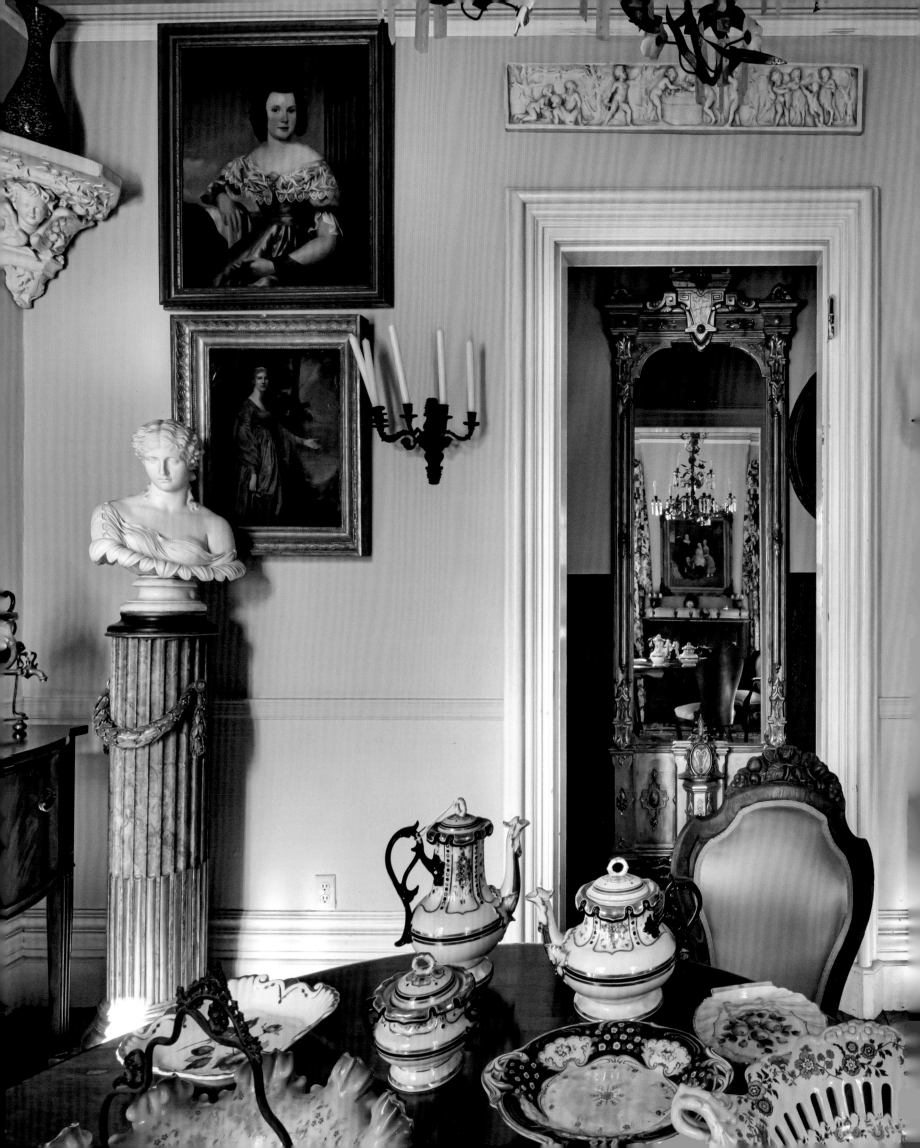

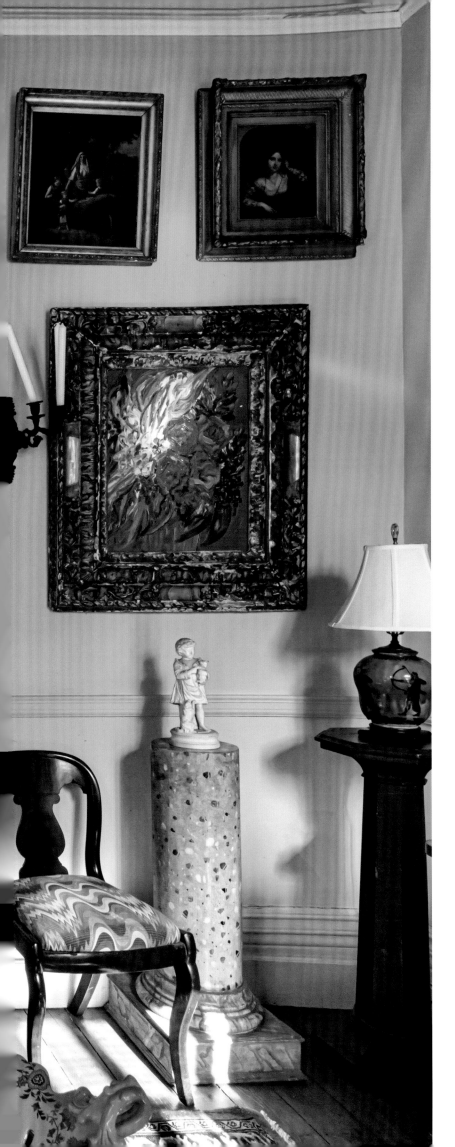

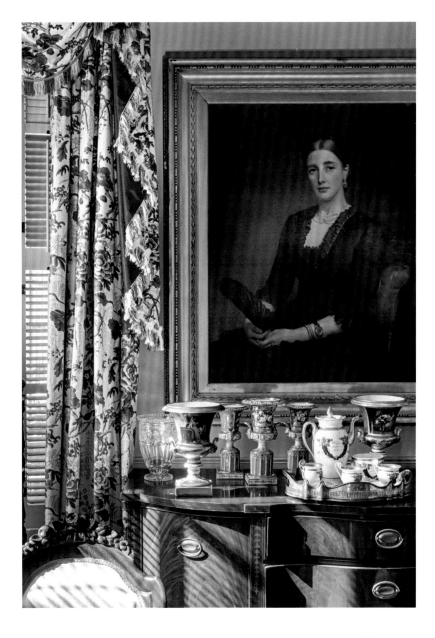

◄ The breakfast room table is set with Old Paris porcelain. Nineteenth-century oil portraits and an early painting by Hunt of flowers in an antique frame are hung on the wall.

▲ Red chintz curtains contribute a cheerful note.

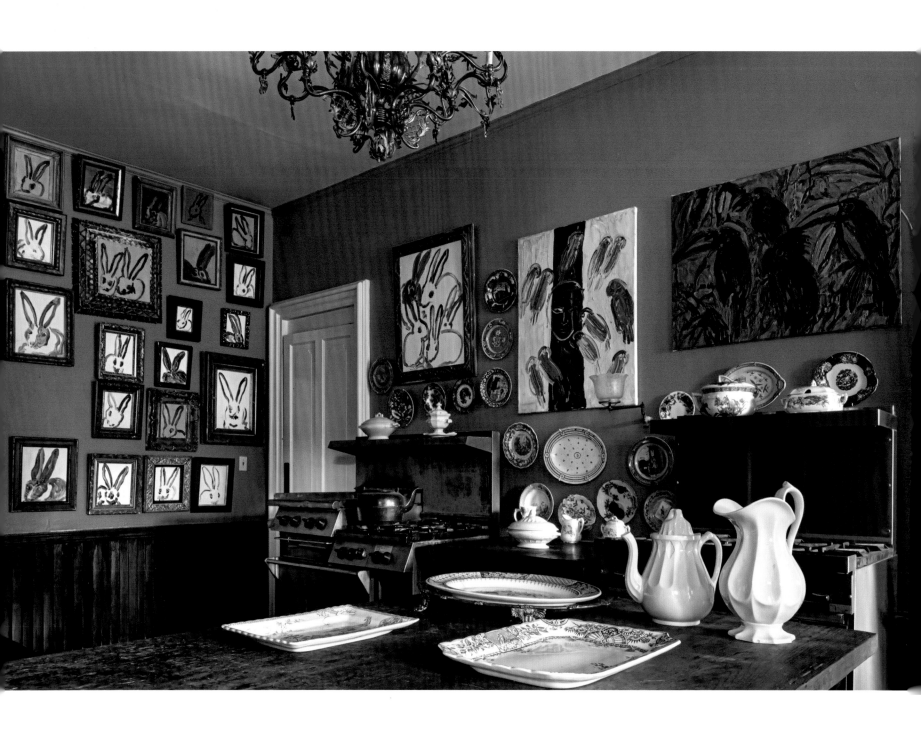

▲ A wall of bunny paintings and *Toucans* on the right decorate the kitchen.

▶ Palissy plates surround the original cast-iron stove.

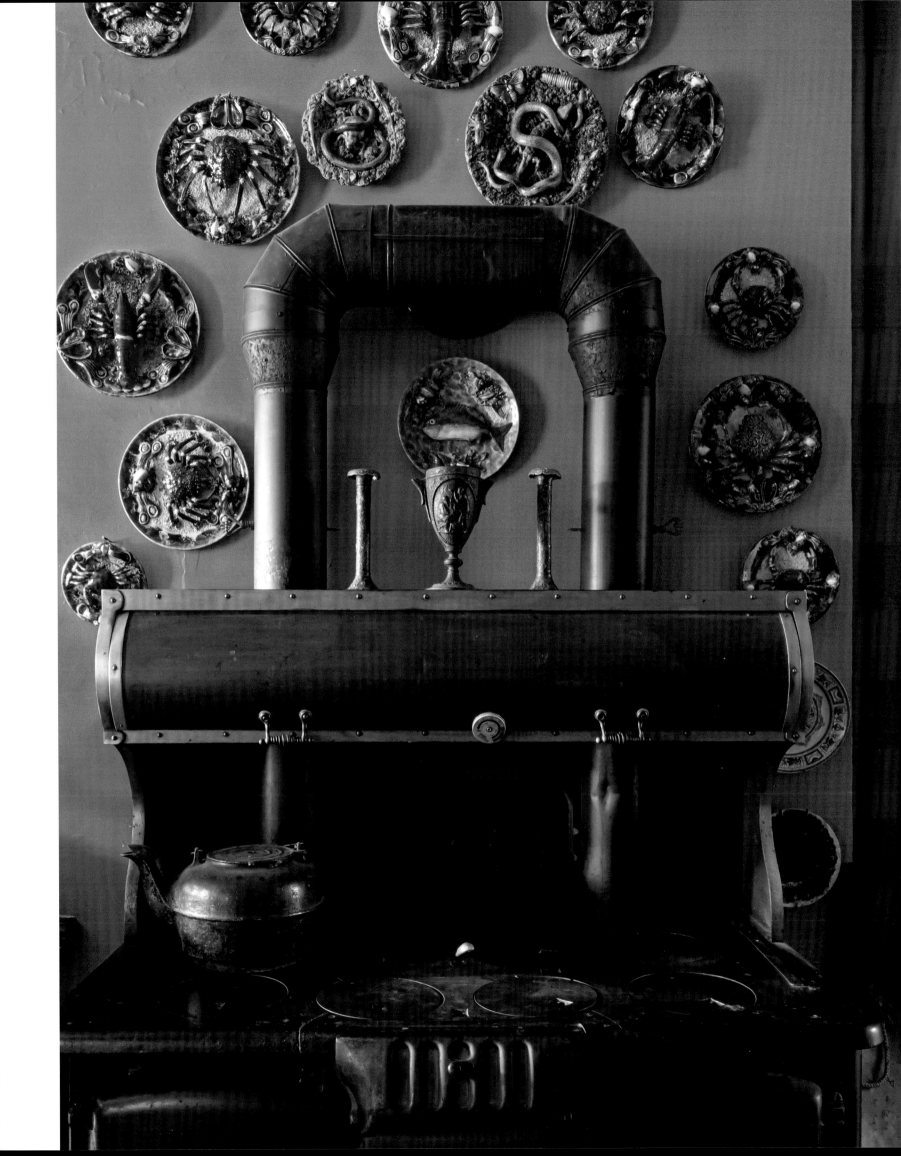

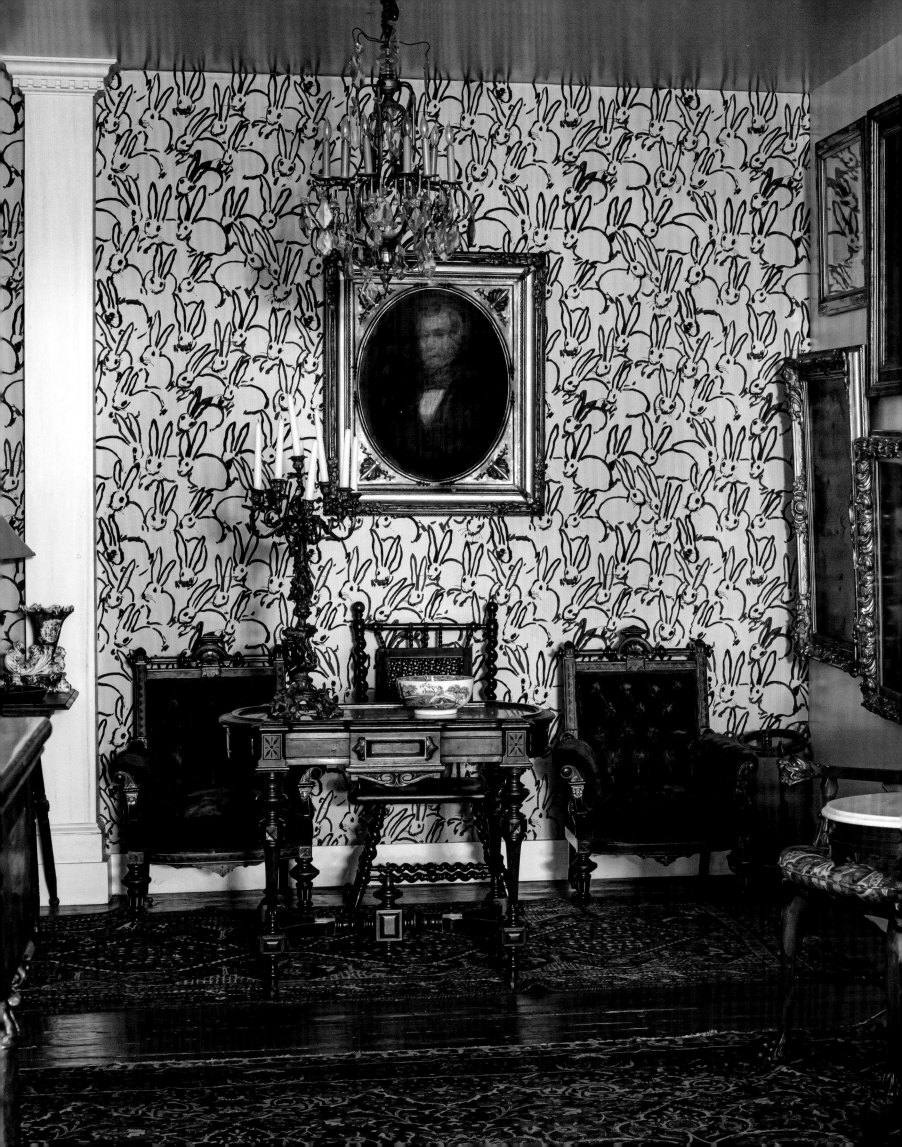

Gold "Hutch" wallpaper, for Lee Jofa, covers the wall of the third-floor billiard room, hung with Victorian oil portraits.

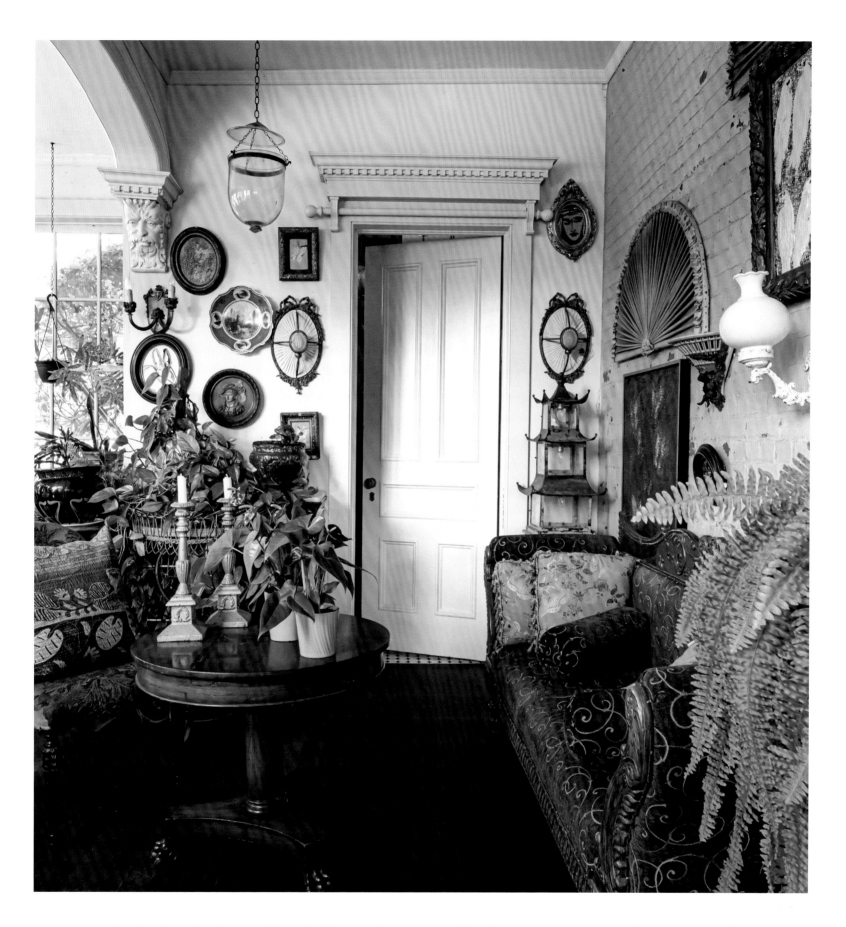

◄ An Empire sofa upholstered in gold silk sits in front of fleurs-de-lys plasterwork in a second-floor sitting room.

▲ A light-filled conservatory was added to the back of the house.

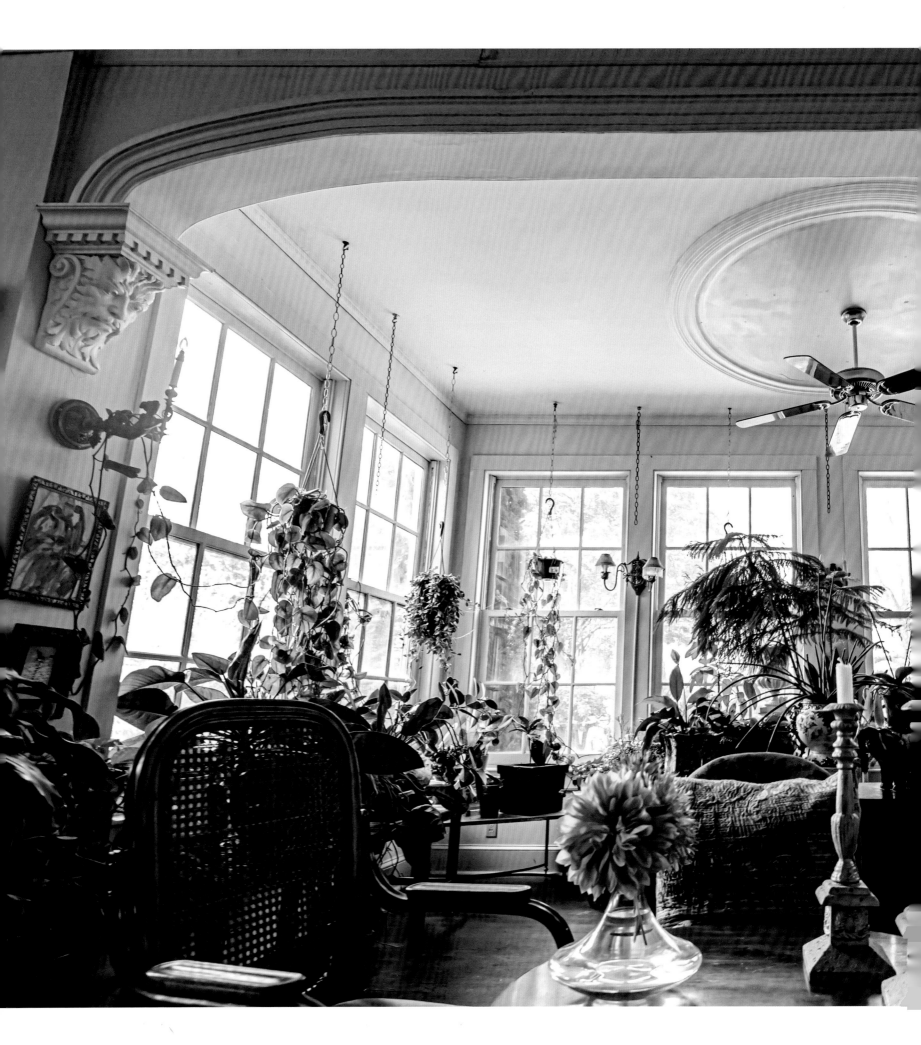

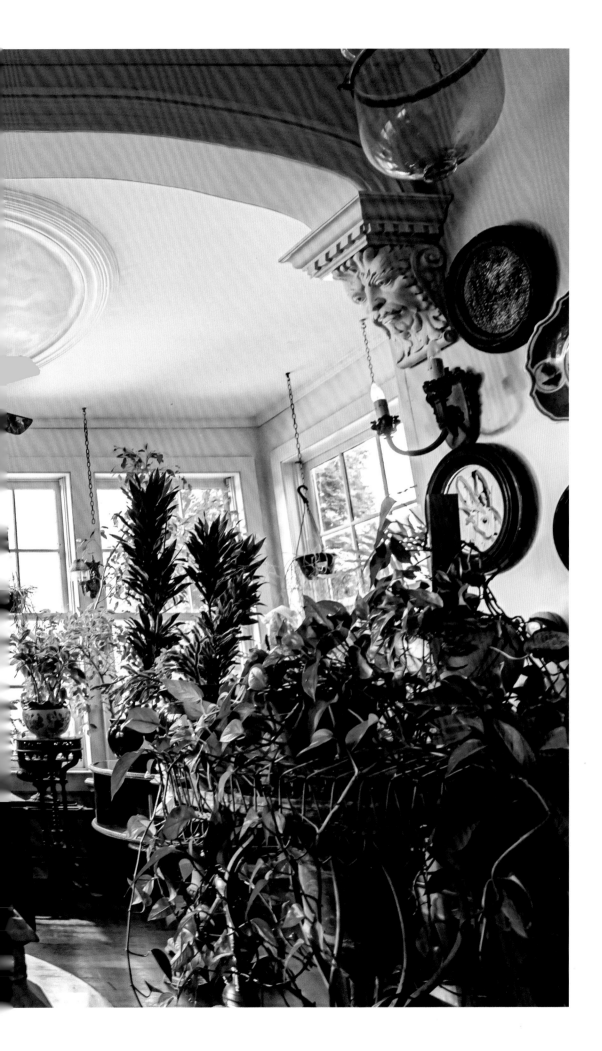

Early Hunt bird paintings line a wall in the conservatory.

Overleaf: The conservatory is hung with fabric fans and Hunt's paintings *Red Butterflies* and *Doves and Guardians*. A Chinese birdcage lantern sits in the corner.

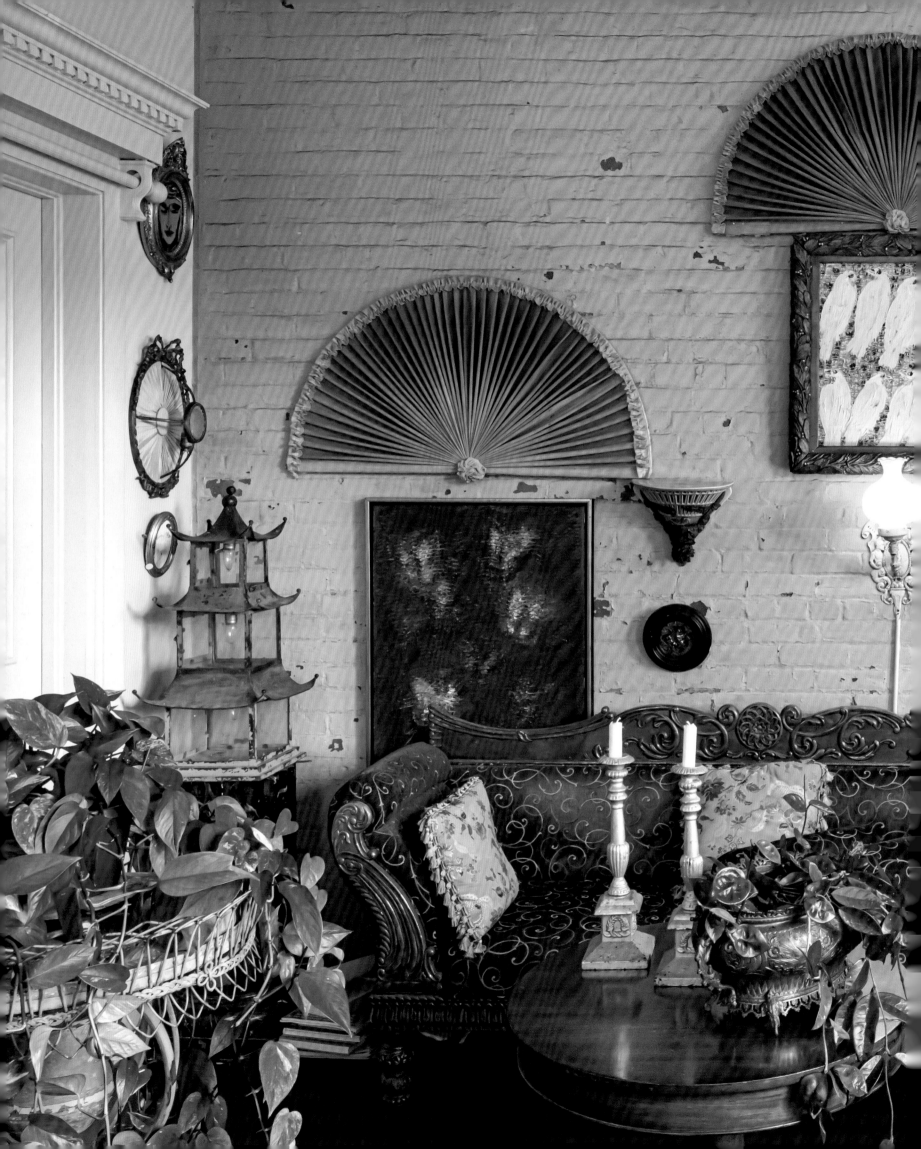

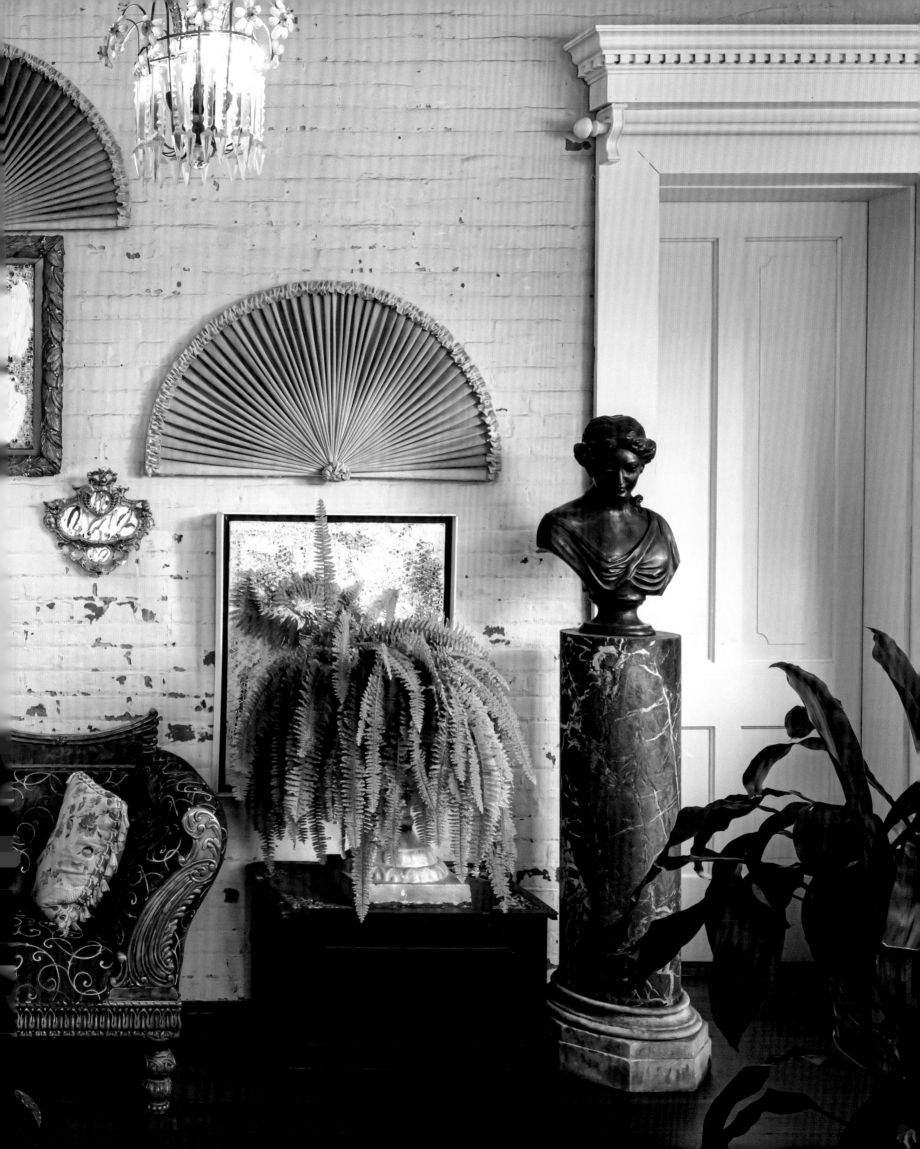

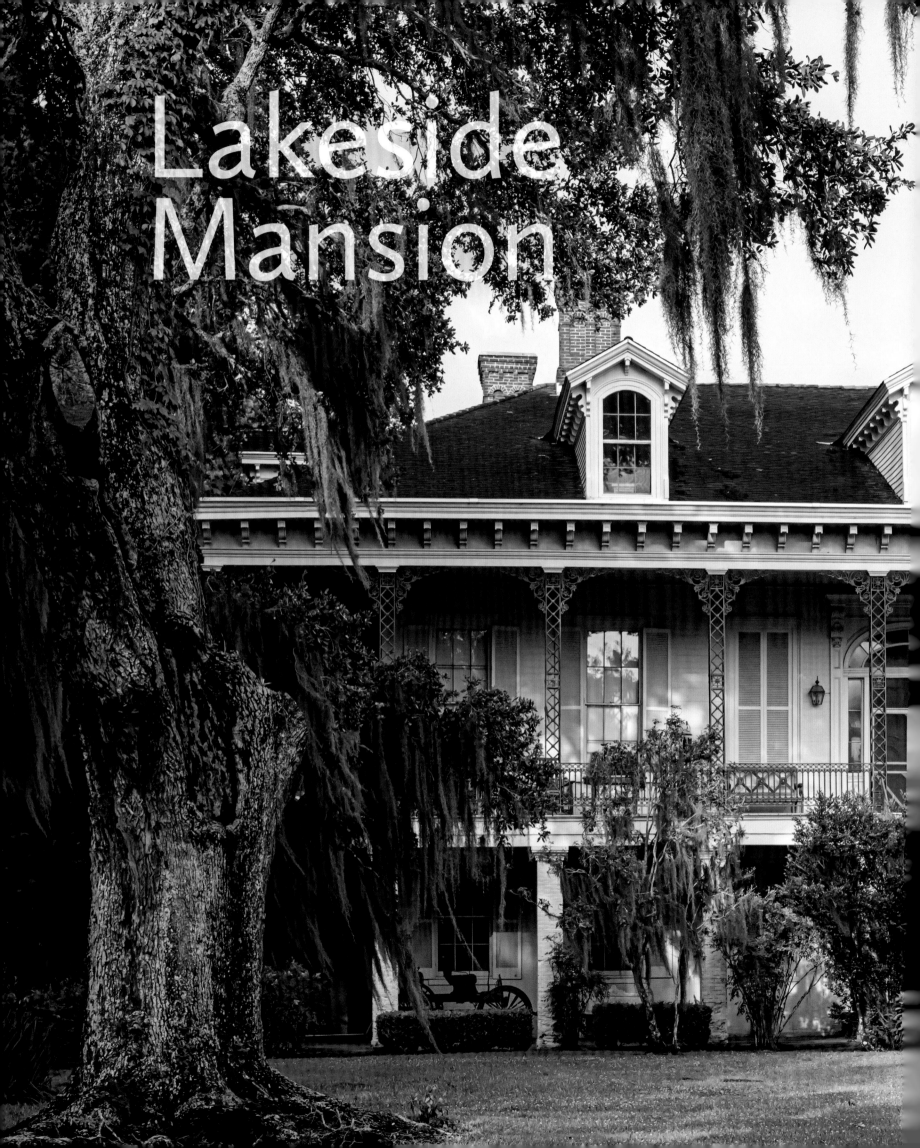

Lakeside Mansion

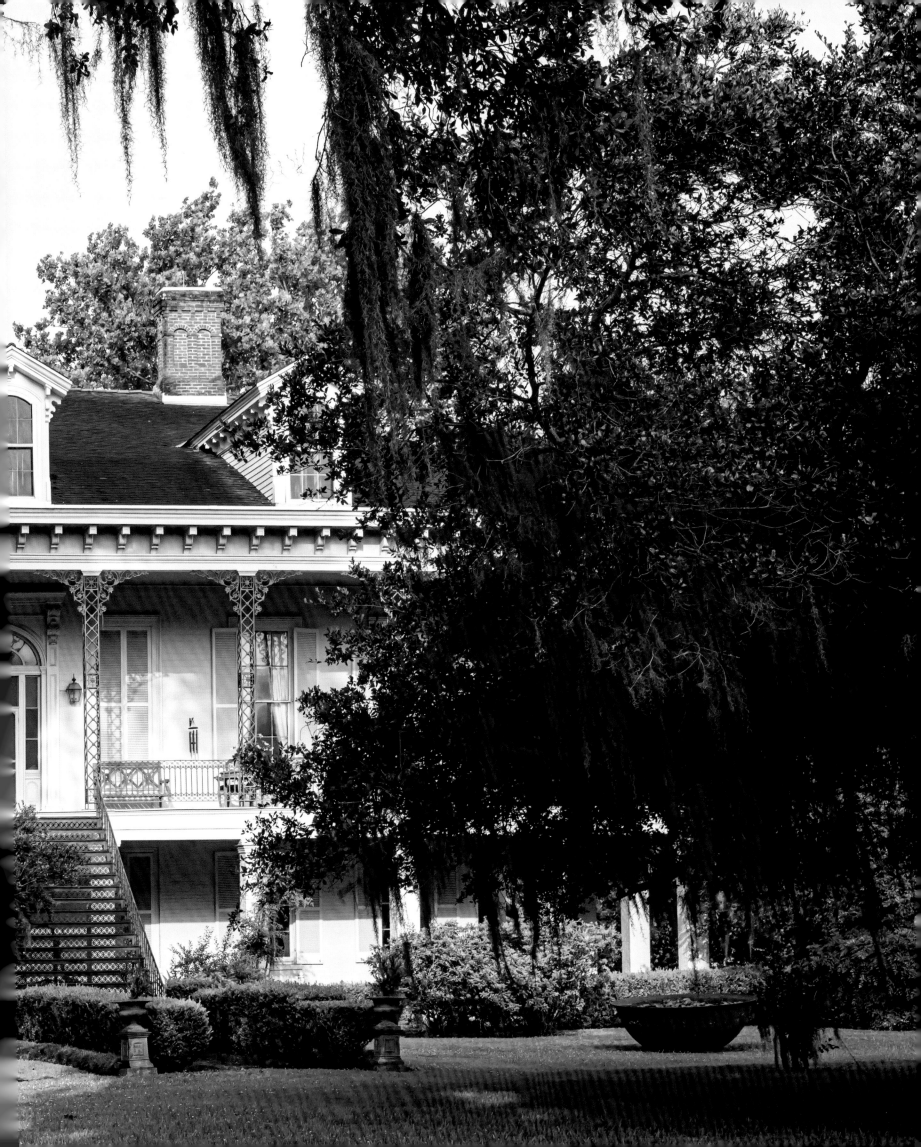

Lakeside Mansion Batchelor, Louisiana

Hunt's roots are in the South. His maternal grandmother's family is originally from Tennessee, he went to school at Vanderbilt and Tulane, and he has always felt at home with Southern architecture. He had recently restored Albania, an 1842 Greek Revival mansion in south-central Louisiana but was ready for the challenge of another project to preserve for future generations, this one on a larger scale.

He was intrigued by an ad for Lakeside Mansion. Built in 1832 on land given to the Marquis de Lafayette from a grateful Thomas Jefferson for his help in the Louisiana Purchase, Lakeside was an 18,000-square-foot raised cottage that hadn't changed significantly in the past two centuries. Reached through a long, winding drive of live oak dripping with Spanish moss, the home was constructed with a redbrick lower level and a framed upper story; later in the nineteenth century, the second floor was encircled by wide, open galleries with cast-iron railings the owners had brought back from a visit to France.

When Hunt saw the mansion, it was painted a dusty pink, as it had probably always been. The "cottage" beckoned with romantic, Southern charm. The interior was like stepping back in time: generous rooms with eighteen-foot-tall ceilings had not been painted in more than a century, resulting in a patina of faded elegance. Hunt was enamored. Being a spiritual man, he sought advice from channelers, who had recently connected him to the Countess Xacha Obrenevitch, a famous 1920s spiritualist, who told him he would soon be buying another Southern mansion—and it turned out she was right: he purchased Lakeside in 2005.

While much of Lakeside's appeal was its untouched condition, the home still required a significant, two-year restoration. Dirt floors on the lower level had not been covered until 1929, and a century of exposed woodwork had to be addressed. Hunt replaced floorboards with vintage wood, repaired plaster, updated the plumbing, rewired the house, and had it reroofed. Most of the

Previous overleaf: The house is set amongst live oak with Spanish moss and faces the river.

◀ A classic Greek maiden centers a Pompeian-red room on the first floor, where a toucan painting and a Louisiana early pine corner cabinet make statements.

mantels on the main level, or parlor floor, had been smashed during the Civil War, when the mansion was a Union hospital. Hunt was able to find period marble replacements.

Gardens were enlarged, planted with gardenias, palms, citrus trees, and beds of camellias, and a brick terrace centered on an antique, cast-iron fountain was added.

Hunt was careful to preserve as much of the home's original patina as possible, not repainting the main entry hall, which runs the length of the house, or his main bedroom suite, allowing the distressed walls to tell Lakeside's story. A master of color, Hunt painted rooms in strong hues of Mykonos blue, Pompeian red, and shades of turquoise, pink, coral, and tangerine. He combed auctions and antique shops throughout the South for Louisiana-focused antiques, and as the word spread, an antiques picker would line up finds on the back porch and driveway for his purview. Rooms were soon filled with Belter and Meeks rosewood parlor suites, sparkling girandoles, iconic Stanton Hall Gothic Revival chairs, and portraits of distinguished nine-teenth-century Louisianans. Hunt's vibrant paintings of rabbits, butterflies, and birds were hung, brightening the interiors with the allure of nature.

Steeped in Southern history, Lakeside has been expertly restored and preserved—an idyllic country retreat where time moves slowly, a place where Hunt can rock on the porch, gaze over the live oak, and feel a primordial connection to nature—a central theme in his work.

To preserve its early nineteenth-century patina, Hunt chose not to repaint the central hall. It is furnished with sofas and chairs upholstered in a Louisiana-themed toile. Louisiana portraits line the staircase.

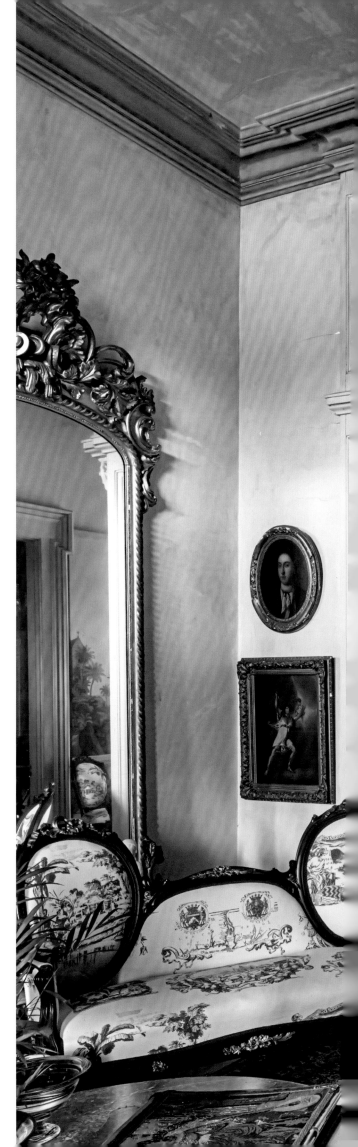

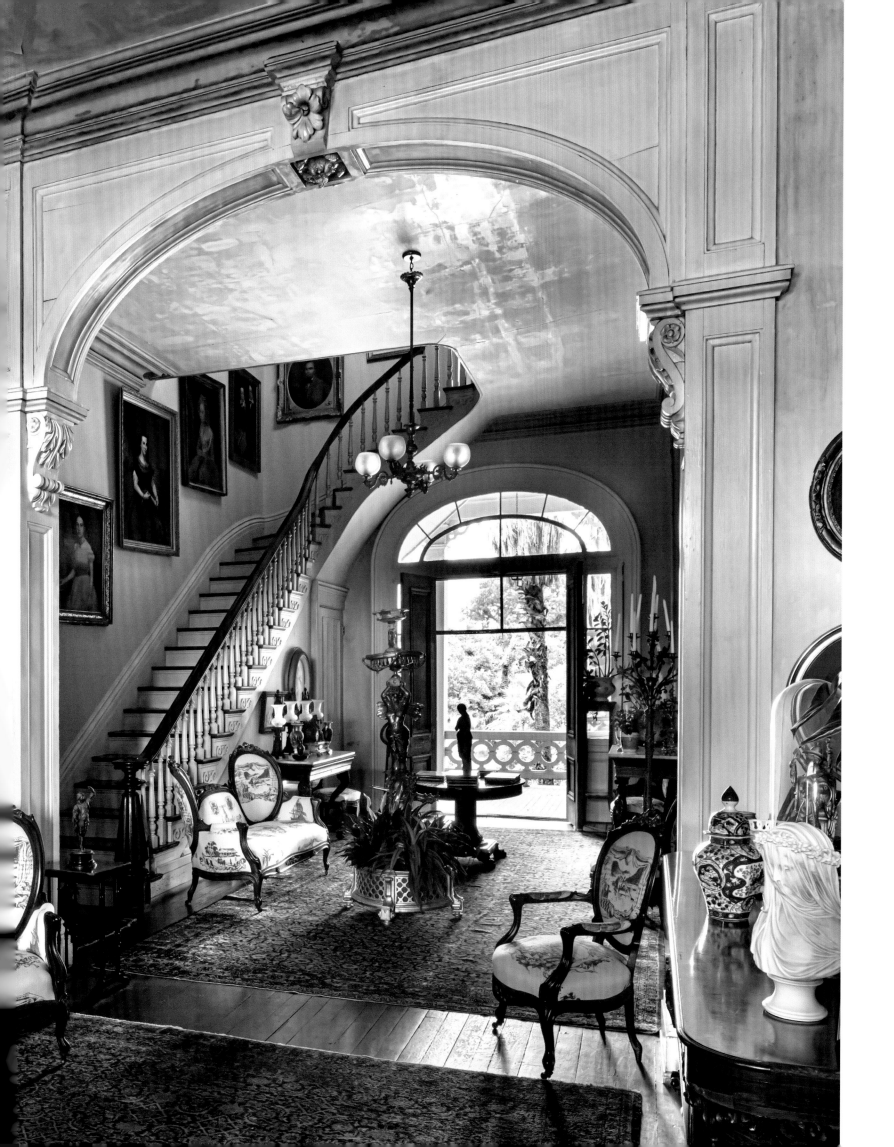

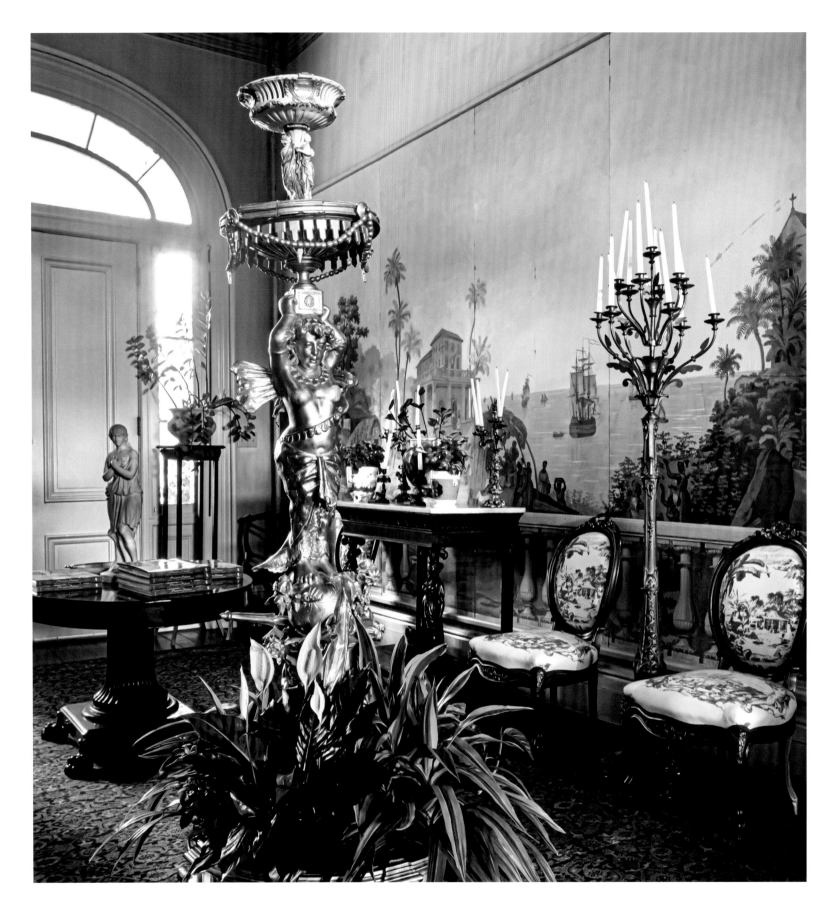

▲ Zuber's 1693 "Views of Brazil" wallpaper, gilded candelabras, and a monumental, gilded, winged-nymph Victorian planter lend historic notes to the front hall.

▶ Wallpaper detail.

Overleaf: The downstairs central hall features classic busts, including the Marquis de Lafayette on the right and a collection of girandoles. Seating upholstered in "Bayou Casino," for Lee Jofa, features brightly colored lories and parrots.

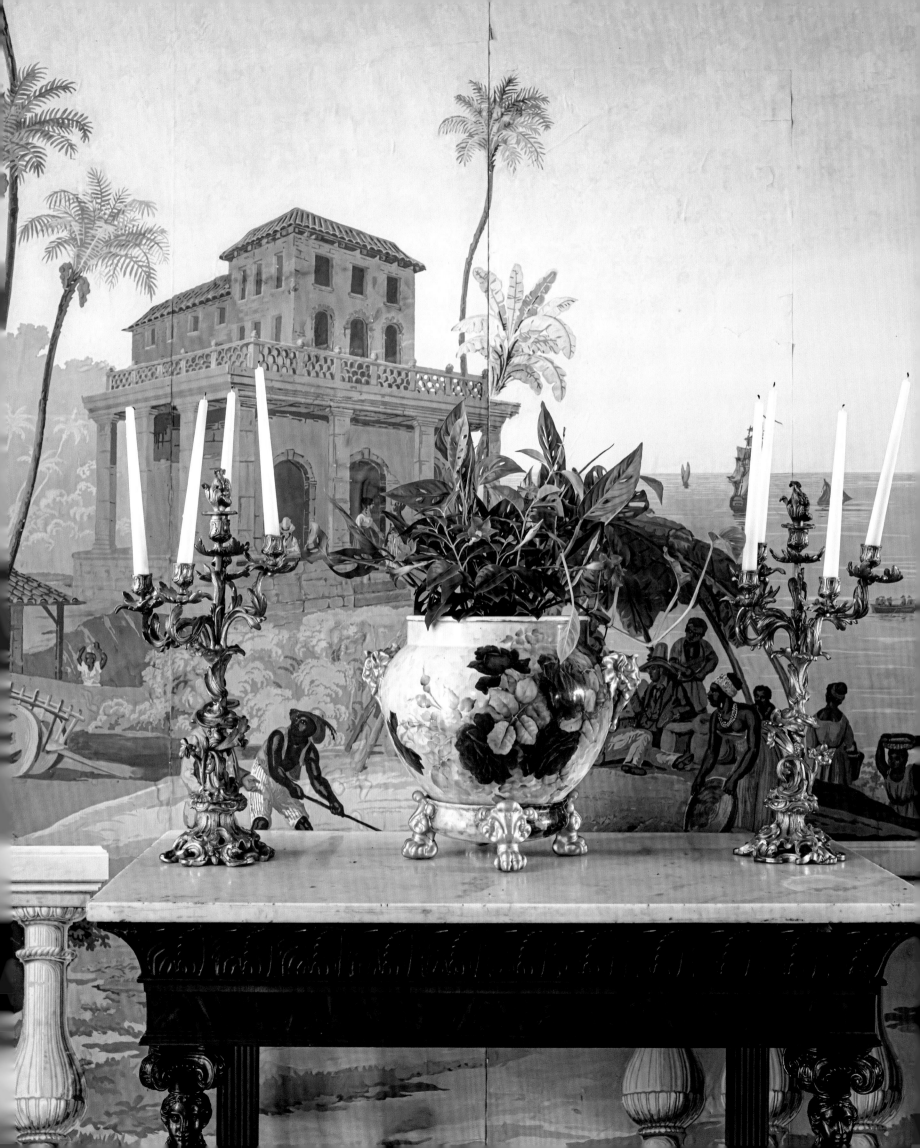

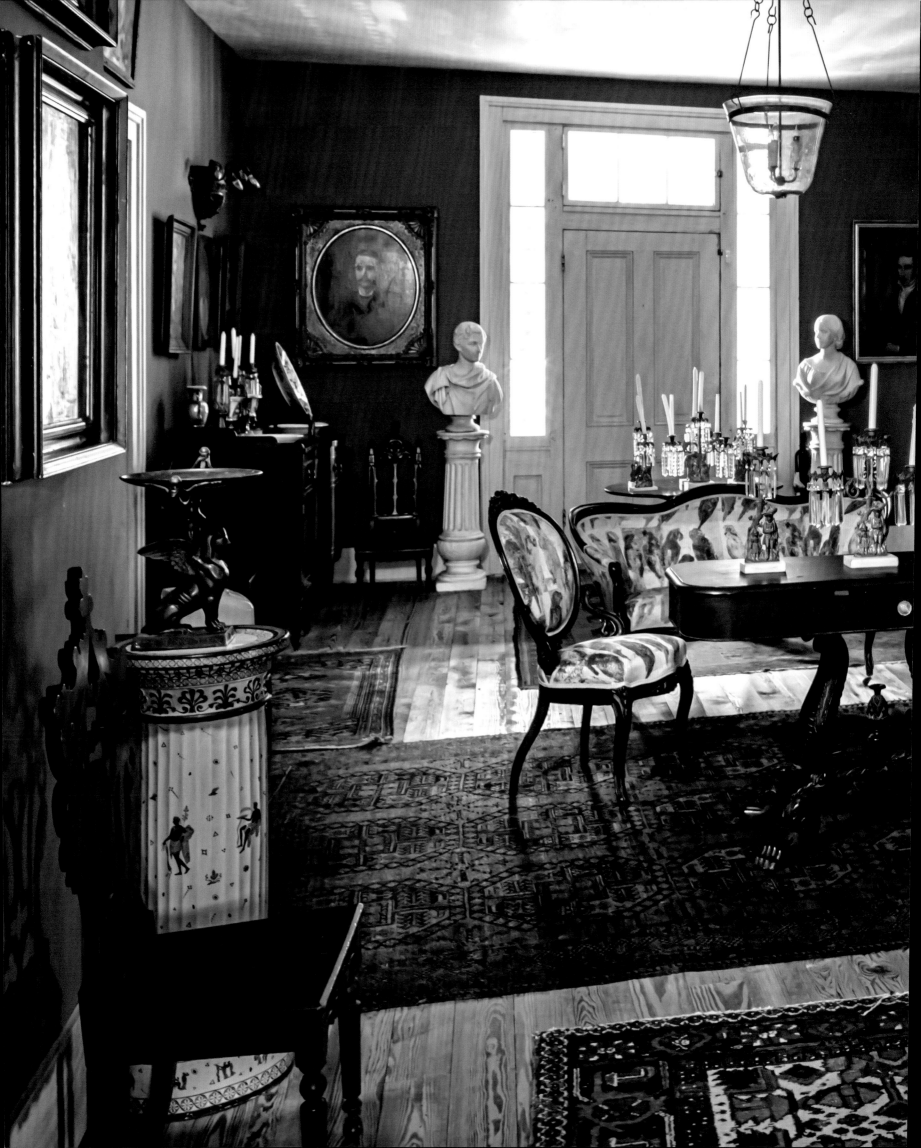

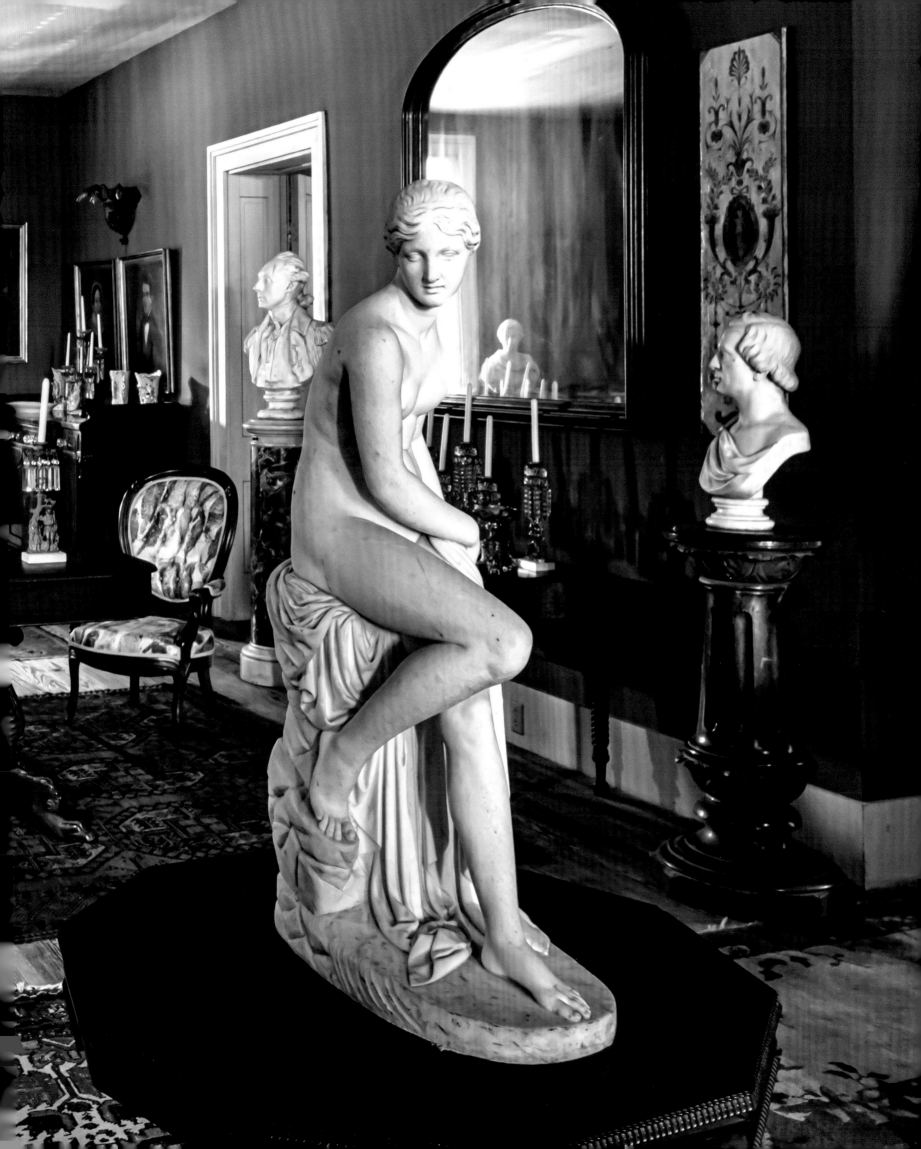

▲ A Venus de Milo statue strikes her pose in front of *Pinwheels*, a painting of petunias.

▶ Bronzes and marble busts highlight the first-floor pink parlor. Mario Lanza's jacket from the 1954 movie *The Student Prince* is laid over a chair.

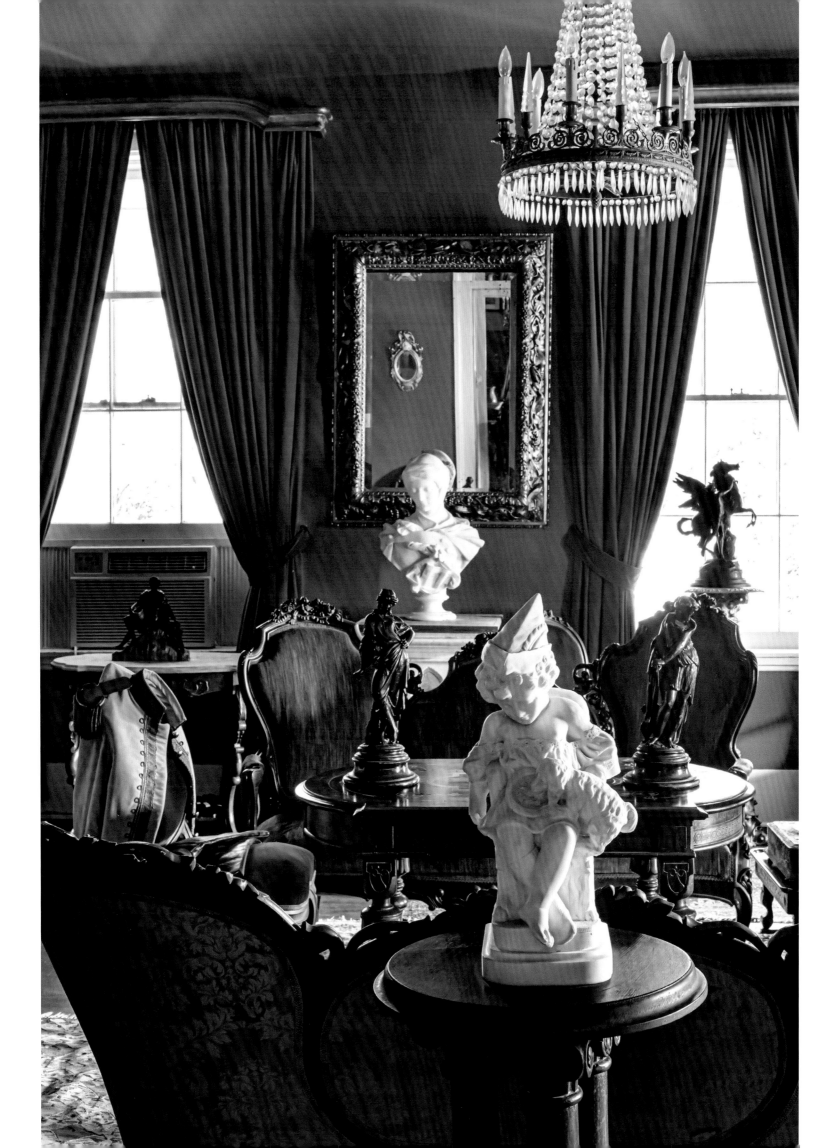

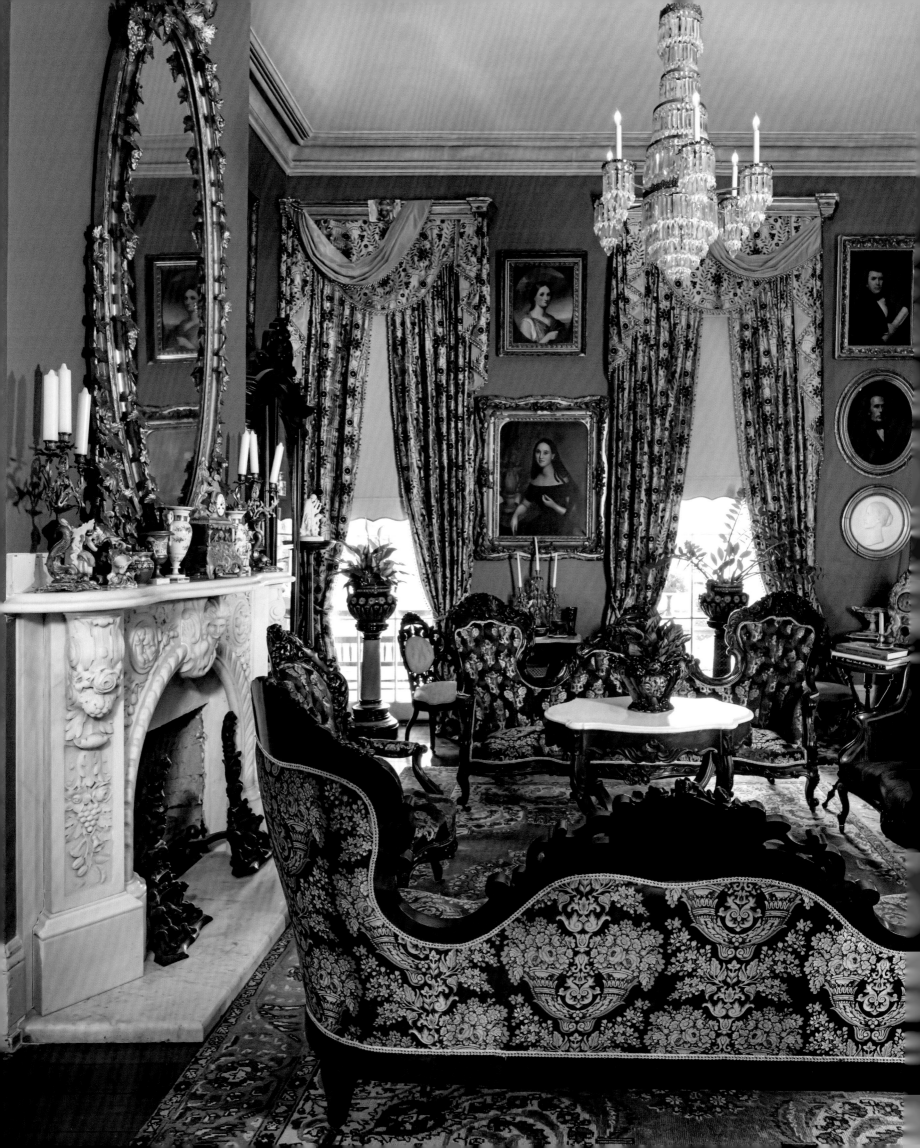

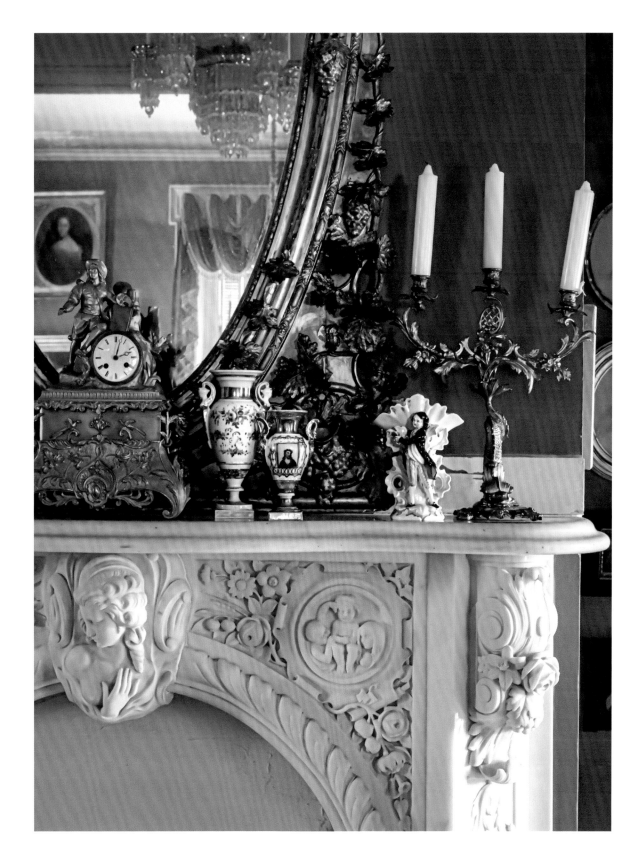

◀ Upholstered and tufted Belter settees in the orange parlor are grouped around a marble-topped Renaissance Revival turtle-top center table.

▲ The marble mantel was added, as the original had been destroyed during the Civil War. Old Paris porcelains adorn the scene.

▲ A collection of blue milk glass.

▶ Bunny paintings punctuate the central hall looking into the orange parlor.

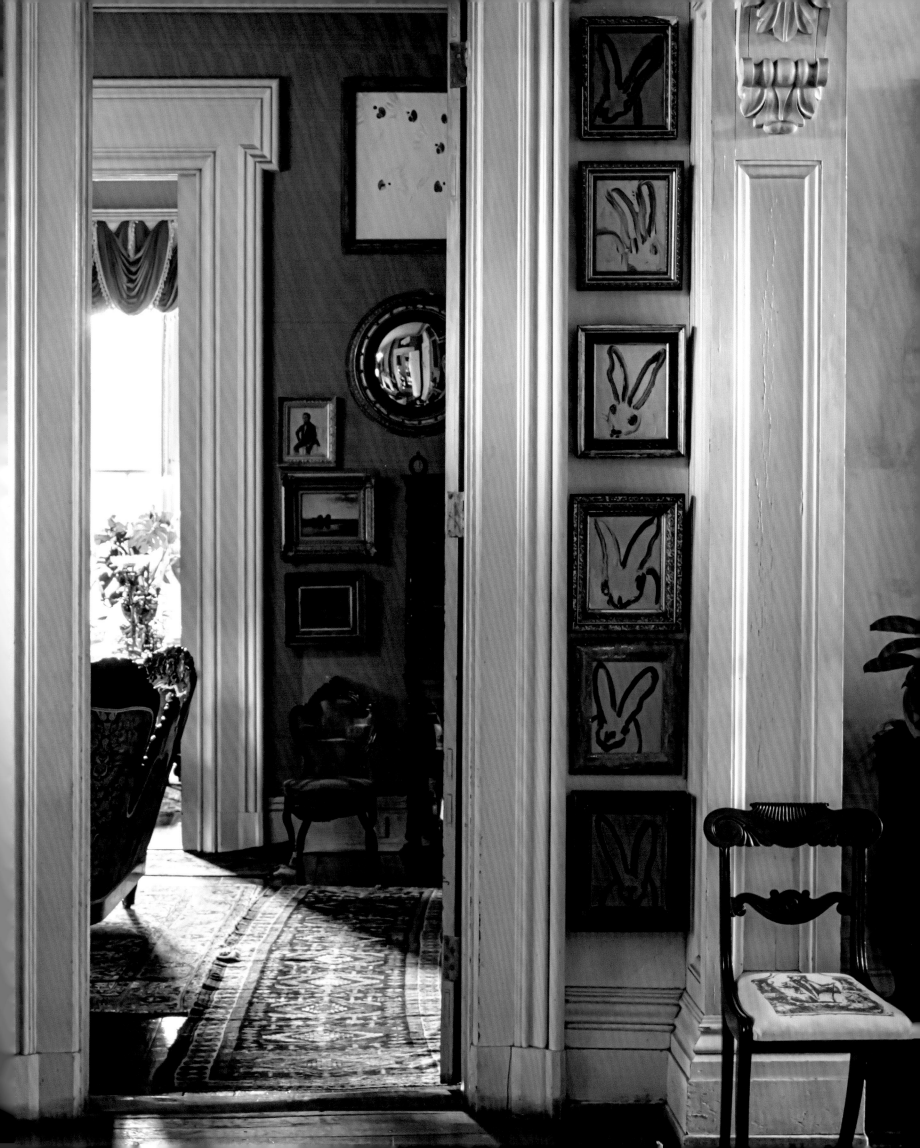

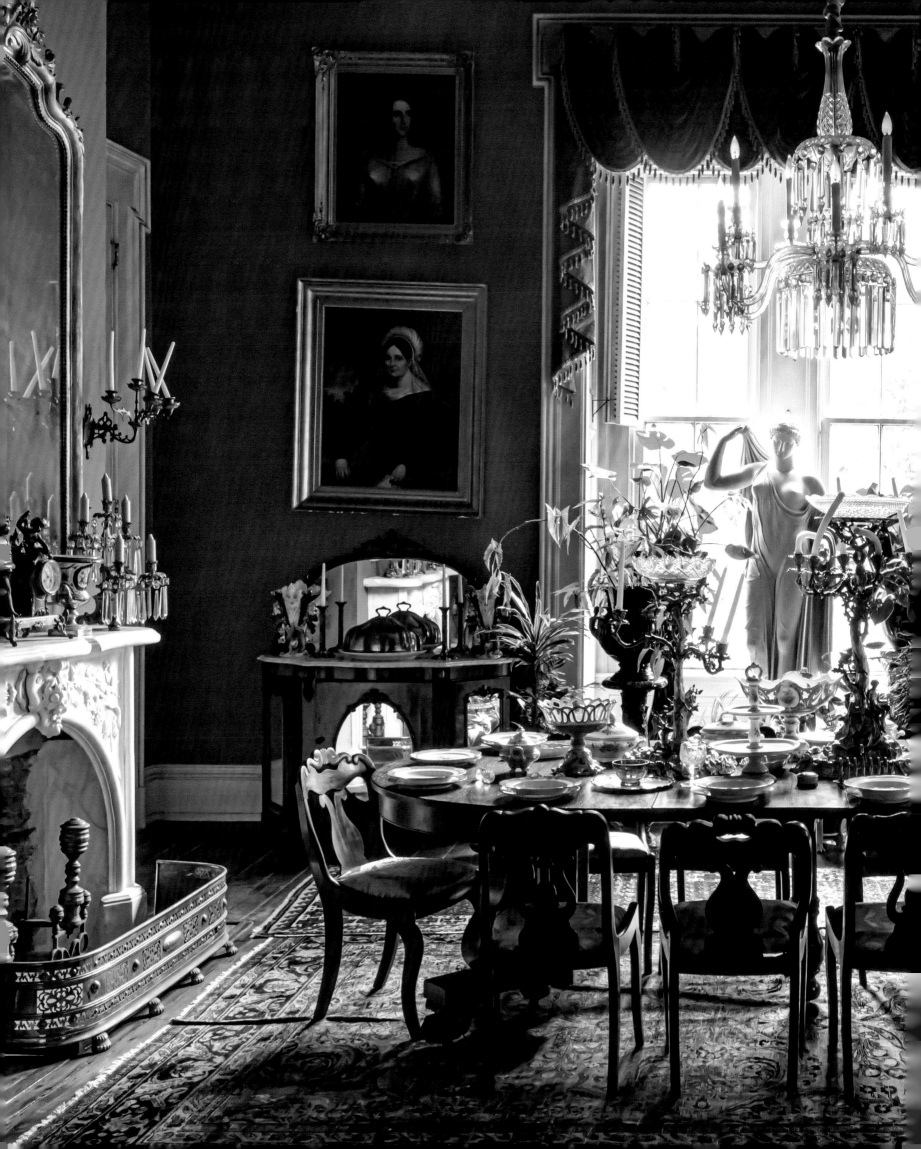

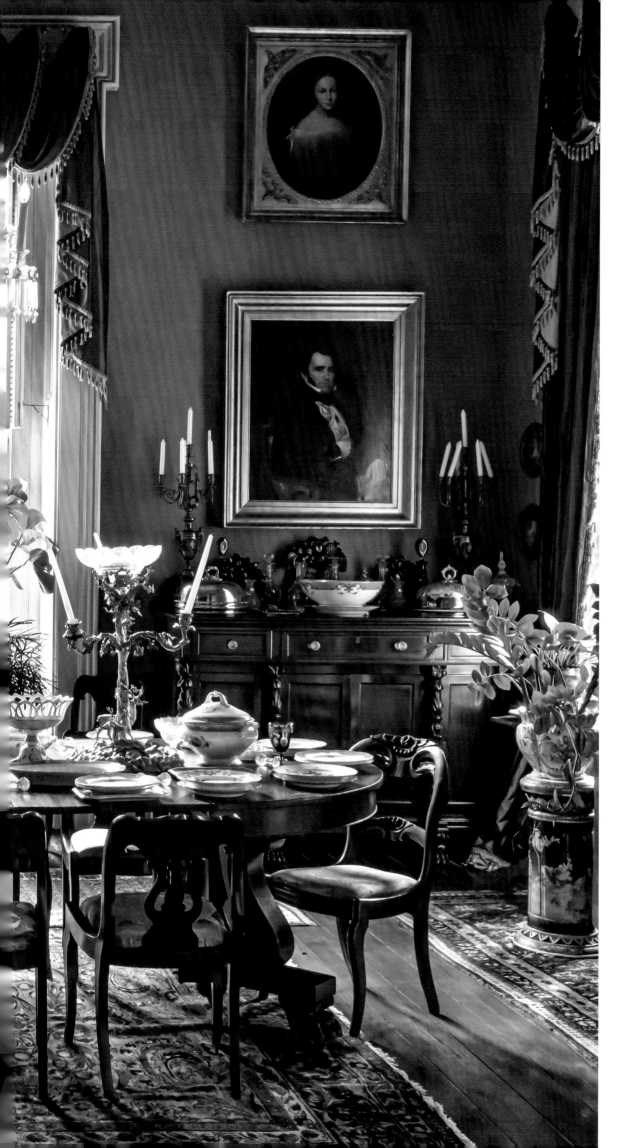

A nineteenth-century plaster statue of Venus Genetrix (from the collection of Fred Hughes, Andy Warhol's business manager) overlooks the dining room; the table is set with an English silver centerpiece and candelabras.

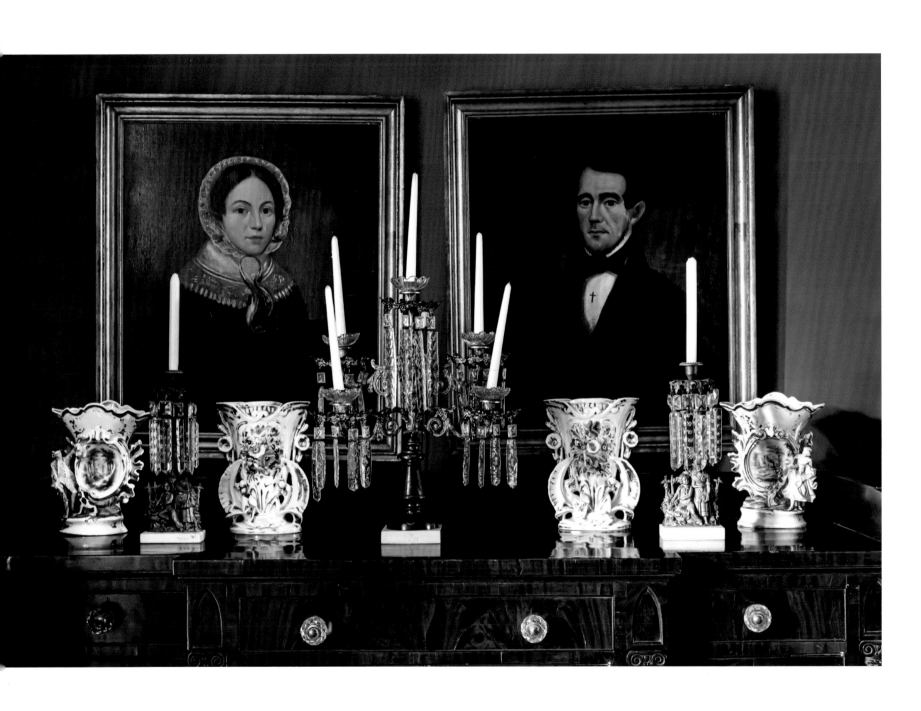

▲ Louisiana portraits, gilded girandoles, and Old Paris porcelain grace a first-floor commode.

▶ The dining room table is blazoned with crystal, silver, and fine china.

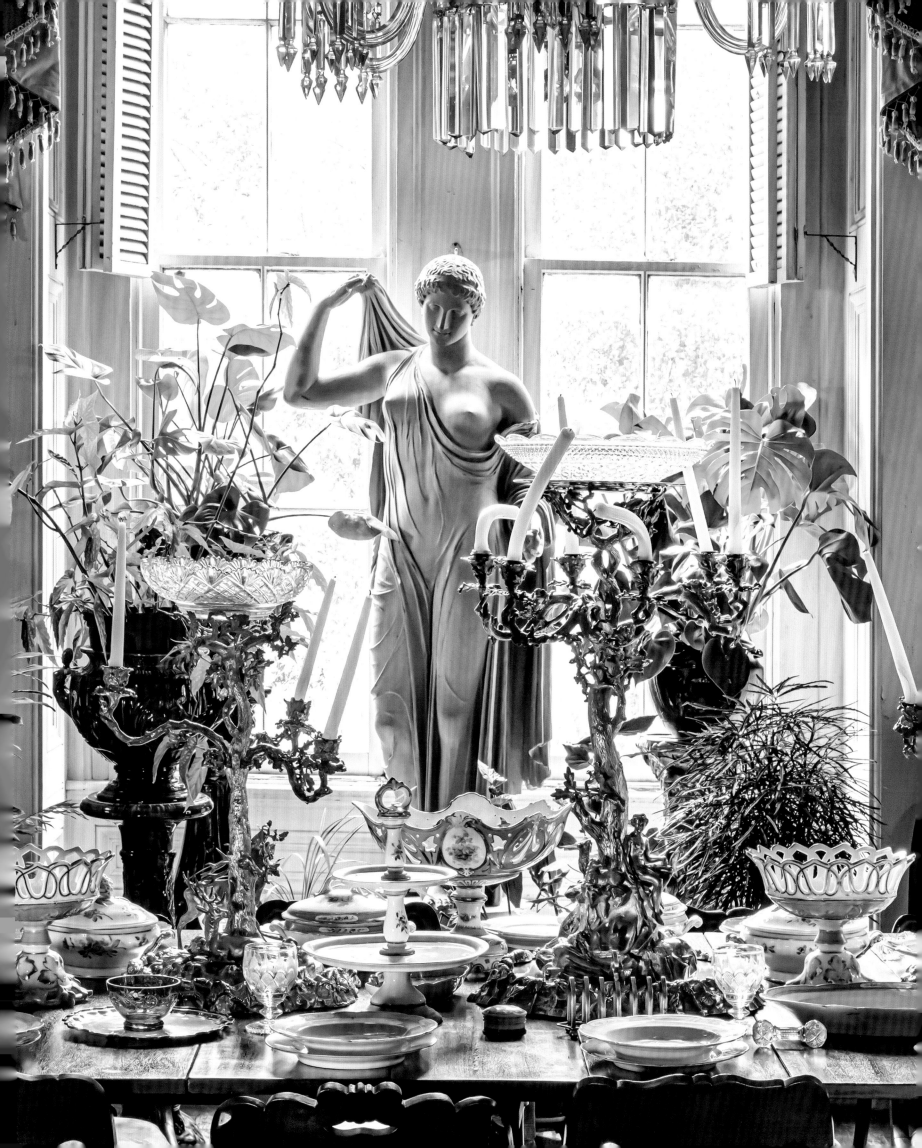

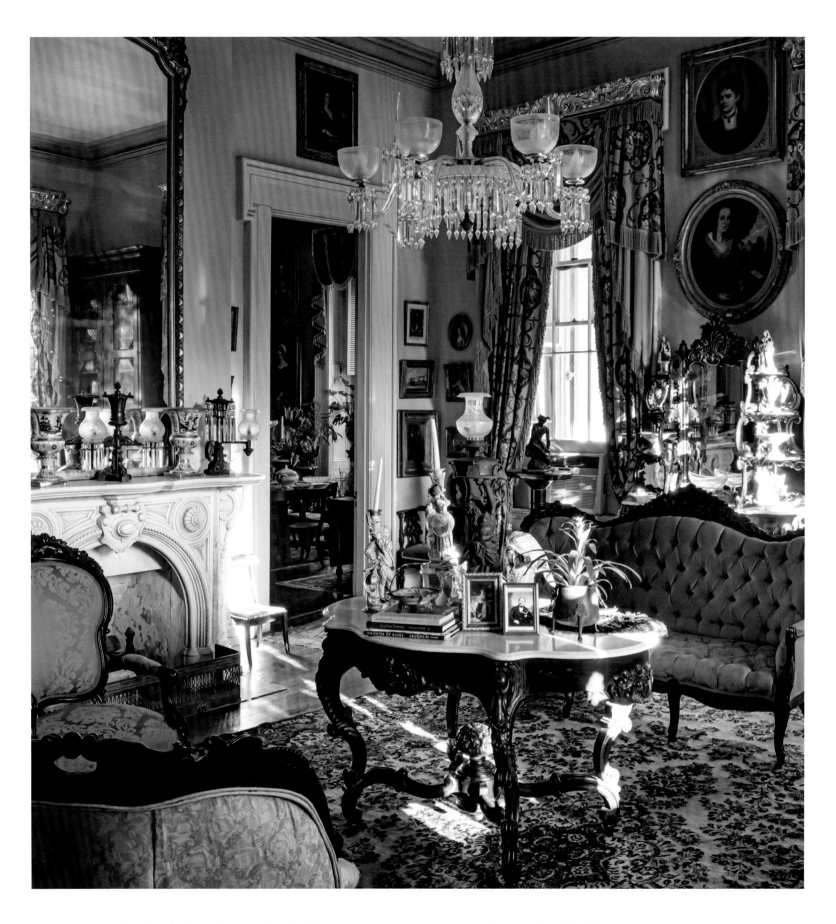

▲ The blue parlor is furnished with old Louisiana portraits, porcelains, and Victorian parlor seating.

▶ The marble mantel holds Old Paris porcelain vases and an argand lamp. Nineteenth-century portraits, including George Washington, reflect in the mirror.

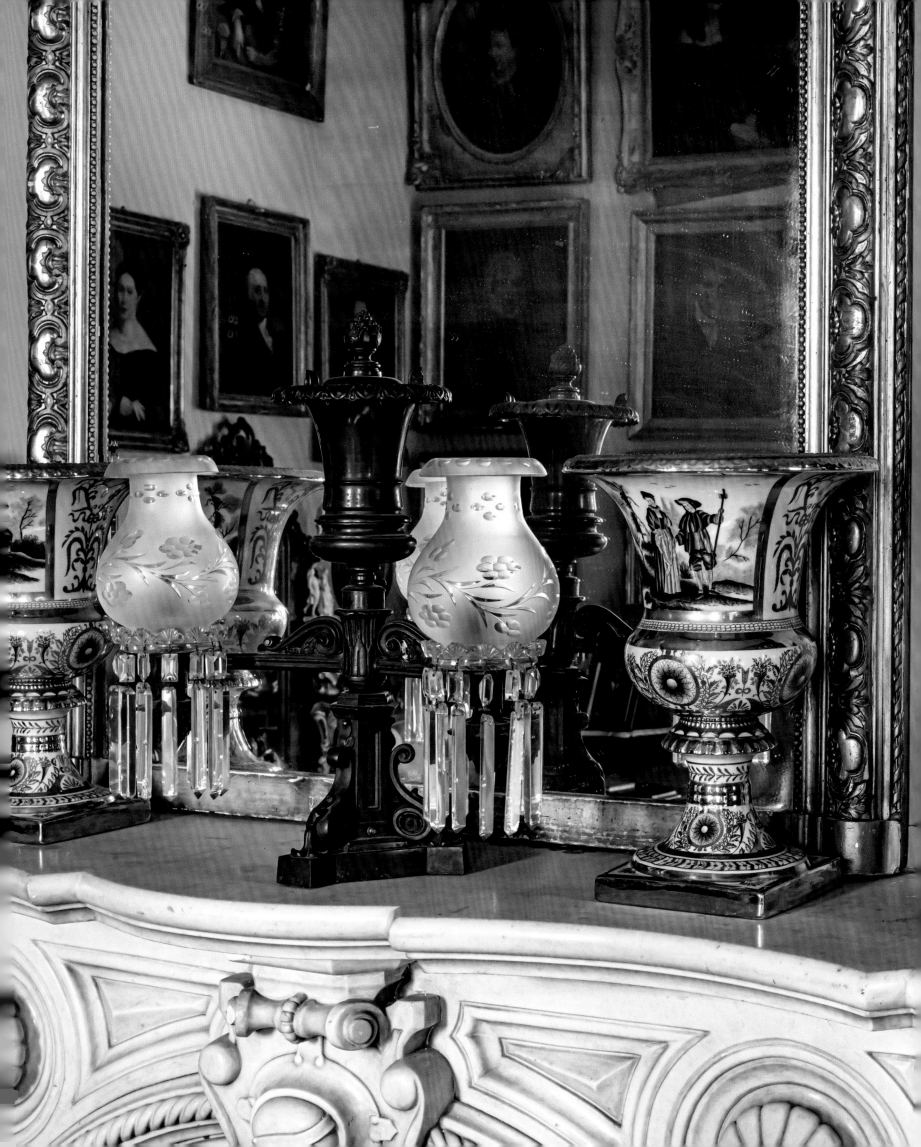

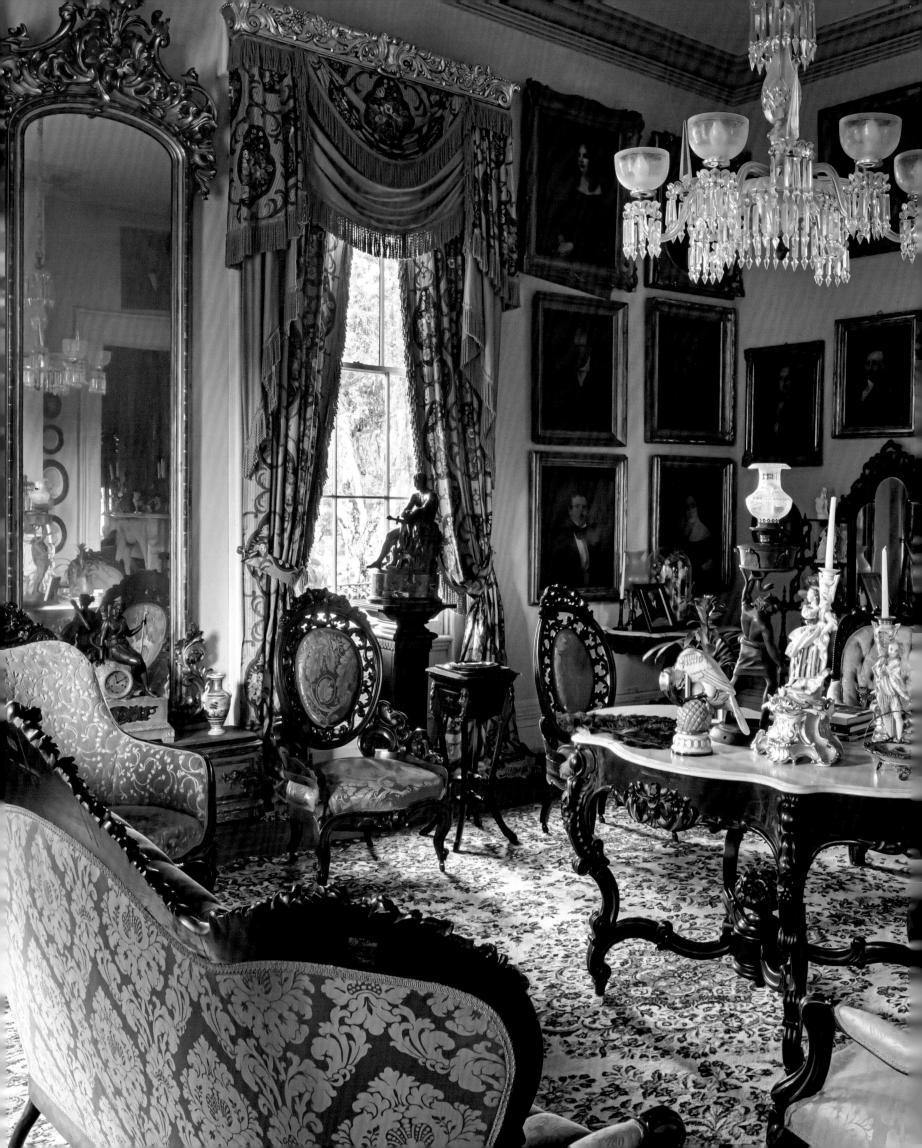

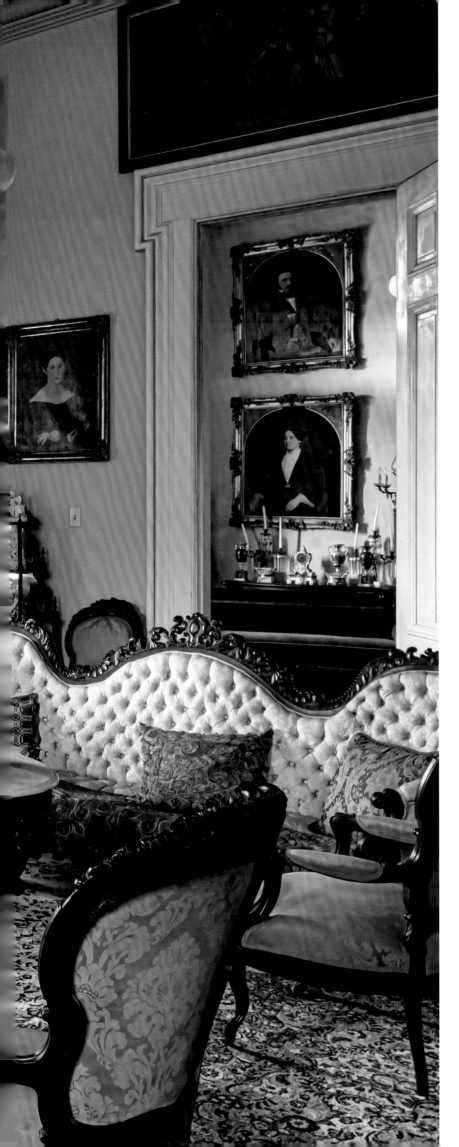

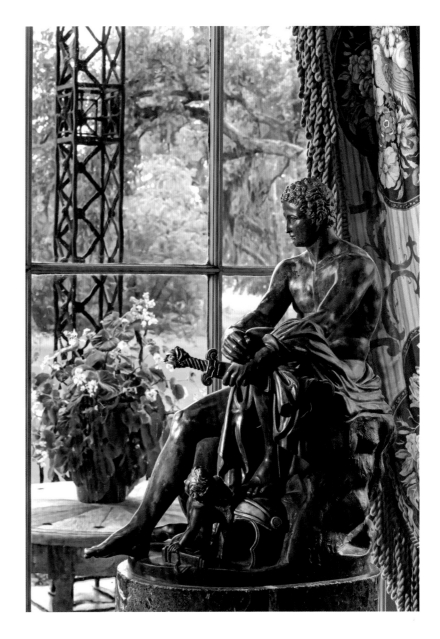

◄ A Meeks parlor set is gathered around a marble-top center table in the first-floor parlor.

▲ A Roman warrior in bronze fronts the window.

▲ An aviary painting, a small self-portrait, and a chair upholstered in "Bayou Casino" add energy to a classic setting.

▶ To preserve the original patina, the walls in Hunt's bedroom were not repainted. The room is centered on a half tester Prudent Mallard bed in mahogany.

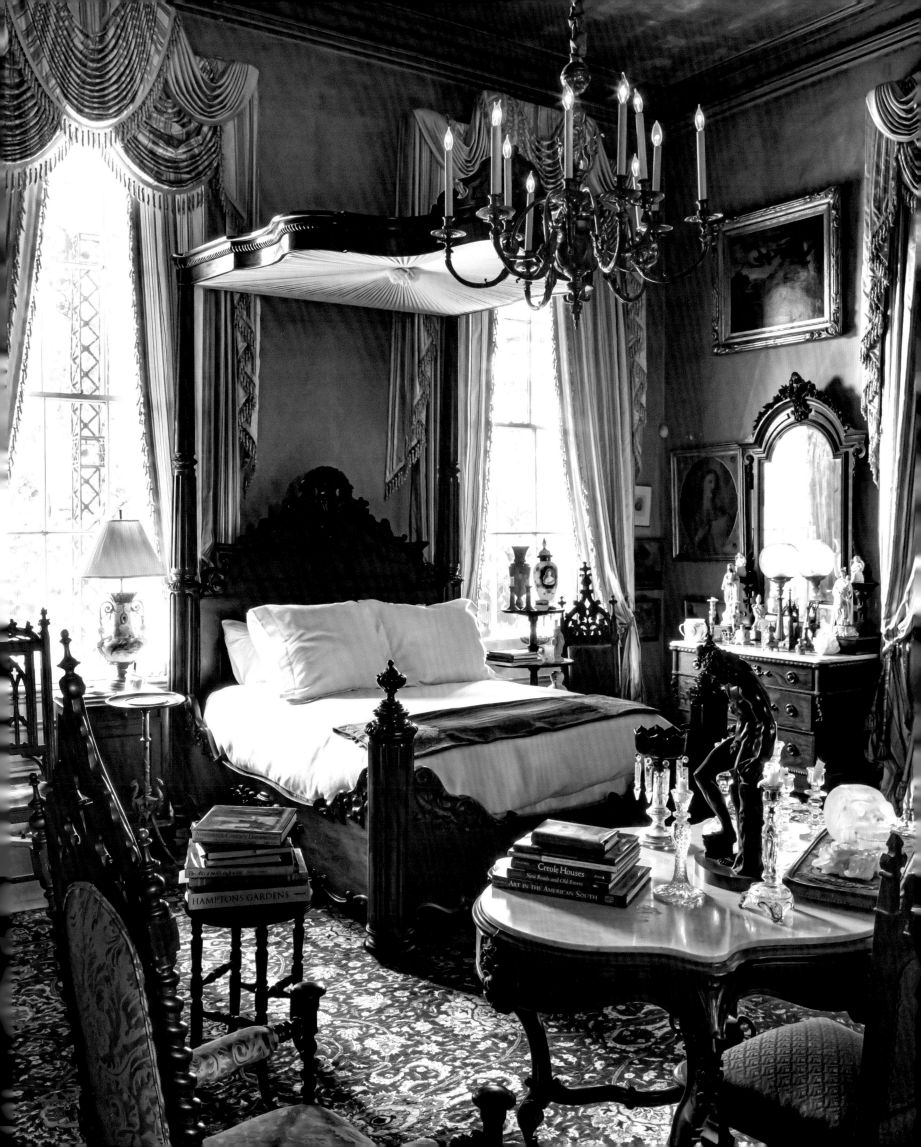

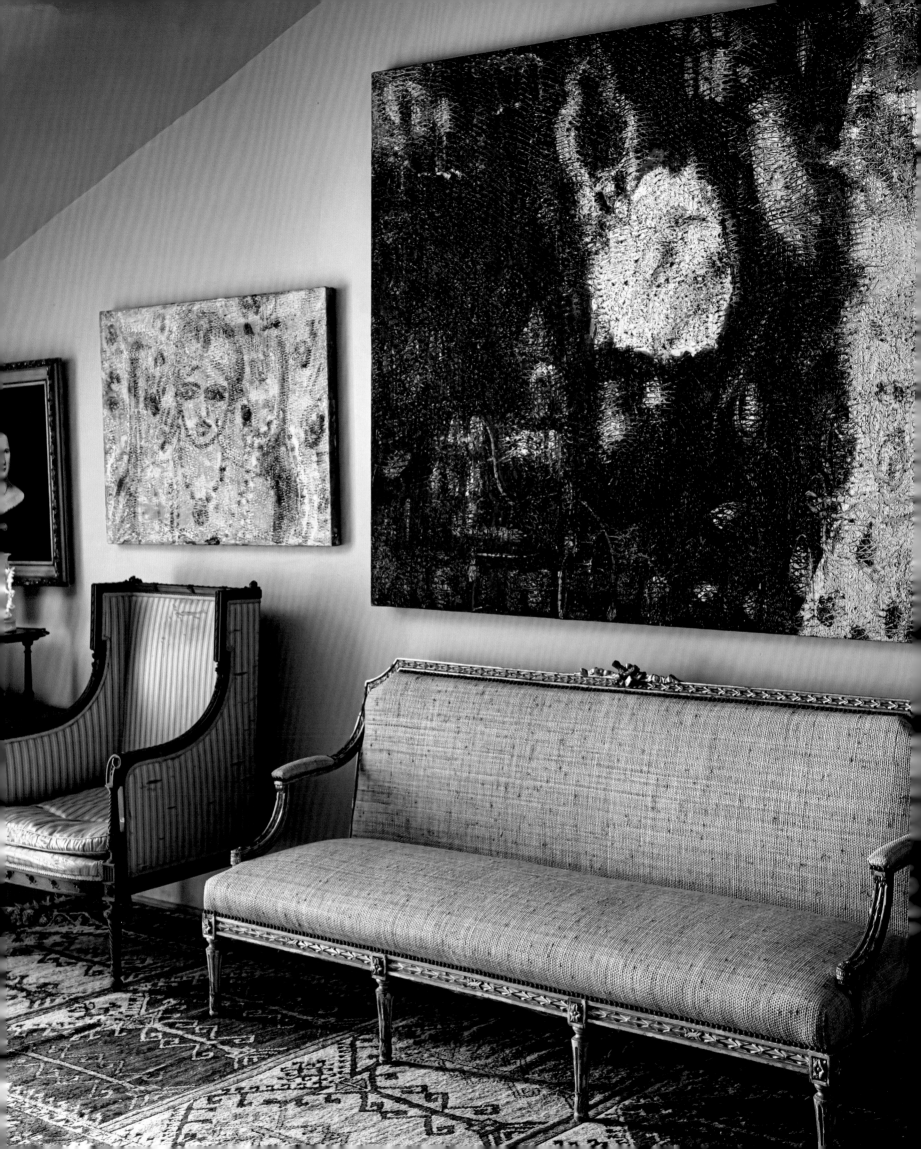

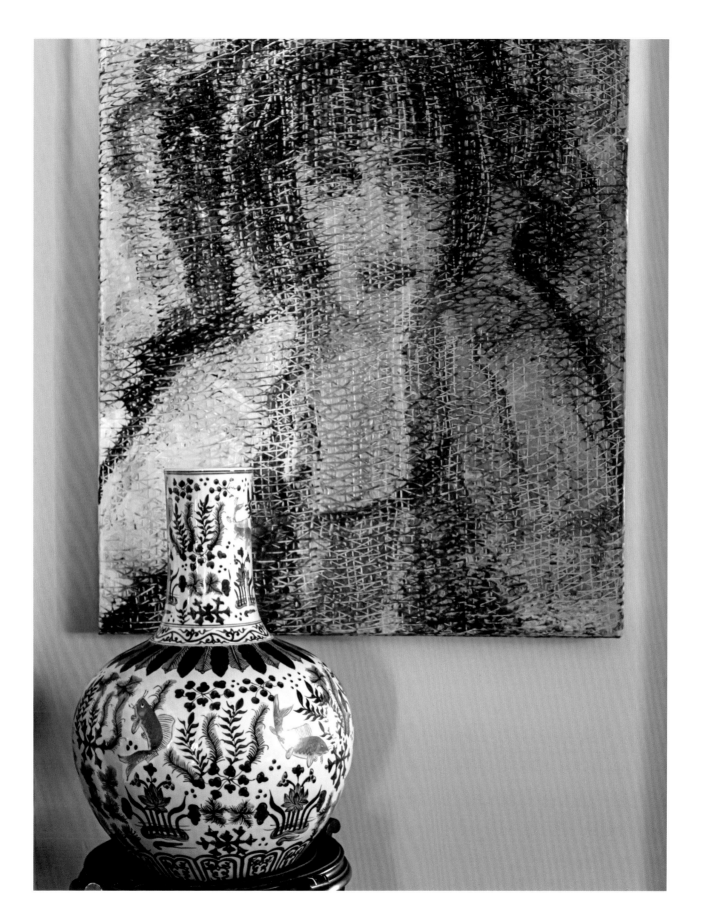

◄ *Blue Picul* and a painting of *The Countess* above a raffia-covered sofa are on the third floor.

▲ The vibrant colors of *The Countess* are repeated in an antique oriental vase.

The reading room is lined with Japanese
prints and a wall of bunnies.

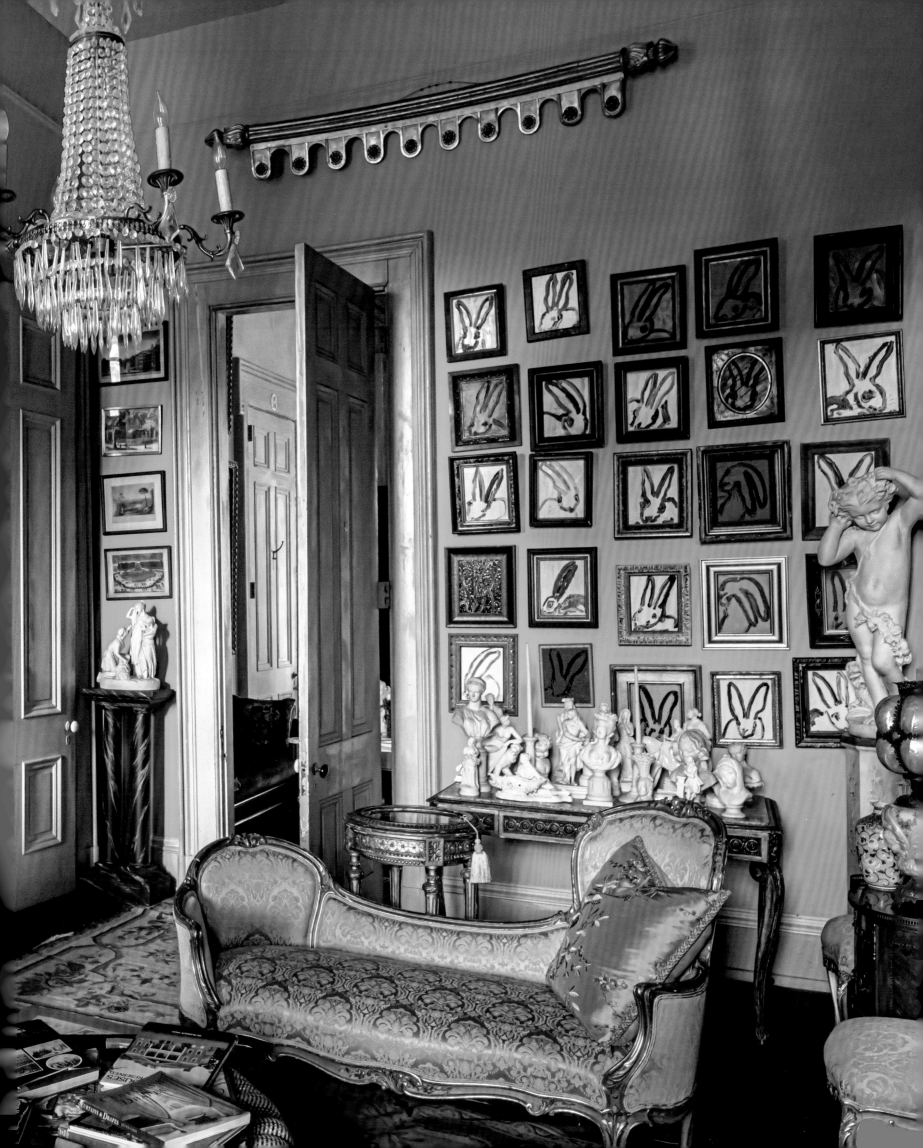

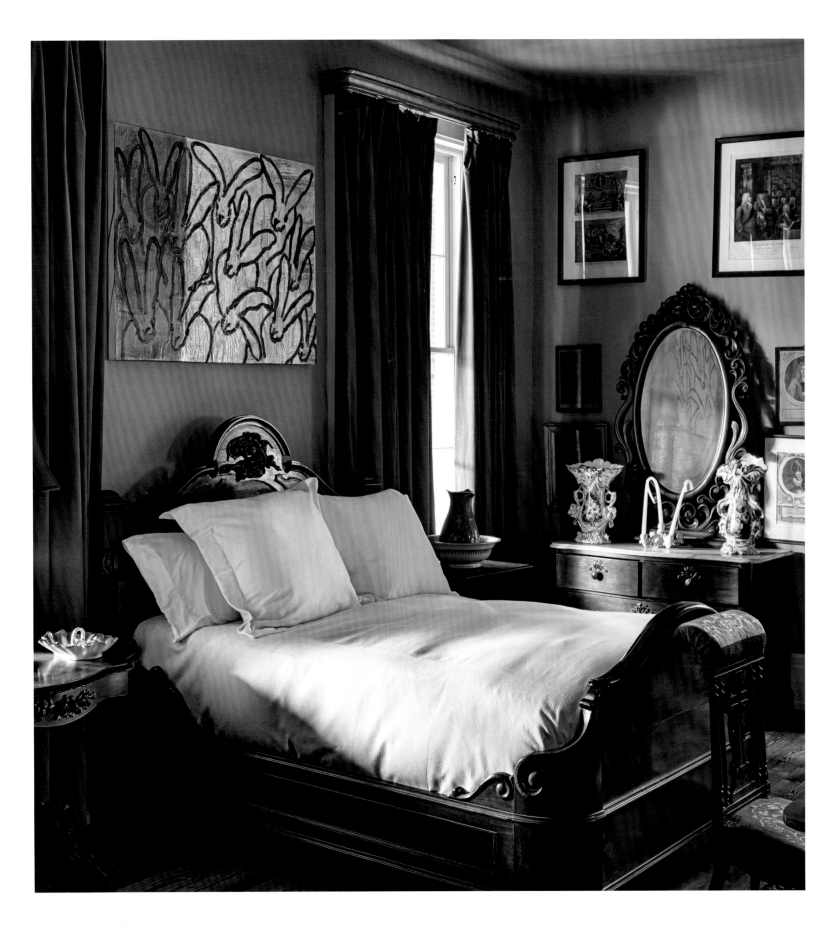

▲ *Three Metallic Hutch* hangs in a downstairs bedroom. ▶ Marble busts, oriental porcelains, and a delightful ombré bunny painting complement the blue bedroom.

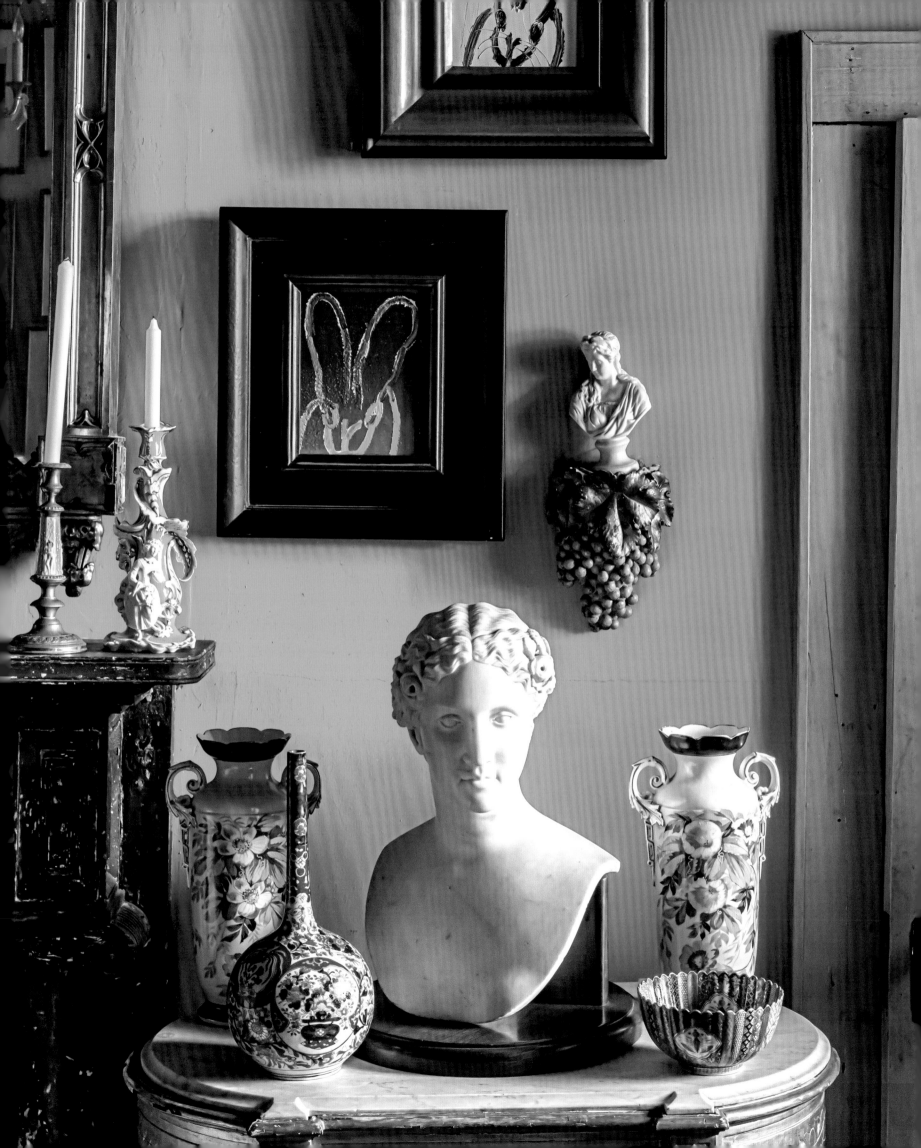

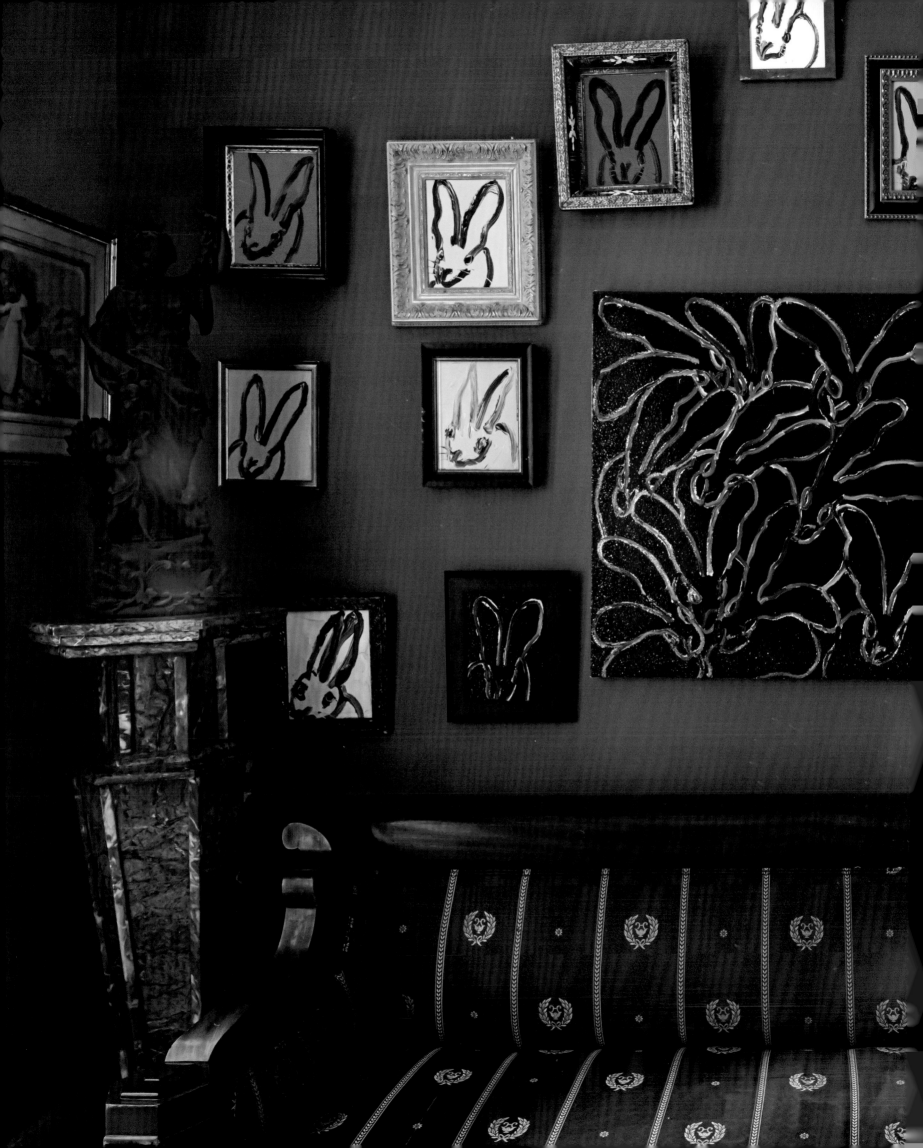

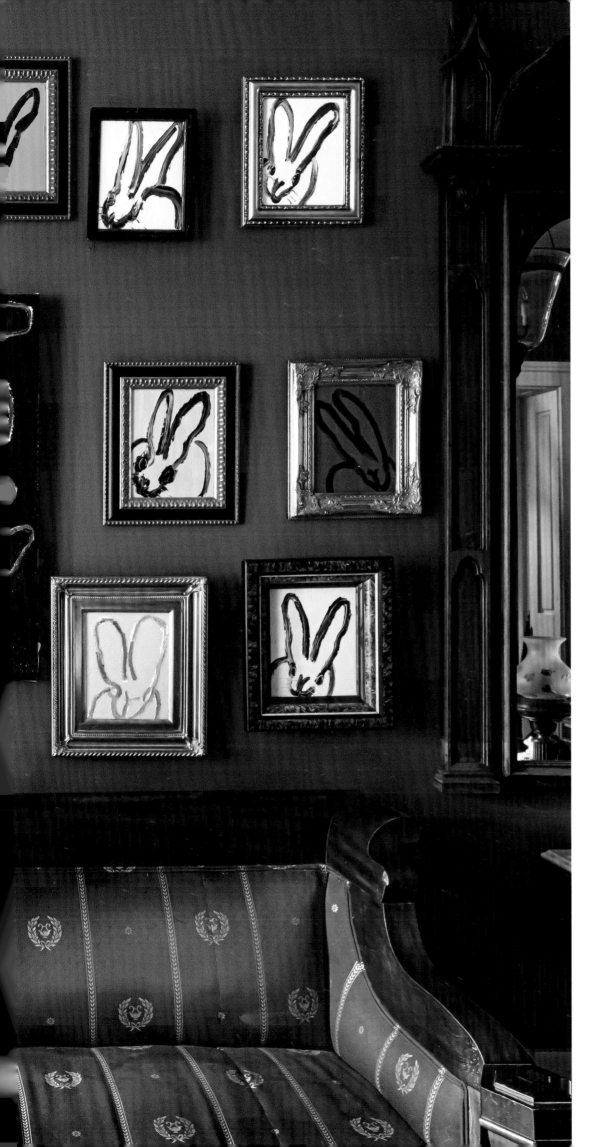

An Empire sofa rests beneath a wall of bunny paintings and *Diamond Dust Hutch.*

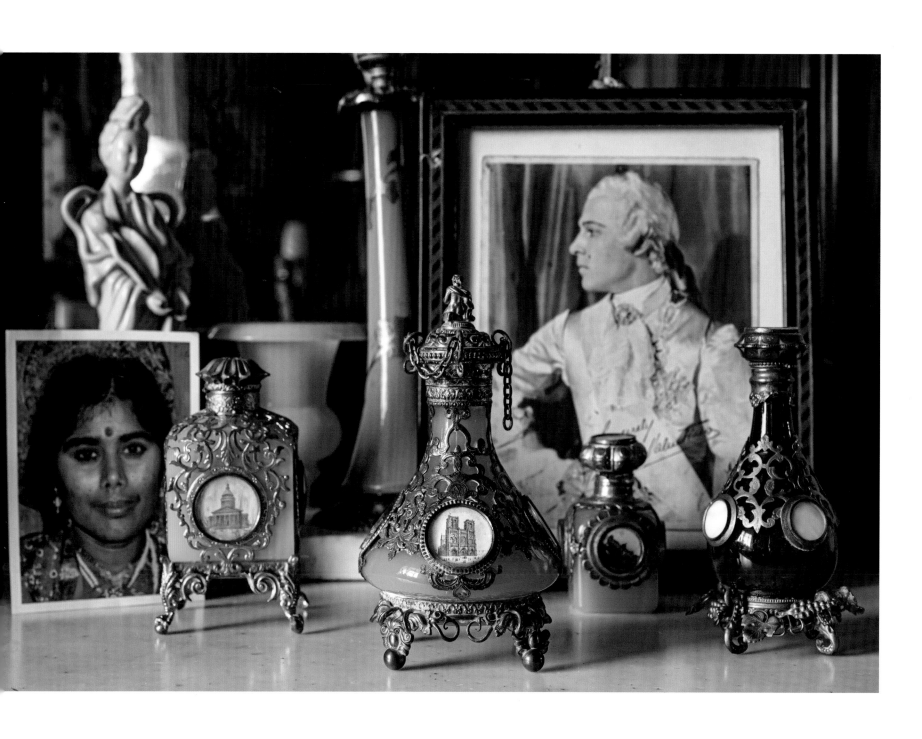

▲ Hunt keeps sources of inspiration on his bureau—
including Mother Meera and Rudolf Valentino—along
with Palais Royale scent bottles.

▶ Candles wilt from the heat in a third-floor bedroom
under the eaves.

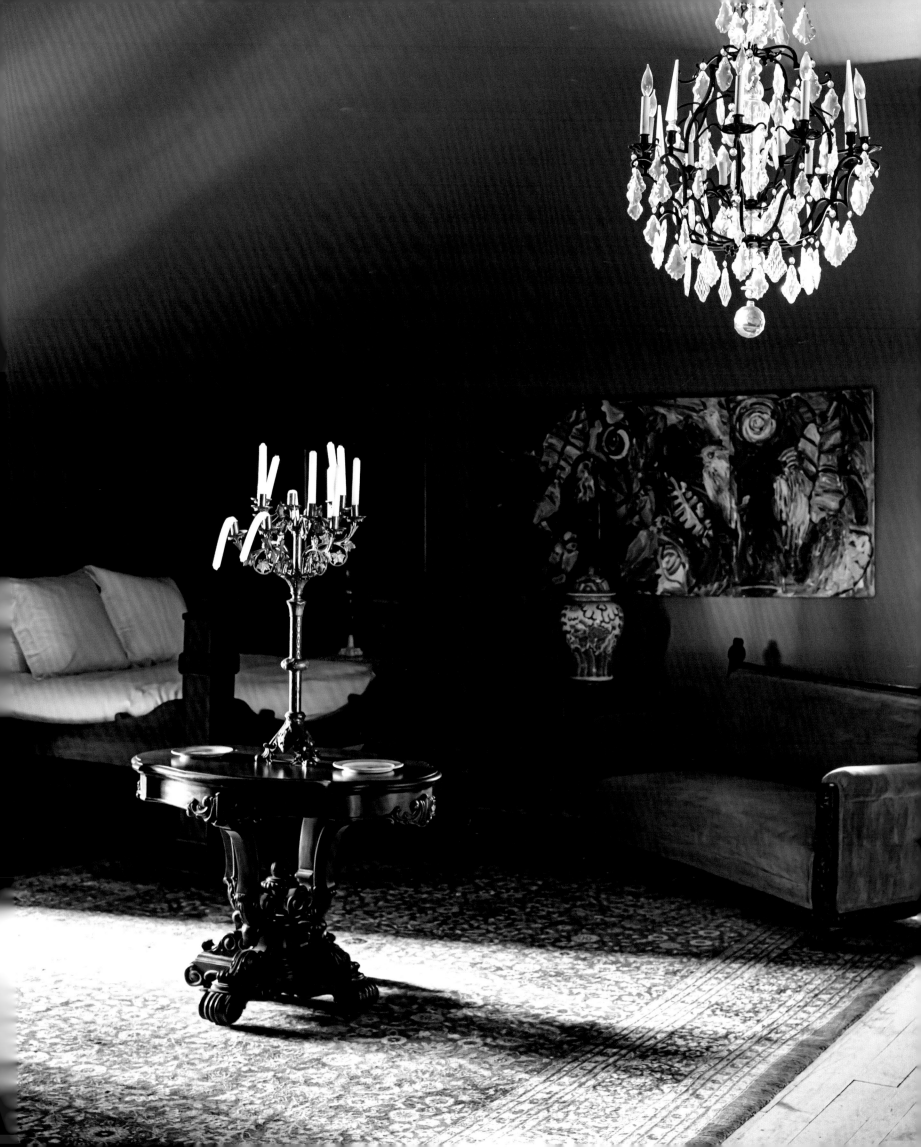

◄ *Flowers* hangs behind a collection of Bristol glass vases on the third floor.

▲ A bust of Prince Albert grandly sits in front of *The Countess*.

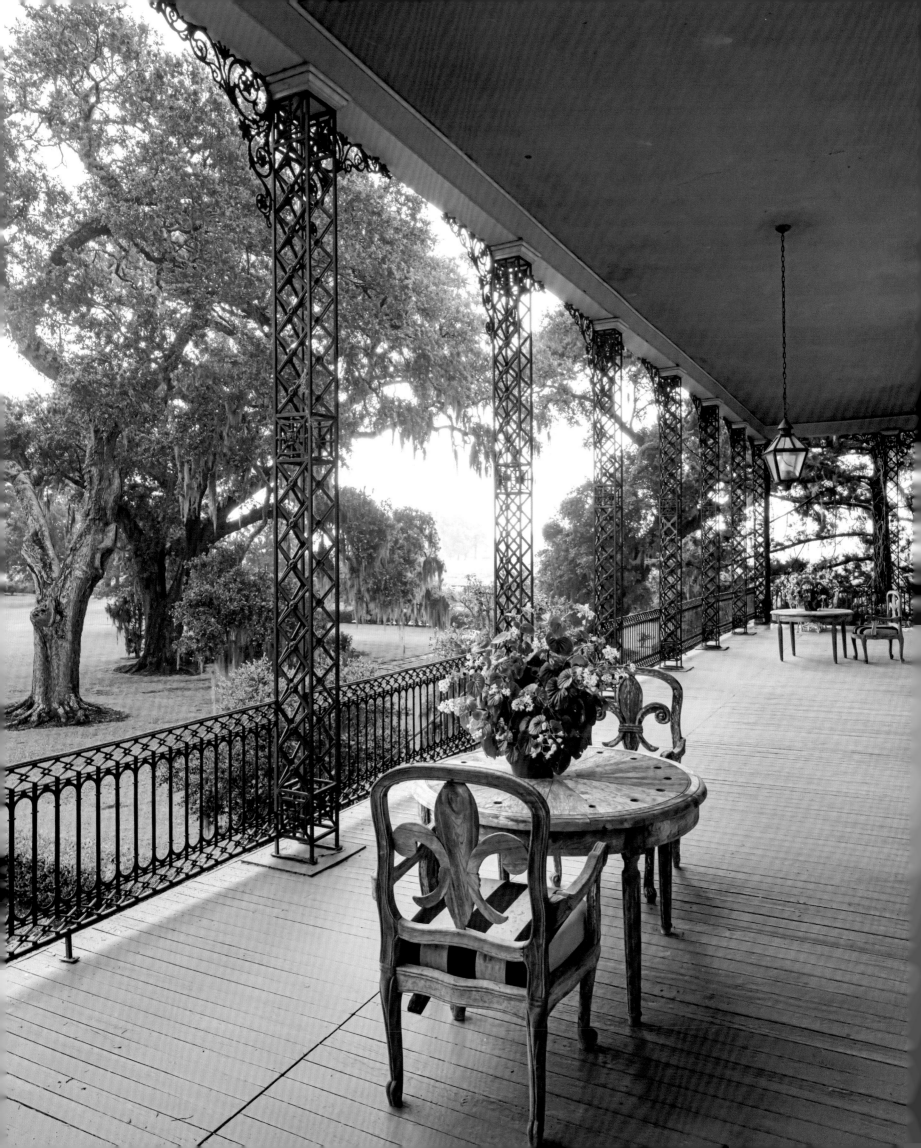

◄ The front porch looks out over the grounds and the levee beyond.

▲ A carved lion enhances the front door.

▶ A stone statue of Hercules defends the garden.

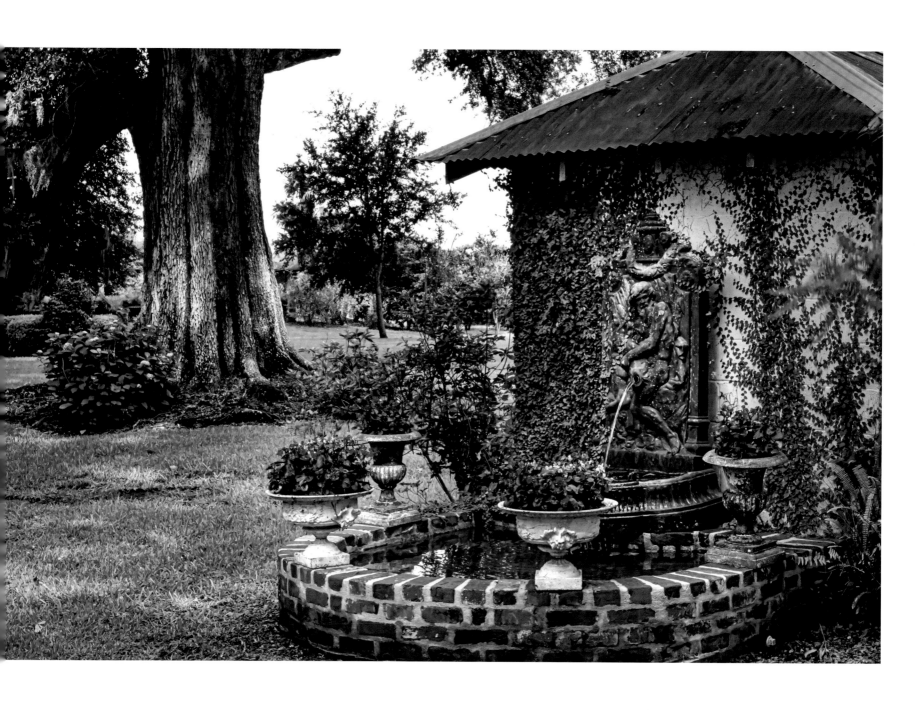

Fountains, cast-iron urns, citrus and palm trees, and brick surrounds were added to the back garden.

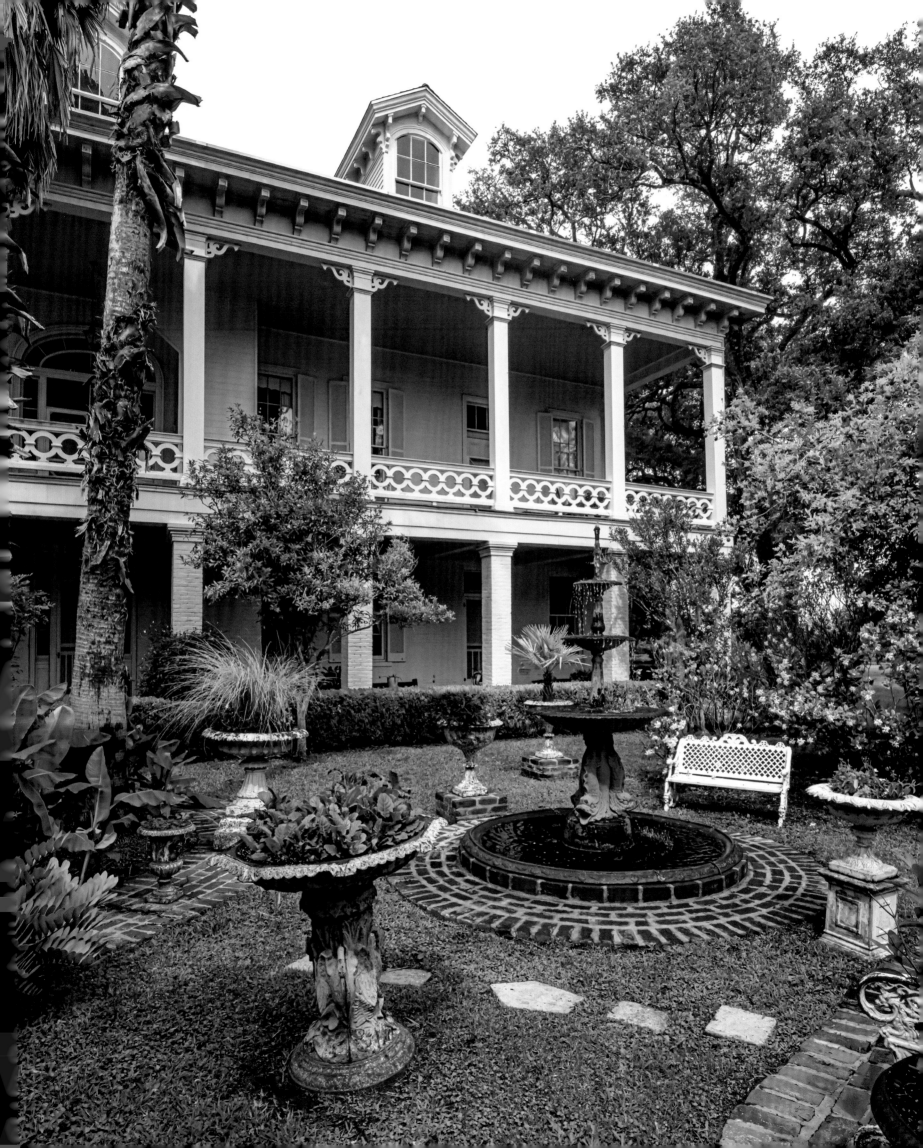

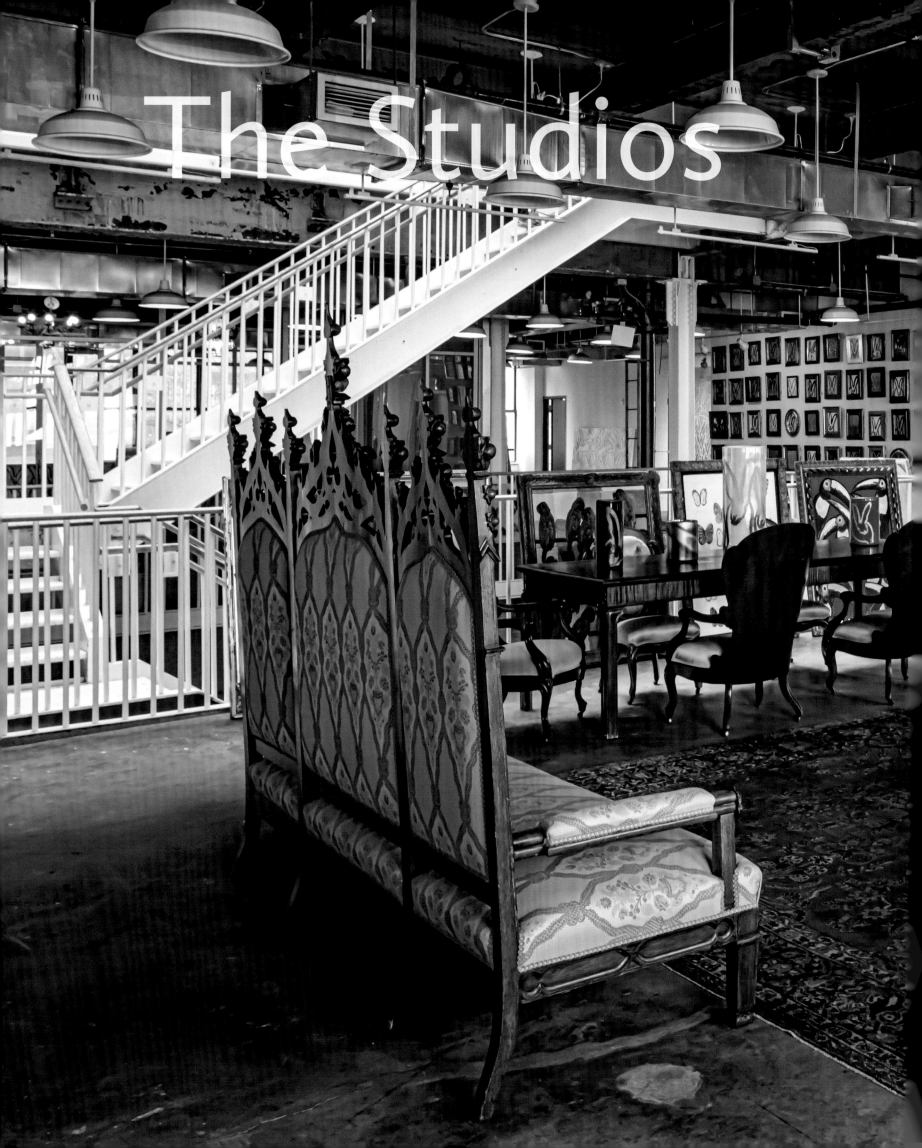

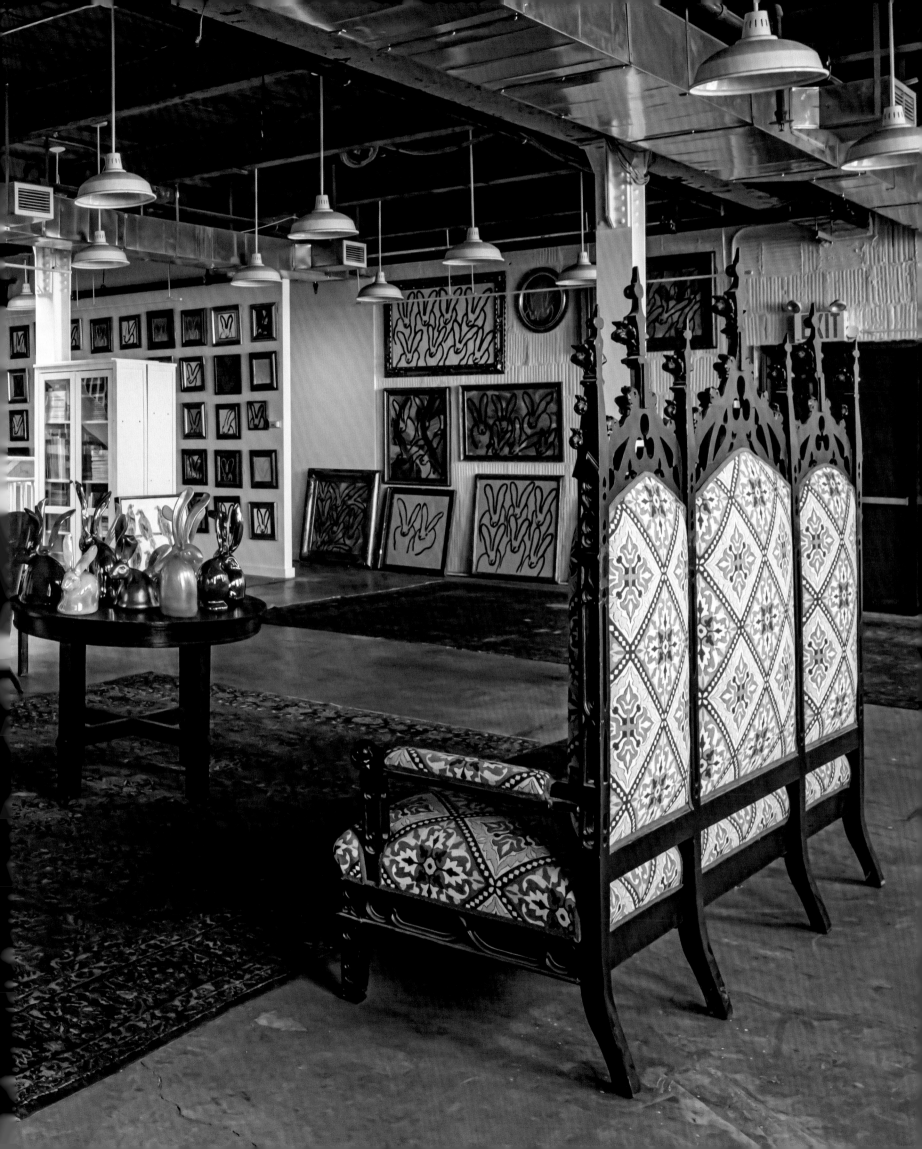

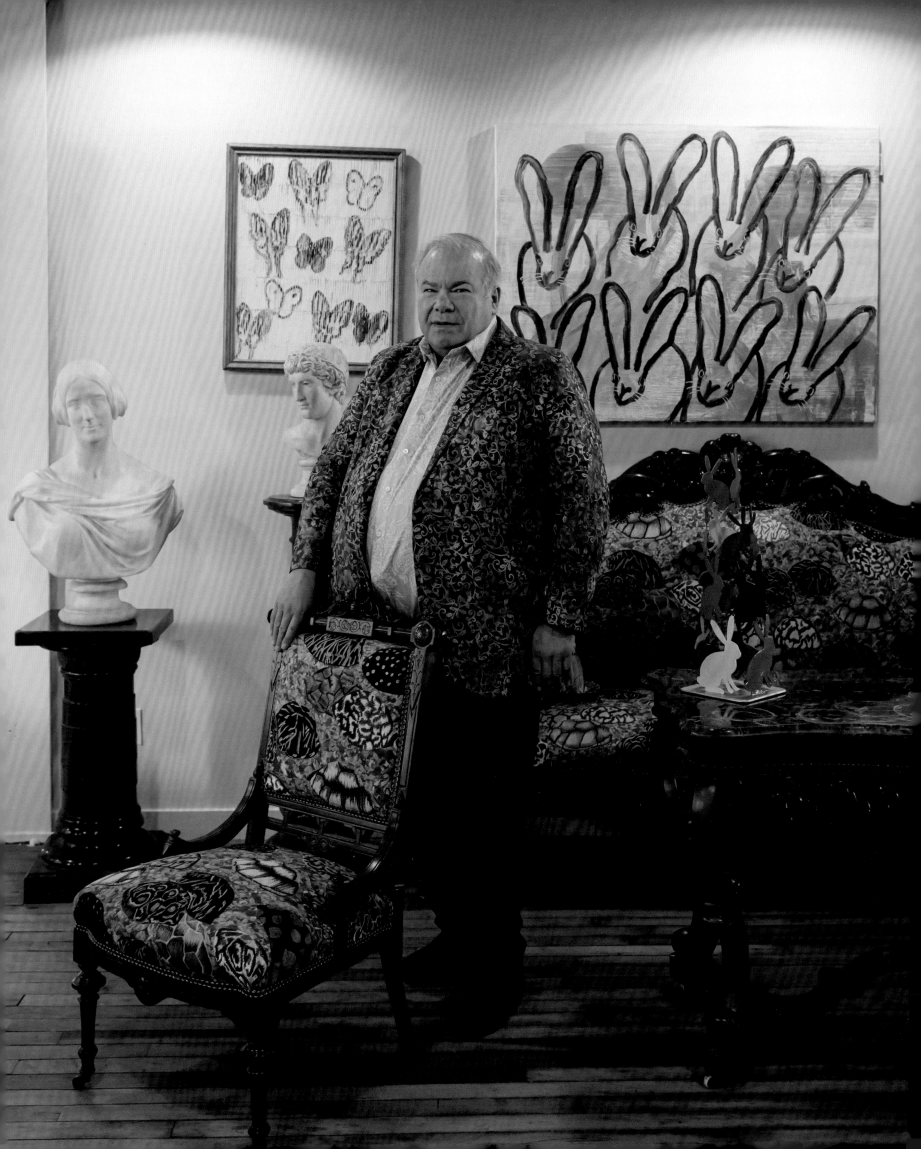

The Studios New York City

Featured here are two of Hunt's studios: the previous one, where he worked from 2015 to 2022, and his current studio in New York City, where he has been since 2022. Hunt surrounds himself with collections, creating environments that are extensions of his art, a theme that we see repeatedly in his homes.

Inspired by his childhood in Hawaii and a year as an exchange student in Nicaragua, Hunt celebrates the beauty and spirituality of nature—butterflies, birds, bunnies, and orchids are consistent subjects of his work.

In the previous studio, walls of bunny paintings—many in period frames—lined corridors opening to brightly colored and richly decorated rooms: for instance, neo-Gothic chairs set against a vivid green wall hung with paintings of parrots and bunnies; classic urns clustered on a table in front of neo-Expressionist portraits of Abraham Lincoln and Queen Elizabeth; Victorian top hats massed on a tabletop; orchids and exotic plants in period jardinières.

Painting is a spiritual endeavor for Hunt, and he likes to begin each day painting bunnies; the repetition is a meditative process for him. He then often works on larger canvases that are displayed in the light-filled ground floor of his New York City studio—paintings of multihued lories or kaleidoscopes of butterflies, which he studied as a boy and now paints from memory, another process of repetition. Early life memories, in fact, inspire the subject matter of many of his compositions: a heavily carved Victorian sofa set against a deep red wall is upholstered in "Star of India," Hunt's fabric of tortoises reminiscent of a former pet. The name also refers to a famous, large sapphire and to Indira Devi, the Maharani of Cooch Behar in the foothills of the Eastern Himalayas, who always carried a jeweled tortoise for good luck.

Previous overleaf: Gothic Revival sofas create a seating area on the second floor of the Manhattan studio. The sofas were made by Louisiana cabinetmaker Henry Siebrecht in the 1850s.

◄ Hunt stands by a nineteenth-century, carved sofa and side chair upholstered in his "Star of India" fabric for Lee Jofa. *Chinensis Bunny* and *Swallow Tails and Morning Cloaks* (oil on wood) paintings hang on the wall.

Color is vital for Hunt and is used throughout the studios, transforming the industrial spaces. In the New York studio, one is greeted at the top of the stairs by a deep blue wall hung floor to ceiling with paintings of bunnies in many colors, while in another room, a gilded Victorian sofa upholstered in blue-and-white "Fritillary," Hunt's fabric of embroidered butterflies, rests in front of a floor-to-ceiling canvas of citron cockatoos.

Art, for Hunt, is combining multiple art forms as a creative whole, as we see in his studios.

◄ Hunt's blown-glass bunny sculptures.

▲ A velvet pouf rests in front of a wall of bunny paintings in the Manhattan studio and a Bunny Pillow from the New York City Hop Up Shop. An acrylic-and-wood Toucan and a plaster, wood, diamond dust, and resin Bunny sculpture are displayed alongside.

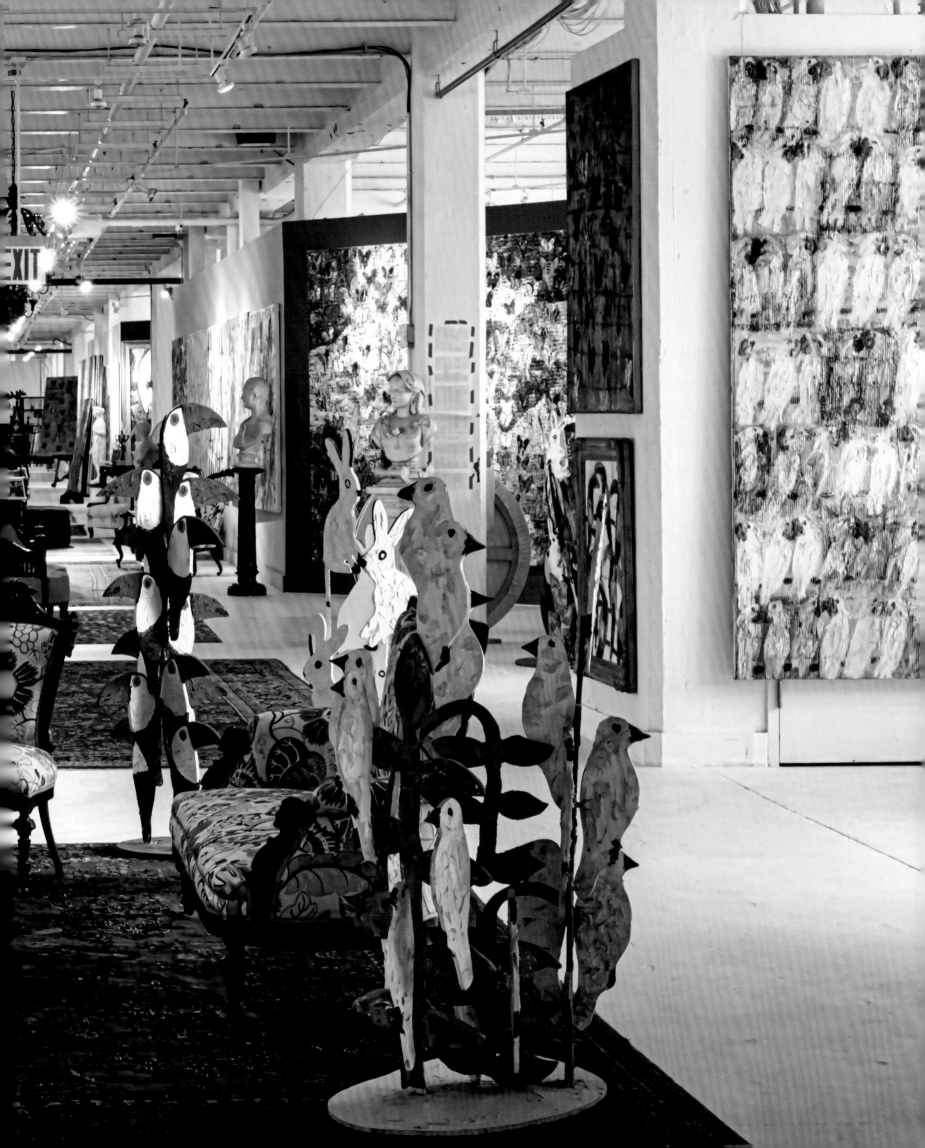

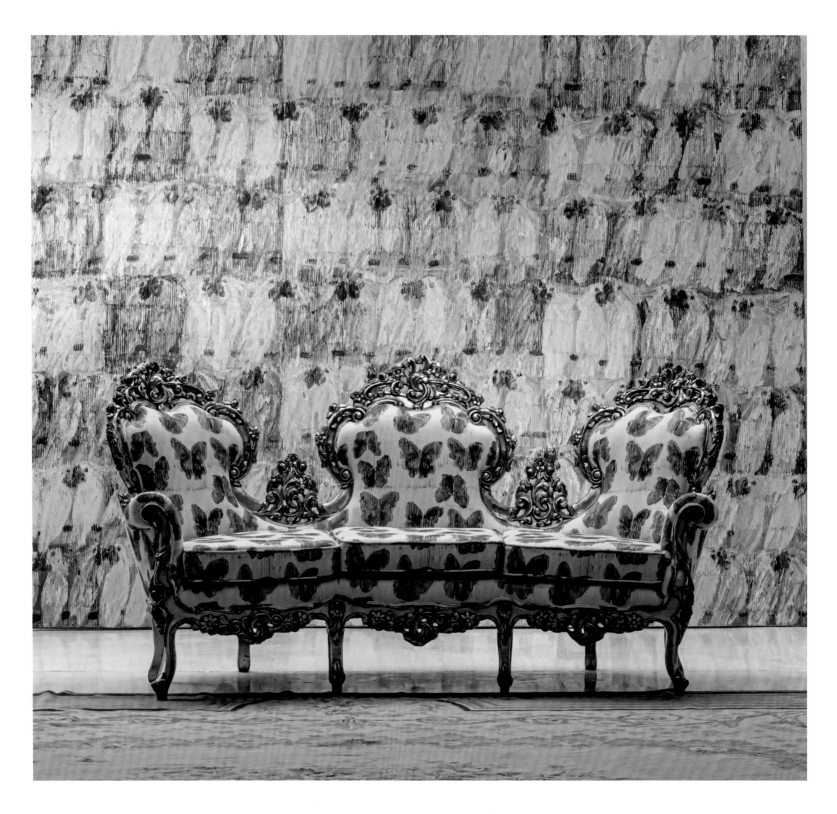

Previous overleaf: A long shot of the previous studio; rooms for display open off the central corridor. Victorian side chairs are upholstered in a floral fabric that Hunt found in England.

▲ An antique gilded sofa rests in front of the immense *Cockatoo Whisper* oil-on-canvas painting on the first floor of the Manhattan studio.

▶ *Finches* hangs on a Manhattan studio wall, partially behind a marble neoclassical bust of Cupid and Psyche. Hunt's blown-glass-on-velvet *Trophy* sculptures hang next to a *Totem* painting.

Overleaf: A dining room–drying room in the previous studio displays an assemblage of porcelain vases and dinnerware in front of recent drying works. Veneered Belter chairs are set around the table.

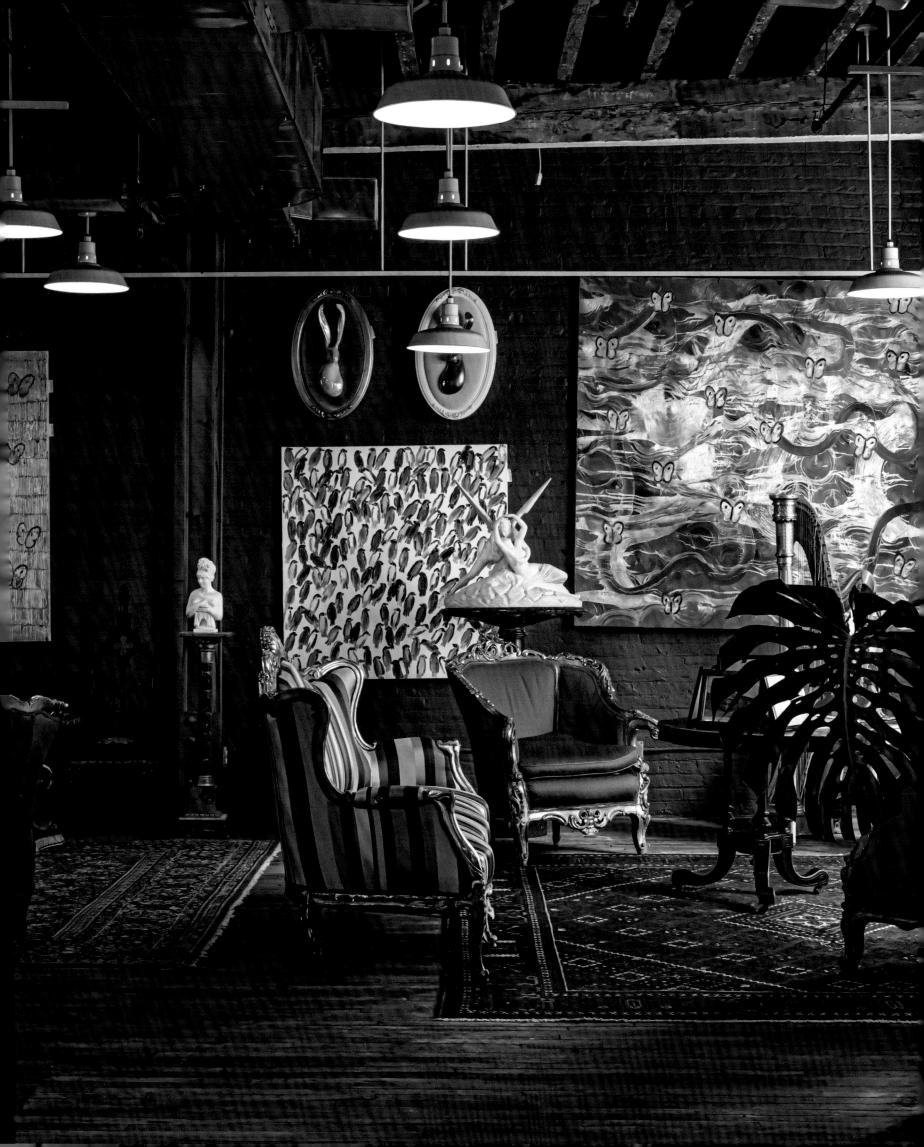

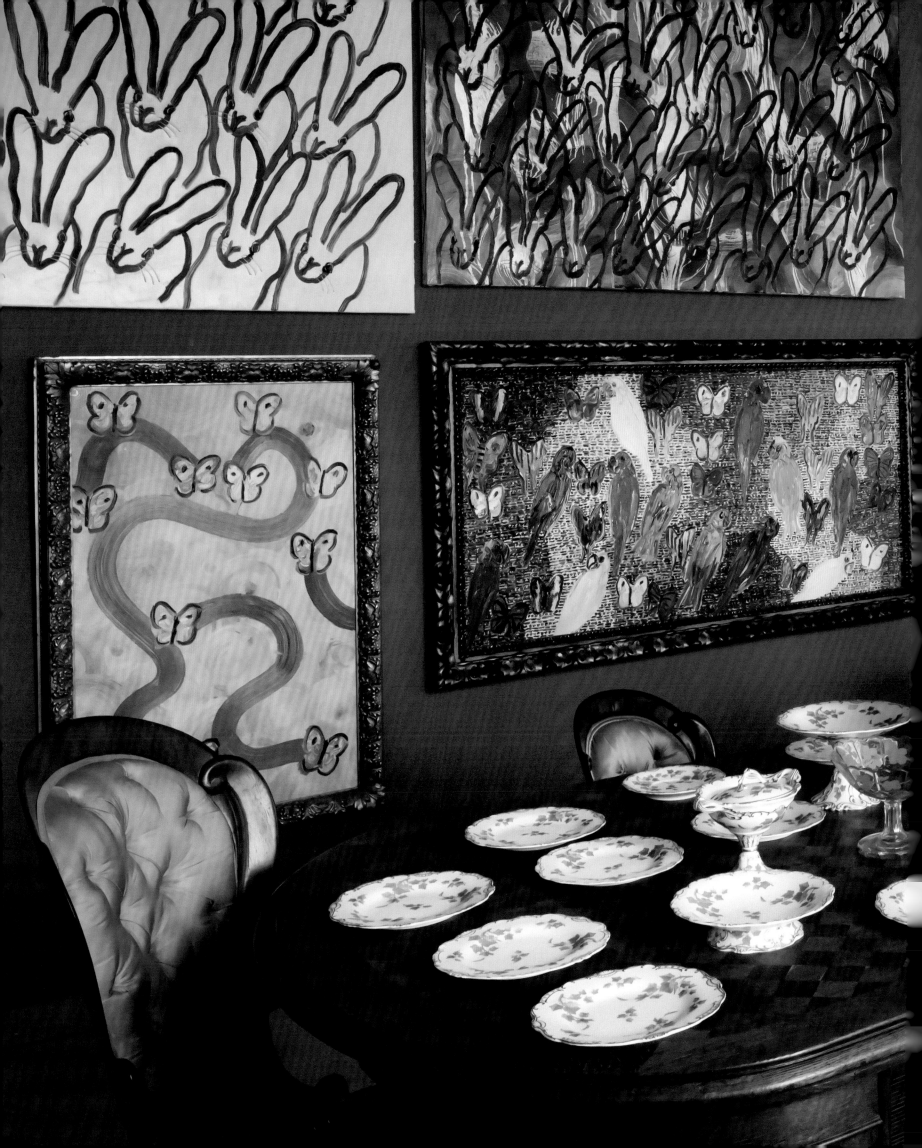

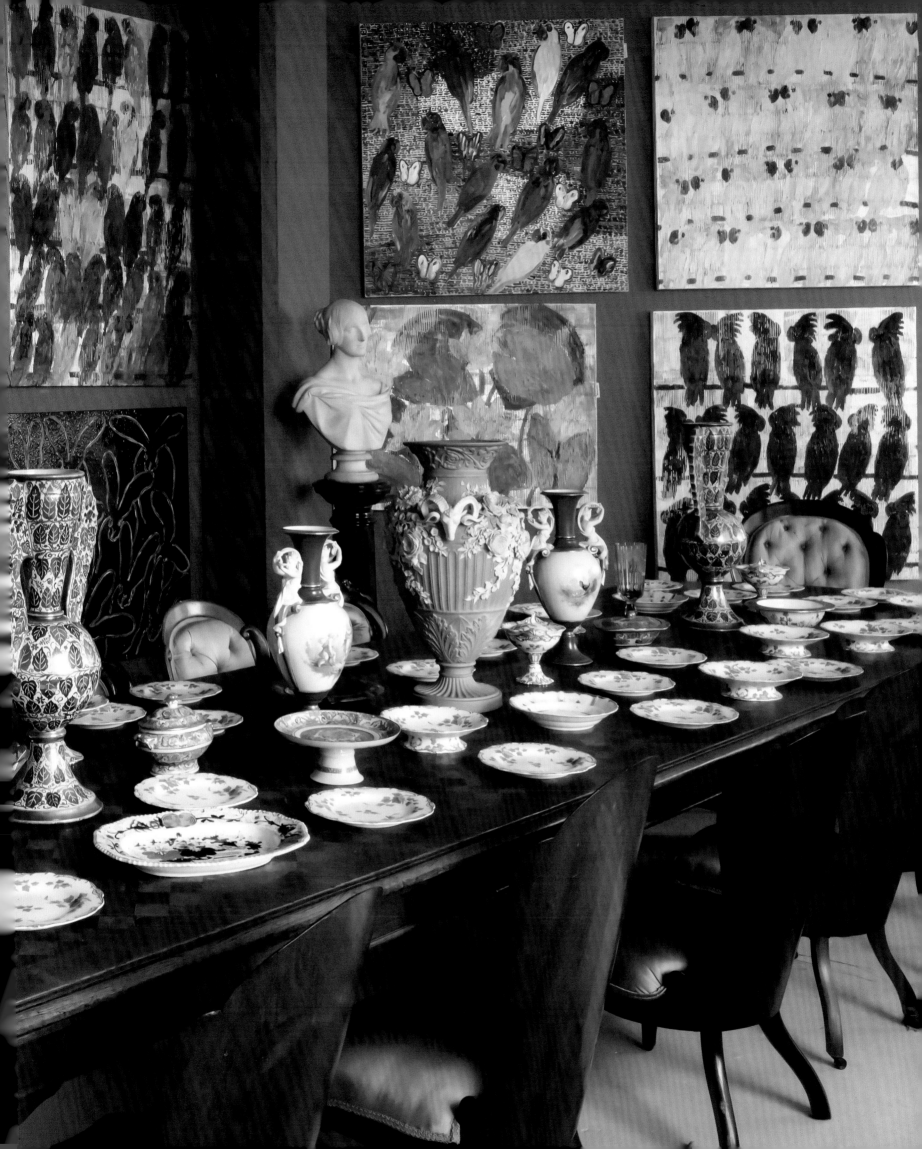

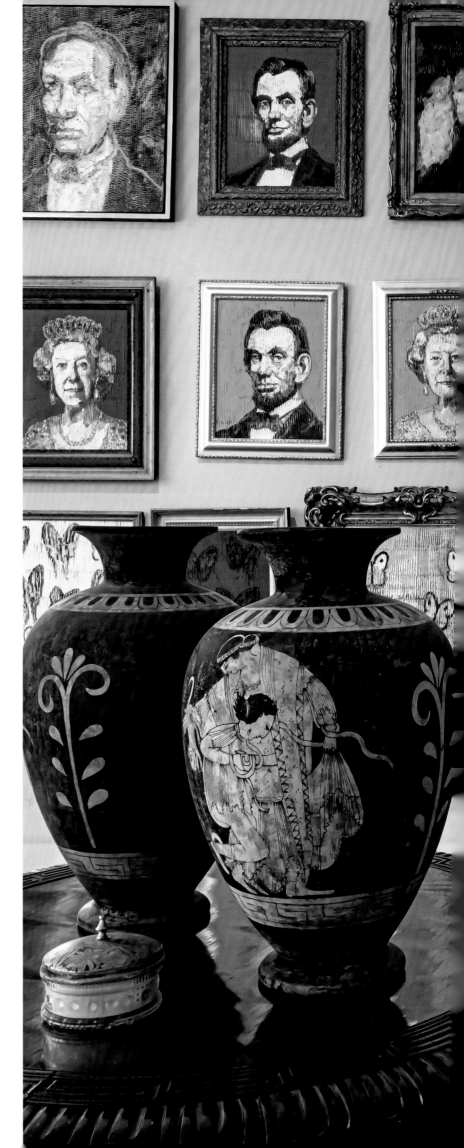

▲ "Hutch" fabric, for Lee Jofa, enlivens an Empire mahogany sofa in the Manhattan studio.

▶ A portrait room in the previous studio includes paintings of *Abraham Lincoln*, *Her Majesty*, and *Sylvia Miles*.

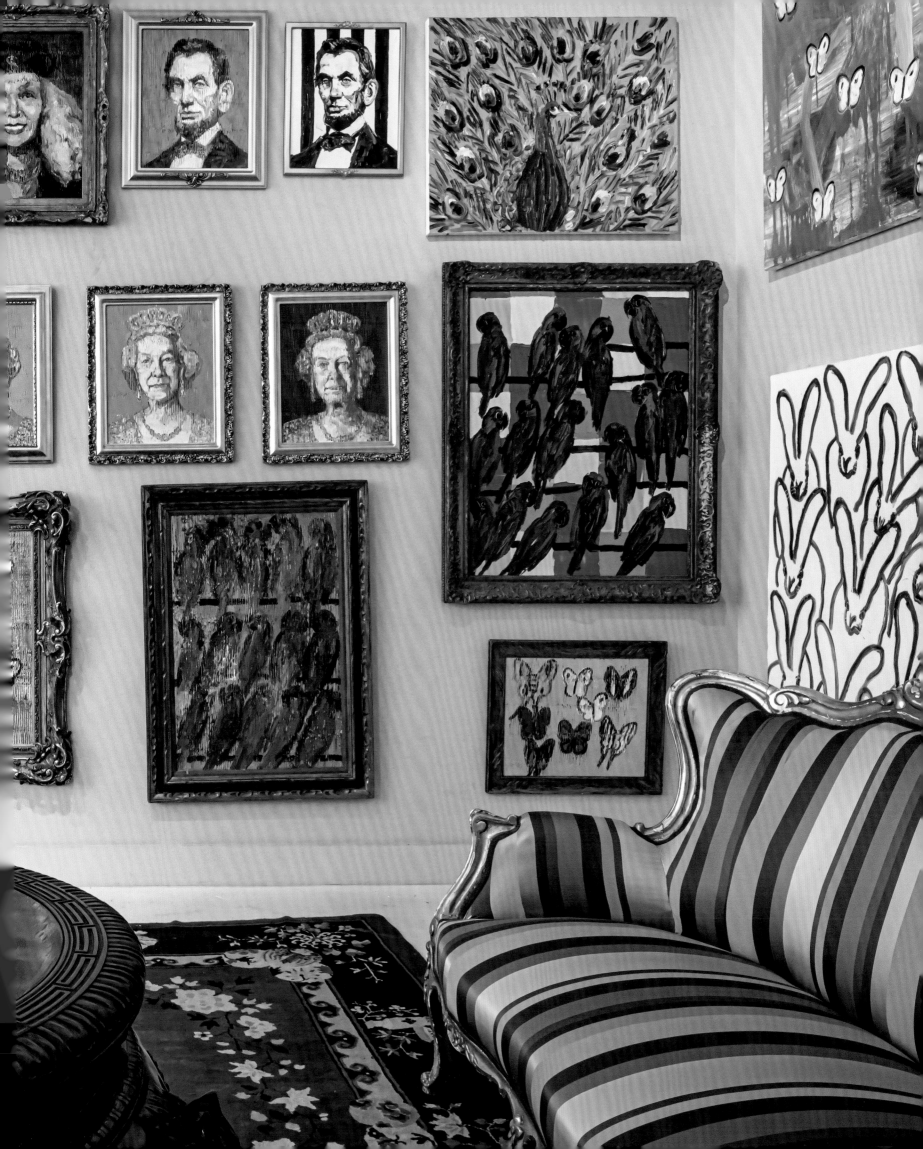

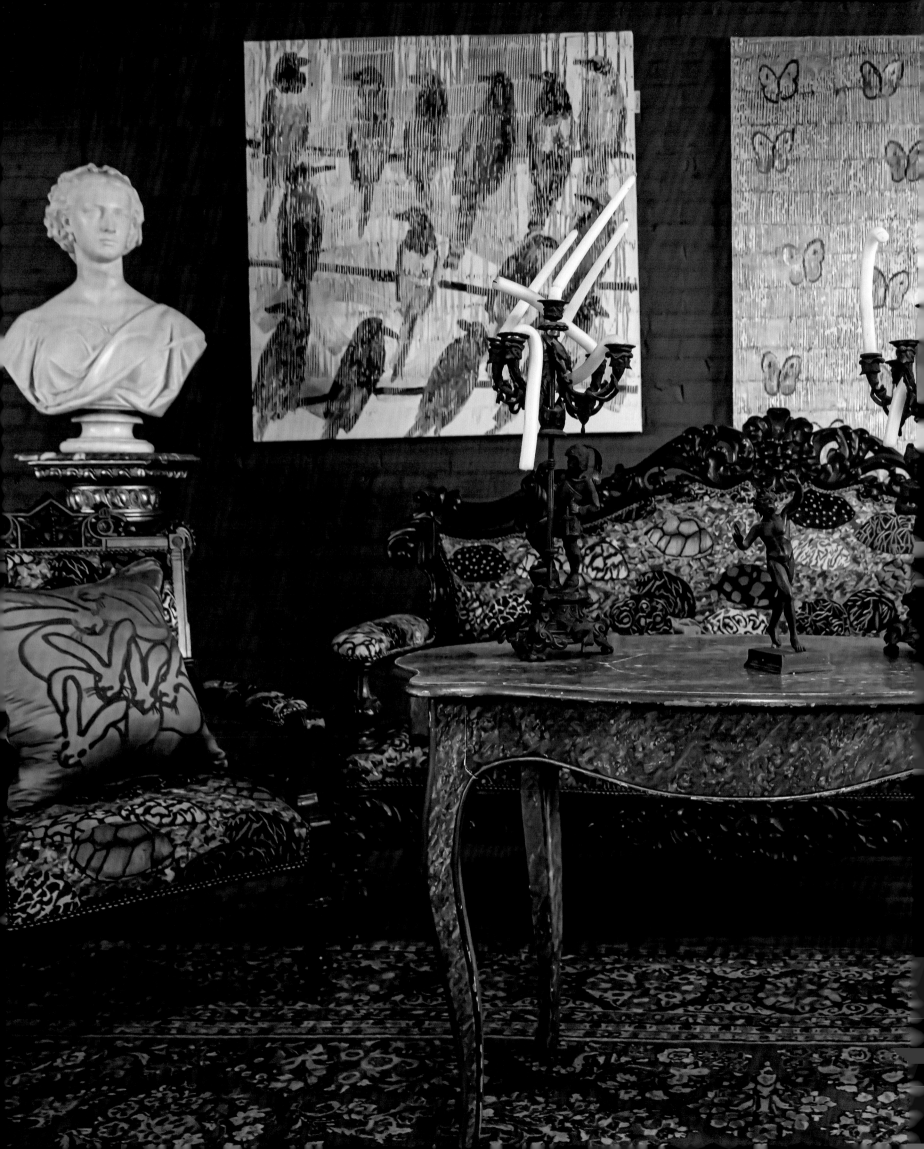

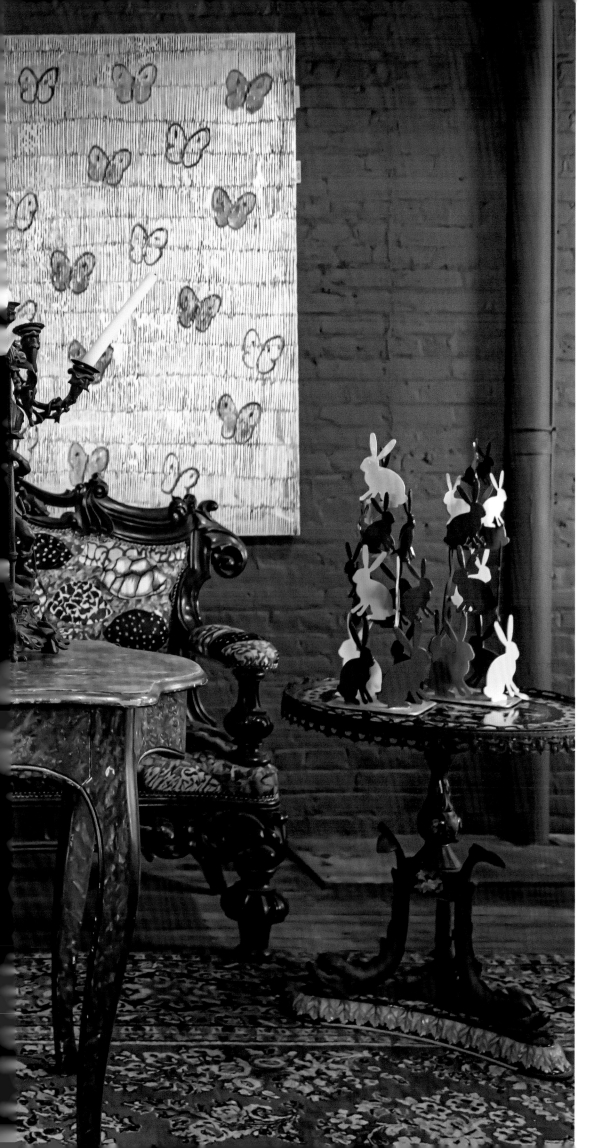

"Star of India" fabric, for Lee Jofa, complements an ornate Victorian sofa and chair in the Manhattan studio. *Trogon*, a painting of rare Mexican birds, and *Blue Ascension* hang behind. A marble bust of Princess Charlotte rests on a gilded pedestal in the corner, and a metal-and-paint sculpture of multicolored bunnies sits on the side table.

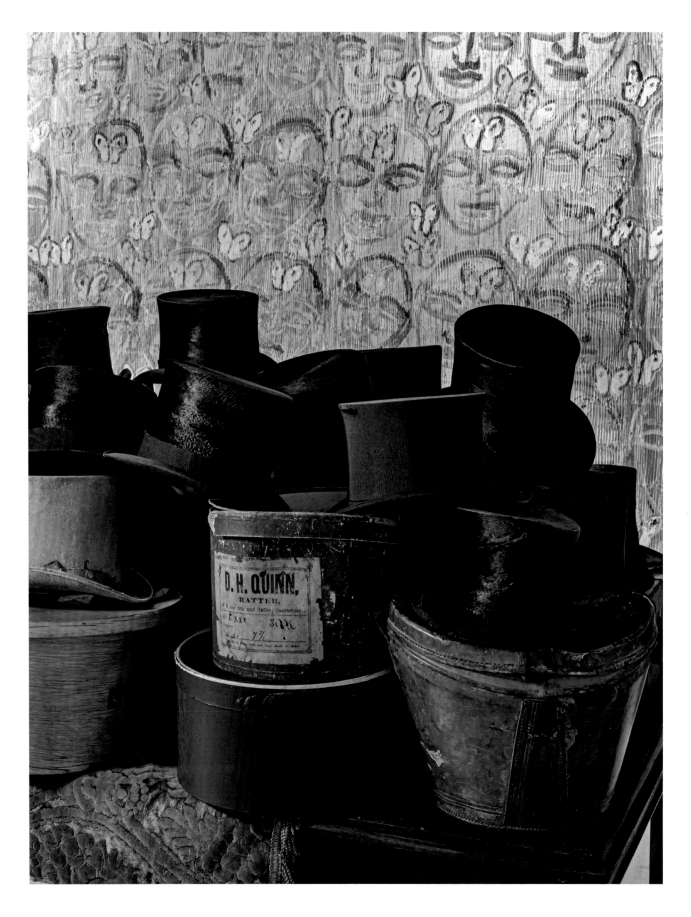

▲ A collection of top hats and carrying cases are backed by *Siddahs and Butterflies* (oil on canvas) in the previous studio.

▶ A stack of felt Fez hats purchased in Dubai centers a studio room hung with *Chinensis Bunny*, *Totem Swirl*, and *White Butterflies* paintings.

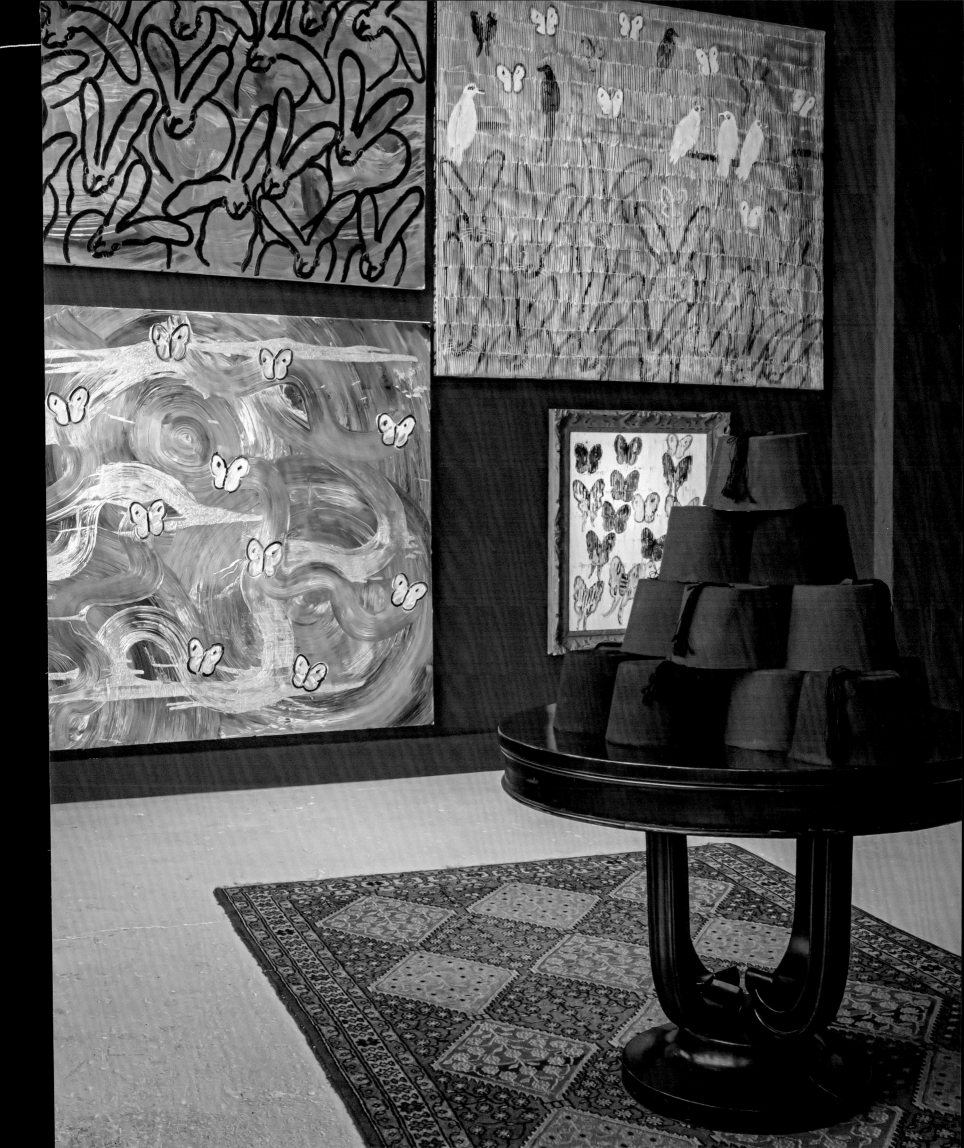

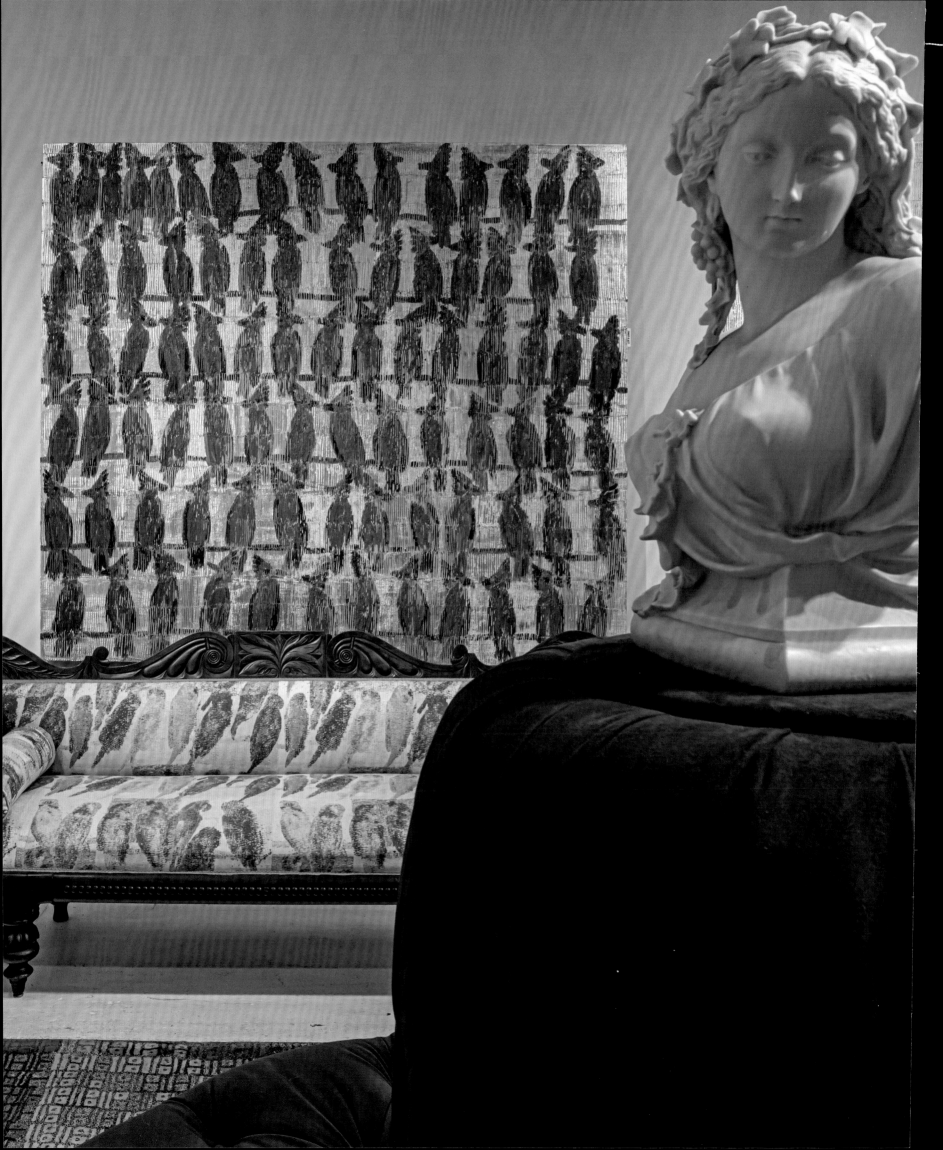

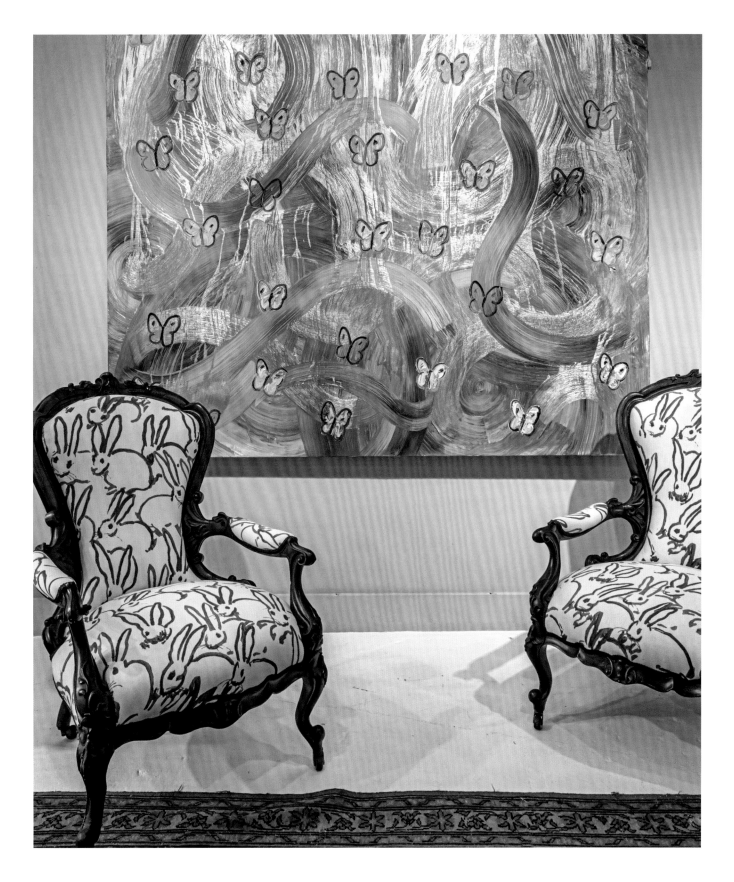

◄ A classic marble bust pairs with *Cardinals* painting in the background, previous studio. The sofa is upholstered in "Bayou Casino," named after Hunt's homes on the Louisiana bayous.

▲ "Hutch" updates a pair of nineteenth-century chairs. The painting is *Totem Swirl*.

Overleaf: A collection of Blenko glass vases centers a room hung with paintings, including *Red Sea* in an elaborate nineteenth-century, gilded, plaster and wood frame.

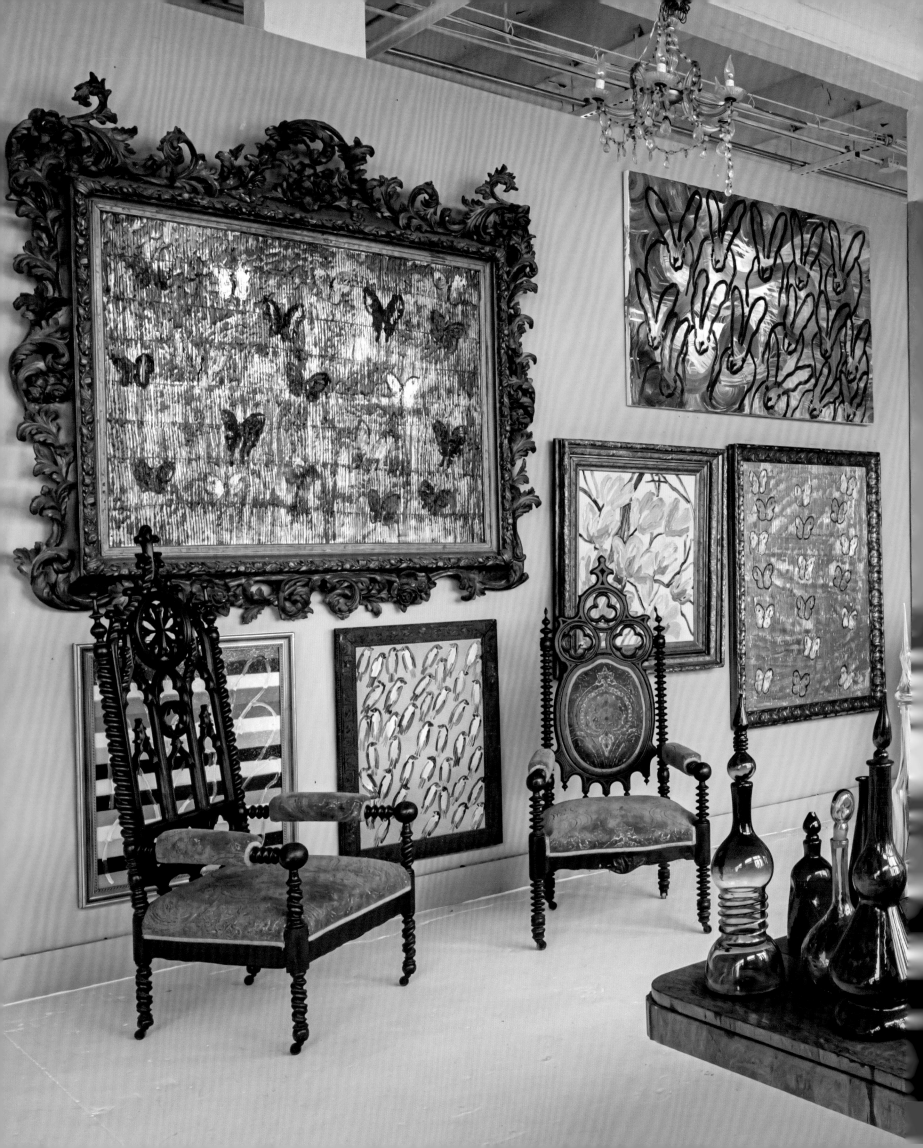

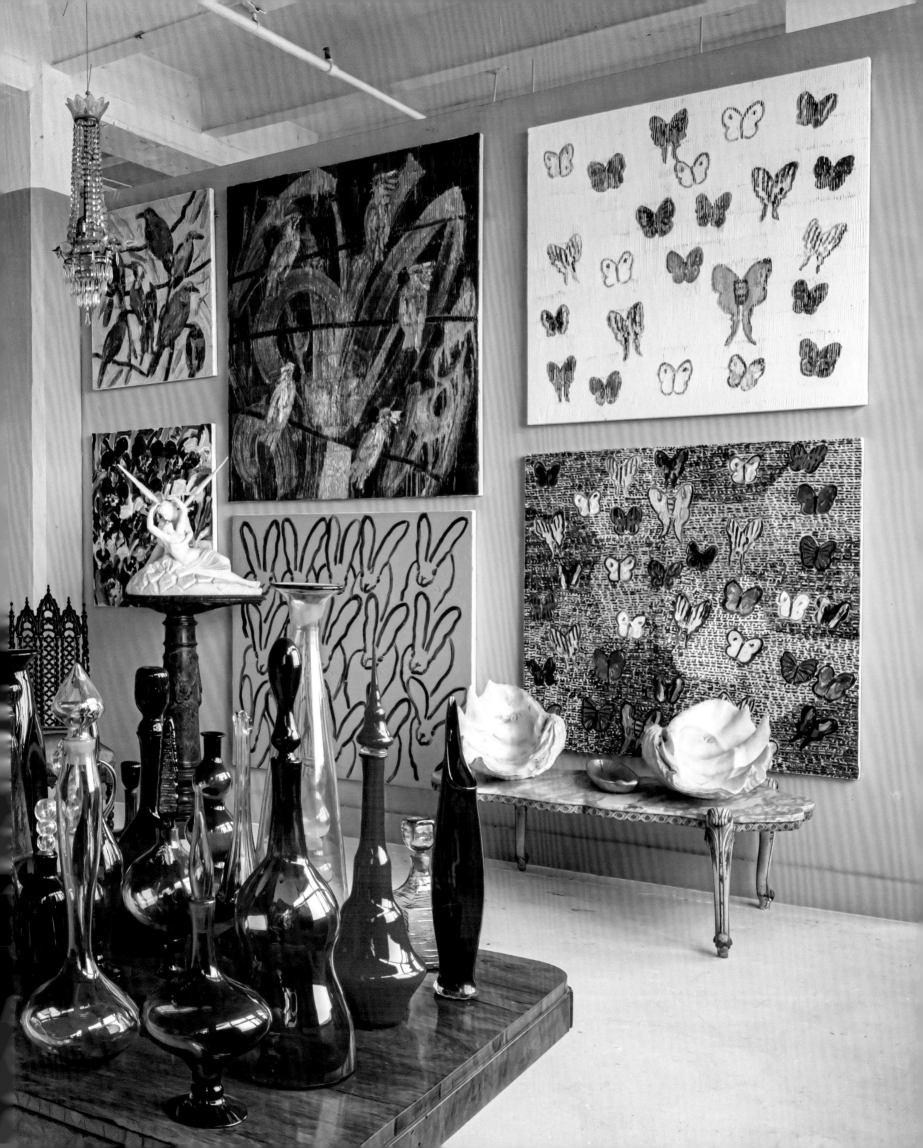

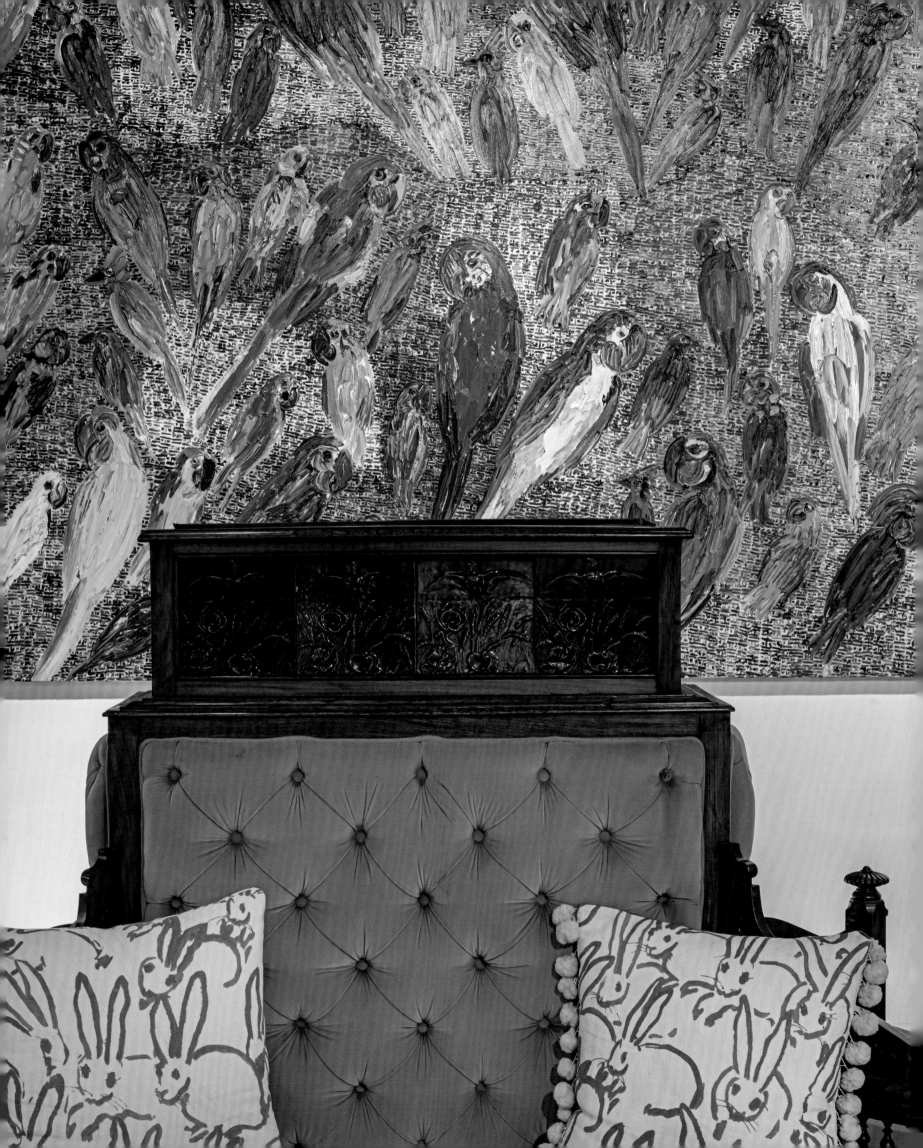

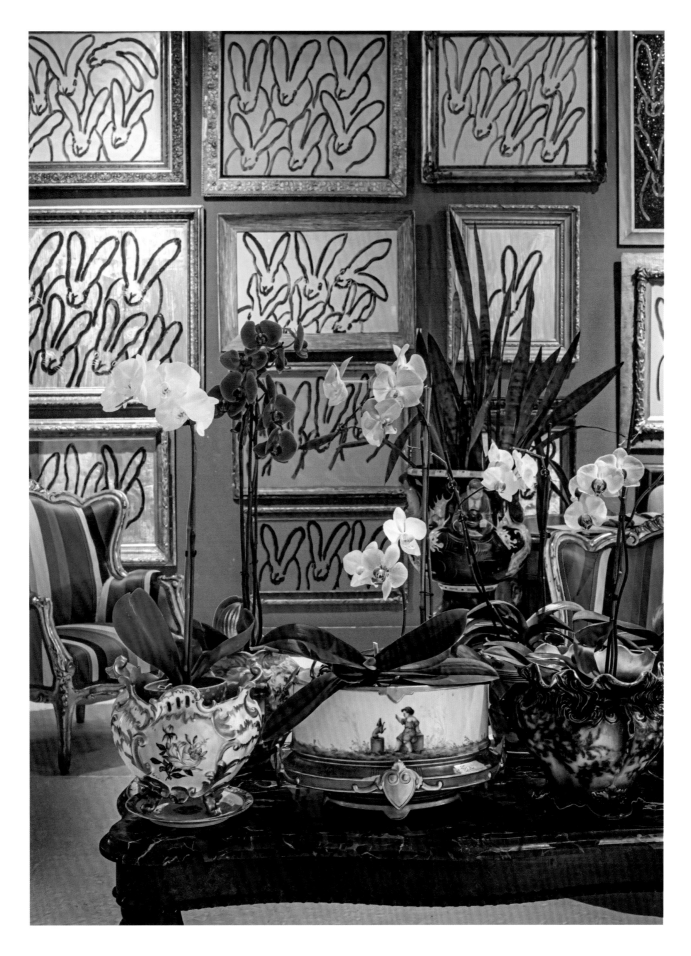

◀ An Aesthetic pouf from Lucknow, India, is set in front of *Birds & Guardians.*

▲ Orchids are displayed in Old Paris porcelain jardinières.

▲ An assortment of recent works, with a Gothic Revival Louisiana sofa (circa 1850).

▶ Detail of *Macaws* sculpture, acrylic and painted wood.

Nineteenth-century majolica jardinières and pedestals hold ferns and tropical plants in the light-filled previous studio.

Overleaf: Paintings of two sources of inspiration for Hunt: *The Countess (Xacha)*—a 1920s seer and mystic— and *Cattleyas*—a reminder of the Cattleya orchids he collected as a child in Hawaii and the most prominent flower he keeps in his studio today.

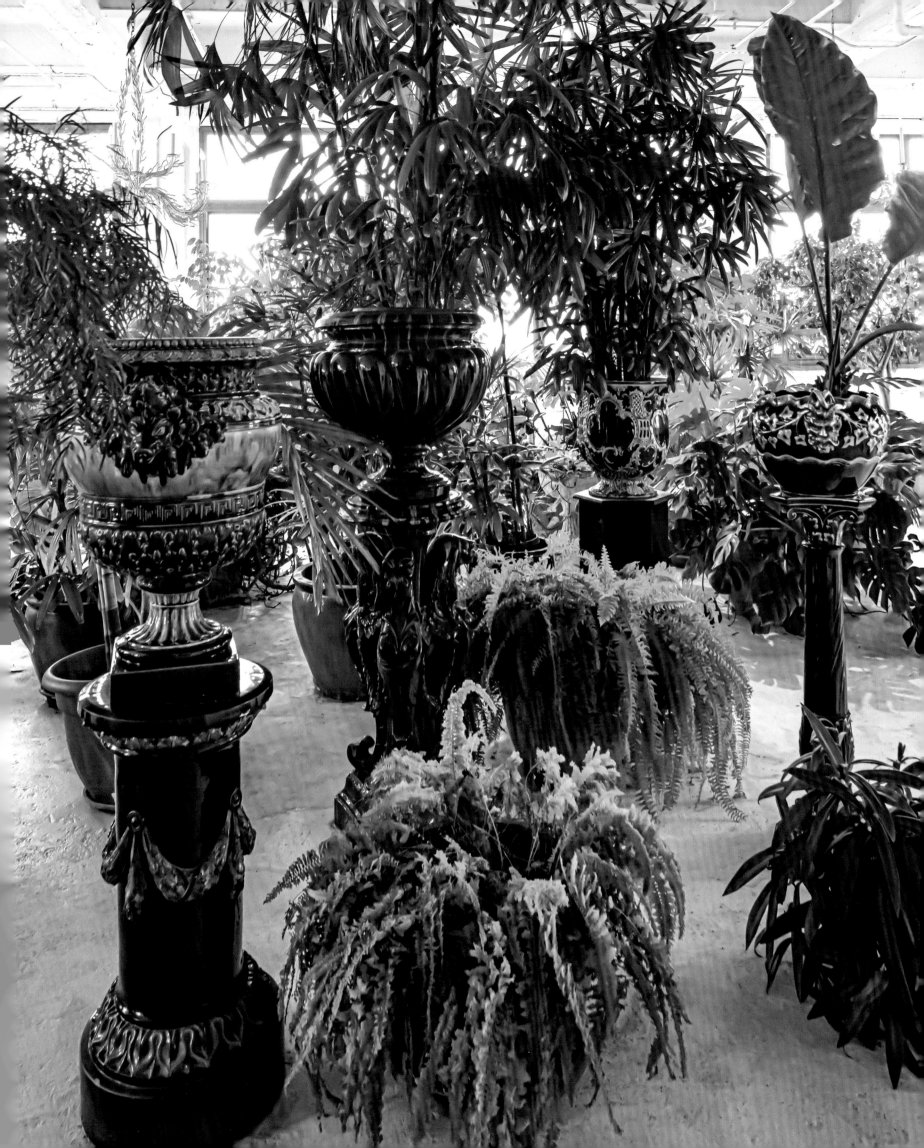

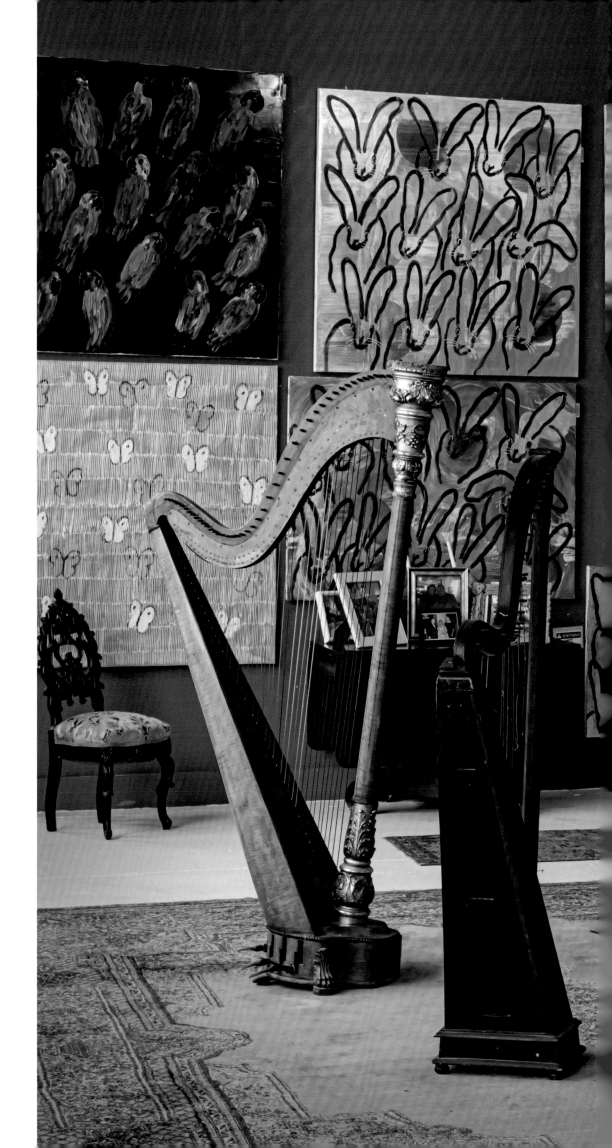

▶ Hunt surrounds himself with collections, including antique harps.

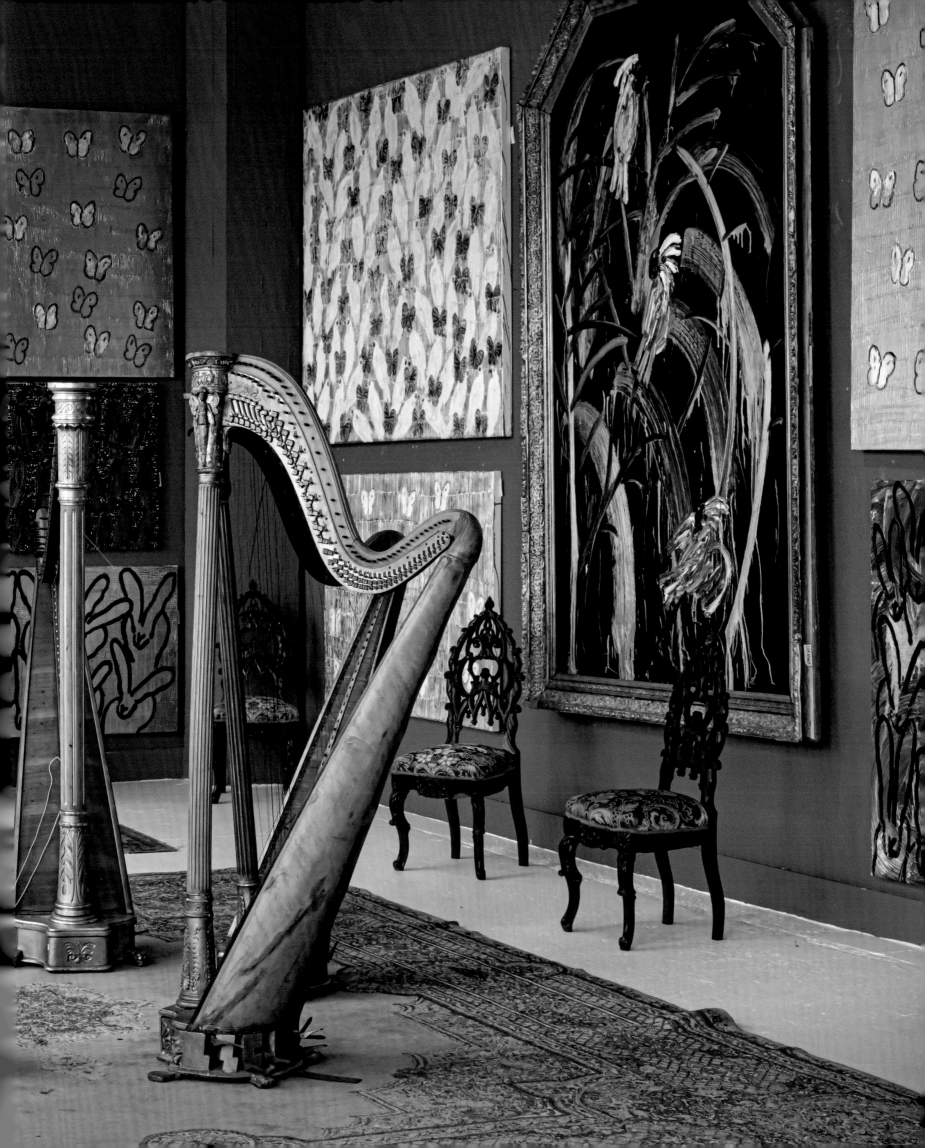

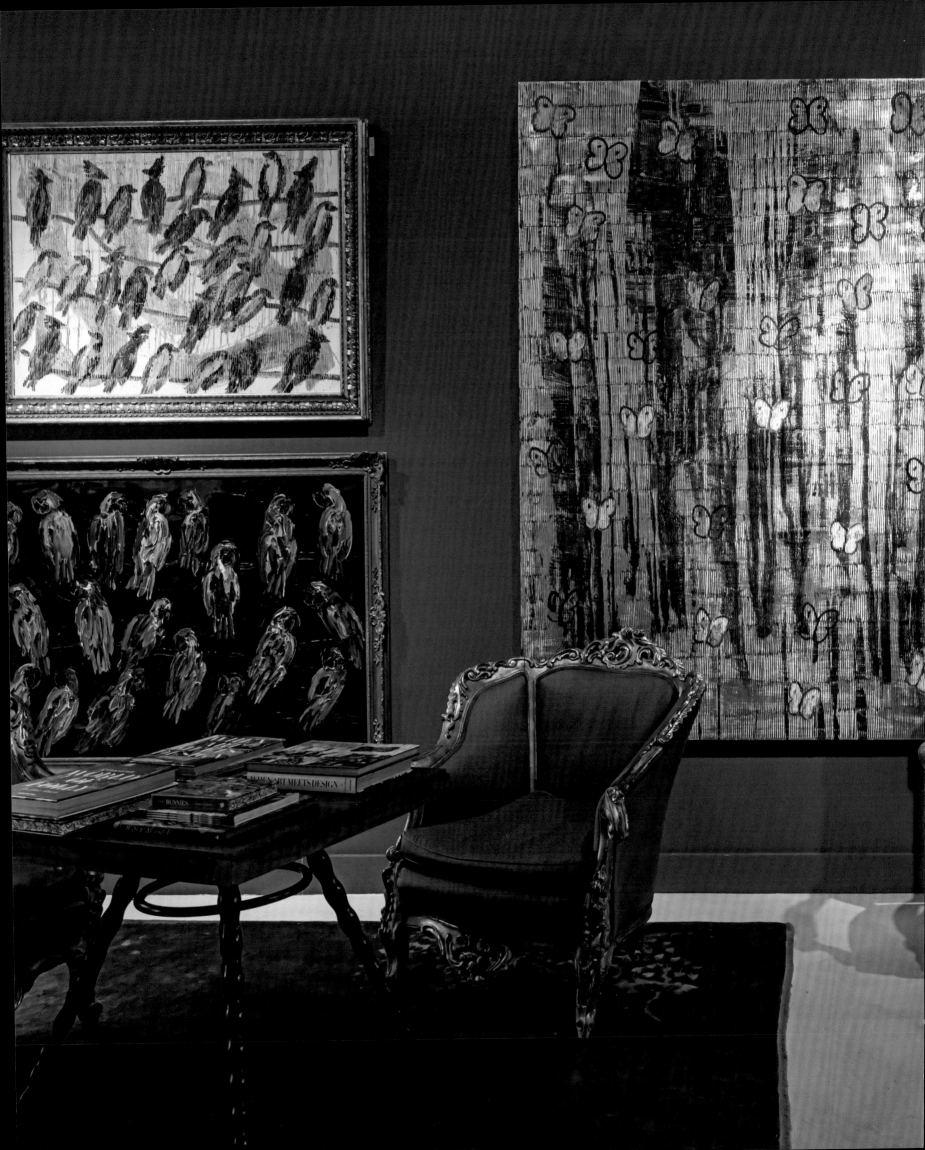

Blue Ascension centers a wall in the previous studio. Butterflies are repeated on a Victorian sofa upholstered in "Fritillary" multi fabric.

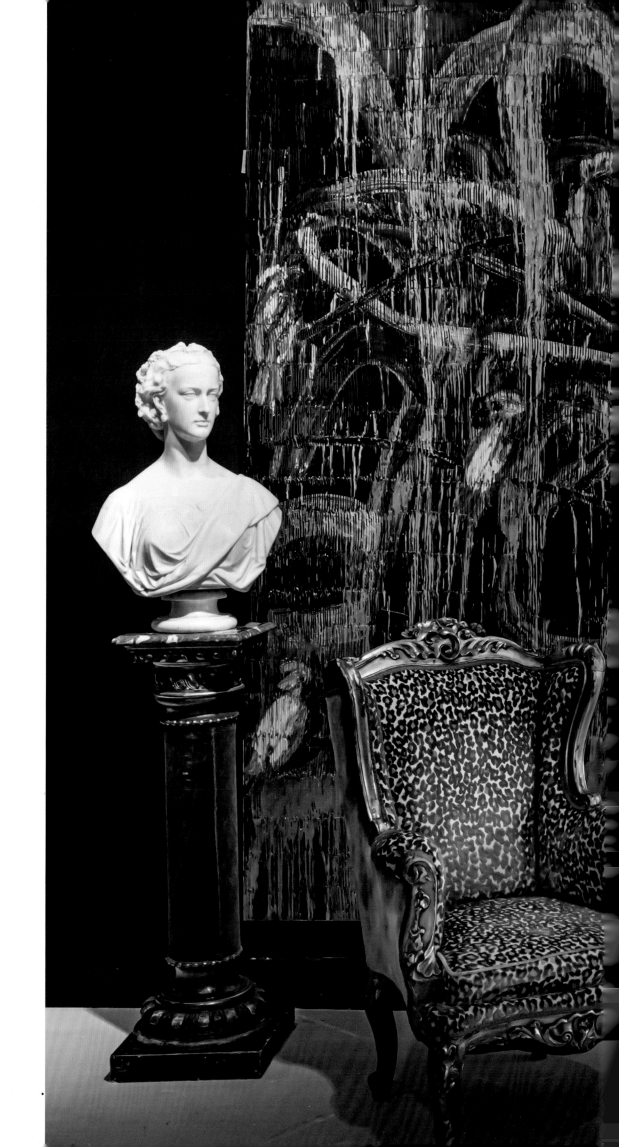

A pair of gilded armchairs and marble busts on pedestals, with *Monsoon* as backdrop.

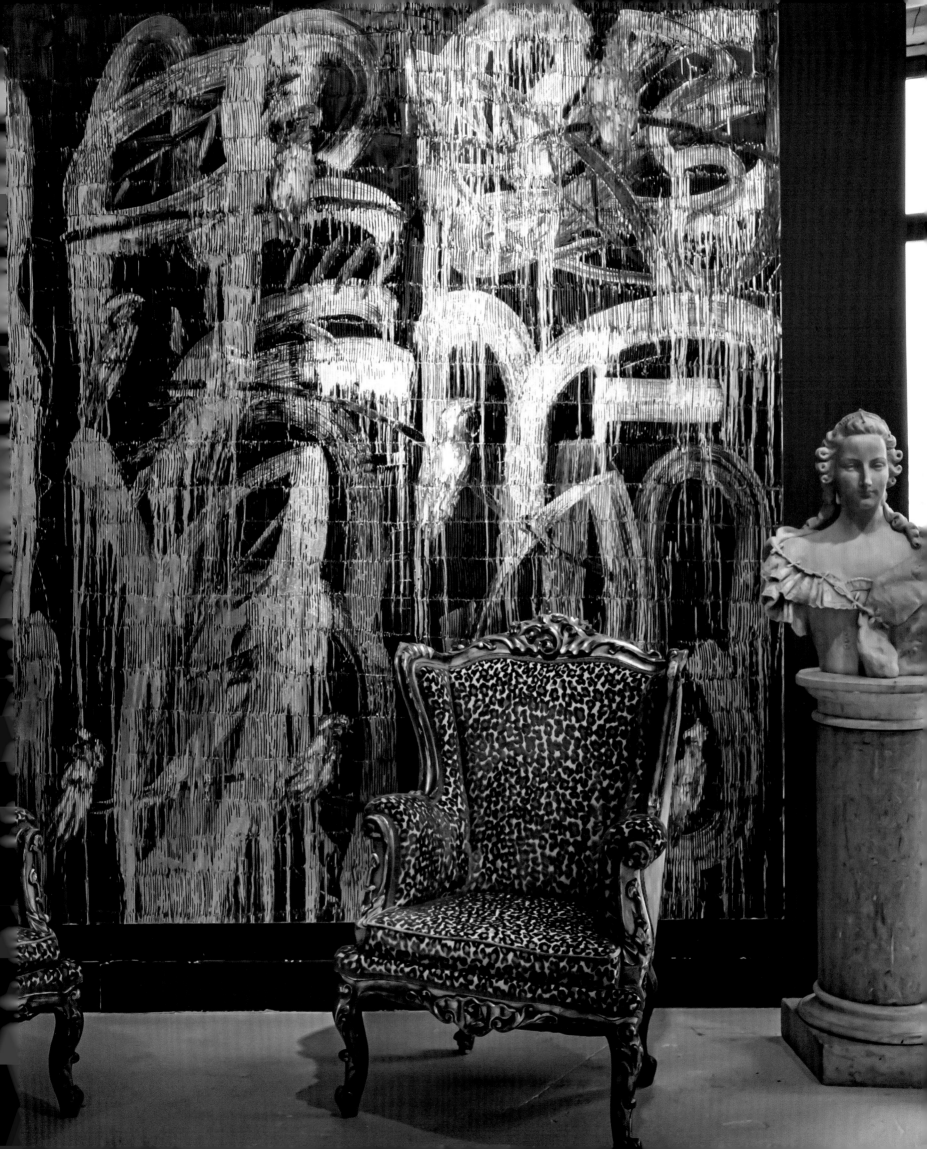

Acknowledgments

The author would like to thank the caretakers of Hunt's homes, who made our photo shoots go smoothly and efficiently; Allison Dayka, Director of Digital Communications for Hunt Slonem, who graciously helped facilitate this project; and antique dealer David Petrosky, who knowledgeably identified many antiques for us.

The artist thanks the following:

Whoopi Goldberg

Brian Coleman

John Neitzel

Allison Dayka

Eric Firestone

Gary Polukord

Allie Gallo

Elijah Sevier

Mark Millene

David Weeks

Giorgio Gogolashvili

Lena Falth

Malcolm Speirs

Mother Meera

Judith Vitanza

Angie Ramagos

Butch Bailey

Mary Frances Giordano

Chris Balton

Joe Roberts

Lisa Howard

Robert Gaughran

Marty Roberts

Jess Nordoff

Leon Grizzard

Lisa Williams

David Green

Eleanor Gronenthal

Charlie Rubin

Nicholas Sorensen

Tracy Zungola

Wady Capellan

Alexander Edwards